CENTURY
OF
CHANGE

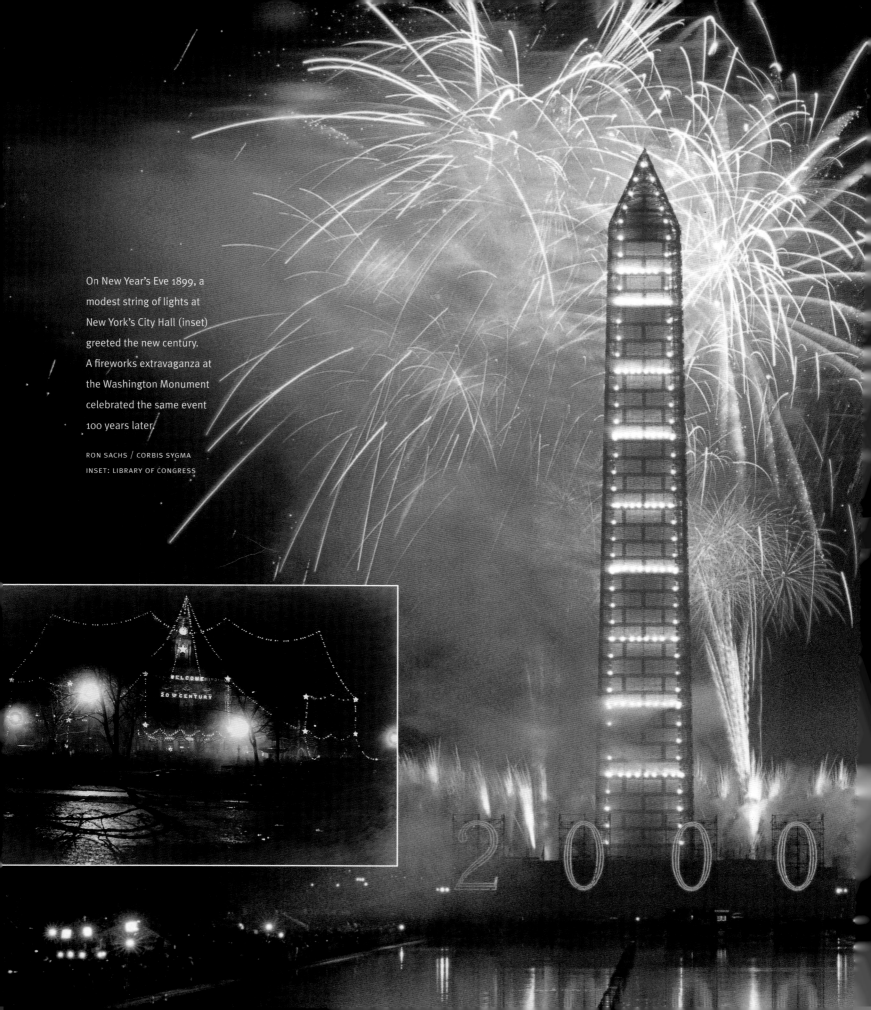

On New Year's Eve 1899, a modest string of lights at New York's City Hall (inset) greeted the new century. A fireworks extravaganza at the Washington Monument celebrated the same event 100 years later.

RON SACHS / CORBIS SYGMA
INSET: LIBRARY OF CONGRESS

LIFE

CENTURY OF CHANGE

America in Pictures

1900–2000

EDITED BY RICHARD B. STOLLEY

TONY CHIU, DEPUTY EDITOR

A BULFINCH PRESS BOOK

LITTLE, BROWN AND COMPANY · BOSTON NEW YORK LONDON

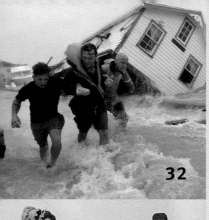

32

41

91

140

197

'This America Is Not Mere Earth'

BY RICHARD B. STOLLEY, EDITOR

O
KAY, GOES the old showbiz question, what do you do for an encore? Indeed. Our first book, *Life: Our Century in Pictures,* turned into a best-seller last year. People bought it for themselves (a personal photo album), for their kids (this is how it was), for their grandparents (you lived through much of it), for their friends and business associates (gift-wrapped). I enjoyed hearing stories about families gathered around our book, going through it page by page, reminiscing, asking and answering questions.

What we did for an encore is in your hands. We returned to the 20th Century but with a new agenda. We concentrated on the social, cultural and artistic sides of life in America, and not on the political, economic and military as we did in the first book. We looked for the American, not the global, context in which the great events of the century occurred, for the quieter times at home between war and depression and diplomatic upheaval, times that occasionally made headlines but often did not.

We were interested in the lives we Americans lived rather than the history we made.

As before, we have told the story in pictures, more than 700 of them, drawn from *Life* files and archives around the world. They show us what it was like to be an American in the last century, the clothes we wore, the places we lived in, the performers we enjoyed, the technology we relied on, the food and medicines we took, the people we put on a pedestal (or didn't).

We divvied up the century into 10 areas of interest, 10 chapters, and in each we tracked developments, progress, changes, setbacks from 1900 to 2000. As the pictures flooded in (75,000 of them), we began to see patterns and overlaps emerge. Some new wrinkle in Design affected Shopping, then Home and Family, then ultimately Celebrity.

It is fascinating to look, for example, at the first decade of the century and marvel at what was happening across the country as recorded by the pictures in this book. Men were beginning to hack at their beards with King Gillette's new invention, the disposable razor. Mostly carriages, but a few automobiles, passed by the construction site that turned into the magnificent New York Public Library. In Boston, the first X-ray in America revealed a broken arm. Jell-O was introduced, and a pizzeria opened in Greenwich Village. The ubiquitous Teddy Roosevelt dined with Booker T. Washington in the White House and camped with John Muir in Yellowstone. Out on the Midwestern plains, most settlers and their families built sod huts, but a few lived in comparative comfort in villages like Dorrance, Kansas, population 282 and counting. Crude incubators

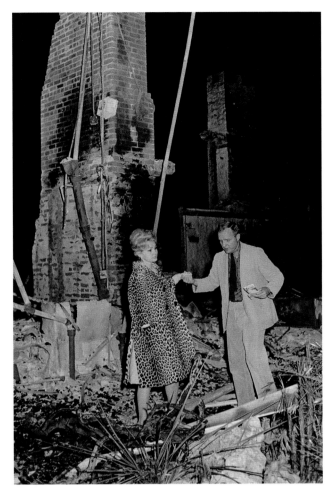

In an unwitting blend of both the Home and the Celebrity chapters of this book, Stolley, then Los Angeles bureau chief for *Life*, helped distraught actress Zsa Zsa Gabor through the burned-out ruins of her house in November 1961 (page 20). It and 446 other houses were destroyed when a massive brushfire roared out of control in one of the most affluent areas of Los Angeles. Miraculously, no one was killed.

RALPH CRANE / LIFE

were saving babies. And the exotic (fully clothed) dancer Little Egypt was touring a receptive country. For Americans then, it was surely the most exciting time possible to be alive.

We've always felt that way, regardless of the decade. It is part of the American character.

Our pictures capture this excitement through the years, I think. Some of them are amazing. Look for yourself: the first toy bear named Teddy for you-

know who; Manhattan eerily blacked out, victim of a mass power failure; the heroic Navajo "code talkers" in the wartime Pacific; two brothers who have survived almost a generation with other people's hearts; Henry Ford swinging an ax at one of his cars; Andy Warhol as you may never have seen him; Drew Barrymore with her famous relatives; the American who changed agriculture around the world.

In my introduction to *Our Century in Pictures*, I observed that the United States was fortunate beyond description to have escaped the violence and misery inflicted on so much of the world during this past century. It is true, but the reason was neither divine intervention nor the happy accident of geography. This country, in my view, has earned its prosperity and relative peace. For 100 years, we moved ahead, gradually improving some of our citizens' lives, then more of them, aiming for all, faltering, recovering, rescuing democracy from evil, offering compassion across our borders, building economic and political institutions at home that astonished the world.

The Illinois poet Edgar Lee Masters wrote of it in the 1930s: "For this America is not mere earth / But living men, the sons of those who shouldered / A destiny and vision. . . ." Our book is the story of how we survived the century and the transition from rural homogeneity to noisy urban multiculturalism. It is a story we should enjoy, share and, most of all, be proud of.

Joining Life *magazine in 1953, Richard B. Stolley served as chief of its bureaus in Atlanta, Los Angeles, Washington and Paris and later as its editor. He was founding editor of* People *magazine in 1974 and then editorial director of the parent company, Time Inc., for which he is now senior editorial adviser. In 1999, Stolley edited* Life: Our Century in Pictures.

home

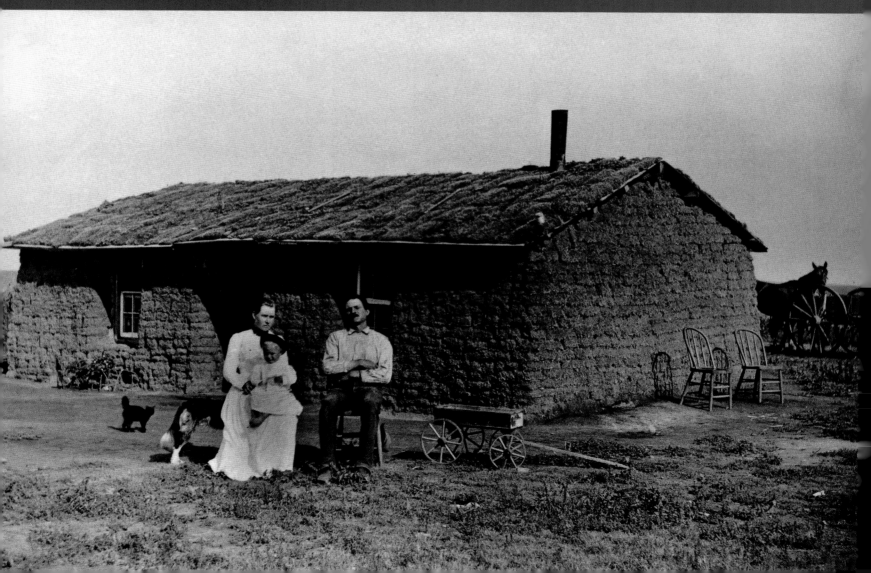

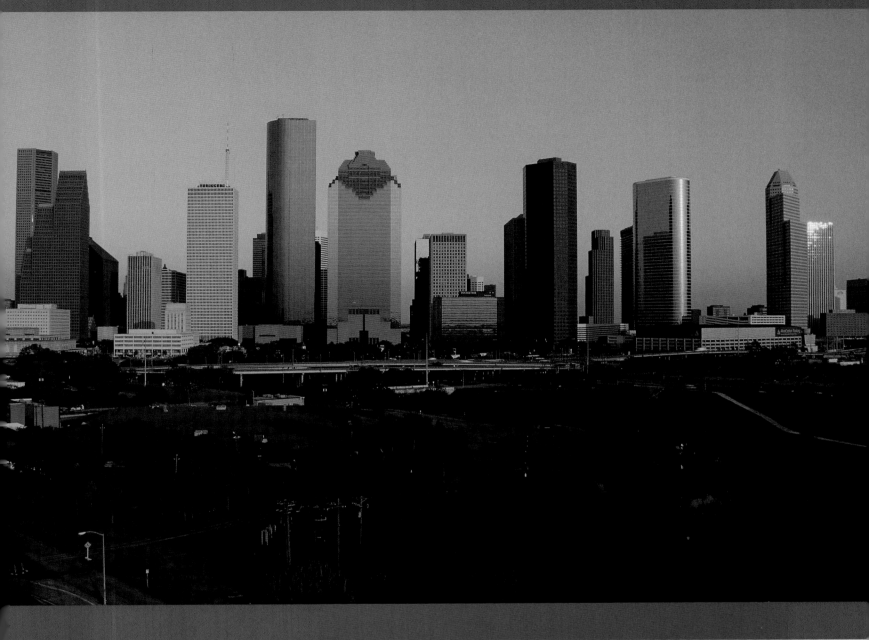

Posing at the turn of the century in front
of its sod house: the George Golden
family of Custer County, Nebraska.
A 160-acre tract of public land cost $200 —
or nothing, if homesteaded for five years.
The shift to urban life is typified by the
growth of the largest city in Texas, Houston.
Today, 1.75 million people call it home.
In 1900, only 45,000 did.

FAREWELL FARM,
HELLO BIG CITY

Our Rural Past Is Prologue

BY JOHN R. STILGOE

WHAT IS THE suburban home, this icon of the American Dream? Nowadays it often lacks an attic, but it holds the past nonetheless. Approach it from any street in the Republic, stroll around outside it, probe through it with ruthless scrutiny. It is the colonization of North America, the Constitution, the industrial revolution, the agrarian values that underlie contemporary metropolitan life, the enduring insistence on wilderness and control, privacy and community, tradition and modernity. Yet always, it is first a farm.

Farms grow houses last. Mile by mile, subdivisions extend away from cities and small towns alike, overwhelming farmland as they have since the 1820s. Nowadays selling a farm often means hitting the lottery, for the last crop brings money enough for retirement, for legacies to children uninterested in farming, for buying another farm far away from sprawl. As one farmer after another sells out, farming grows difficult for those remaining and for businesses dependent on farming. First the tractor dealer closes, then maybe the feed mill, then the slaughterhouse, then the fertilizer dealer, each closing forcing farmers to drive farther for vital supplies and services.

But the newcomers hasten the demise of farming too, even in this era of right-to-farm legislation.

They complain of dust raised in the spring, of the smell of manure used by organic farmers and of the cloying, sweet scent of pesticides and herbicides sprayed by others, of lumbering tractors delaying traffic on narrow roads, of biotech loose in the barnyard. Picturesque farming — wood barns and fences, stone walls and mixed crops, varied livestock and small fields — indicates either economic stagnation and failure or hobby farming. Prosperous farming shows itself in the immense flat fields created for gigantic tractors pulling high-technology seeding, cultivating and harvesting equipment, in metal barns and machinery sheds, in towering, glass-lined crop-storage cylinders and enormous rolls of hay, above all in specialization, of raising one crop or breed of livestock only. Far from cities and suburbs, prosperous farm country nowhere resembles the mixed-agriculture, circa 1850 landscape of museum paintings, Currier & Ives lithographs, Depression-era photographs and contemporary children's books. But that is the landscape most Americans still value above all others, the landscape before the horror of the Civil War and the wrenching changes of the industrial revolution and subsequent urbanization, and it is that landscape they re-create in miniature as home once the real farmers leave.

Walk the grounds of any suburban home. The front and back lawns represent meadow and pasture. Only rarely is the front-lawn meadow used for any ac-

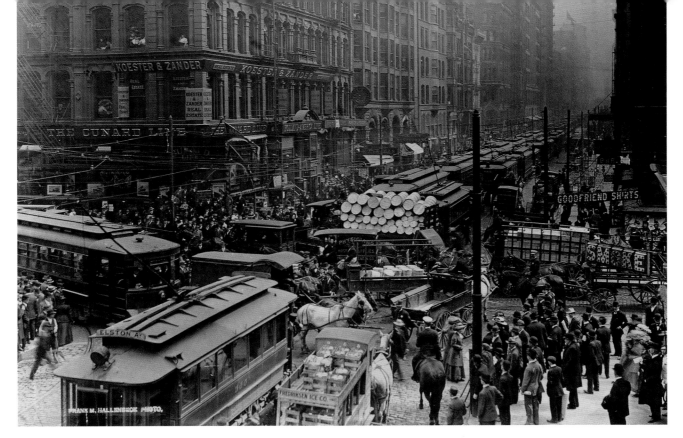

By 1909, 38 years after the Great Fire, Chicago had recovered to the point of gridlock. Two million people lived in the economic center of the Heartland, second only to New York City's 4.8 million.

CHICAGO HISTORICAL SOCIETY

tivity, and as Little Boy Blue once kept away sheep, homeowners keep away dogs. But they regularly fertilize and mow it, although no one collects and dries the mowed grass as hay for winter livestock feeding. The back lawn, less rigorously maintained, pastures the domestic animals that serve as substitute livestock, the dog and the cat — and perhaps a rabbit in a hutch, maybe a guinea pig outdoors in summer. In the vegetable garden, sometimes merely a wooden tub planted with patio tomatoes but carefully weeded and fertilized, the thoughtful explorer finds a trace of long-ago arable fields, and in the one or two fruit trees, often species that flower but never bear fruit, the explorer sees vestiges of the orchard and the lone pasture trees that shaded livestock in summer. Usually the deciduous trees are pruned of their lower branches, and the height to which they are pruned, a height half-consciously known to every

suburban American armed with handsaw and shears, is what 19th Century farm families knew as the "browse line," the height up to which cows nibble leaves from trees. Even now, decades after the perfection of the attached garage, a small shed often interrupts the backyard, and in it slumbers a riding lawn mower, maybe one manufactured by the same firms that make farm tractors, along with bottles and boxes of organic and inorganic fertilizers, insecticides and the herbicides that kill crabgrass. While the whole ghost farm may not have an in-ground irrigation system, almost always it has hoses and sprinklers. Sometimes it even has a livestock-watering pond turned swimming hole, carefully chlorinated of course.

Over this miniature ghost farm, the American family exerts control. Much of it is maintained, often by children doing chores derived from long-ago agricultural effort but sometimes by hired hands, at great cost in time and effort. The front lawn must be green in droughts, free of crabgrass and regularly

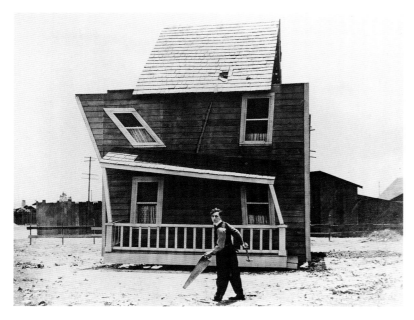

In the 1920 one-reeler *One Week*, Buster Keaton hoped to join the 45 percent of Americans who owned a home. The kit guaranteed a house in no more than seven days. Where's the Tool Guy when you need him?
THE KOBAL COLLECTION

mowed. Fallen branches must be collected, leaves must be raked, and lately, wood mulch must be spread around the shrubbery. Fascination with landscape control originated before the Civil War, when political control deteriorated and agricultural newspapers insisted that farm-family morality advertised itself in well-maintained fields, fences and buildings. Good fences made good neighbors by confining livestock, and weed-free fields meant that few weed seeds blew downwind. Farmer Slack caused all sorts of troubles for his neighbors, but Farmer Proud reached out even to strangers, planting trees along the road to shade travelers in summer.

Since the well-ordered American farm represented in microcosm the emergent and still somewhat disordered landscape of the Republic, every farm family owed every traveler a pleasing view, and that pleasing view originated in the fields and woodlots and orchards and buildings that epitomized order and industry and purity. Expensive white paint, the paint of the pure-minded young Republic, which prized its white-painted Capitol, appeared on the fronts of houses by the 1820s even when sides and backs went unpainted or were covered with the far cheaper red paint that was also slathered on barns and other structures away from the road. The white-painted houses glaring in sunlight advertised the artificial agricultural order won by immense effort from the shadowy forest wilderness that only continuous effort kept from retaking the fields, the wilderness that symbolized political dangers stalking the Republic. Surrounded by well-ordered fields, the white-painted house exemplified order created and maintained by families working together.

By what signs does one know the morality of apartment dwellers? What does the apartment dweller do *personally* to beautify the public view? Such were the questions asked as late as the 1950s by social critics convinced that people renting apartments lurked in temporary anonymity, that they did not really live but only dwelled in units over which they exerted no real control, that demonstrated nothing of their ability to order nature, maintain social order and please passersby. Manufacturers and advertisers advanced the message, for homeowners bought everything from washing machines to lawn mowers, but the Depression, then World War II, delayed the vast move to the suburbs made possible after the war by GI loans.

GIs and their wives bought the small, freestanding house-on-a-lot that Hollywood insisted lay at the end of the post-Depression, postwar lover's lane. The love-nest cottage stood behind a rose-covered picket fence, and while its grounds remained remarkably like the farm-in-miniature ones of earlier suburban homes, its interior announced changed notions of United States living. The parlor gave way to the ever less formal living room, the dining room struggled vainly against breakfast nooks and open-form eating areas, and television lured everyone into the den. Places for work and storage disappeared. Cabinets replaced the pantry, sewing rooms van-

ished, laundry rooms shrank to closets filled with washer, dryer and a shelf for detergent. Gas- and oil-fueled furnaces shrank cellars once necessary for food storage, then for coal bins serving immense furnaces. While the conversion of cellars to rumpus rooms began in the late 1930s as coal bins vanished, by the 1960s new houses sat atop mere crawl spaces that forced Dad's workbench into the garage. Informality shaped everything from family rooms to barbecue-studded patios and decks, picture windows let passersby see perfect families enjoying perfect family harmony, and all the while, the vast subdivisions from which men commuted were built ever farther away from work-for-money.

Into the 1960s, the well-cared-for house symbolized the subtle and important care women lavished on their husbands and children. Each well-kept house and lot became a family refuge from the social, economic and cold war disruptions that nonetheless sneaked indoors by television. The shutters once made of wood and hinged to shade windows in summer and protect glass in winter gales became ornaments. But those plastic shutters nailed alongside windows reminded thoughtful observers that — at least in theory — the American home can be sealed off against disorder and become as self-sufficient as an 1850 farmhouse nestled down against a blizzard.

Balance, control and order, which survived from long-past agricultural values, now expand in scale. Americans expect the cleanliness of vacuumed rugs and mowed lawns to extend beyond family property lines to entire subdivisions and regions. They expect harmony maintained among competing land uses. They want the wilderness preserved yet made accessible; they want streams made clean but streets to drain instantly after heavy rain; they want traffic jams unsnarled, factories screened behind trees, shopping malls nearby but not too close to overwhelm Main Street merchants; they want fresh food in supermarkets but no heavy

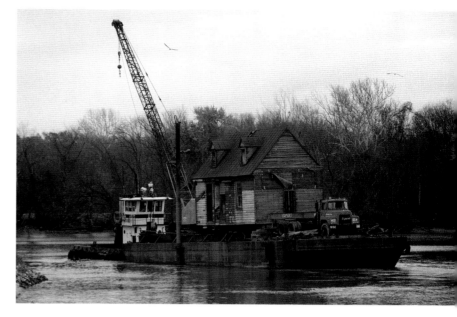

In 1994, two centuries after Richmond View was built, the landmark Virginia house was barged down the James River for preservation in a park. The 45-mile cruise to Charles City County took six hours.

LINDY RODMAN / RICHMOND TIMES-DISPATCH

truck traffic; they want privacy but not loneliness.

Against the national memory of the traditional farm and the landscape of farms, maintained and cherished by independent families and like-minded neighbors, the memory kept alive on every suburban house lot, grates the reality of technological, social and economic change that is essentially urban.

Modern architecture gives form to factories, office towers, shopping centers, even schools. But the American house and residential neighborhood remain true to our agricultural origins. The American Dream still conjures up the farm-family space and structure that dominate the suburban landscape in which more than half of all Americans live and which extends farther into rural America every day.

John R. Stilgoe is Robert and Lois Orchard Professor in the Department of Visual & Environmental Studies at Harvard University. He is the author of Borderland: Origins of the American Suburb, Metropolitan Corridor, Alongshore, *plus other books and scores of articles.*

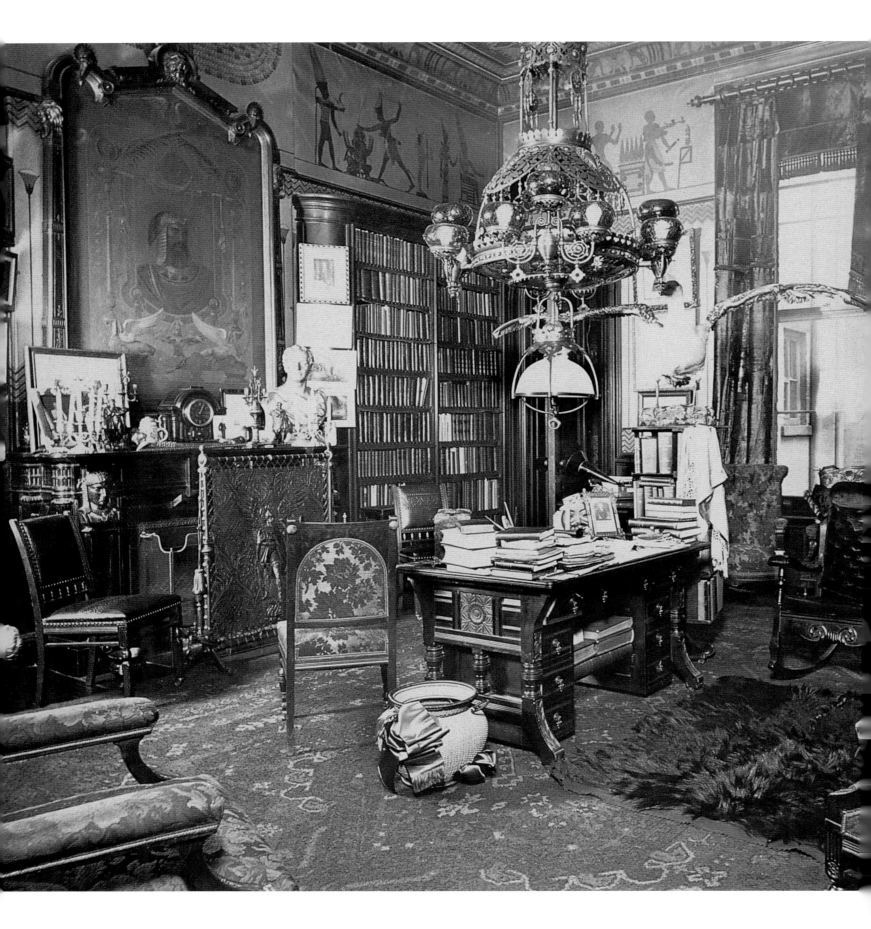

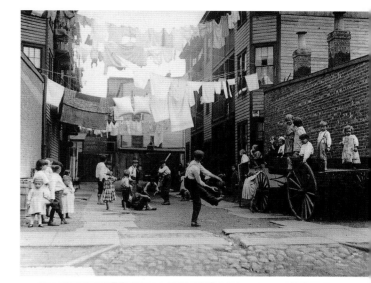

THE WAY WE WERE

At the dawn of the 20th Century, U.S. industry was concentrated in the North-east and Midwest, as were the immigrants who came to work in the factories and the mills (right, tenements in pre–World War I Boston). The average annual wage in 1900 was $418 — a mere $7,900, adjusted for inflation — but some were obviously doing better, like the Sturgeon Bay, Wis-consin, family (middle right) photographed in 1903. Nowhere was poverty greater than in the South, and none were more desperate than blacks like the Virginia family (bottom right) still occupying an old slave cabin. As late as 1910, 80 percent of America's blacks lived in the 11 states of the defeated Confederacy.

ABOVE RIGHT: LEWIS W. HINE / GEORGE EASTMAN HOUSE
RIGHT: HARRY DANKOLER / STATE HISTORICAL SOCIETY OF WISCONSIN
BELOW RIGHT: COOK COLLECTION / VALENTINE MUSEUM

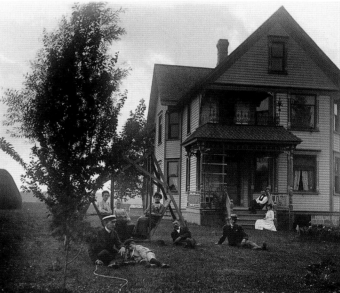

<

CAPITALISM'S BOUNTIES

In 1899, this library was one of 32 rooms in the midtown Manhattan home of Chauncey Depew. That year the longtime president of the New York Central Railroad was kicked up to chairman so that he could serve in the U.S. Senate. America had five million millionaires in 1999; a century earlier, Depew, 55, was one of just 3,000.

BYRON COLLECTION / MUSEUM OF THE CITY OF NEW YORK / ARCHIVE PHOTOS

AT THE CROSSROADS

In 1910, 40 years after its founding, Dorrance, Kansas, boasted a post office, a drugstore, two churches and 281 residents. But farming towns, long America's backbone, were about to be hit by the exodus to the cities. In 1998, Dorrance's population stood at 182.

KANSAS STATE HISTORICAL SOCIETY

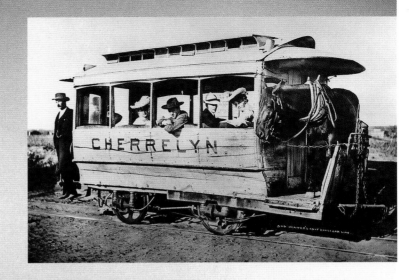

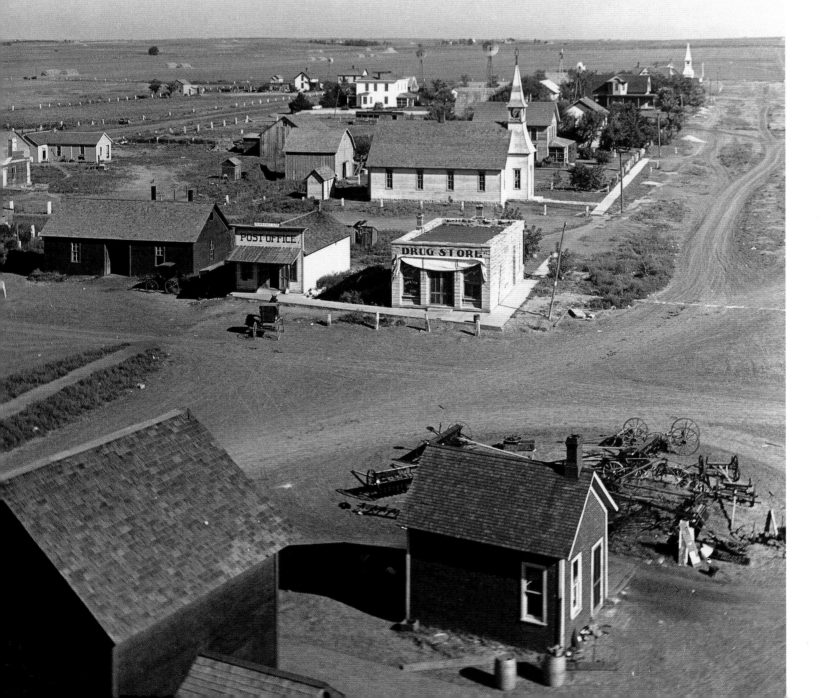

DON'T LOOK BACK

Denver was certainly no one-horse town in 1900 (population: 133,859), but it had a trolley that was strictly Toonerville. The Cherrelyn Line's 1½-mile route was served by a single car, shown at left on its three-minute downhill run. On the 15-minute uphill trip, Dobbin had to get out and pull.

DENVER PUBLIC LIBRARY, WESTERN HISTORY COLLECTION

>
INFORMATION, PLEASE

The Manhattan phone books being delivered in 1910 were far slimmer than today's 3½-pound door- stops. Since the launch of commercial telephony in 1876, 7.6 million had subscribed, mostly in the Northeast; the New York Telephone Company alone employed 6,000 operators. Today there are 178 million accounts nationally.

NEW YORK TELEPHONE COMPANY

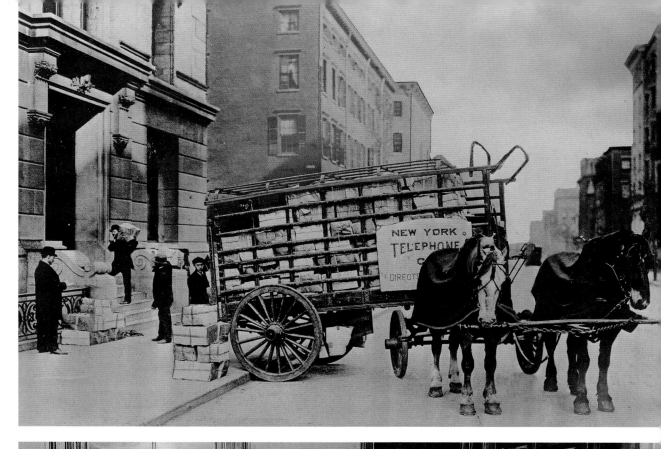

>
STAYIN' ALIVE

Turn-of-the-century immi- grants like this family in New York City (whose 1910 population was 40 percent foreign-born) lived hand to mouth. To supplement Dad's $1.50 a day as an unskilled laborer, Mom put everyone to work making artificial flowers. At a dime per six dozen, it took 24 dozen a day to cover the rent. One victim of such survival tactics was child- hood education.

MUSEUM OF THE CITY OF NEW YORK

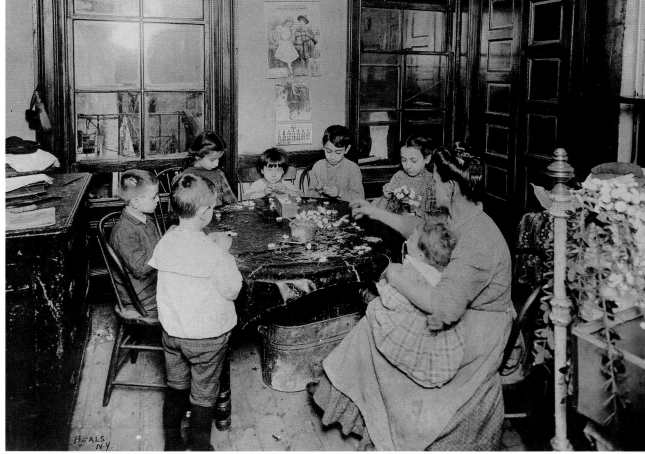

CLOSE UP

The Liquidator

In the early 1900s, the brackish Los Angeles River provided the drought-prone city's 100,000 residents with their only potable water. So waterworks head William Mulholland decided to siphon mountain runoff from distant Owens Valley. Ranchers there squawked. But Mulholland's pals — secretly buying up arid acreage around L.A. — thwarted Owens Valley's own irrigation project. Mulholland built his aqueduct (which, until 1928, was guarded against sabotage by armed riders). In 1975, a case challenging the diversion of Owens Valley water reached the California Supreme Court. The system that provides L.A. with 80 percent of its water was ruled legal.

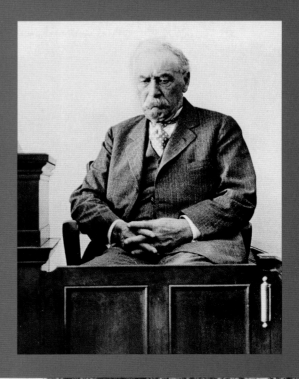

On November 3, 1913, water from 238 miles away first reached Los Angeles (below). Declared Mulholland, who had built the $23 million aqueduct in five years: "There it is. Take it." In 1923, at 68 (below left), he was still visiting project sites. But in 1928, one of the system's intermediary dams collapsed, killing 500; though found blameless in court (right), Mulholland soon left office.

LOS ANGELES DEPARTMENT OF WATER AND POWER (2)
RIGHT: CORBIS / BETTMANN-UPI

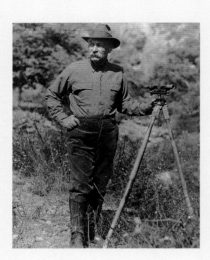

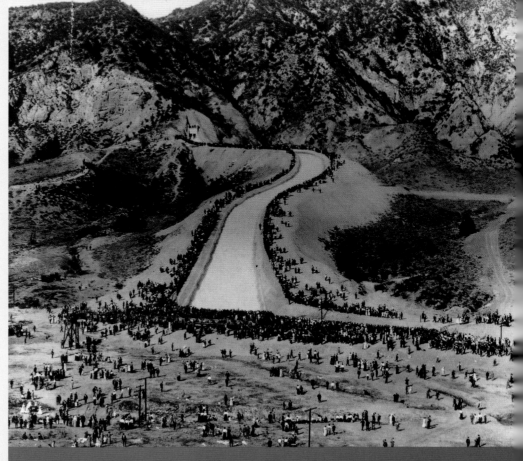

His reputation was tarnished by the dam disaster and by later revelations of cronyism with land speculators, yet two Los Angeles landmarks bear Mulholland's name. The water from Owens Valley is stored in Hollywood Reservoir (right, a mid-1920s postcard), formed by Mulholland Dam. And the most spectacular views of the City of Angels (below) and the San Fernando Valley — both nourished by Owens Valley water — are from Mulholland Drive.

RIGHT: CORBIS /
LAKE COUNTY MUSEUM
BELOW: JOSEPH SOHM /
CORBIS / CHROMOSOHM INC.

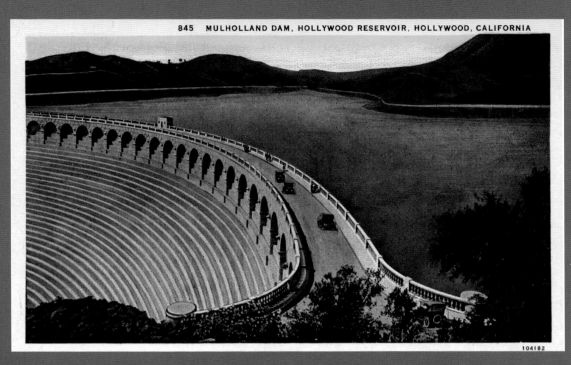

845 MULHOLLAND DAM, HOLLYWOOD RESERVOIR, HOLLYWOOD, CALIFORNIA

104182

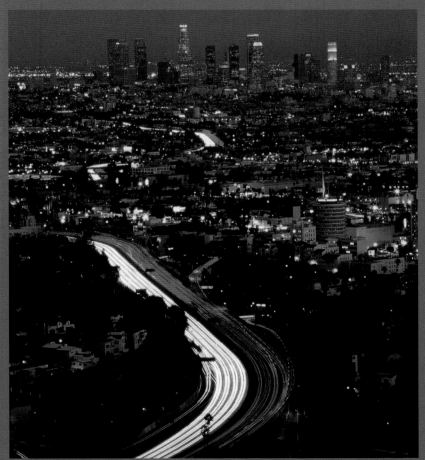

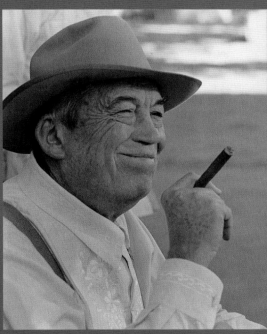

The skulduggery and violence behind the channeling of Owens Valley water to Los Angeles were fictionalized in the 1974 movie *Chinatown*. John Huston, 68 (above), played larcenous mastermind Noah Cross. But to make sure no one missed the Mulholland connection, other characters were named Mulwray and Mulvahill.

PHOTOFEST

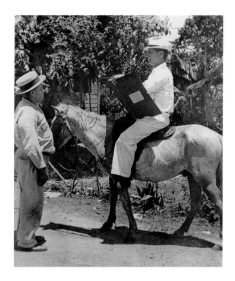

WHERE'D EVERYONE GO?

The census data collected in 1920 (above, one enumerator traveled by donkey) revealed that America was no longer a rural nation. Fifty-one percent of its 106 million citizens now lived in cities. The population leaders were New York, Chicago and Philadelphia; at No. 10 — its highest ranking to date — was Los Angeles.

U.S. CENSUS BUREAU

UNCLE SAM HELPS OUT

Begun in 1933, the Civilian Conservation Corps was a Depression lifeline to men aged 18 to 25. Volunteers got bed, board and medical care at a work camp, plus $30 a month; in return, they toiled on reforestation and reclamation projects. Some three million served before the U.S. found a more pressing duty for its young men: fighting World War II.

LIBRARY OF CONGRESS

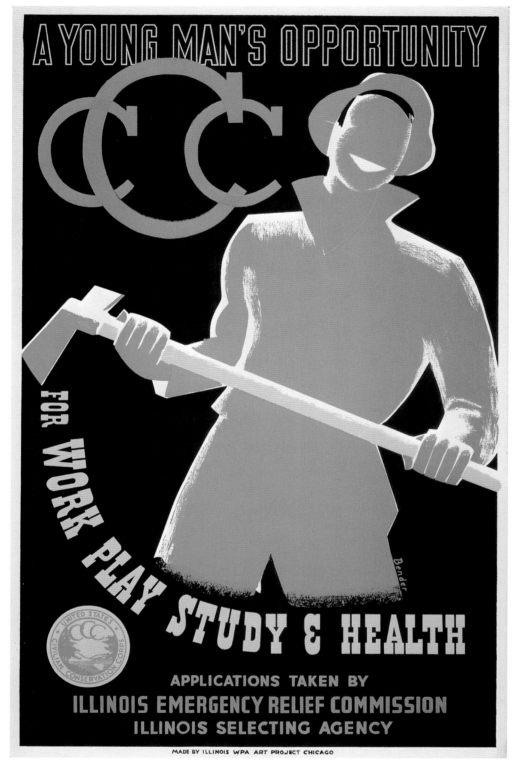

A YOUNG MAN'S OPPORTUNITY

CCC

FOR WORK PLAY STUDY & HEALTH

APPLICATIONS TAKEN BY
ILLINOIS EMERGENCY RELIEF COMMISSION
ILLINOIS SELECTING AGENCY

MADE BY ILLINOIS WPA ART PROJECT CHICAGO

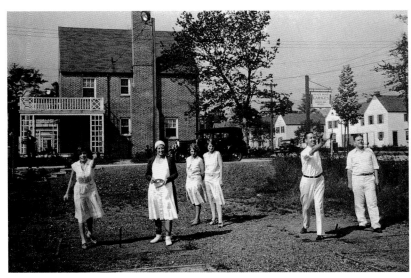

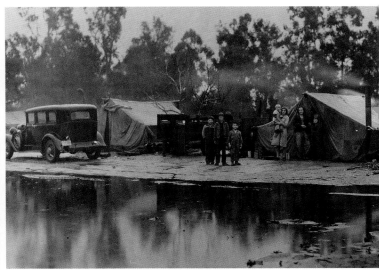

GIMME SHELTER

Pitching horseshoes in mid-1929: early residents of Radburn, New Jersey (above), a new planned community 16 miles west of New York City. Its builders' vision of creating a suburb of 25,000 vanished after that fall's market crash. The Depression resulted in widespread evictions everywhere (right, the Lawsons of Los Angeles were one of 273,000 families thrown out of their homes by the nation's sheriffs in 1932). Many of the dispossessed hit the road in search of work (above right, a 1937 camp for pea pickers in Nipomo, California). In the 1930s, migrants contributed to population surges of at least 20 percent in Florida, New Mexico, California and Nevada.

CLOCKWISE FROM ABOVE: RADBURN HISTORICAL SOCIETY / AP; DOROTHEA LANGE / RESETTLEMENT ADMINISTRATION; CORBIS / INTERNATIONAL NEWS PHOTOS

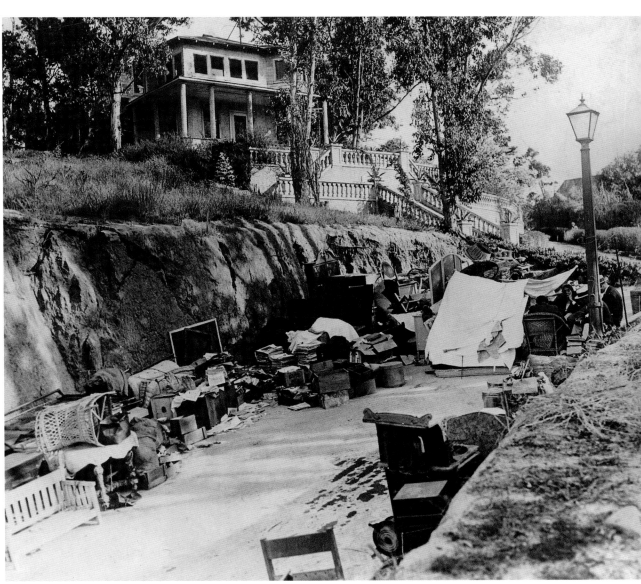

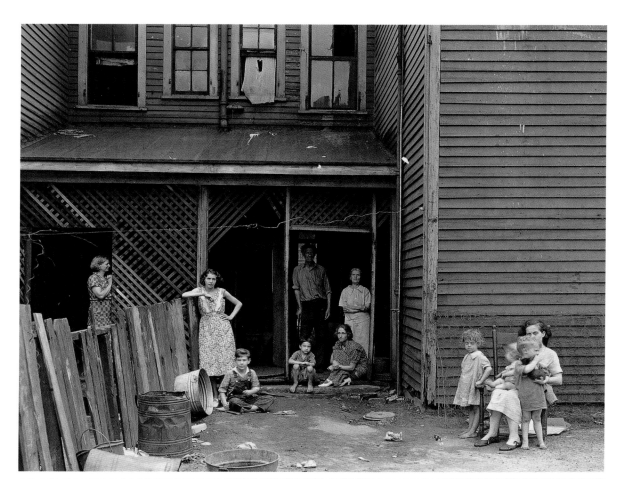

URBAN RENEWALS

A hardscrabble slum in downtown Atlanta (left) gave way in 1935 to the first public-housing project built with federal funds (below left). The $2.1 million Tech-wood Homes (named for nearby Georgia Tech University), which had 457 units, initially charged $16.40 a month for three rooms. It, in turn, gave way in 1995 to Centennial Place, a mixed-income complex with 900 units planned and one-bedrooms starting at $749.

BOTTOM: CORBIS / ACME

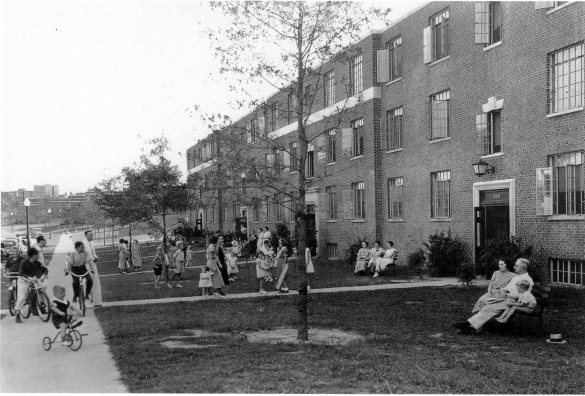

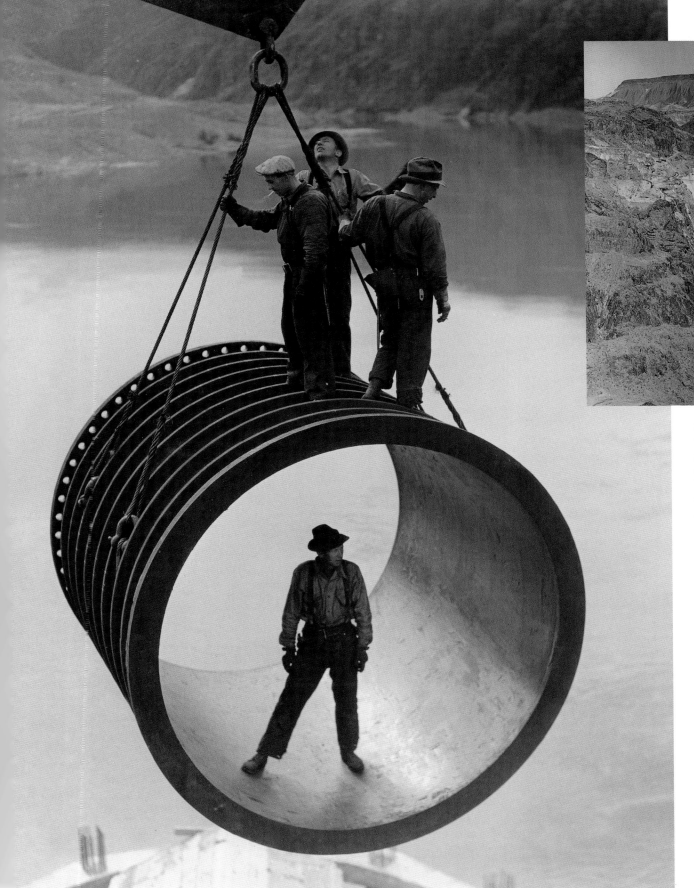

A RIVER RAN THROUGH IT

Workers in 1938 hitched a ride on a 13-ton length of conduit (left) as it was lowered into place on Grand Coulee Dam, being built across Washington's Columbia River. The lower Colorado River had already been harnessed by Boulder Dam (above, in 1938; it was renamed Hoover Dam in 1947). The two Depression-era projects would provide enduring benefits. The Hoover, on the Arizona-Nevada border, has enabled the growth of the South-west. And Grand Coulee, still the largest U.S. source of hydroelectricity, powers up the Pacific Northwest.

ABOVE: STOCK MONTAGE INC. /
HARRIS & EWING
LEFT: BUREAU OF RECLAMATION /
DEPARTMENT OF THE INTERIOR

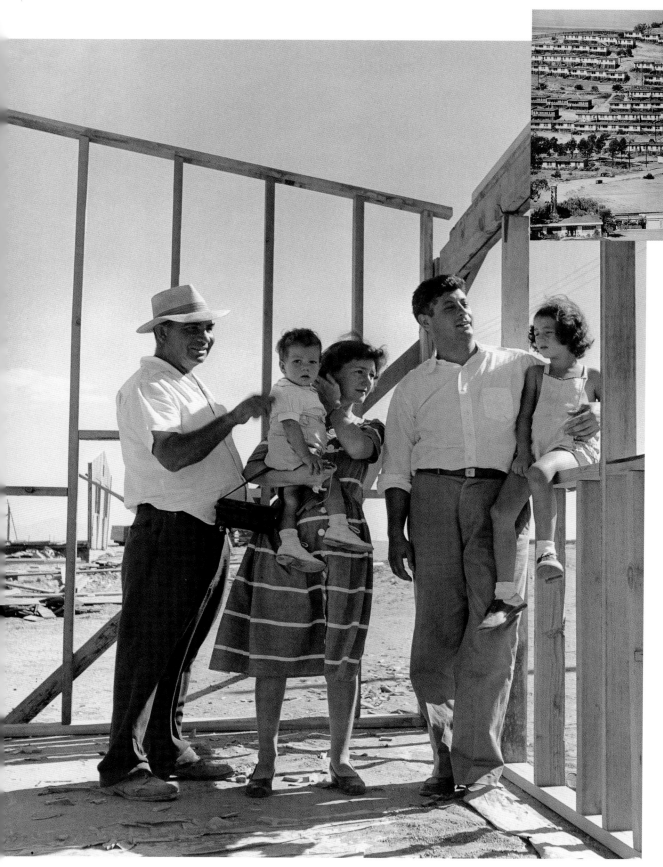

HOMESTEAD ACTS

After Pearl Harbor, the government hastily erected digs to attract defense-industry workers; those quartered in the Vallejo, California, project above built ships at nearby Mare Island. Because of housing shortages, the units remained occupied even after the war. One provision of the 1944 GI Bill promised servicemen low mortgage rates. In 1948, a vet and his family at a nascent development in Tucson (left) looked to cash in the IOU.

ABOVE: ANDREAS FEININGER / LIFE
LEFT: PETER STACKPOLE / LIFE

>
AND HOW WAS YOUR DAY?

The post–World War II baby boom coincided with the first great migration by professionals from America's cities. Bedroom towns like Larchmont, New York (right, Dad arrives home in 1947), already ringed metropolises that had commuter rail lines; now, new suburbs sprang up alongside the growing highway network. With prosperity came a panoply of labor savers for the suburban homemaker (inset, a 1955 ad).

RIGHT: MORRIS ENGEL

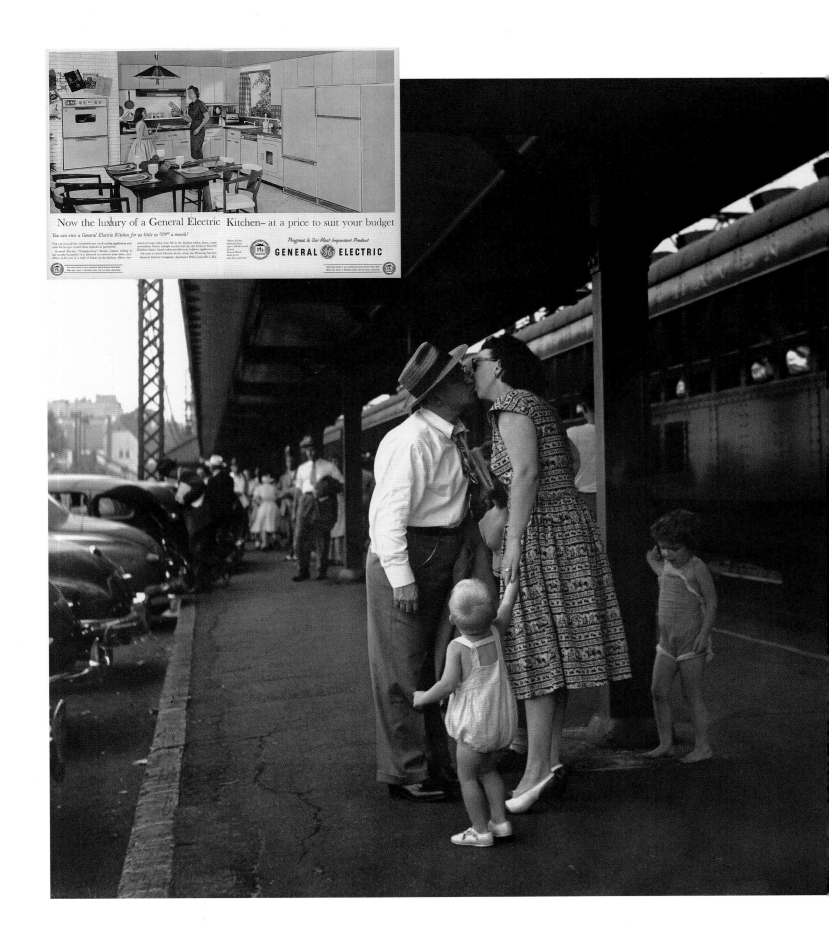

WILLIAM LEVITT

Burbs 'R' Us

Families began moving into Levittown, New York, in 1947. It didn't take long for the tract houses to grate on some. "Cookie-cutter" mentality, sniffed architectural critics, and folk song writer Malvina Reynolds, in "Little Boxes," decried such planned communities as "ticky-tacky." But the development was not designed for them. Postwar prosperity had created a new middle class. The few suburbs that then existed were priced for management; Levittown made it possible for salaried workers to raise their kids in a house with a yard. The Levitts went on to build two more towns bearing their name, in Pennsylvania and New Jersey.

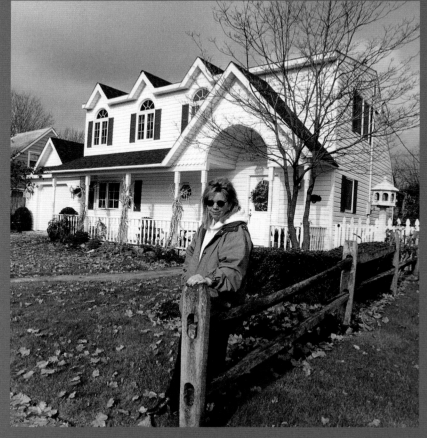

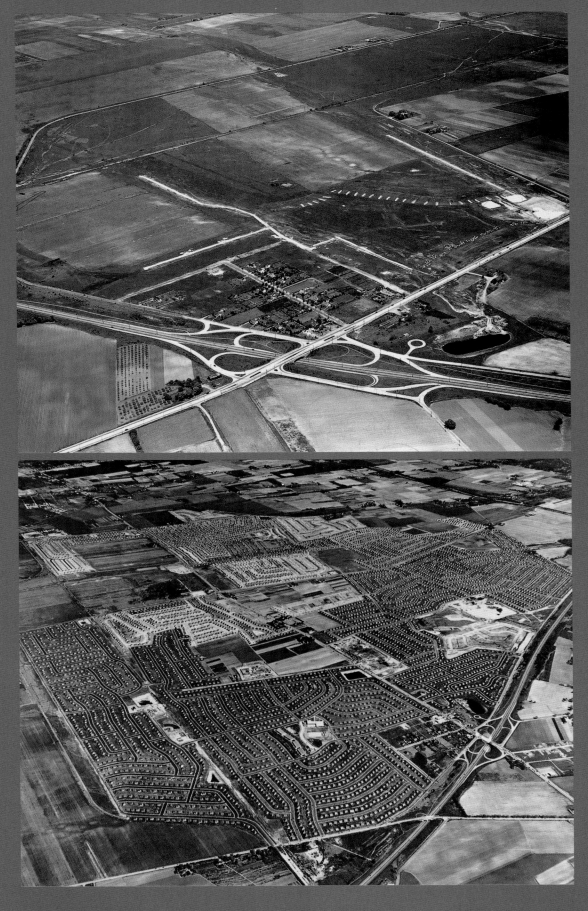

No fledgling developer was William Levitt (seated, far left, in 1950, at 43, with father Abe, 70, and brother Al, 39, the team's architect). They had already built upscale subdivisions on Long Island and, during World War II, government housing in Virginia and military barracks in Hawaii. The Levittown houses, each on a 60-by-100-foot lot, came in two styles. The Cape Cod (far left) offered 750 square feet for $6,990; the larger ranch cost $9,500. All the original houses survive. Those that have been extensively modified (below left, 1997) can fetch $200,000.

FAR LEFT: WALKER EVANS
LEFT: EMIL REYNOLDS
BELOW LEFT: ED BAILEY / AP

In 1948 (above right), several hundred acres of Long Island potato farmland some 30 miles east of New York City were about to be transformed into homes for 300 Levittown pioneers. Construction did not slow. By 1967 (right), the community had achieved its present size: seven square miles, 17,400 houses. Its current population: 54,000.

ABOVE RIGHT: THOMAS AIRVIEWS
RIGHT: LEVITT & SONS

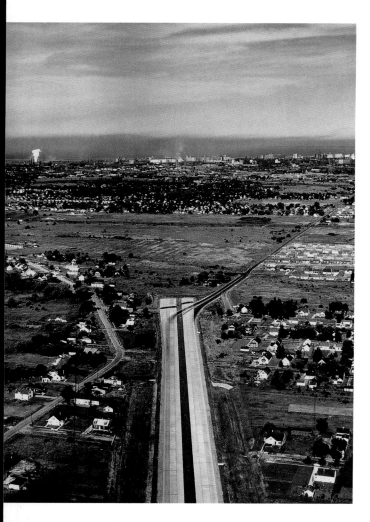

<

A ROAD TO SOMEWHERE

Shuffling in and out of Buffalo got easier shortly after this photo was taken in July 1954, when workers paved the New York State Thruway past the city line. That same year, President Dwight D. Eisenhower signed a bill to start a network of national highways. By 1999, the lower 48 were connected by 45,469 miles of stoplight-free interstates.

MARGARET BOURKE-WHITE / LIFE

>

A FRAGILE WEB

Manhattan did not twinkle on the night of November 9, 1965 (right), nor did most other cities and towns in an 80,000-square-mile swatch of the U.S. and Canada. A relay switch had blown at a Toronto substation, overloading the electrical grid serving 30 million customers. Power was mostly restored by morning — but not confidence in a system guaranteed to be fail-safe.

ROBERT GOMEL

<

THE HOT ZONE

In 1961, during Southern California's dry season, a brushfire raced through the posh Bel-Air section of Los Angeles (left). Lost were more than 480 houses that had been built in the arid canyons (climatologically classified as desert). But the land was too prime to leave vacant; today homes on Chalon Road sell for seven figures despite the continuing risk of fire.

RALPH CRANE / LIFE

TURNING POINT

A Precious Past

There were a million Indians and a handful of white settlers around when the Pilgrims arrived. So vast was the virgin continent that we peopled it by dangling free land. After the Civil War, voices arose urging that some wildernesses be kept wild, an idea fought by commerce. Happily, the conservationists won. Today, 12 percent of these 50 states' area — or 430,000 square miles — is protected by federal or state governments and enjoyed by 1.4 billion visitors annually. And in this century, we realized that some of what our forebears constructed was equally worth landmarking for future generations.

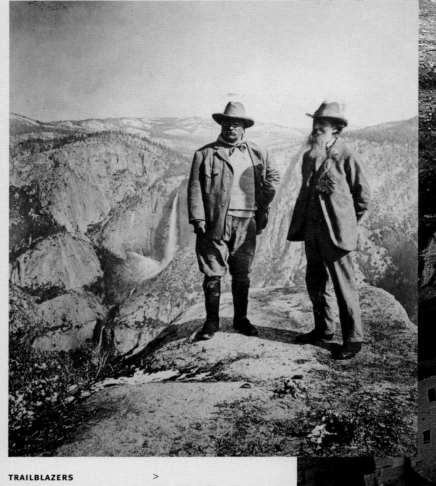

TRAILBLAZERS

The guest invited in 1903 by Teddy Roosevelt, 44, to join a presidential camping trip in Yosemite: conservationist John Muir, 65. Two years later, TR greatly expanded the national parks system. There are now 378 federal parklands, including a footpath from Maine to Georgia (left) that was made a national scenic trail in 1968. Volunteers created it between 1922 and 1937; some 5,300 hikers have since walked its entire 2,000 miles.

ABOVE: CORBIS
LEFT: KENNETH WADNESS

>
DRY AND HIGH

The cliff houses of Mesa Verde, Colorado (right), were built in the 13th Century, and abandoned 100 years later, by Pueblo Indians. By making the area a national park, in 1906, Roosevelt ended the looting of artifacts. Mount Rainier in Washington had been under federal protection for 27 years when Paradise Glacier got sitz-marked in 1926 (inset right). In 2000, snowmobiles were banned from this and all other national parks.

RIGHT: ELIOT ELISOFON / LIFE
BELOW RIGHT: NATIONAL PARK SERVICE

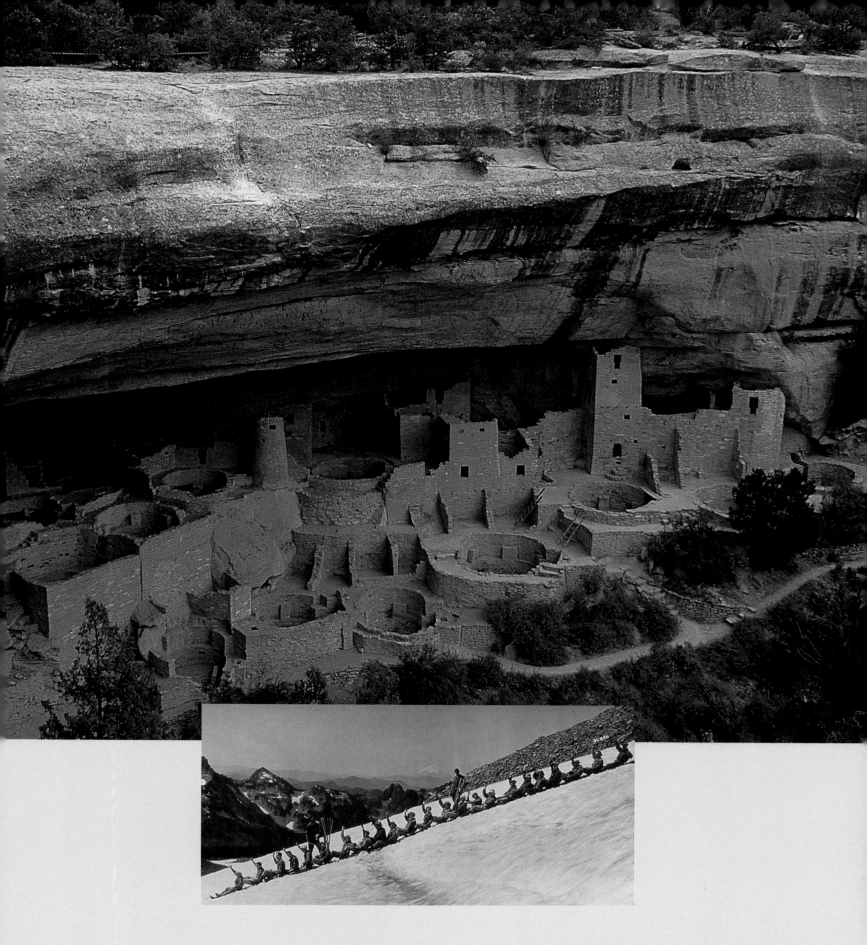

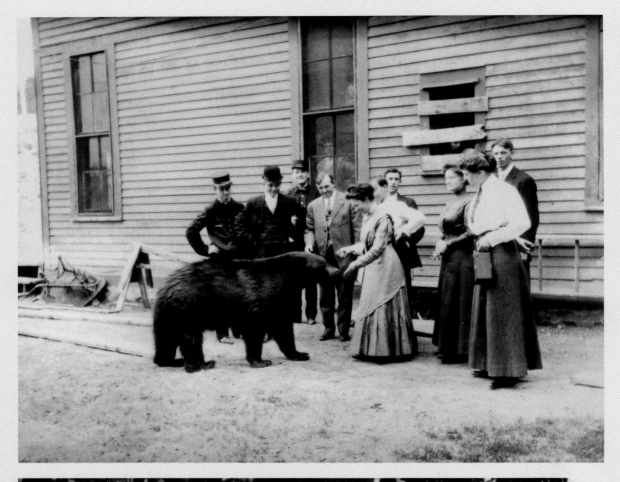

HISTORY LESSON

Depression-era Charleston, South Carolina, was where George Gershwin researched *Porgy and Bess*. In 1931, in hopes of saving antebellum glories like St. Philip's Church (right), the impoverished city enacted the nation's first municipal preservation ordinance. Tax credits spurred the restoration of the downtown district, which in turn led to Charleston's rebirth as a major tourist destination.

ALFRED EISENSTAEDT / LIFE

<

GENTLE BEN (WE HOPE)

The first national park — created by Congress in 1872 — was Yellowstone, which in 1910 drew an estimated 30,000 visitors (not all of whom understood that bears are wildlife, above left). Attendance grew apace with car ownership. By the early 1920s, when the couple at lower left roughed it in California's Cleveland National Forest, Yellowstone was logging 100,000 visits a year.

TOP LEFT: HAYNES FOUNDATION / MONTANA HISTORICAL SOCIETY
LEFT: PAUL J. FAIR / NATIONAL ARCHIVES

>

WET WILDERNESS

The unique natural wonder defining South Florida is a wide, shallow river that wicks Lake Okeechobee into the Gulf of Mexico (at right, mangrove islands). The Everglades became a national park in 1947, yet farmers and developers continued to drain it to create dry acreage. Only in 1997 did the Army Corps of Engineers reverse the trend by increasing the flow of fresh water.

ALFRED EISENSTAEDT / LIFE

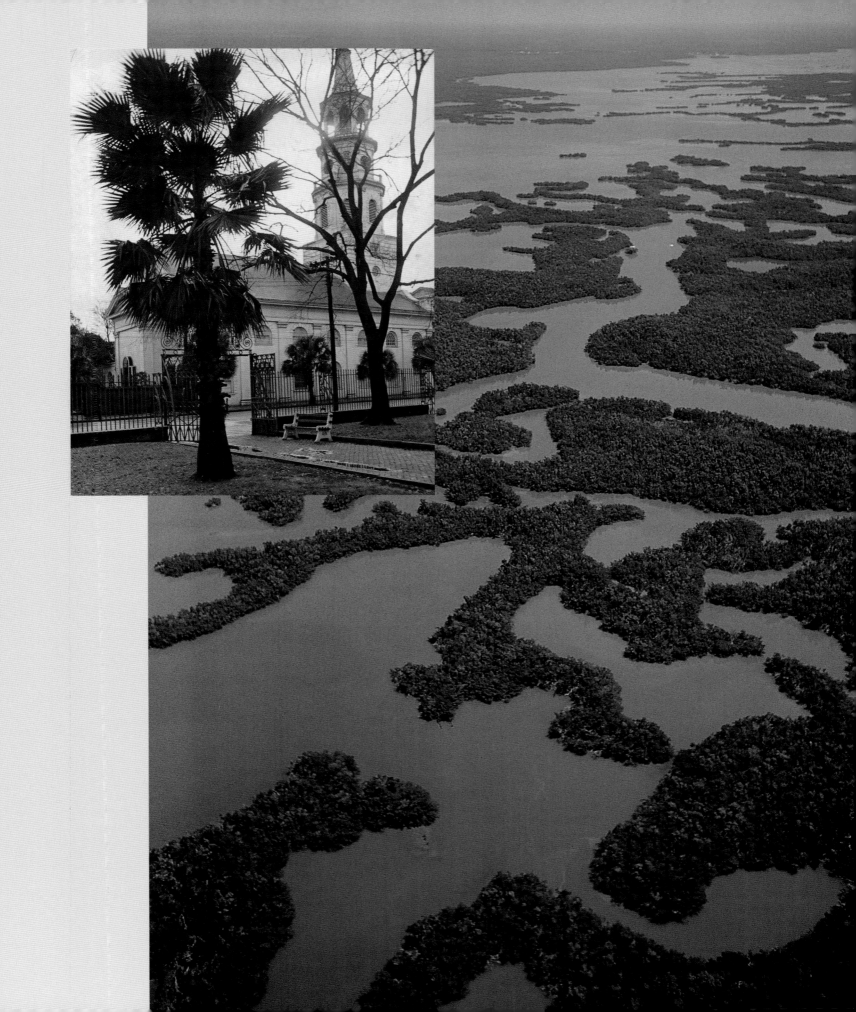

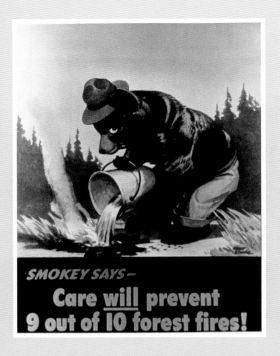

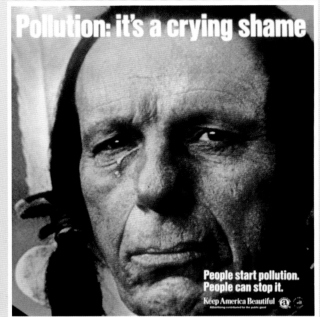

MIXED MESSAGES

Smokey Bear, drawn in 1945 (far left) for the Forest Service by Albert Staehle, reminded tenderfoots of a woodland basic. Iron Eyes Cody, who made his debut on Earth Day 1971, reminded us all to clean up our acts; the ecology campaign won two Clios (the advertising industry's Oscar) for an actor billed as Cree-Cherokee but born Espera DeCorti, a second-generation Italian-American.

FAR LEFT: USDA FOREST SERVICE
LEFT: KEEP AMERICA BEAUTIFUL

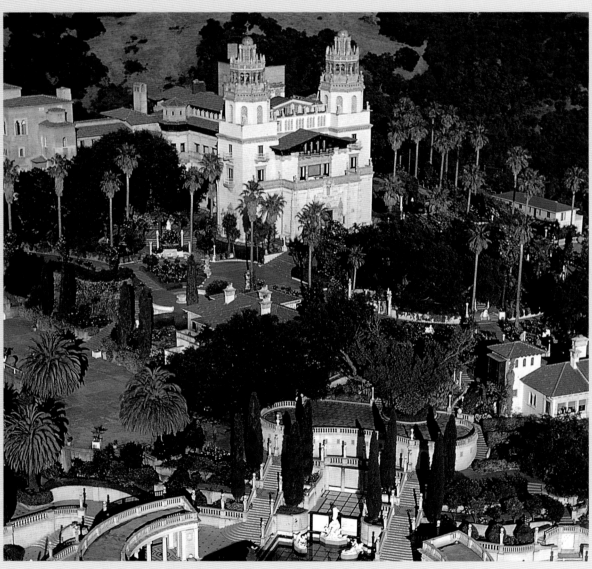

GATHER YE ROSEBUDS

The lavish estates of Bill Gates and TV mogul Aaron Spelling pale beside that built by press lord William Randolph Hearst. He moved into La Cuesta Encantada (The Enchanted Hill), set on 127 acres in San Simeon, California, in 1927. When finished in 1947, the complex included 165 rooms, a 25-limo garage and a zoo. It was given historic landmark status in 1976, 25 years after Hearst's death.

GJON MILI / LIFE

DESERT AND DUNE

As late as 1880, Bodie, Nevada (above), boasted 12,000 gold miners, 65 saloons and gambling dens, and two churches. In 1962, the Old West ghost town was named a historic landmark. Before Plymouth Rock, the *Mayflower* Pilgrims set foot on Cape Cod. In 1966, 40,000 of the peninsula's 255,360 acres were made a national seashore (left). Other states with federally protected stretches of coastline: New York, North Carolina, Georgia, Florida, Texas and California.

ABOVE: GALEN ROWELL / CORBIS
LEFT: RALPH MORSE / LIFE

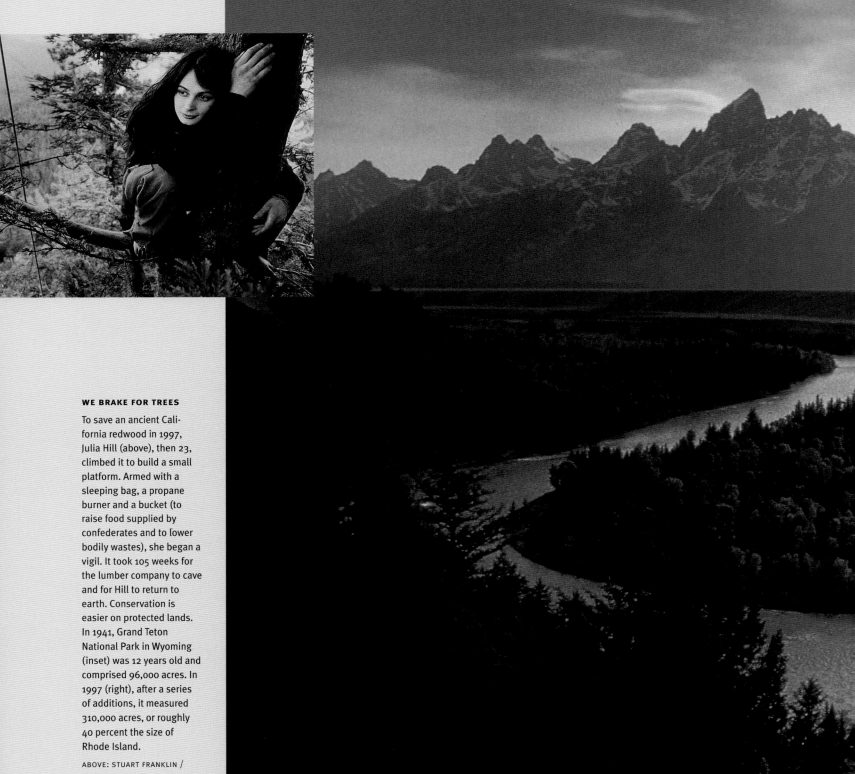

WE BRAKE FOR TREES

To save an ancient California redwood in 1997, Julia Hill (above), then 23, climbed it to build a small platform. Armed with a sleeping bag, a propane burner and a bucket (to raise food supplied by confederates and to lower bodily wastes), she began a vigil. It took 105 weeks for the lumber company to cave and for Hill to return to earth. Conservation is easier on protected lands. In 1941, Grand Teton National Park in Wyoming (inset) was 12 years old and comprised 96,000 acres. In 1997 (right), after a series of additions, it measured 310,000 acres, or roughly 40 percent the size of Rhode Island.

ABOVE: STUART FRANKLIN /
MAGNUM
RIGHT: MICHAEL J. HOWELL /
NETWORK ASPEN
INSET: ANSEL ADAMS /
NATIONAL ARCHIVES

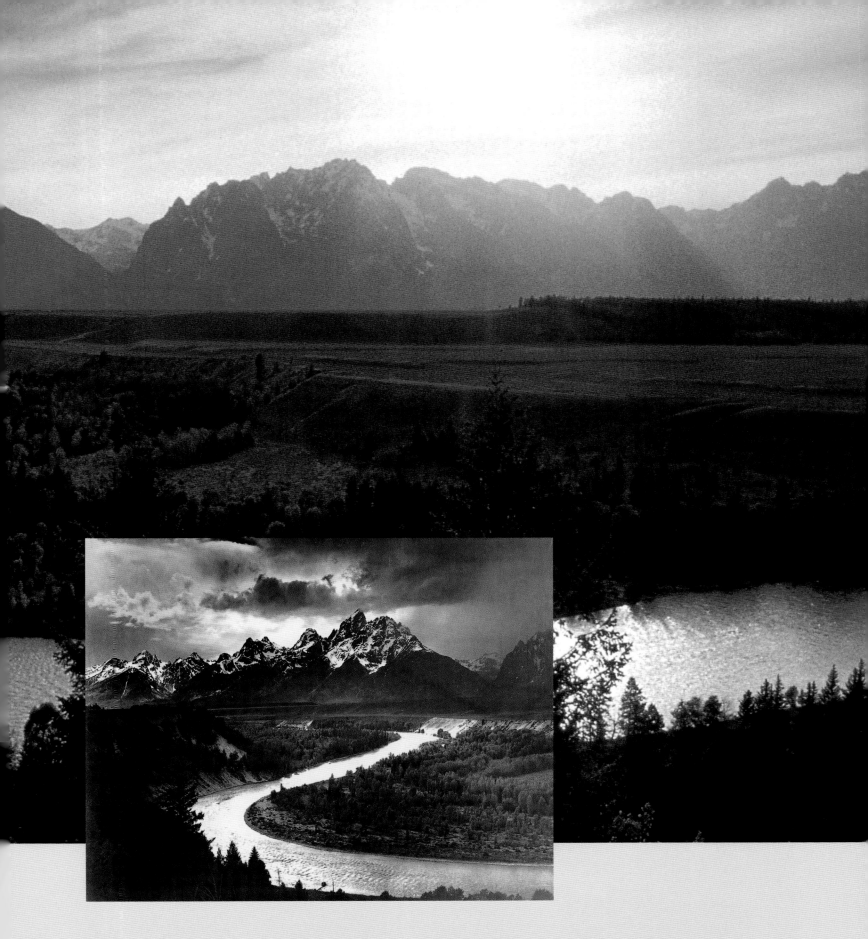

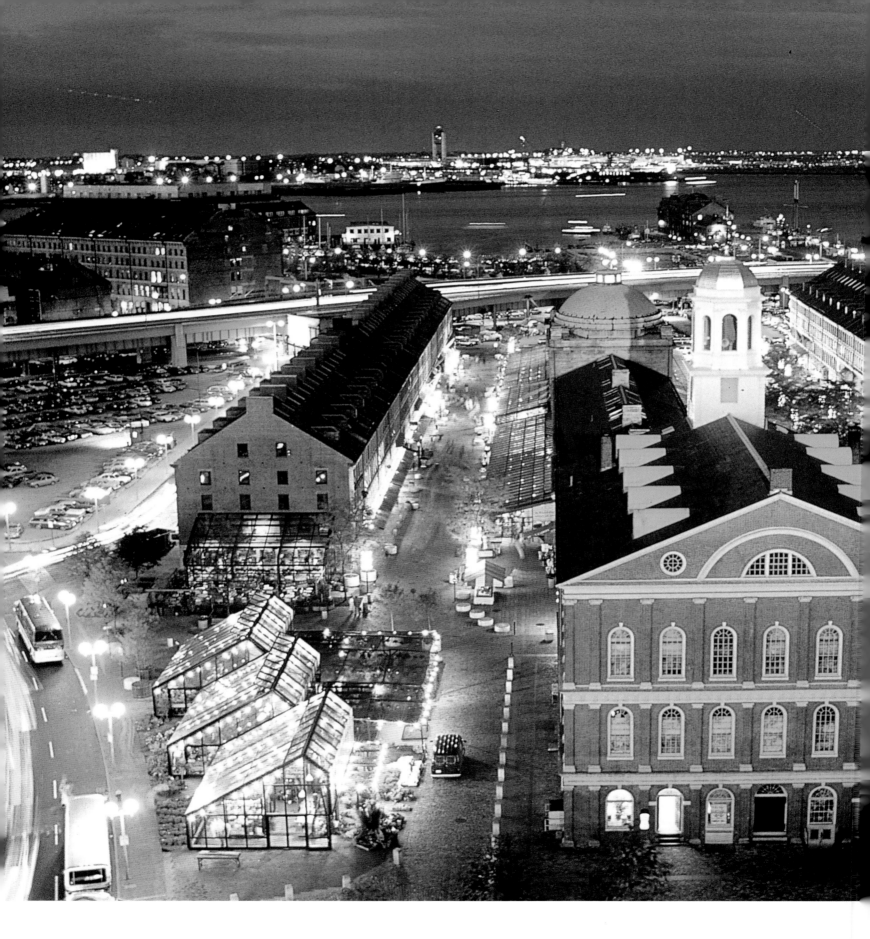

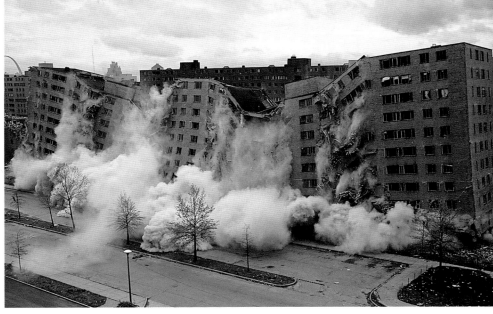

DELETE ME IN ST. LOUIS

With controlled dynamiting (above), St. Louis, in 1972, leveled a $36 million urban-renewal project that had opened just 16 years earlier. What went wrong? The original working-class tenants were displaced by welfare recipients. Maintenance and repairs went undone. Crime went unchecked. No one mourned when Pruitt-Igoe, once home to 12,000, was replaced by three schools.

LEE BALTERMAN / LIFE

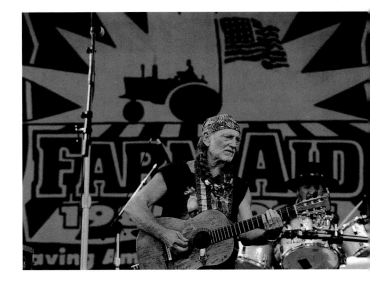

HARD ROW TO HOE

The first concert to benefit cash-strapped farmers was organized in 1985 by Willie Nelson (above, 62, playing in the 10th edition). But charity could not turn the tide. At century's end, 60 percent of agricultural sales were made by just six percent of the U.S.'s farms, those controlled by agribiz giants. The other two million farms each grossed less than $250,000 a year.

TIMOTHY D. EASLEY / AP

REDOING DOWNTOWN

It was the vision of developer James Rouse (left, in 1966, at 52) to reverse the decay of urban centers through gentrification. His first project: Faneuil Hall in Boston, a retail complex finished in 1978 (far left). Other cities that availed themselves of a Rouse makeover: New York, Baltimore, Philadelphia, New Orleans, Miami and Jacksonville.

FAR LEFT: HENRY GROSKINSKY
LEFT: JOHN LOENGARD / LIFE

HIGH-WATER MARK

The fury of 1998's Hurricane Georges turned even permanent abodes on Key West's Houseboat Row into floaters. (The men below had been hiding behind a nearby hotel until forced to flee by 90-mph winds.) A run of punishing tropical storms in the 1990s led Washington to rethink federal disaster insurance. Now, homeowners are discouraged from building or rebuilding on shorelines vulnerable to flooding.

DAVE MARTIN / AP

BE IT EVER SO HUMBLE

Martha Stewart (right, in 1999, at 58), that doyenne of domesticity, was easily lampooned for her chirpy tips on everything from pot roasts to peonies to house paints. But her $232 million net worth proved that, for many Americans, home is indeed where the heart is. Even if that home's brain was increasingly a microchip: In 1997, a San Anselmo, California, family (far right) displayed all its possessions dependent on Silicon Valley wizardry.

RIGHT: TIMOTHY GREENFIELD-SANDERS
FAR RIGHT: PETER MENZEL

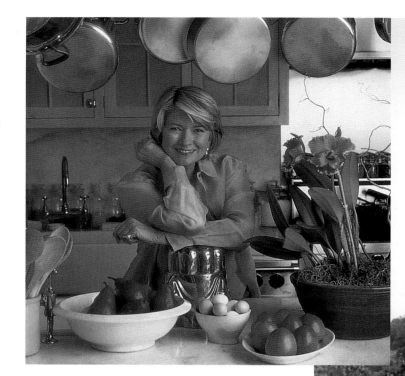

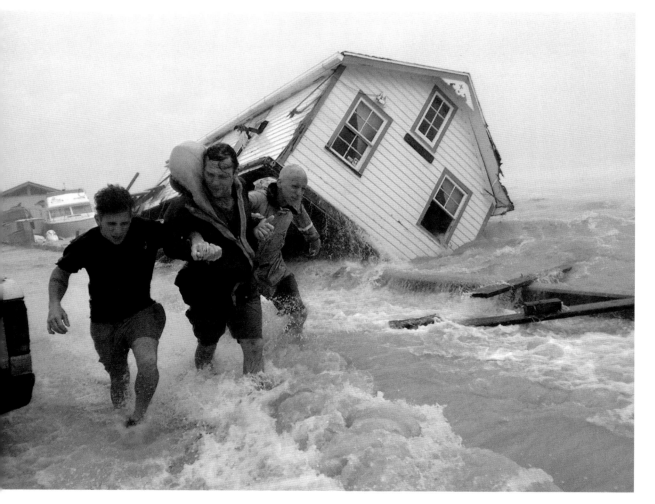

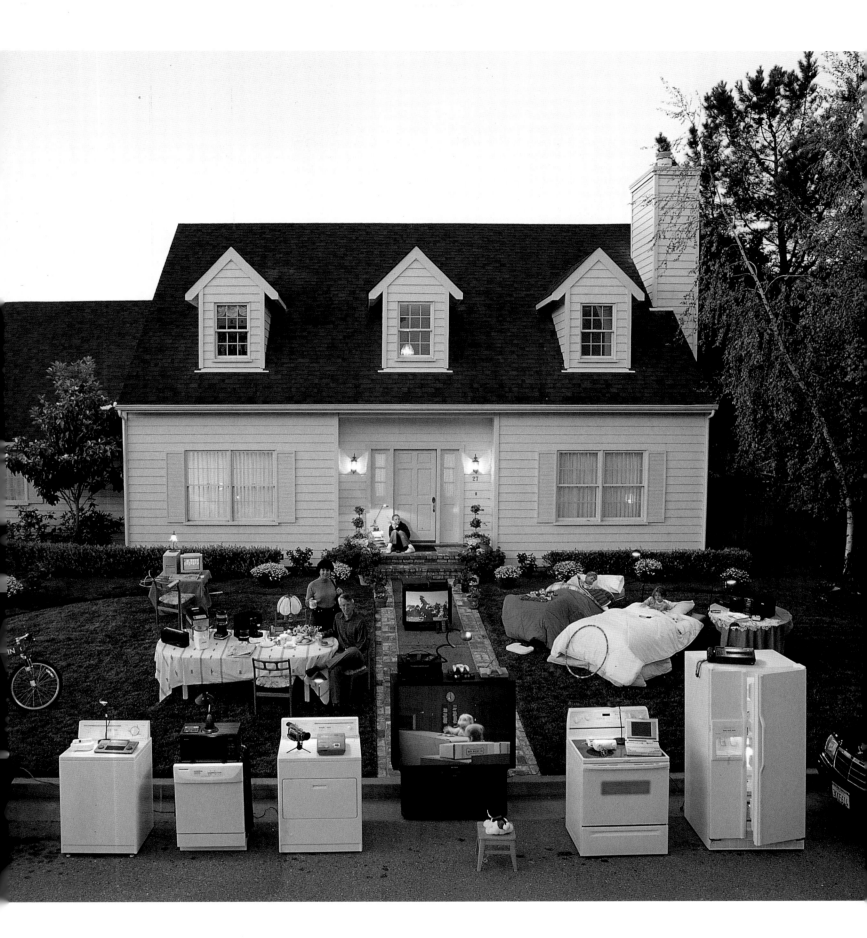

family

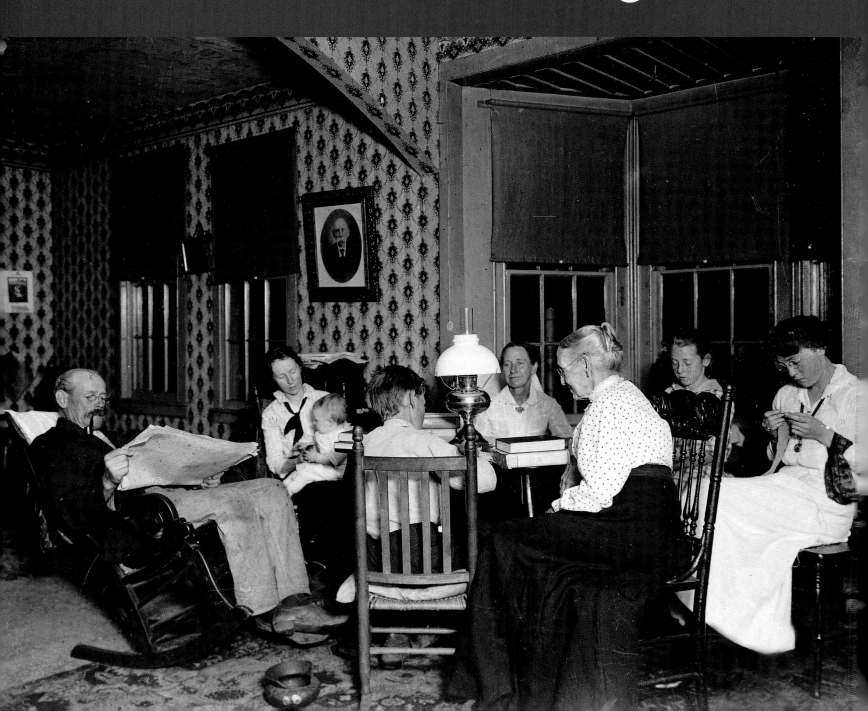

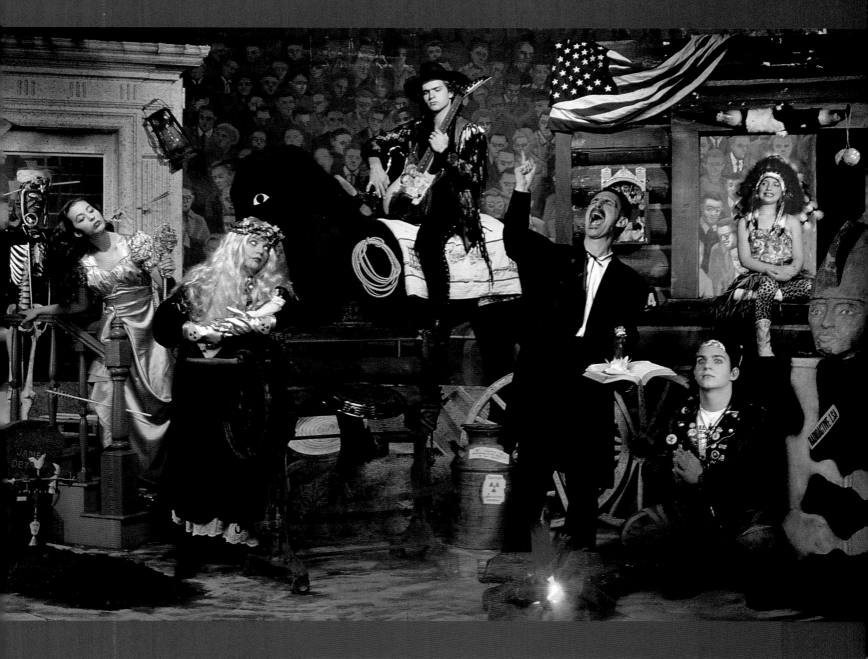

On the farm in 1908, knittin' and spittin' constituted family entertainment for the three generations in this living room. Eighty years later, California's ebullient Zappa clan (from left, Moon Unit, Gail, Dweezil, patriarch-rocker Frank, Ahmet and Diva) parodied the past while being, in its loving nature and communal spirit, a paragon of the present.

CHILDREN MATTER, MORE THAN EVER

To Strengthen a Fragile Icon

BY STEPHANIE COONTZ

IN THE FIRST DECADE of the 20th Century, diversity was as much a hallmark of family life as it was in the final decade. Fifteen percent of the population was foreign-born, a higher percentage than today, generating a hodgepodge of languages, religious practices and family values. Single-mother families, created by desertion or widowhood, lived next door to households crowded with extended kin and boarders. One of every 11 Italian immigrant households and one in eight black households included unrelated people and their families.

Daily life was grim for most working-class families — and most families were working class. In the tenements of New York City, only half of all households had indoor toilets and just 306 of 255,000 residences had bathtubs. Three-quarters of industrial workers labored 60 hours a week or longer — that is, when they weren't laid off without unemployment benefits. Work was dangerous. Approximately 25,000 workers were killed and another 700,000 maimed each year in industrial accidents. Poverty and malnutrition were widespread.

Thousands of youths, many under the age of 16, worked in mines, textile mills or sweatshops. Low wages, lack of opportunity and chronic unemployment forced more lower-income young women into houses of prostitution than at any other time in the century. Less than half of all adolescents finished

eighth grade, and only six percent graduated from high school.

Urbanization and industrialization brought many material benefits to middle-class families in the early 1900s, but even comparatively affluent housewives did not lead lives of leisure. In 1908, it took almost 30 hours a week to clean the average house, not counting time spent on laundry, shopping and food preparation.

Middle-class parents welcomed the new department stores and electrical appliances but were appalled at the revolution in courting practices that accompanied growing prosperity. Boys no longer came to "call" on a girl, sitting in the parlor or on the front porch under parental supervision. Instead, they began to take girls out on dates and eventually into the backseats of automobiles. Among older women, a different challenge to family norms alarmed observers. Educated career women were far less likely to marry in the early 1900s than they were at the end of the century.

In the 1920s, working conditions and real wages improved, thanks to hard-fought struggles by unions, women's activists and consumer reformers. But worries about families mounted as America experienced a revolution in gender roles. Women won the right to vote, bobbed their hair, danced the Charleston and began what observers correctly predicted was an inexorable march toward full partici-

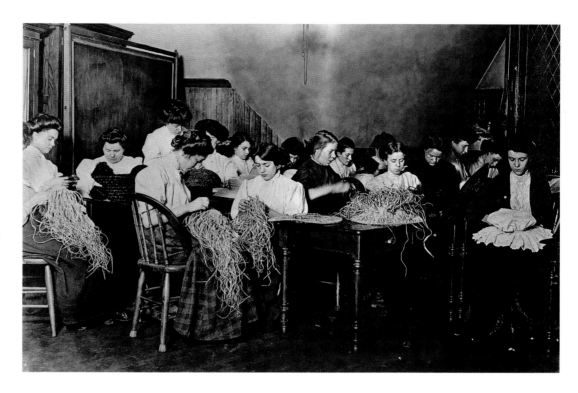

pation in the labor market. Family experts warned that the spread of birth control would erode marriage by elevating pleasure-seeking above self-denial, and indeed, by the 1920s, America had the highest divorce rate in the world.

During the Great Depression, debates over gender roles receded as families struggled simply to survive. Some families doubled up in crowded housing, while others split apart with young people hopping trains or hitching rides to look for work elsewhere. Child labor, supposedly outlawed in the 1920s, reappeared. Adversity may have drawn some families together, but in others, economic stress led to desertion, punitive parenting and domestic violence. In response, President Franklin D. Roosevelt introduced his New Deal, and industrial unions began to create a safety net — pension plans and seniority programs that in combination with Social Security would revolutionize family life and old age.

World War II changed the lives and the family dynamics of an entire generation of young men. Women who took over men's jobs on the home front got their first taste of work that was socially respected and comparatively well-paid. Employers and government experimented with on-the-job child care, sometimes even offering a filled dinner pail for mother and child to take home at the end of the day. War's end brought joyful family reunions but also serious adjustment problems. By 1947, one in three marriages contracted during the war was ending in divorce, and psychologists reported that both women and children often resented the returning soldiers' attempts to assert their old parental authority.

But fears about the future of marriage were seemingly laid to rest in the 1950s. In the postwar economic boom, spurred by generous government benefits to veterans for housing and education, young couples rushed to get married at an earlier age than ever before in the century. Anxieties about the Cold War, the atomic bomb and McCarthyism led many Americans to see the nuclear family (sometimes equipped with a bomb shelter) as an oasis of security in a perilous world. Divorce rates dipped, and fertility rates soared. The male-breadwinner, female-homemaker family with three young children became a national icon, immortalized in the new medium of television. Yet the idealized images of white suburban ranch houses obscured continuing change, including the massive

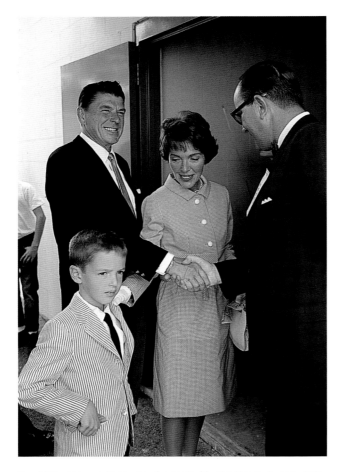

Ronald Reagan was divorced and remarried by the time he became California's governor in 1966. In that role he signed the nation's first no-fault divorce law. In 1980, he was the first divorced man elected president.
JOHN LOENGARD / LIFE

migration of Puerto Rican and African-American families to Northern cities. A major rearrangement of marital and sexual norms was also under way. Rates of childbearing by unmarried women tripled between 1940 and 1958, although most "illegitimate" children were put up for adoption. The number of working mothers quadrupled. A new youth culture attracted the attention of advertisers and the burgeoning rock and roll industry. Sexuality began to be commercialized. *Playboy* was launched in 1955; the well-endowed Barbie doll replaced the sexless baby dolls of earlier generations.

In the 1960s and 1970s, social and economic changes demonstrated the fragility of the 1950s fam-

ily icon. In 1963, Betty Friedan's *The Feminine Mystique* captured the frustrations of 1950s housewives. Meanwhile, as civil rights activists, Vietnam War opponents and counterculturalists challenged their parents' values, the daughters of those housewives fought the battle of the sexes on two fronts. They rejected the expectations of their parents that they "save themselves" for marriage and confronted the pressure from male peers to "give themselves" to anyone who asked — and then make him breakfast in the morning.

As women gained new education and work opportunities in the 1970s, many began to delay marriage. At the same time, the inflated costs of housing and falling real wages of the 1970s and 1980s accelerated the entry of wives and mothers into the workforce. The divorce rate also resumed its upward course, reaching historic peaks in the late 1970s and early 1980s, then dropping slightly but remaining at a high level.

By the 1990s, unprecedented numbers of stepfamilies, single-parent households, unmarried cohabitors and gay and lesbian couples created new kinds of family diversity. Yet the problems of new family arrangements were often the flip side of new opportunities. In the early 20th Century, for the first time in history, couples began to feel that they had a right to happiness, sexual satisfaction and intimacy in marriage, not just a duty to procreate. These rising expectations created more fulfilling partnerships for many couples, but they also made people less willing to put up with a relationship they considered unsatisfactory.

Reinforcing the decline in the lifelong permanence of marriage was the dramatic increase in longevity. Until the 1940s, the typical marriage was ended by the death of one partner within a few years from the time the last child left home. By the 1980s, a couple could expect to live more than two decades after its nest had emptied. Staying together "until

death do us part" became a commitment that many couples found impossible to keep. The compulsion to stay married was also undercut by women's growing economic independence and a decline in the penalties and stigma attached to unwed status.

As women increased their participation in the workforce in the late 20th Century, observers noted that America's child care facilities were far below the norm of many other industrial nations. Paradoxically, mothers and fathers were actually spending much more time with their children in the second half of the century than did parents in the first half. This was a result of having fewer children in the home, less time-consuming housework and higher expectations for quality parenting.

One disturbing trend from the 1960s through the 1980s was a sharp rise in youth violence. Even with significant declines during the 1990s, in 1999 it was still at historically high levels for the century. Nevertheless, America is now a safer place for children than ever before. Children aged 1–15 were three times less likely to die in the 1990s than in the 1950s, and teenagers aged 15–19 were 27 percent less likely to die. Rates of infanticide also reached new lows in the final decades of the century.

Furthermore, despite the fragility of marriage and the rise in absent fathers, most families at the end of the century were doing more for their members, over a longer period of time, than ever before. In the early 1900s, only a few affluent parents supported their children through high school. Most sent their children out at a comparatively early age to support themselves or contribute to parental finances. By the end of the century, however, parents were subsidizing their children's education, training and even homeownership much more extensively than ever before.

Family commitments had also lengthened at the other end of the life cycle. In the 1920s, with only four percent of the population aged 65 or older, few

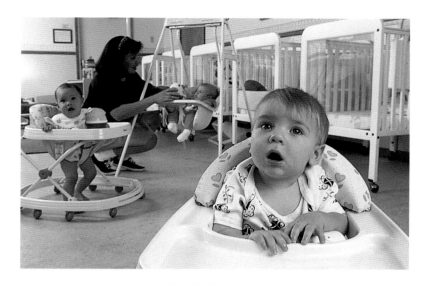

In the two-parents-working world of the Nineties, quality child care was a vexing issue. KinderCare Center in Plano, Texas, helped by being open from 6 a.m. to 7 p.m. A few companies provided care for employees' kids.
CHARLES THATCHER

adults had much responsibility for aging parents. By the 1990s, one in four households was providing more than 10 hours of care each week to an aging relative, and half of all adults said they expected to take on elder care some time in the next decade.

Through all the shifts in family life during the 20th Century there have been important continuities. The older generation still complains, as it has for 300 years, about the behavior and mores of youth. Young people still declare, as they have for 300 years (though certainly in more explicit language) that their parents don't know anything important. But multigenerational families still gather to celebrate their bonds, most children report that they trust the adults in their lives, and most parents still struggle to do their best for their kids.

Stephanie Coontz teaches history at Evergreen State College in Olympia, Washington. Her books include The Way We Never Were: American Families and the Nostalgia Trap *and* The Way We Really Are: Coming to Terms with America's Changing Families.

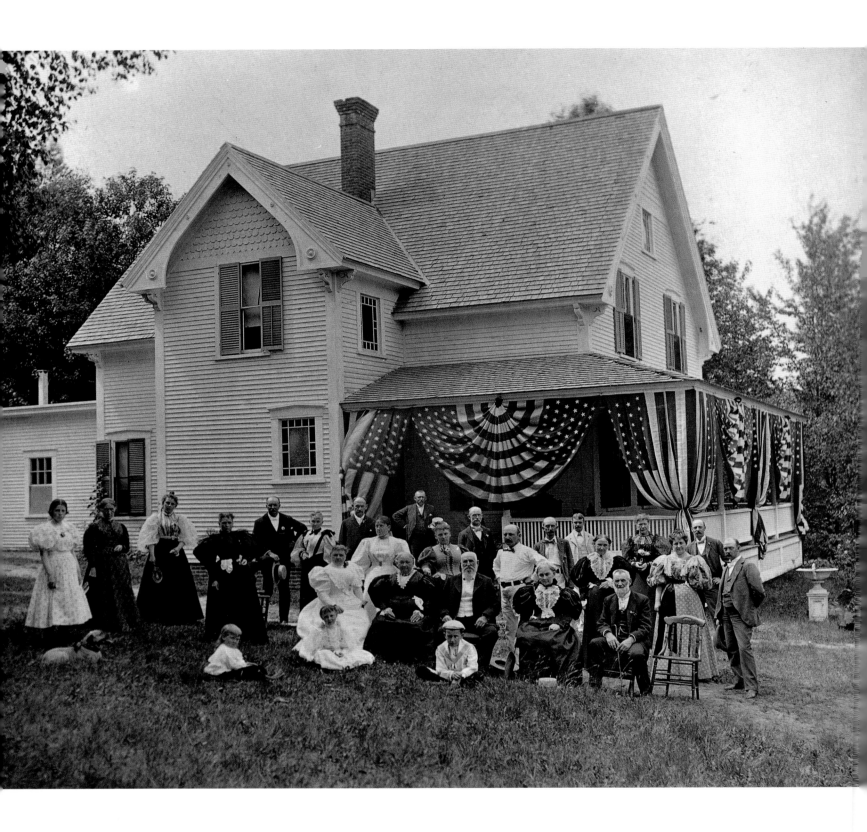

<

GENERATION GAPS

When the Dow family of Manchester, New Hampshire, gathered for the golden anniversary of the matriarch and patriarch (center) in 1895, the youngest generation was already gathering new notions of what family meant. By the time those kids on the grass became parents, they'd have cars to worry about, for example — 458,000 registered in 1910.

THE MANCHESTER HISTORIC ASSOCIATION, NEW HAMPSHIRE

>

AGRARIAN RULES

Farm life set the pattern of daily existence for a majority of American families. It dictated the school calendar (so kids could help with planting and harvesting) and classroom hours (so morning and evening chores could be done).
In 1908, a Kansas clan gathered on a wagon that was hauling water out to a steam-engine-powered threshing machine.

THE KANSAS STATE HISTORICAL SOCIETY

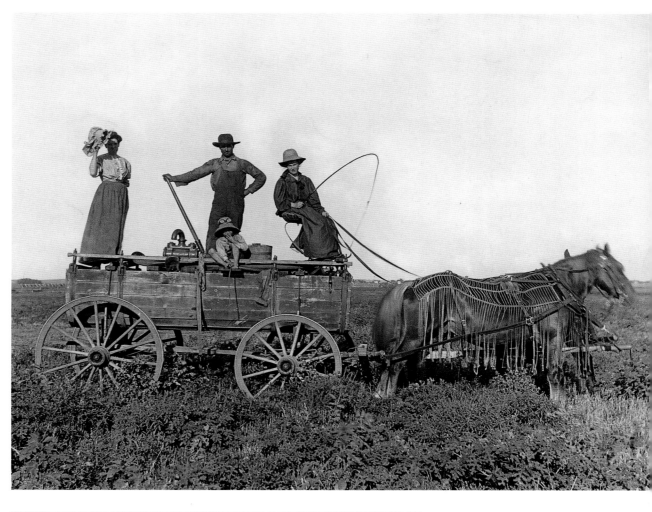

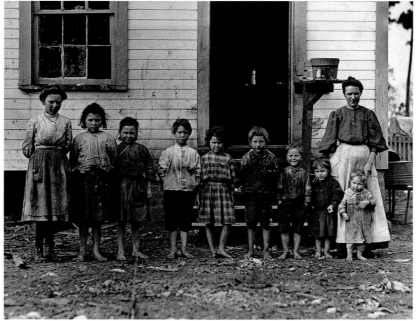

<

STAYING TOGETHER

It was a familiar story, this time from Tifton, Georgia, 1909. The father had died. The mother of 11 left the farm to work in a cotton mill. Nell, the oldest and tallest, exchanged shifts with her mother at home and at the factory. Truth is, all but the four youngest took turns at the mill. The family earned a total of nine dollars a week.

LEWIS W. HINE

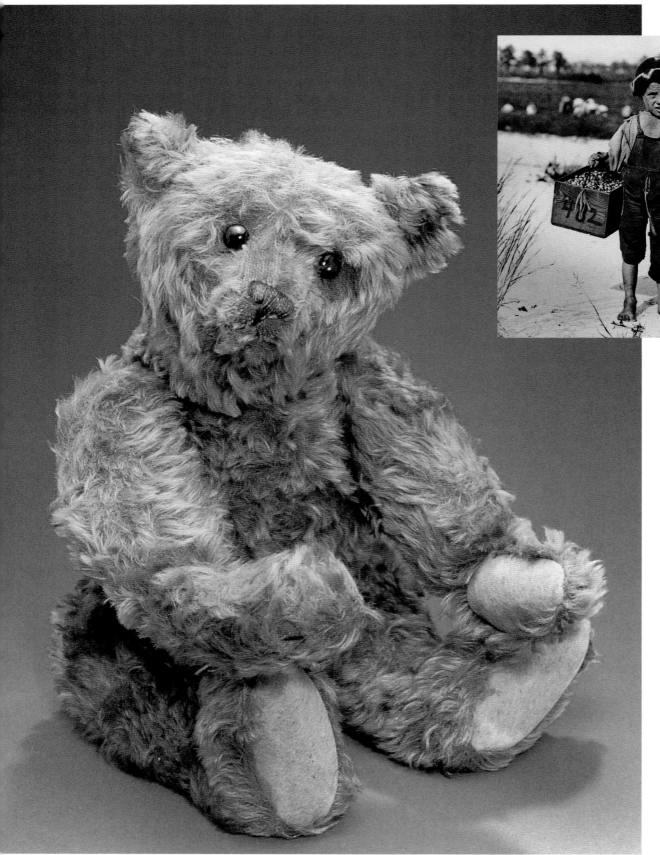

HEAVY LIFTING

In 1910, Salvin should have been home. Instead, this five-year-old in Browns Mills, New Jersey, carried two pecks of cranberries for pennies. He was not much comforted by the formation, six years earlier, of the National Child Labor Committee. It wasn't until the Fair Labor Standards Act was passed in 1938 that any attempt at child-labor reform succeeded.

LEWIS W. HINE

NAME THIS BEAR

Long before Tickle Me Elmo and Beanie Babies, there was the Teddy bear. Designed by German toymaker Margarete Steiff in the late 1800s (at left, an early model), it became a craze in 1902 after great white hunter and president Teddy Roosevelt refused to shoot a young bear during an outing in Mississippi. America began to see the little stuffed critter as Teddy's bear.

CHRISTIE'S IMAGES LTD.

BABES IN ARMS

At a day nursery in New York City around 1910, four infants and a toddler were tended to. The need for such care was increasing as cities grew. Although America still seemed a vast, rural society, many citizens were choosing not to live on farms. Of the 8.8 million immigrants who arrived here between 1900 and 1910, most settled in urban areas.

CORBIS

WOMEN AND WAR

During World War I, women were mobilized on the home front and found themselves making munitions or, like these uniformed workers at a plant outside Indianapolis, building airplane engines. The effect of two absent parents on the family was new and not beneficial, but the effort was, after all, to make the world safe for democracy.

U.S ARMY SIGNAL CORP

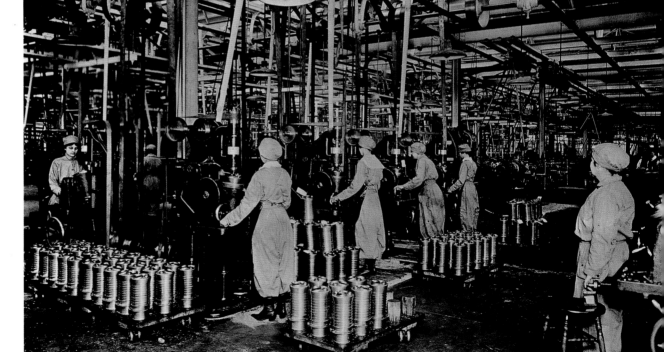

CLOSE UP

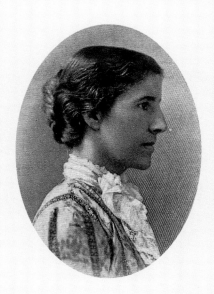

CHARLOTTE PERKINS GILMAN

A New Woman

Born in 1860 in Hartford, Connecticut, Charlotte Anna Perkins (above) was a different kind of American. By the 1890s, married to the artist Charles Walter Stetson, she was publishing essays and works on social issues. In 1898, her seminal *Women and Economics* argued that the traditional role of motherhood was a straitjacket and that only by gaining some social and economic independence could a woman realize her potential. After divorcing Stetson, Perkins married George H. Gilman, a lawyer, in 1900 and continued her crusade. In 1935, she gave up her fight against cancer and committed suicide.

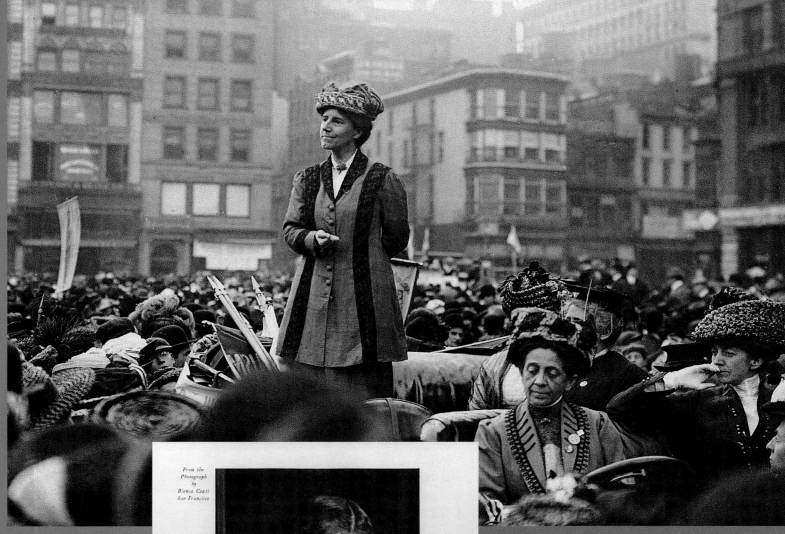

From the Photograph by Bianca Conti San Francisco

CHARLOTTE PERKINS

GILMAN

Under the Exclusive Management of

JAMES B. POND, "The Pond Bureau"

25 West 43rd Street - - - New York, N.Y.

< Within the women's movement in the first decades of the century, Gilman was a thinker, theorist and writer (upper left, in her New York City office). In 1909, she founded the magazine *Forerunner* to promote her vision of the liberated American family. In 1915, as World War I raged, she and Jane Addams of Hull House fame organized the Woman's Peace Party. The next year she (left, second from left) gathered with like-minded members of the American Suffrage Movement.

TOP FAR LEFT: CULVER PICTURES
TOP LEFT: BROWN BROTHERS
LEFT: CORBIS / BETTMANN

Women and Economics was translated into seven languages, and Gilman's fame as a lecturer spread worldwide. She was in such great demand that she was represented by a New York agency — an extraordinary feat for a woman then — though of course she appeared pro bono at political rallies, such as this 1915 gathering in Manhattan. She also spoke at Cooper Union, Columbia University and even Carnegie Hall.

LEFT: SOPHIA SMITH COLLECTION / SMITH COLLEGE
ABOVE: KEYSTONE VIEW CO. / CORBIS SYGMA

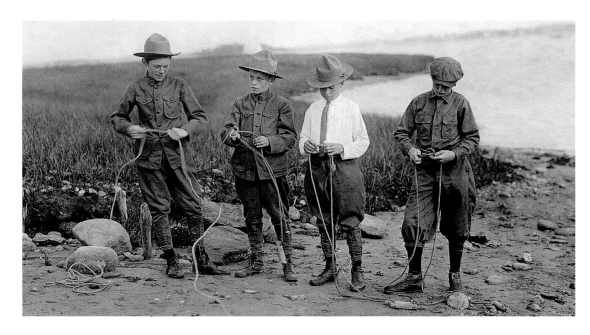

UNIFORM RULES

Turn-of-the-century kids on farms and in tenements had to develop a sometimes lonely self-reliance. Then, encouraged by the Progressive Movement, parents got more involved — the community too. In 1910, Daniel Carter Beard, author of *The American Boy's Handy Book*, helped found the American Boy Scouts, giving ritual and organization to knot-tying youths like these.

BROWN BROTHERS

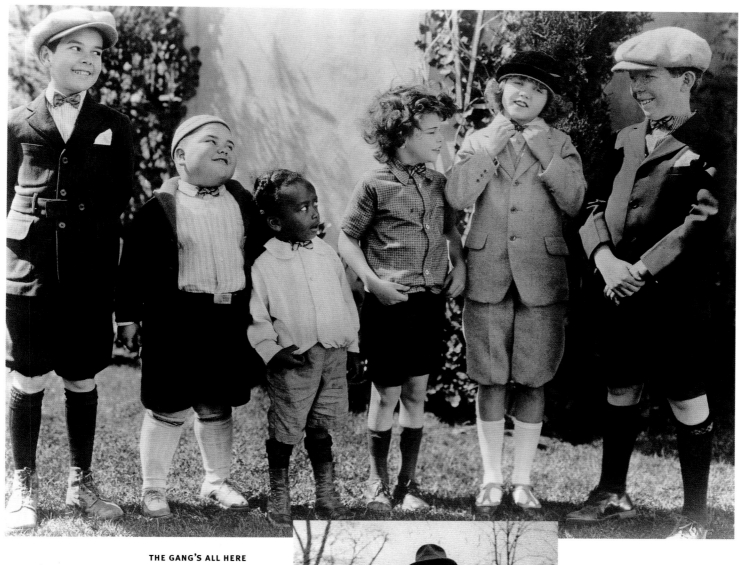

<

GOLDEN RULES

Written in mid–19th Century, the *Six Readers*, by Professor William Holmes McGuffey and his brother Alexander, were still part of the classroom curriculum in this Louisville school around 1920. Deportment and grooming were important too; here, fingernails are carefully checked. Still over the horizon: educational reform.

UNIVERSITY OF LOUISVILLE

THE GANG'S ALL HERE

Our Gang was a microcosm of American kid-dom: black and white, boys and girls, full of mischief, ignoring adult attempts at intervention, yearning to stay young. The wildly popular series — 221 comedy shorts from 1922 to 1944 — presented a prepubescent version of what would become a scourge of families everywhere: the teenage rebel.

NEAL PETERS COLLECTION

THE GOOD DOCTOR

Did Benjamin Spock's ideas about trusting your instincts nurture the Baby Boom or lead to the dysfunction of the 1960s? In 1934, when the pediatrician pushed his son, Michael, through Central Park, such questions were far off. The *Common Sense Book of Baby and Child Care* was published 12 years later and sold 50 million copies worldwide.

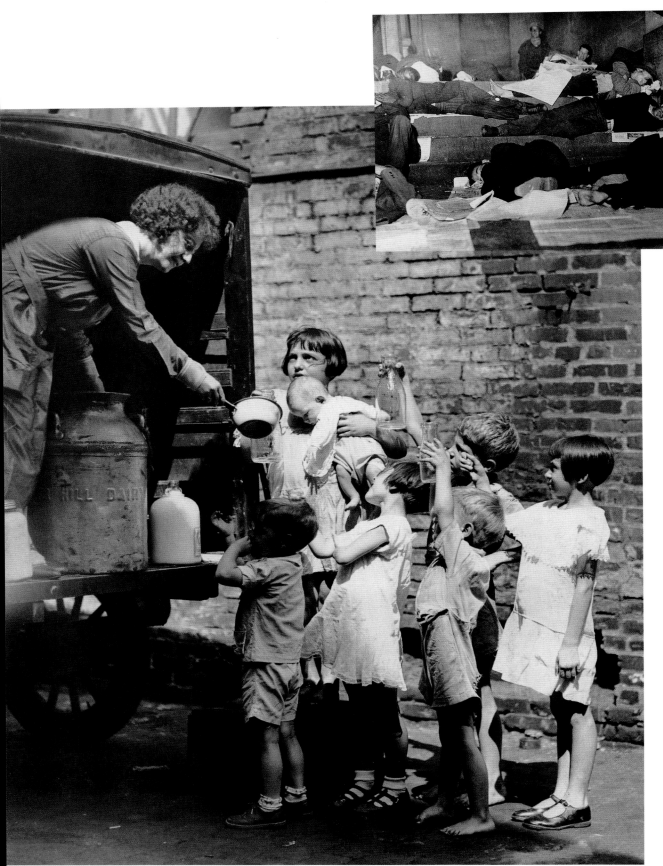

MEN NOT AT WORK

The Quaker City Haven in Philadelphia was meant to house jobless men. But sometimes it was full, so on this night in 1931 the unemployed had to endure the humiliation of sleeping on building steps with newspapers for blankets. At the height of the Depression, those out of work numbered 13 million, 25 percent of the labor force. By decade's end, New Deal work projects were helping some.

CORBIS / BETTMANN

<

EMPTY STOMACHS

Hungry children were an agonizing sight. Here, in Washington, D.C., the Volunteers of America ladled out milk. In New York City, 82 breadlines served 85,000 modest meals every day. Throughout the U.S. the unemployed were estimated to have 30 million other mouths to feed. Few Americans were untouched by the misery around them. In Chicago, even gangster Al Capone sponsored a soup kitchen.

CORBIS / UPI

RING TOSSING

The Depression eroded marriage vows already weakened by the excesses of the Roaring Twenties. Nevada had the easiest divorce laws in the country, and in 1932, these two women observed local Reno custom and threw their wedding bands into the Truckee River. The divorce rate climbed slowly until after World War II. Then it boomed. In 1900, there were 56,000 divorces; in 1960, 393,000.

CORBIS / BETTMANN-UPI

SAFETY NET

Ida Mae Fuller, a retired schoolteacher in Vermont, (far right, in 1974) was the first American to receive Social Security (poster, near right). On January 31, 1940, check number 00-000-001 was issued in her name for $22.54. By the time she died at age 100 in 1975, Fuller had collected $22,888.92 on a three-year contribution of $24.75.

RIGHT: LIBRARY OF CONGRESS
FAR RIGHT: CORBIS / UPI

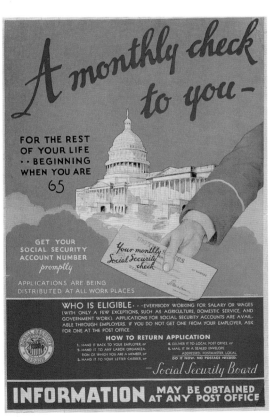

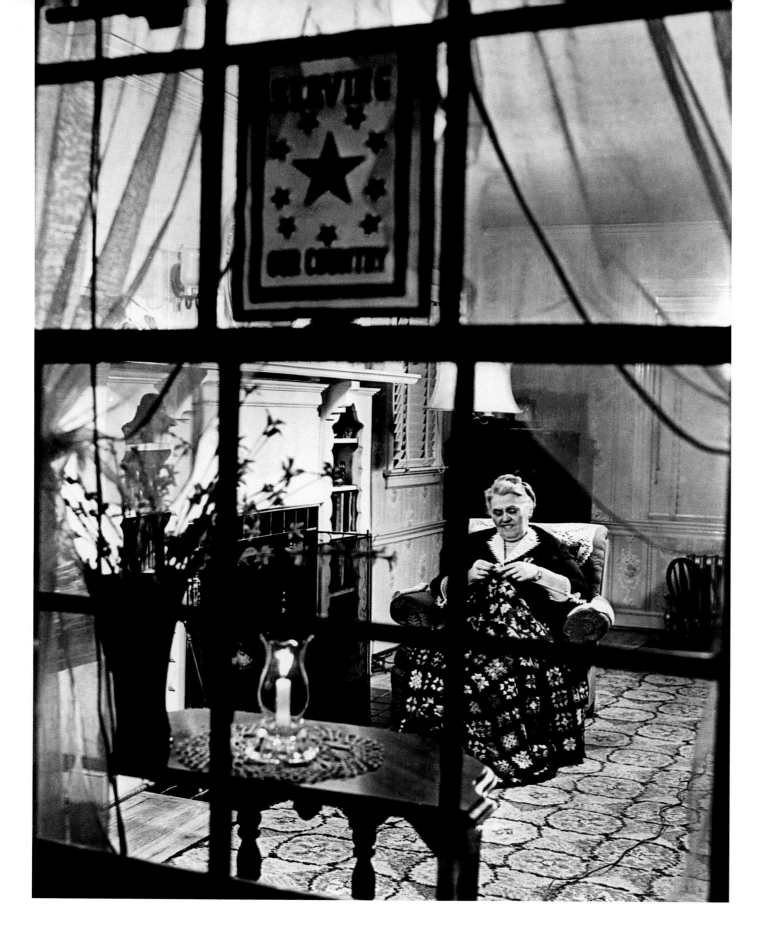

WESTWARD, HO

During World War II, the extended Brauckmiller family pulled up stakes in the Midwest and chased high wartime wages in Portland, Oregon, where 15 of them found work in the shipyards. To support the military effort, civilian employment rose from 47.5 million in 1940 to nearly 54 million in 1945 (including a flood of Riveting Rosies).

RALPH VINCENT

HOME FRONT

The service flag in her window indicated that Emma Van Coutren of New York City had 10 children serving in World War II. There were 1.6 million Americans in uniform when Pearl Harbor was bombed; by 1945, there were 11.4 million. Obviously the war had a major impact on the American family, hastening or forestalling many marriages, ending many others.

CORBIS

DADS BECOME GRADS

In 1947, graduating married veterans at the University of Colorado tossed mortarboards and babies into the air. The GI Bill made college possible for returning soldiers, and the country's educated class quickly began to grow. In 1946, half of the two million Americans in college were veterans. One postwar effect: With his college degree, the male in a marriage reclaimed his place as breadwinner.

FLOYD WALTERS

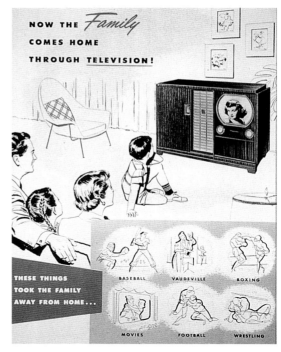

A NEW HEARTH

This 1950s ad promised togetherness through television. And the whole family did sit down to watch Uncle Miltie. Radio and Hollywood had begun to break down regional barriers; TV accelerated the process. It was the great equalizer — and historian. Think of the American family as Lucy to Dick Van Dyke to Archie Bunker to Seinfeld to Raymond.

DANE A. PENLAND

ROLE REVERSION

When the war ended, women went back home, their factory jobs taken by returning veterans. This 1947 group of 4-H girls near Valley, Nebraska, tried gamely to learn traditional skills and virtues. But women had changed; they knew they could perform many tasks as well as men. In 1949, Simone de Beauvoir's *The Second Sex* was a global blockbuster. Feminist stirrings were unmistakable.

JERRY COOKE / LIFE

DADDY DOES DIAPERS

As an experiment. In 1956, Joe Gordon, a 33-year-old Dallas architect, gave his wife, Jo Lea, a weekend off. Their four kids, aged two months to nine years, ran the old man ragged — even baby Clark, who dangled placidly during an inexpert change. "It never ends, that's what's discouraging," Joe admitted. The American father wasn't ready for this. Not yet.

JOSEPH SCHERSCHEL / LIFE

GETTING A CHANCE

One of LBJ's Great Society programs to shore up the lives of Americans on the edge was called Operation Head Start. It served children to age five (like this New Orleans preschooler in 1965), pregnant women and their families. The main goal was to make sure that kids from low-income families would be ready to start school. It worked. Today, Head Start has an enrollment of 950,000.

V. THOMA KERSH

<

THE SUBTERRANEANS

The first of several postwar countercultures was the Beat Generation. As author Jack Kerouac and company saw it, they were "beat down" by Eisenhower-stifled America. What made sense was to apply the loose-limbed rhythms of jazz to their own lives. Here, in 1959, beatnik artist and daddy-o Arthur Richer hung with his wife and kids in the their L.A. pad.

ALLAN GRANT / LIFE

TURNING POINT

Coming of Age

Work, school and play: These were central issues in a young American's life. Early in the century, you rarely did all three. If you worked, it was dawn to dark to contribute to the family pot, and you didn't have time for school, much less play. If you were lucky enough (that usually meant rich enough) to attend school and play, you took full advantage of your opportunities. School was about status as much as education. Work was something that would befall you later. Then the country, a newly minted superpower after winning the war, boomed with babies and wanted these golden children to have all and be all. The era of the teenager dawned.

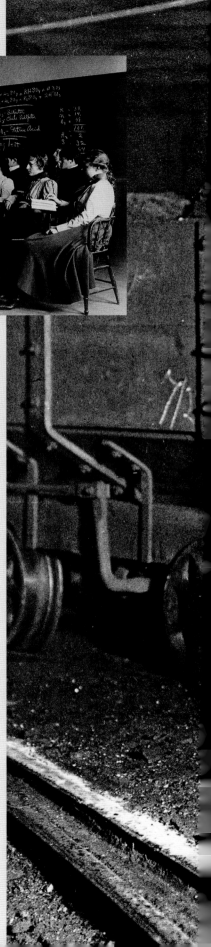

THE LUCKY ONES

A co-educational high school science class in 1900 was fairly common. At that time, nearly 17 million children were enrolled in elementary or secondary schools, but fewer than 100,000 were graduating from high school each year — about six percent of Americans their age. Many of their teachers had only high school diplomas themselves and earned on average $325 a year.

CORBIS / BETTMANN

<

MISS AMERICAN PIE

In 1963's *Bye Bye Birdie*, Ann-Margret, 21, played a high schooler who dug boys, idolized an Elvis look-alike, cheerfully mocked her fuddy-duddy parents, burst with optimism and danced like a dervish: She was the compleat American teen, representing what had become a full-fledged social class. Nearly two million were graduating from high school every year.

NEAL PETERS COLLECTION

>

THE UNLUCKY ONES

In 1908, this West Virginia boy worked underground for 10 hours a day with an uninsulated electric wire just above his head. The coal-mining industry employed more than 15,000 boys under the age of 16; some were as young as nine. In Pennsylvania, they earned only three dollars a week, tops. Conditions were ghastly: The dust caused asthma, machinery mangled hands.

LEWIS W. HINE

>

THE GLITTERING CLASS

At Long Beach, New York, in the Roaring Twenties, teens on holiday showed they were cool by lighting up cigarettes. For generations, rebellion was reserved for upper-class men. Now women showed a bit of spunk by smoking. Cigarette production rose to 50 billion a year. Americans smoked a sixth of a pound of tobacco per capita in 1910, three pounds by 1930 and more than seven by the Fifties.

CORBIS / UPI

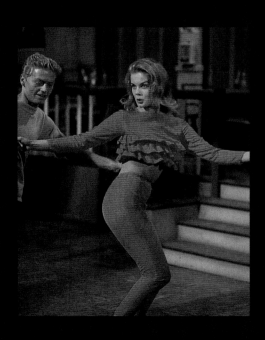

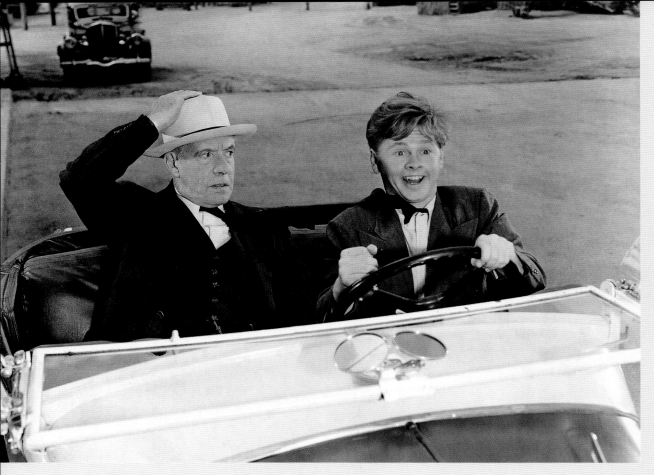

DRIVING LESSON

In happier times, America's idea of a rambunctious teen was Andy Hardy as played by Mickey Rooney in 16 gentle films (here, 1939's *Judge Hardy and Son*, with Lewis Stone as his father). Soon the country's real Andy Hardys would be fighting a war and growing up fast. And the girls would be swooning over Frank Sinatra, a far more dangerous idol than Mickey.

CULVER PICTURES

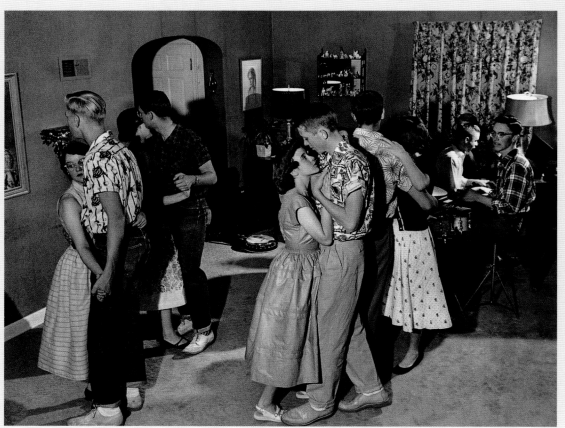

WHERE'S THE CHAPERONE?

Slow dancing in somebody's living room in Greeley, Colorado, in 1954 seems such tame stuff; a Paul Anka song called it puppy love. But in the Fifties, boys were getting advice about girls and life from their older brothers and other war vets. The teen population had swelled to 15 million, and the early wave of the postwar baby boom was just ahead. Elvis became their dark hero, much to parents' dismay.

CARL IWASAKI / LIFE

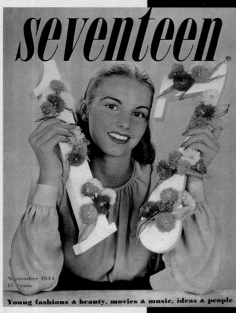

MONTHLY COUNSEL

Seventeen debuted in 1944, defining the world for girls that age and younger: what to wear, how to look, what to think, whom to admire. By 1950, it was selling a million copies a month. For adolescent boys, there was *Mad* magazine, starting in 1952.

COURTESY SEVENTEEN
MAGAZINE

I'M ON THE PHONE!

Between 1945 and 1965, 81.6 million kids were born in America. In the same period, the number of phones increased to 93.6 million. Teen girls were the big talkers (as here in St. Louis). What about? Boys, clothes, their figures (a survey indicated) and, ugh, skin problems. In 1951, relief came in the form of a 59-cent tube of Clearasil (inset), which sold millions of containers by sponsoring *American Bandstand*.

NINA LEEN / TIME INC.
INSET: COMBE INC.

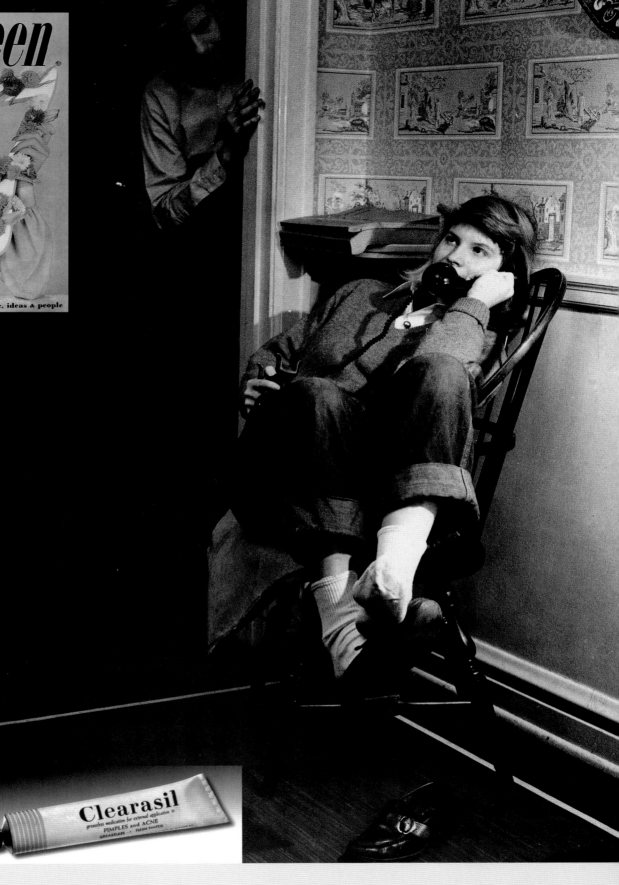

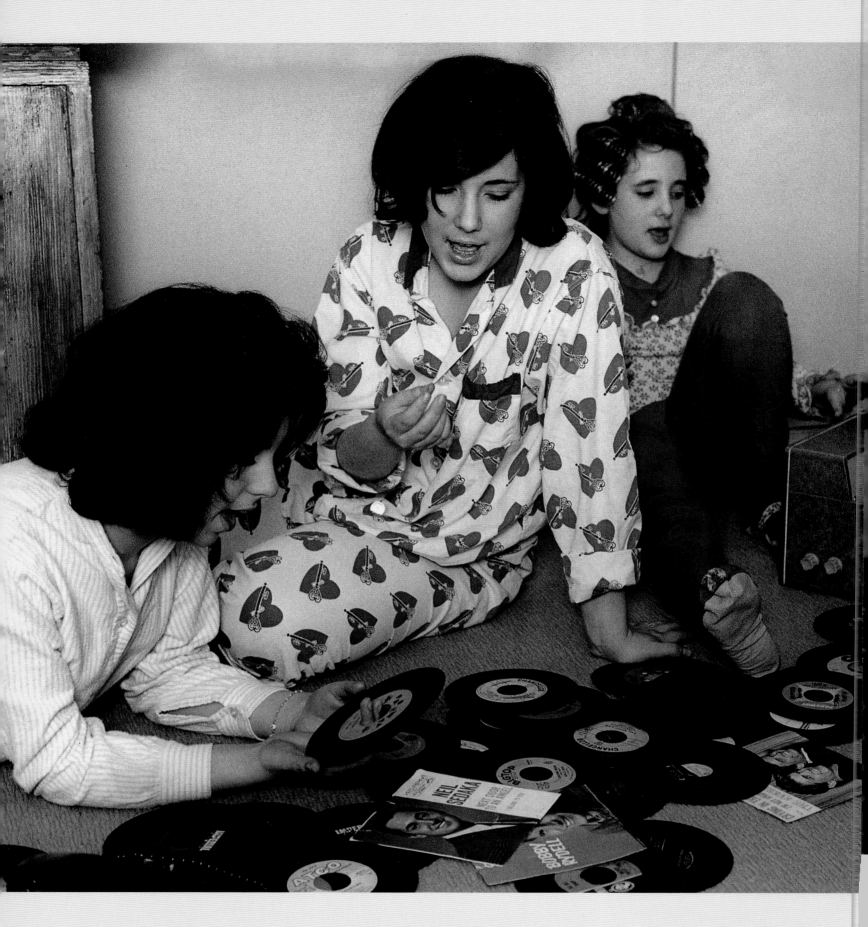

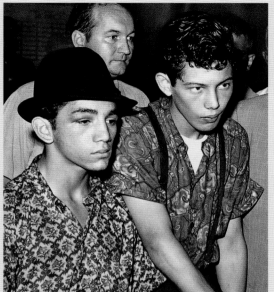

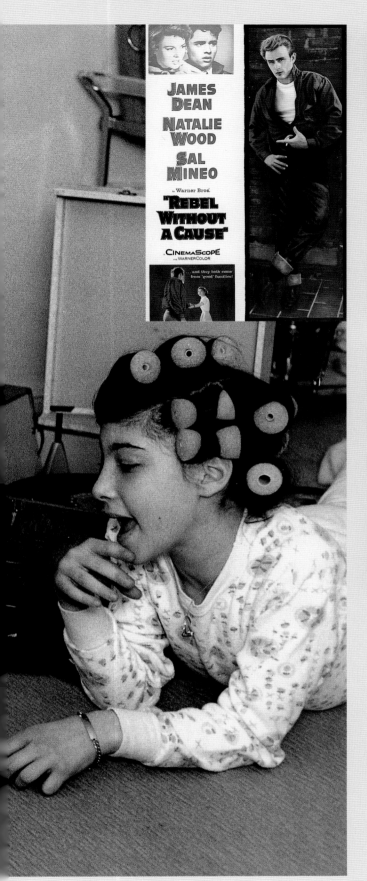

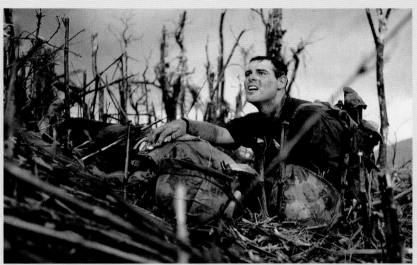

LOST BOYS

James Dean could be a rebellious teen (far left) on screen, and nobody worried. But big city teenage street gangs were a real problem. In 1959, Antonio (Umbrella Man) Hernandez, 17 (left, wearing a hat), and Salvador (Cape Man or Dracula) Agron, 16, were booked after they knifed two other teens to death in the Hell's Kitchen section of New York. Agron's turbulent life was the plot of a Paul Simon musical *The Capeman* in 1998. It flopped.

FAR LEFT: WARNER BROTHERS / NEAL PETERS COLLECTION
LEFT: CORBIS / UPI

DYING YOUNG

Vietnam was called an old man's war fought by the young. The average age of a combat soldier was 19, seven years younger than in World War II. This is medical corpsman Vernon Wike, 19, treating casualties under fire on Hill 881 North above the Khe Sanh Valley in 1967. Back home, teenagers joined antiwar protests. Vietnam indeed defined a generation, there and here.

CATHERINE LEROY / AP

LIFE AT 45 RPM

One cultural innovation was the slumber party, like this get-together in New York City in 1963, which led to another: the closed door. Behind it, in privacy, the hair was in rollers and the floor littered with 45s. The gab and the music often lasted until dawn. Great party, no slumber. You could always sleep in the car as Mom drove you home.

HENRY GROSSMAN

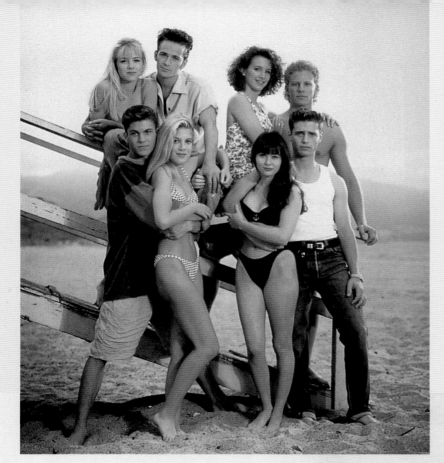

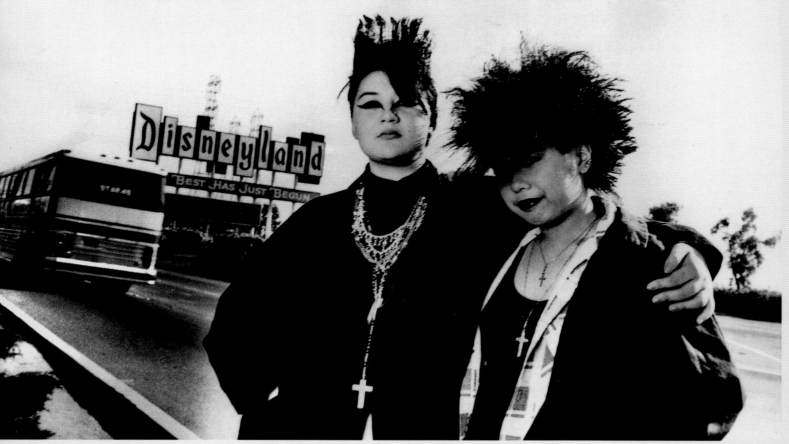

MUSICAL ECSTASY

"Rave on" wasn't an old Buddy Holly song; it was the slogan of the spontaneous dance party scene in the Nineties. At this 1992 gathering in Berkeley, California, the music of choice was techno-pop, but it could have been hip-hop, ska, thrash metal, neopunk or Christian hardcore. Raves were the ultimate social nose-thumbing at adults. And it was a rare rave that was drug-free.

MARK RICHARDS

THE PIRATE KING?

It seemed clear that Teenage Nation would get its future marching orders from the Internet, just as earlier teens got theirs from TV. Among those likely to show the way is Sean Fanning, who at 19 created Napster, a site that delivered music for free. The music industry was trying to squash them in court, but Sean, a student at Northeastern, figures to be around for a while.

ERIC O'CONNELL

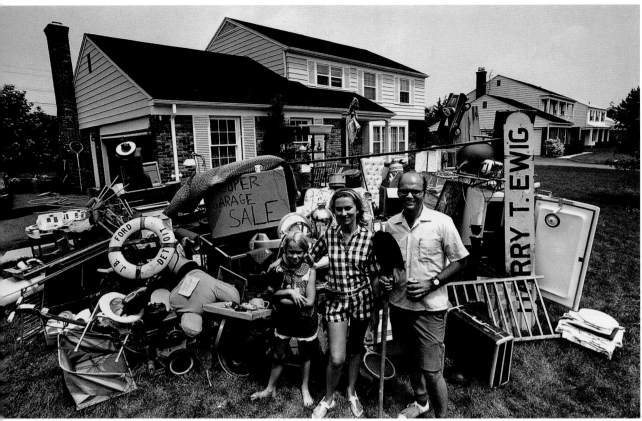

EMPTY THE ATTIC

Tag sale, garage sale, yard sale; it's a way to get rid of stuff other people may think valuable. In 1972, in Bloomfield Hills, Michigan, Chuck Erickson and his family went from a yardful to a handful — of dollars, $442 to be exact. For some families, this was a way to scrape up cash; for others, like the Ericksons, it was more a social occasion than a financial one.

HEINZ KLUETMEIER (2)

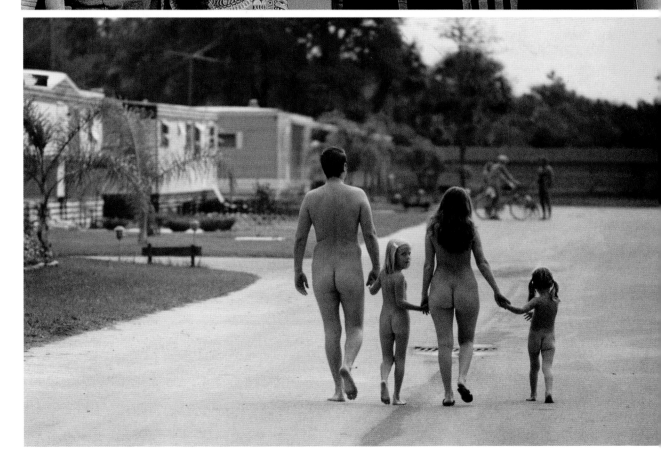

BETTER TIMES AHEAD

Blacks represented 11.4 percent of the population in 1974, the year TV finally got around to reflecting this fact. *Good Times*, about a family in a high-rise ghetto on the South Side of Chicago, debuted at 17th in the ratings and the next season finished an impressive seventh overall. More than a quarter of all TV sets were tuned in. The industry was surprised, setting the stage for the Huxtables and the Jeffersons.

CBS PHOTO ARCHIVE

THE SUNSCREEN, PLEASE

Just a typical family stroll in Florida in 1974? Well, not quite. In 1992, according to *Forbes*, nude recreation was a $120 million industry, and an industry association reported a 76 percent growth in the preceding 10 years. Communes and colonies were thriving in warm states. Yet, nudism was no-news. America had seen lots of people take off their clothes. We adjusted.

LYNN PELHAM / LIFE

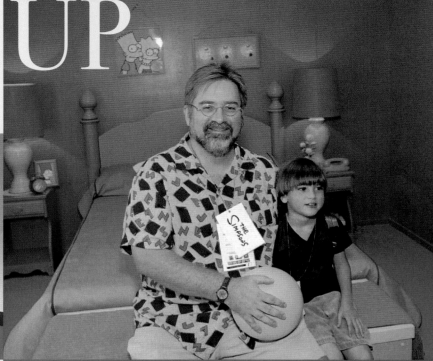

MATT GROENING

Post Nuclear

He was all tradition in anarchist's clothing. Born in Portland, Oregon, in 1954 and educated in public schools, Matt Groening was more normal than Bart Simpson, if not as bright as Lisa. In the Seventies, he started a weekly single-panel comic called *Life in Hell* (about moving to L.A.). Then he invented the Simpson family of Springfield, and in 1987, they began popping up on Tracey Ullman's variety show. When the Simpsons emerged in their own weekly show three years later, with one dead-on plot after another, it was clear that Groening was cutting closer to the bone in his portrayal of the American family than any live TV show was — or probably ever could.

In a replica of Homer and Marge Simpson's bedroom (the whole cartoon family is top left), Groening and his son, Will, 8, celebrated the launch of a virtual Springfield CD-ROM in 1997. Three years later, he signed autographs (above) after getting his own star on the Hollywood Walk of Fame. Before the Simpsons were an institution, they were an issue. President Bush attacked the show, saying it was a lowlife portrayal of the family unit. Untrue: Dad was employed and trying his best, Mom was a matriarchal figure, daughter had ambitions, and son loved them all. Homer Simpson felt wounded by the Bush criticism; he had voted for the man.

TOP LEFT: EVERETT COLLECTION
TOP: LENOX MCLENDON / AP
ABOVE: CHRIS PIZZELLO / AP

>

In 1999, Groening's *Futurama* debuted. The Simpsons of tomorrow? Maybe, but the Simpsons of today are enough for now. Groening has a peculiar kind of fame: He has created characters who are far better known than he is.

F. SCOTT SCHAFER / CORBIS OUTLINE

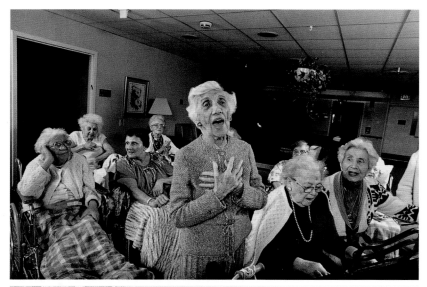

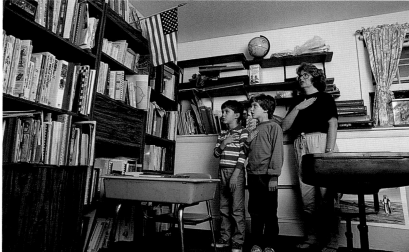

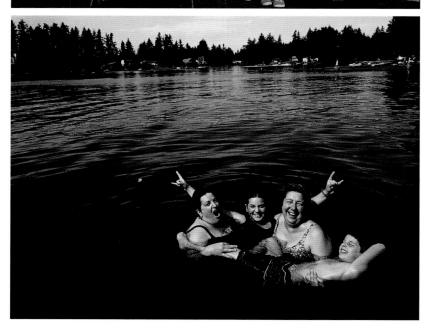

SENIOR YEARS

Americans lived longer; baby boomers were busier than ever. One poignant offshoot of these unrelated trends was that more aging parents were being placed in nursing homes. Here, at the Lieberman Centre in Skokie, Illinois, Celia Goldie, 90, entertained other residents with "Let Me Call You Sweetheart" at an afternoon social in 1988. She was one of 1.5 million elderly people living in managed-care facilities.

HARRY BENSON

HOMEWORK

In Topsham, Maine, in 1990, Diane Ruthazer pledged allegiance with her children, Jonathan and Joy, in their classroom — right in the house. By the mid-1990s, nearly a million children were being home-schooled; it was legal in all states, many with standard programs and tests. Parents kept their kids home for reasons ranging from dissatisfaction with curricula to safety concerns.

STEVE LISS

NEW DEFINITIONS

Lisa Brodoff, 44 (left), and her partner of 18 years, Lynn Grotsky, 43, swam behind their Lacey, Washington, home in 1999 with their children, Evan and Micha. Lisa gave birth to both, with the help of a sperm donor. The Family Pride Coalition estimated that three million children were being raised by gay and lesbian parents in the U.S. All but three states allowed unmarried people to adopt the biological children of their partners.

DONNA FERRATO

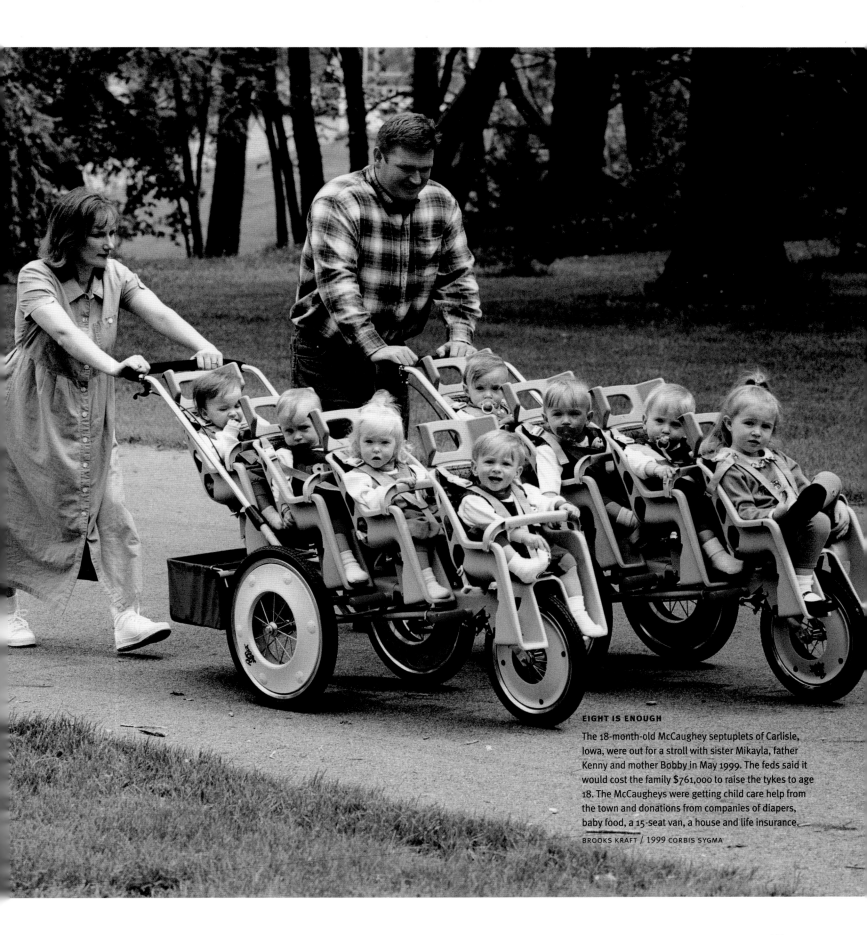

EIGHT IS ENOUGH

The 18-month-old McCaughey septuplets of Carlisle, Iowa, were out for a stroll with sister Mikayla, father Kenny and mother Bobby in May 1999. The feds said it would cost the family $761,000 to raise the tykes to age 18. The McCaugheys were getting child care help from the town and donations from companies of diapers, baby food, a 15-seat van, a house and life insurance.

BROOKS KRAFT / 1999 CORBIS SYGMA

machines

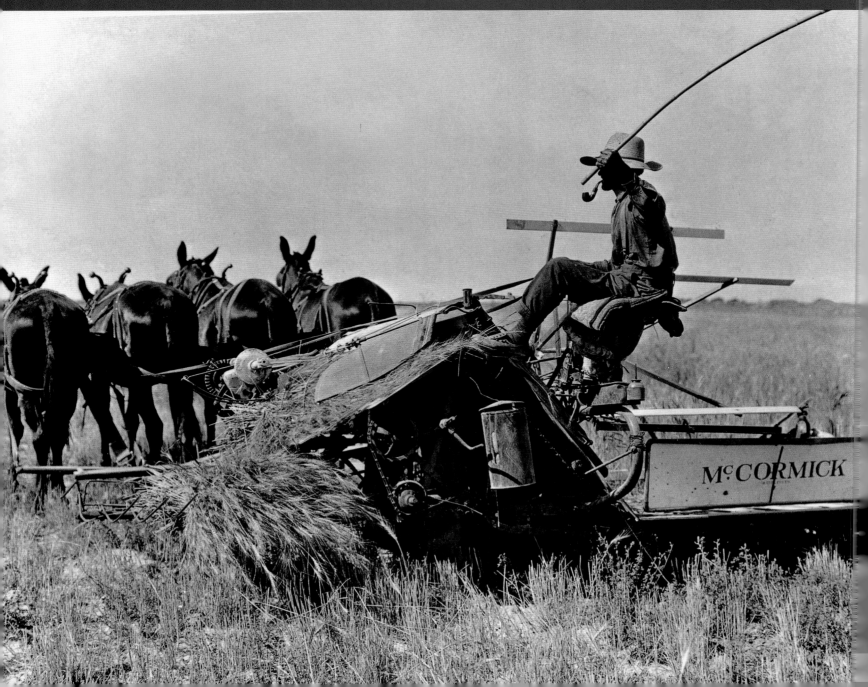

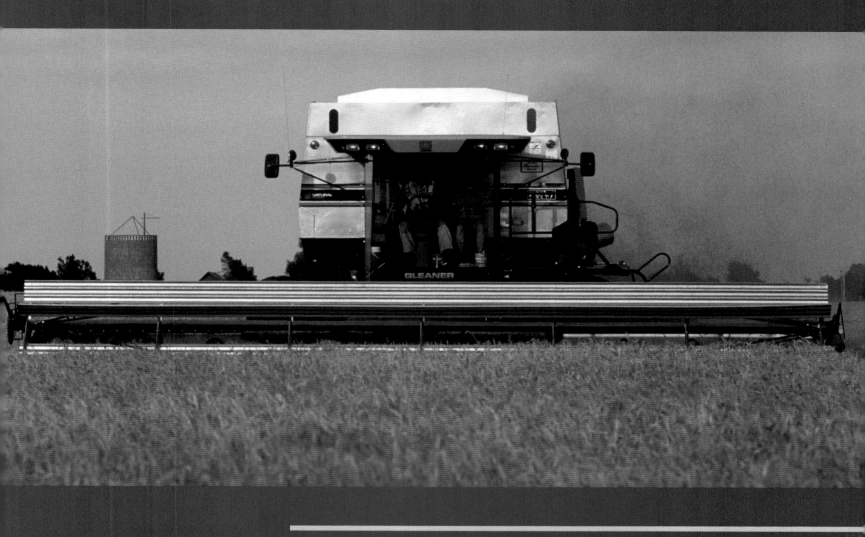

In 1916 New Mexico, it took three-and-a-half weeks to harvest the North Forty with a gas-powered, but team-drawn, reaper. A modern combine fitted with a 36-foot-wide header does the same job in two hours. And the driver of a $200,000, 280-hp rig sits in an air-conditioned cab with a view more pleasant than the south end of a mule going north.

ABOVE: PHILIP GOULD / CORBIS
LEFT: H.T. CORY / NATIONAL ARCHIVES

NEW WAYS TO HARNESS HORSEPOWER

Faster, Higher, Smarter, Smaller

BY DAVID GELERNTER

THE STORY OF 20th Century machines begins on a cold windy day in 1903 with a vaguely nautical object made of spruce, muslin and bicycle chains beating its way into the air for 12 seconds at Kitty Hawk, North Carolina. A small boy is supposed to have dashed down the beach afterward shouting, "They done it! They done it! Damned if they ain't flew." And the same story ends with a swan dive into the tiny space of an integrated circuit chip and a streaking, twisting underwater sprint through the depths of science and engineering culminating (with a splash and a gasp) on the far side, in a new millennium, under the expanding bright galaxy of software. In between, the 20th Century put great brilliance and heart into its machines.

Edison's phonograph, lightbulb and movie camera were all new in 1900; the telephone was new; Marconi's radio was new; and the machine-made landscape had reached stupendous maturity. It was an age of steam, rivets and arrogant grandeur. From 1904 through '14, we built the Panama Canal — a famous photograph shows President Teddy Roosevelt in the cab of a 95-ton steam shovel that helped scoop the Culebra Cut. Meanwhile engineers and laborers using pneumatic drills, steam derricks and high explosives carved a foundation for Pennsylvania Station out of stony Manhattan Island and then put up the great station itself, a soaring singing monument to the power of machinery. Machines changed the landscape; next thing, they *were* the landscape.

In 1917, Henry Ford started building "one huge, perfectly timed, smoothly operating machine" — the gigantic Rouge factory complex, finished at last in 1927; a 1,100-acre, 23-building "machine" that turned coal and iron into steel into cars. Meanwhile the cars themselves were maturing, along with all sorts of other machinery. The Douglas DC-3 airliner of 1935 epitomized the curvaceous streamlined era, *the* Machine Age. Svelte shimmering machines in chrome, steel and aluminum suggested (at their best) Ginger Rogers in silver lamé; in the suave Thirties, machine chic reinforced silver-screen chic and vice versa. Streamlined machines inspired art and architecture, furniture, jewelry, advertising, plumbing, cocktail shakers, wastebaskets. Radios had playful plastic cases. In 1939, American television began.

The Forties were dominated by war machines and the by-products of war: the roar of jet engines, the portentous silence of electronic digital computers, the nuclear flash. The flash kept rerunning like an endless film loop through the world's nightmares.

The Fifties surprised us with reckless, touching confidence in the whole idea of *new*. (Fifties America loved pastel pinks and aquas — reckless, touching colors.) Movies and radio lost ground to the mesmerizing slate-blue glow of "black and white" TV. Ocean liners and long-distance trains lost ground to

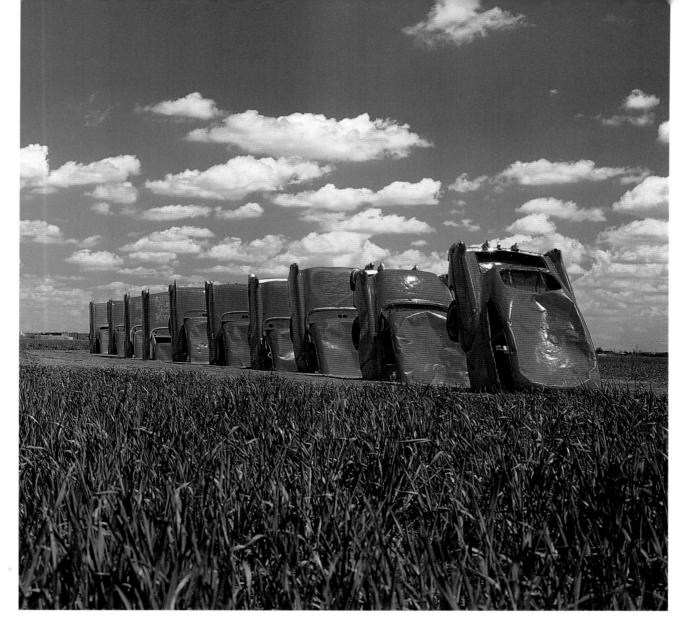

Alongside I-40 just west of Amarillo, Texas, jut 10 buried Cadillacs. The artwork was commissioned by eccentric oil and gas millionaire Stanley Marsh 3. Pastel once, the autos are now covered with graffiti. Local citizens wryly call them their "bumper crop."

WYATT MCSPADDEN

airplanes and automobiles. American cars of the Fifties had ridiculous chrome, ridiculous tail fins, ridiculous big engines, ridiculous colors — they were beautiful. Blessed is the nation that is wholly comfortable in its own skin — "proud without being arrogant, tranquil, at ease in the ring at all times," as Hemingway once said of a bullfighter — a nation where intellectuals thrive and eat well and are free, and no one pays attention to them.

In the early Sixties, the automobile (our favorite machine, our national machine) suddenly developed gorgeous simplicity: the '61 Lincoln Continental, '63 Buick Riviera, '64 Shelby Cobra Daytona, '66 Oldsmobile Toronado; the toniest era in history. Lasers appeared, transistors spread, communication satellites and skirts rose, and finally (in July 1969) came the biggest engineering climax in history: the moon, where a man had to be wrapped in machinery or he would die. By now color TV was ubiquitous, but the moon was black and white.

We had (on second thought) demolished Pennsylvania Station, starting in 1963. It took nearly as

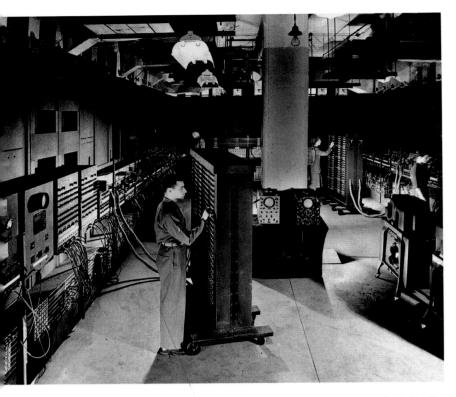

In 1946, the fastest number cruncher on earth was ENIAC, funded by the Pentagon to analyze missile trajectories. The 30-ton machine did 5,000 calculations per second. A low-end modern PC does 300 million.

long to wreck as it had to build, but we kept at it. In 1977, we promised to hand the Canal over to Panama. But it was the premature end of the Apollo moon program in 1972 that marked the turning point in American machine history. We beat a hasty retreat from the moon, as if we were teenage boys who had been caught doing something shameful in the backyard. (Kissing girls?) And in a sense that is just what had happened. The prudes and sourpusses had caught us in the act. Henceforth romance and grandeur were out, to be laughed at or (better) sneered at. Cynicism and smallness were in. Computers and software took off.

During the 1970s, Xerox researchers invented the desktop computer. During the Seventies and Eighties, integrated-circuit chips hatched, swarmed and took over electronics. Today the microcircuitry itself is beautiful, but computing is still in its Slap-

stick Age — all power and no finesse. The hardware is wonderful; the boxes in which it is installed are bland and ugly; the software is absurdly complex, sloppy and weak. Today's computer mouse shows how low we have fallen in the art of machinery; it is dainty and numb, with no feel or feedback, like over-boosted power steering.

Throughout the century, machines grew steadily more potent, important and inscrutable. At first they made us feel proud. Today they have been promoted so many times they almost outrank us, and naturally we are uneasy. In 1900, electric lightbulbs were transparent and not too bright to look at head-on. Steam engines dominated engineering; everyone who had ever boiled water understood them. Today's electronic chips are micro-landscapes sealed in plastic, utterly impenetrable, stupendously important. Today's most significant machines are built out of software. Software is not even a "material." The once-solid stuff of machinery is draining away like water through our fingers. And our mysterious trick engineering is supported by a mysterious trick economy.

We are confused about machine design today, but after all, that is only natural, given the big changes of recent years. Machines felt different when I was growing up in the 1960s. Cameras had gleaming cylindrical shutter buttons with quarter-inch throws that made positive, crunching clicks. The portable typewriter with its taps, smacks and once-a-line dings was a rhythm section all by itself. (Fred Astaire danced with one in *Follow the Fleet* of 1936.) To manipulate a computer, you could type commands at a teletype (*thrunk thrunk thrunk* as you pressed the keys), and the computer responded in a breathless flurry of counter-*thrunking*, and it all sounded like something tremendous.

The speed, power and precision of machinery still enthrall us. The painter and photographer Charles Sheeler wrote in 1927 about his brand-new Ford-built Lincoln that "my pleasure in it is akin to

my pleasure in Bach or Greco and for the same reason — the parts work together so beautifully." Last summer I took my family to an air show, and we watched an F/A-18 barrel across a field in an elegant clean sweep that shook the ground. Twentieth Century machines had *speed* the way a great Bordeaux has (whatever it has) — say, silkiness: in excess, to burn, to the smug pleasure of aficionados everywhere. And those machines specialized in taking off and flying high. They took Lindbergh to Paris, Hugo Eckener around the world in *Graf Zeppelin*, Gagarin and Glenn into orbit, Armstrong and Aldrin to the moon. But E.B. White's cross-country journey in a Model T was just as important. All sorts of young Americans in a newly mobilized, mechanized nation climbed into or onto machines to leave home, make love or money or have fun or grow up.

We don't know quite what to make of machines today. The art of power unsettles and confuses us. New York City's Museum of Modern Art has led the way since the Thirties in recognizing machine art, but has always kept its beautiful machines segregated in isolation galleries, where they can't mix with and corrupt the legitimate stuff. Some people have difficulty admiring machines the way they admire art because (they think) the engineer's hand is forced. He draws lines not because they are beautiful but because science makes him do it. Untrue. Clarence Johnson of Lockheed (for example) had an infinity of plausible, flyable shapes to choose from when he designed the P-38 fighter of 1939 and the SR-71 Blackbird spy plane of 1962, two of the century's most beautiful objects. But he drew the shapes he did because, like all great engineers, he was a great artist.

If you line up the very best objects of the 20th Century, the loveliest and most powerful ones, you will have sculpture by Giacometti and Joseph Cornell, Matisse cutouts, abstract paintings by de Kooning and a nude or two by Modigliani; you will also

It was designed in four months and rushed into production. Then America's P-51 Mustang, a World War II long-range fighter that was more nimble than Germany's best, turned the tide in Europe.
BOEING AIRCRAFT / NORTH AMERICAN AVIATION

have paintings by Stuart Davis that are full of machine images. And you will have the machines themselves. The P-51 Mustang fighter (first flown in its definitive form — American airframe, British engine — in 1942) might well be the 20th Century's most beautiful object. It has surging grace, uncanny poise, moral grandeur — embodying the power and heroism that ventures everything to defend home and freedom and truth. Eventually you will find a P-51 at the center of some great American art museum, and then you will know that this country has finally come to terms with the last century and its machines and their greatness.

David Gelernter is professor of computer science at Yale University, chief scientist at Mirror Worlds Technologies and art critic of the Weekly Standard. *He is author of* Mirror Worlds, The Muse in the Machine, Machine Beauty *and the novel* 1939.

No. 775,134. PATENTED NOV. 15, 1904.
K. C. GILLETTE.
RAZOR.
APPLICATION FILED DEC. 3, 1901.
NO MODEL.

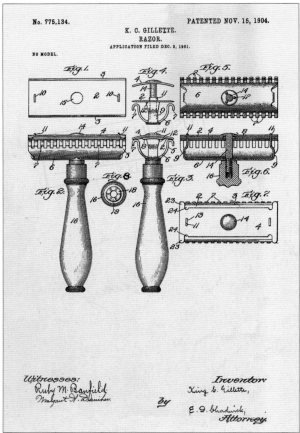

THE NEW BLACK GOLD

Oil spewed from a field near Beaumont, Texas, in early 1901; before workers could cap Spindletop, a million barrels escaped (quadruple 1989's *Exxon Valdez* spill). America's first oil well, in Titusville, Pennsylvania, dates to 1859, when coal was king. But Spindletop blew as internal-combustion engines were coming on line. And those newfangled gizmos demanded another, less lumpy form of fossil fuel.

BROWN BROTHERS

<
CUTTING-EDGE CONCEPT

The razor invented by King C. Gillette (top left, 1907) was simple yet revolutionary. Until 1903, men who owned double-edged razors had to hand-sharpen blades dulled by use. The Gillette offered affordable replacements that only the company was licensed to produce. By the time the ex–traveling salesman was awarded Patent 775,134, his customers had purchased 124,000 new blades after disposing of the old ones.

TOP LEFT: GILLETTE COMPANY
LEFT: U.S. PATENT OFFICE

>
ARE WE THERE YET?

In June 1909, Mrs. Alice Huyler Ramsey, 22, piloting her brand-new Maxwell, and three companions left New York City. They hit San Francisco in 59 days, the first women to motor coast to coast on their own. Sightseeing aside, the trip was not speedy, because the U.S. had less than 150 miles of paved intercity roads and not one filling station. (Gas was available at general stores.)

COURTESY MOTOR VEHICLES
MANUFACTURING ASSOCIATION

. . . THREE IF BY AIR

A half decade after coaxing their heavier-than-air machine aloft, the Wright Brothers were buzzing over France. Orville, 37, and Wilbur, 41, had become international celebrities. They had also contracted with the American and French governments to develop potential military uses for their invention.

WRIGHT STATE UNIVERSITY

ON THE LINE

The assembly line that revolutionized automaking (below) was still a bit primitive in 1914. Yet that year, Henry Ford's Highland Park, Michigan, plant cranked out 300,000-plus cars. Efficiency had its price. The Model T now came only in black. (Earlier models had also been available in red, blue, green or gray.)

FORD MUSEUM

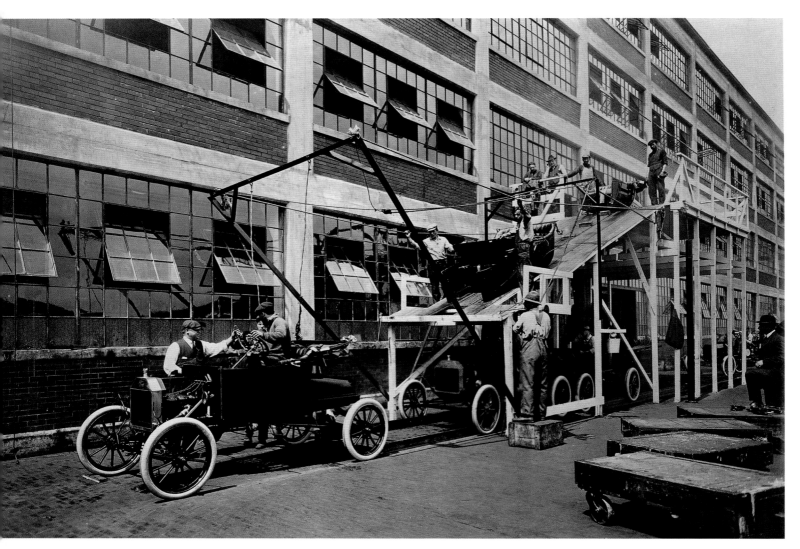

TRY CALIFORNIA LATER

AT&T counted 2,241,367 telephones in use in 1905 when it unveiled a model (below) that encouraged long-distance calling. Its network then stretched from Boston to Omaha; the West Coast would not be in the loop for another decade. And until trials for direct-dial long distance began in 1951, the only way to reach out and touch someone far away was with an operator's assistance.

STEVEN MAYS PHOTOGRAPHY

MY FELLOW AMERICANS

The first 27 U.S. presidents could address only those within earshot. Then Warren G. Harding cut his voice onto a wax cylinder and spoke on radio during his short tenure (less than three years; he died in 1923, probably of a stroke, at 57). FDR tapped radio's growing reach into homes with his "fireside chats" and also did the first TV gig, an experimental telecast at the 1939 World's Fair.

H.E. FRENCH COLLECTION

> **EARLY COUCH POTATO**

In 1928, radio was less than eight years old and fewer than eight million households owned a set. That didn't stop America from eyeing the next step in broadcast entertainment: television, which was already being demonstrated by working prototypes. But because of the Depression and World War II, TV would not jump from lab to living room for another two decades.

H. GERNSBACK

CLOSE UP

WILLIS CARRIER

The Big Chill

Imagine extending the Mason-Dixon Line until it hit the Pacific near Eureka, California. In 1900, half the U.S. lived above that divide. Today, 38.5 percent of us do. Of the myriad factors behind the Sunbelt's growth, few are more key than Willis Carrier's system for regulating indoor climate. In 1902, the engineer, 25, was asked to dehumidify a New York printing plant. He did. Four years later he was asked to cool a South Carolina cotton mill. He did. In 1915, armed with the first of his 80 patents and with financial backing (below), Carrier began to produce an "apparatus for treating air." (It took a rival to coin the catchier phrase *air conditioning*.)

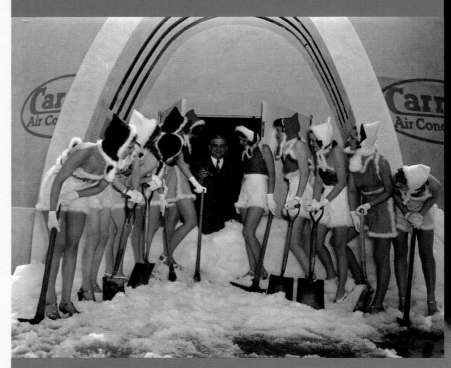

Industry was the first to place orders with the Carrier Corporation (below left, Carrier, seated second from left, and his six investors). Soon to follow: department stores and movie theaters (1924), high-rise offices (1928) and cars (1939). The home market developed in the 1950s. A millionaire who by 1938 had developed a taste for dog breeding (right), Carrier was not above hamming it up (top, at his company's exhibit at the 1939 World's Fair). So that thermometer in his hand read 90 degrees? No sweat.

LEFT: CARRIER CORPORATION
TOP: CORBIS/BETTMANN
RIGHT: AP/WIDE WORLD PHOTOS

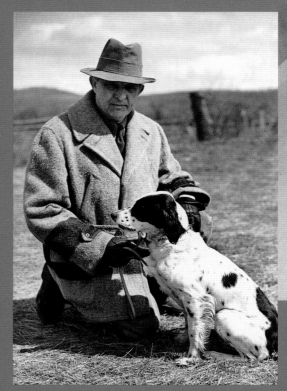

Carrier (at right, with an industrial-strength unit) had a fondness for smoke-filled rooms: His researchers used them to study diffusion patterns. The 1945 test pictured here was of a system using floor vents. The lightbulbs around the card table approximated the body heat of four bridge players. The smoke indicated how high the cooled air had climbed.

BERNARD HOFFMAN
INSET: CARRIER CORPORATION

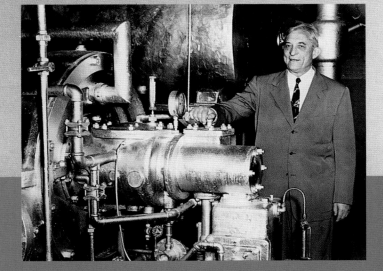

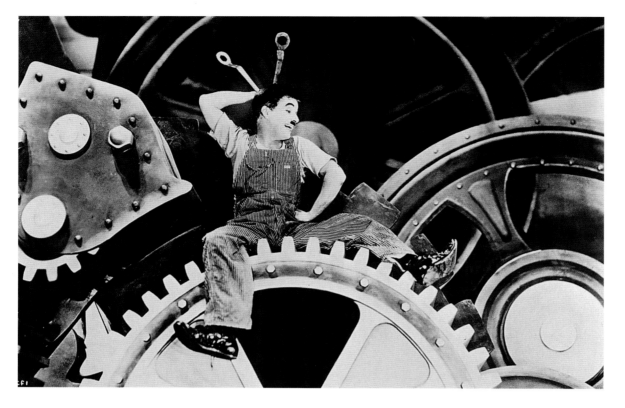

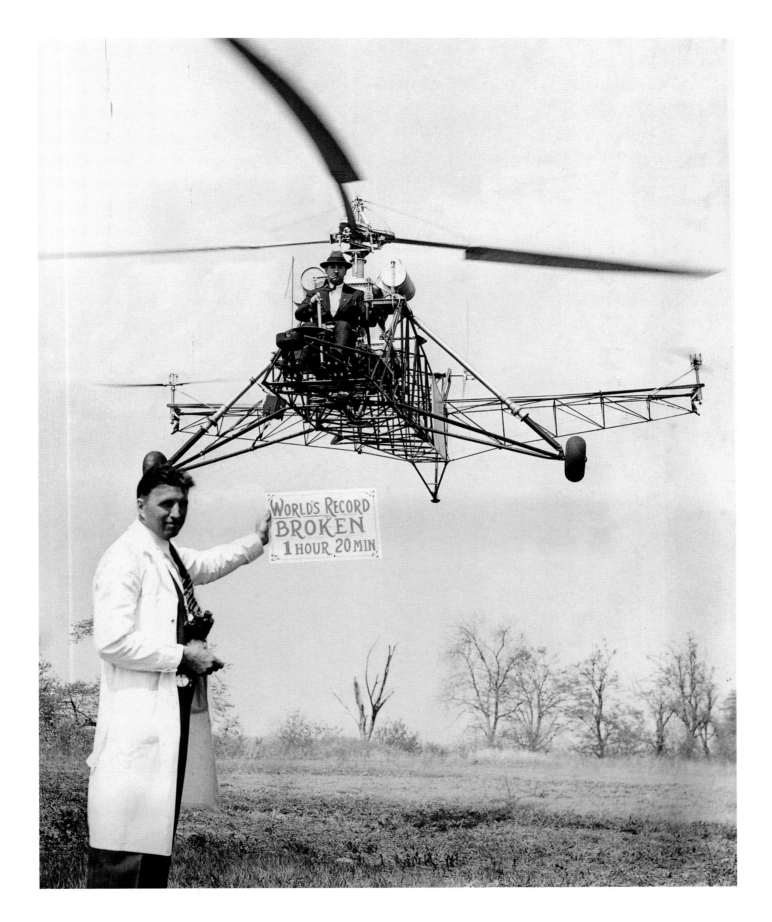

WORLD'S RECORD
BROKEN
1 HOUR 20 MIN

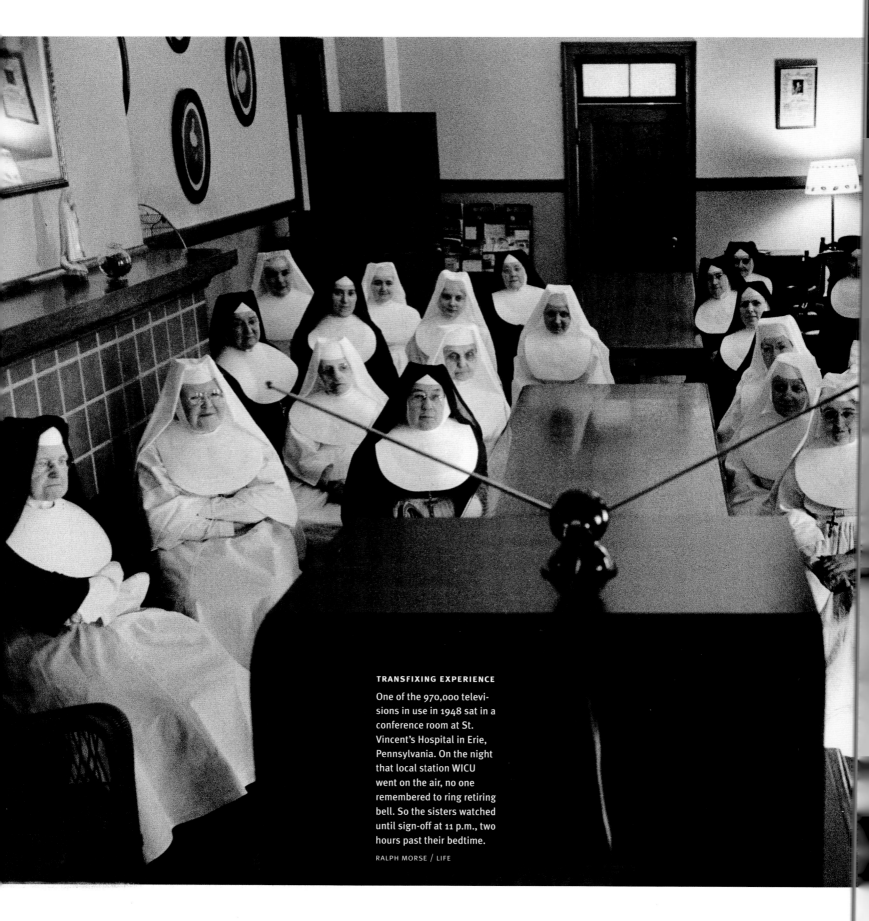

TRANSFIXING EXPERIENCE

One of the 970,000 televisions in use in 1948 sat in a conference room at St. Vincent's Hospital in Erie, Pennsylvania. On the night that local station WICU went on the air, no one remembered to ring retiring bell. So the sisters watched until sign-off at 11 p.m., two hours past their bedtime.

RALPH MORSE / LIFE

REASON TO BLEAT

Billy Goat Gruff? No, it was more like Billy Goat Huff-and-Puff as this poor ruminant fought suffocation during a 1940 U.S. Army experiment. With planes attaining ever higher altitudes, the military needed to study the effects of oxygen deprivation. (Goats, it turned out, handle thin air better than humans.)

EUGENE SMITH / BLACK STAR

TOO LITTLE, TOO LATE

In July 1944, Germany unleashed a fighter that soon wreaked havoc on the Allies: the Messerschmitt Me 262. This first-generation jet outclocked the fastest U.S. plane, the P-51, by 100 mph. But Hitler was already short of able pilots; though 1,433 Me 262s were built, no more than 200 saw aerial combat.

AP

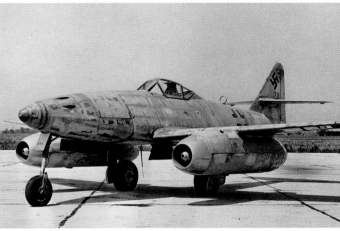

SEE IT NOW

Four years after his daughter asked why snapshots couldn't be viewed instantly, Edwin Land, 37, gave a 1947 demonstration of Polaroid photography, which yielded an image in 60 seconds. Earlier, the Harvard dropout had invented a process to combat glare by polarizing light. Land earned more than 530 patents, second only to Thomas Edison's 1,300-plus.

CORBIS / UPI

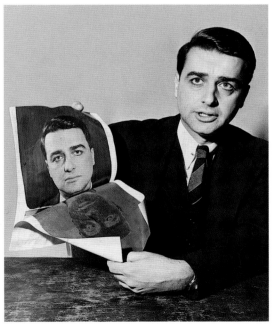

TURNING POINT

USAuto-mania

Cars are no more than an accretion of some 21,000 parts, a ton or more of metal, glass, plastic, rubber. So why do we bond with them as if they were Cabbage Patch dolls with wheels? Because they demand as much care and maintenance as any household member, human or animal. Because they express our sense of self; imagine a Saab sister driving her father's Olds. But most of all, because they seduce with their power to take us to "the territory ahead." Mark Twain, who coined the phrase, knew the American psyche was rooted in a compulsion to light out for the unknown. See the U.S.A. in your Chevrolet? Put the pedal to the metal!

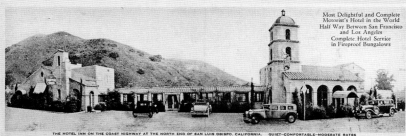

<
THE FAMILY WAY
In 1948, this Chicago drive-in was one of 800 vying with conventional theaters for the family trade. They offered carhops, cheaper tickets and no babysitter fees (just park the pj'ed kids in the backseat). By 1958, the number of open-air screens had mushroomed to 5,000. But their patrons proved to be mostly passion-pit teens; Mom and Dad were home watching that new free mass medium, television.

ALLAN GRANT / LIFE

JUST . . . SMOKIN'!
Gentlemen first started their engines at the Indianapolis Motor Speedway in August 1909 (top); the trial race above was for a fifth of the distance of today's Memorial Day classic. The entrants probably couldn't have finished 500 miles, even with the help of the mechanics riding shotgun. The winner: Lewis Strang in car 33, averaging a breath-taking 64 mph.

AUTOMOBILE MANUFACTURERS ASSOCIATION

MOTEL ONE
Few in 1925 drove the 450-mile Pacific Coast Highway linking San Francisco and Los Angeles in a day. So architect Arthur Heineman cleverly erected a 56-room inn ($2.50 a night) at the midpoint of the journey, San Luis Obispo. It was the first designed expressly for the horseless-carriage trade. And by compressing *motorists' hotel* into *motel*, he added a new word to the language.

DAN MACMEDAN

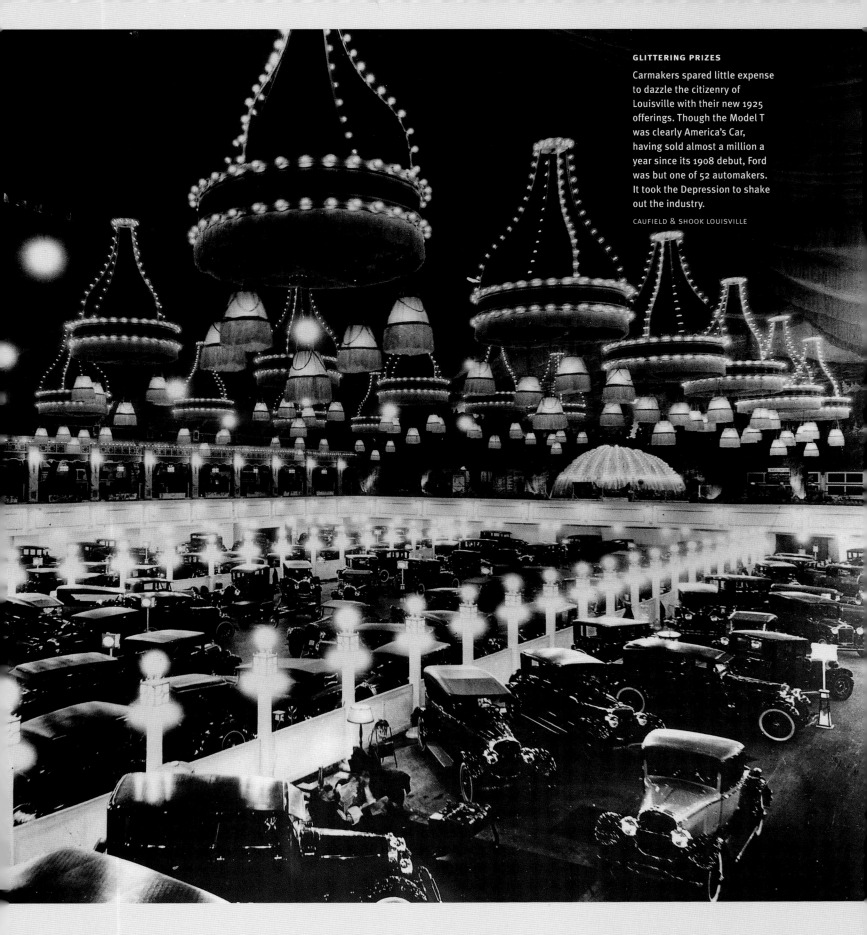

GLITTERING PRIZES

Carmakers spared little expense to dazzle the citizenry of Louisville with their new 1925 offerings. Though the Model T was clearly America's Car, having sold almost a million a year since its 1908 debut, Ford was but one of 52 automakers. It took the Depression to shake out the industry.

CAUFIELD & SHOOK LOUISVILLE

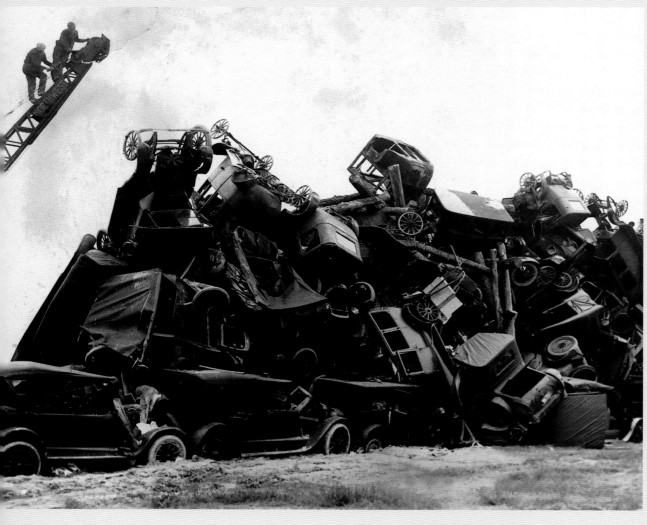

END OF THE ROAD

By 1929, U.S. automakers had sold 40 million cars. What to do with those that had run their last mile? Chicago dealers promoted Used Car Week by stacking junkers 50 feet high on an island in Lake Michigan (left), then torching them. Some 100,000 gathered to watch the pyre, which dispatched some 200 cars to vehicular Valhalla.

AP

BEAT THE CLOCK

Free street parking died in 1935 when Oklahoma City installed America's first meter (right). The device spread like kudzu; today it guards some four million spaces in the 50 states. Was it mere coincidence that two years later banks in Los Angeles pioneered drive-up windows (far right)? After all, motorists now needed change to feed the meters.

RIGHT: TIME INC.
FAR RIGHT: PETER STACKPOLE / LIFE

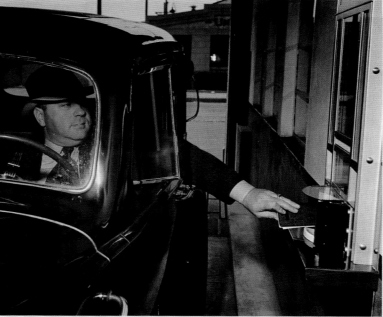

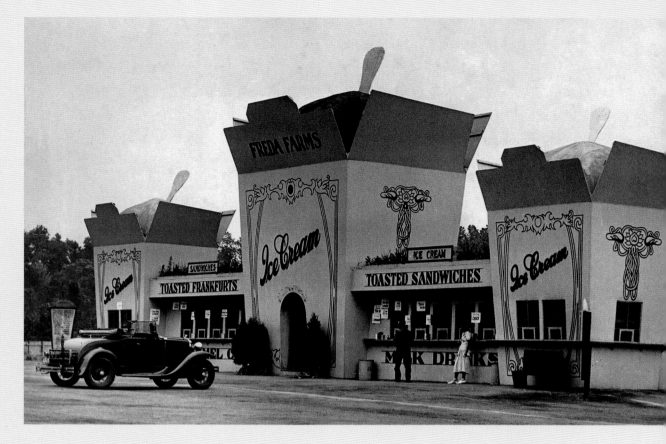

MAKE THAT TO GO

Long before HoJo put up orange roofs and Mickey D golden arches, roadside restaurateurs knew how to catch the eye of passing motorists. Nor in 1934 did these patrons outside Hartford, Connecticut, exactly need a printed menu. So ingrained has the car-spawned, eat-and-run habit become that Americans now drop an average of $14 a week at fast-food joints.

CORBIS / SYGMA

NO WHEELS? NO PROBLEM

As early as 1916 entrepreneurs began to rent out automobiles. The reason? Most new cars back then cost less than $1,000 — but the average family earned only $700. Yet sometimes, yesteryear did offer true bargains. Those depth-of-the-Depression rates posted in 1938 by one Connecticut firm (right) translate, in today's money, to $12 per day plus 60 cents per mile.

ALFRED EISENSTAEDT / LIFE

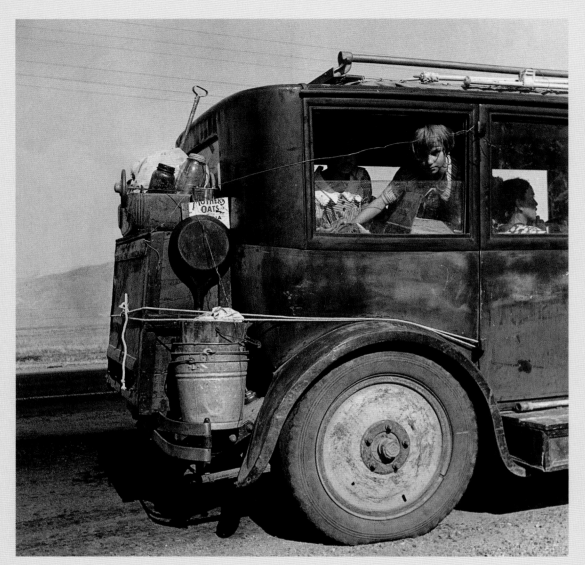

THE GREAT ESCAPE

The year: 1936. The family in a battered Dodge was fleeing the Dust Bowl disaster area of Abilene, Texas. Its destination: a place where the air was said to be sweet and work plentiful. During the 1930s so many at rope's end — commonly referred to as Okies — resettled in California that in one decade, the Golden State's population grew by a quarter.

DOROTHEA LANGE / RESETTLEMENT ADMINISTRATION

PLEASE HONK "AMEN"

The cost of erecting a house of worship plummeted in 1955. At the Venice, Florida, ministry of the Reverend Robert White, most of the congregants even brought their pews. That same year, the alfresco Garden Grove Community Church in Orange County, California, opened with room for more than 5,000 sinners (or 1,700 cars).

HANK WALKER / LIFE

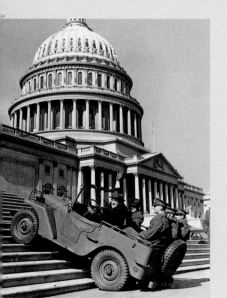

A CAPITOL VEHICLE

Using the steps of the Capitol, Senator James Mead of New York test-drove the Army's new all-terrain vehicle in early 1941. When the U.S. entered World War II later that year, Willys Overland and Ford began manufacturing jeeps (from General Purpose, or GP, vehicle). By V-J Day in 1945, they had produced some 700,000.

CORBIS / ACME

ANYONE SEEN DA FONZ?

Hurst shifter, three-deuce carbs, lake pipes, glass-pack mufflers — those were performance tweaks made by hot-rodders like these 1950 teens from Altadena, California. Want a show car for Saturday night cruisin'? Then it's metal-flake paint, French headlights, blue-dot taillights, tuck-and-roll seats. (Uh, Daddy-o, can you advance me some bread?)

LOOMIS DEAN / LIFE

CHANGE OF OIL

Twenty-six when he painted 1964's *Standard Station, Ten Cent Western Being Torn in Half* (upper right of canvas), Ed Ruscha was not the only young artist to comment on the growing car culture. Pop pioneers Oldenburg, Lichtenstein and Indiana also recycled roadside icons; Allan D'Arcangelo executed an entire series titled *The Great American Highway*.

COURTESY ED RUSCHA

THE WANDERERS

America's interstates were still being built in 1960 when CBS tapped into the lure of the open road with *Route 66*. George Maharis, 32 (near right), and Martin Milner, 29, roamed the land in a Corvette, dispensing good deeds. But others in Hollywood soon adopted a darker take on the highway. Case in point: that seminal 1969 road movie, *Easy Rider*.

CBS PHOTO ARCHIVE

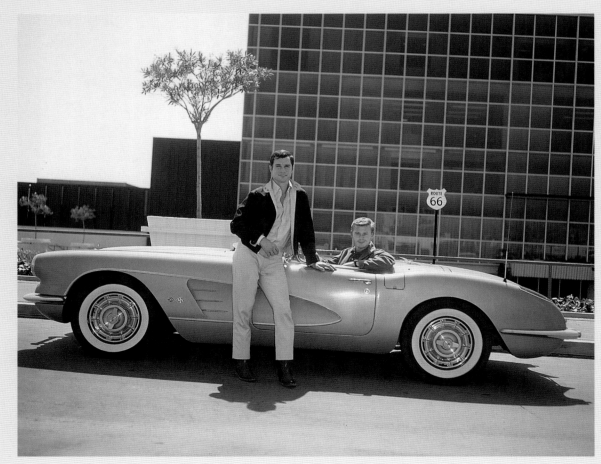

AMERICAN GRAFFITI

One cliché of the counter-cultural Sixties was a VW repainted into a Love Bug. The Flower Power look didn't suit author Ken *(One Flew over the Cuckoo's Nest)* Kesey, who was beyond reefer madness. His drug of choice was LSD, so a psychedelic palette made sense for the old school bus that ferried him and his pals, the Merry Pranksters, around the country.

TED STRESHINSKY

ROAD RAGE 101

Demolition derby's one rule couldn't be simpler: The last car able to move is the winner. At tracks like this on Long Island, New York, in 1966, fields of 100 or more jalopies pounded each other into scrap metal. Americans remain fans of potential auto mayhem; today, motor sports command more paying customers than the NFL.

AL FENN / LIFE

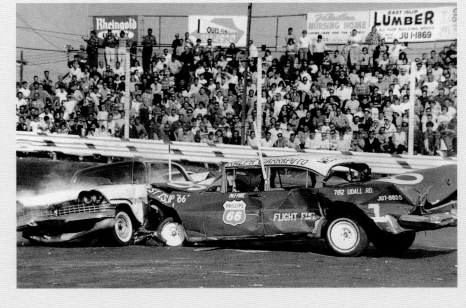

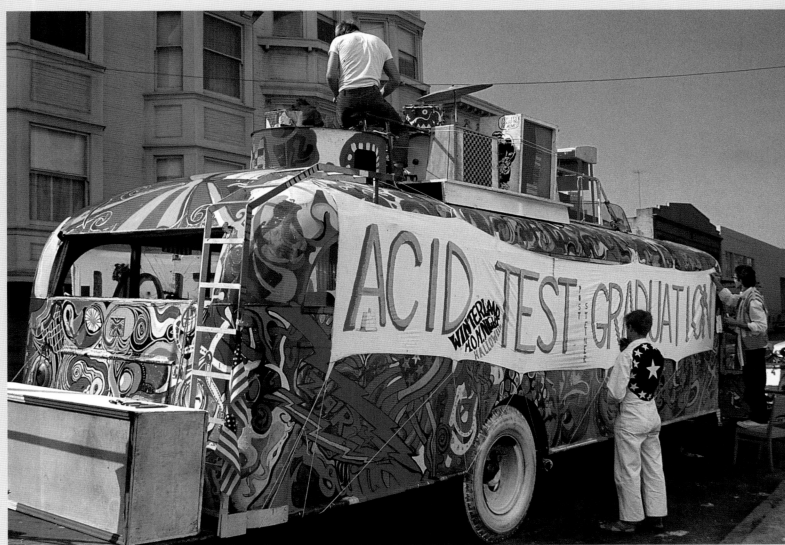

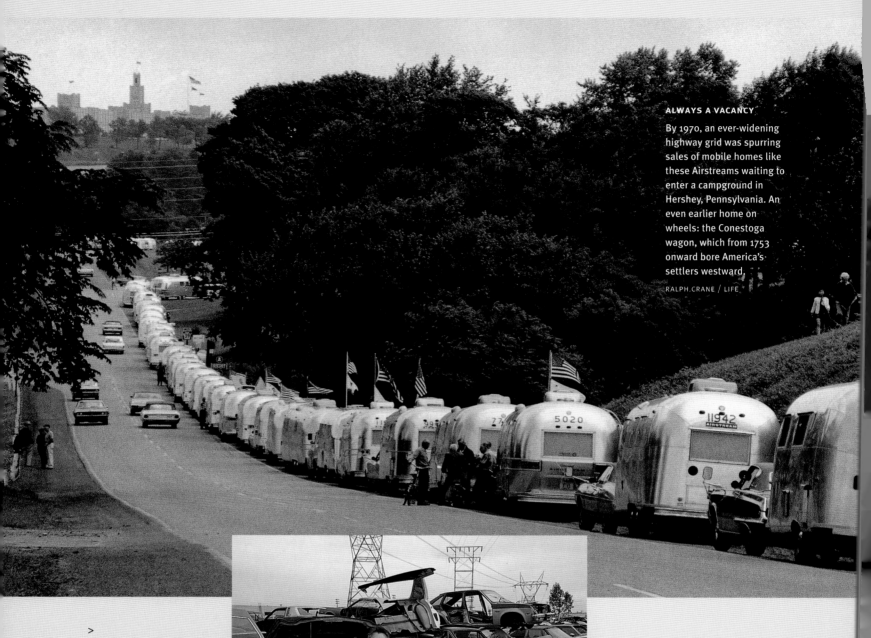

>

THE OLD SOFT SELL

The unsavory rep of used-car salesmen (on a par with Dick Nixon's) was the conceit behind a droll TV ad campaign launched in 1986. As Joe Isuzu, actor David Leisure, 35, would make an impossible claim, then grin broadly and say, "Trust me!" The last laugh was on the auto industry. In 1989, due to sticker shock, used cars began outselling new models.

JIM MCHUGH PHOTOGRAPHY

>

LET'S TRY A U-TURN

Its length: 863 inches, or 54.8 feet longer than on leaving the Cadillac plant. Its amenities: obvious. Its reason for being: In 1982, Finnish pickled-herring czar Heikki Reijonen vowed to build the world's stretchiest limo. Forget about a Prom Night booking, though. At 15,992 pounds, it can't do much more than park.

UK PRESS / LIAISON

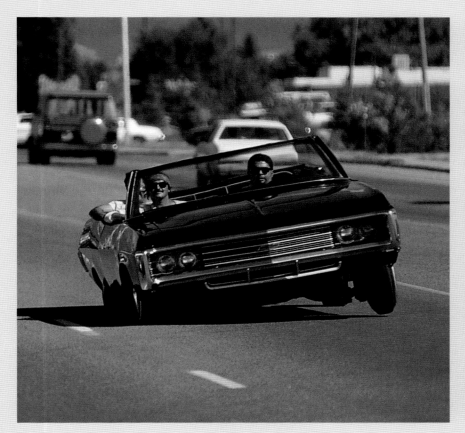

FUNNY CAR I

The ragtop cruising Taos, New Mexico (above left), didn't need new shocks. Driver Dominic Ocanas had dropped the chassis and put in four lifters to let him make any fender hop or dip on cue. The custom of crafting low riders, begun by Chicanos, had its critics. As did the mostly Anglo practice of assembling hot rods.

MACDUFF EVERTON

FUNNY CAR II

Sylvan Goldman would have been proud of the chromemobile above, shown in 1996 in Bristol, Tennessee, promoting a supermarket chain. Fifty-nine years earlier Goldman, the 40-year-old owner of a Humpty-Dumpty in Oklahoma City, had invented the shopping cart. Now you know.

GEORGE TIEDEMANN

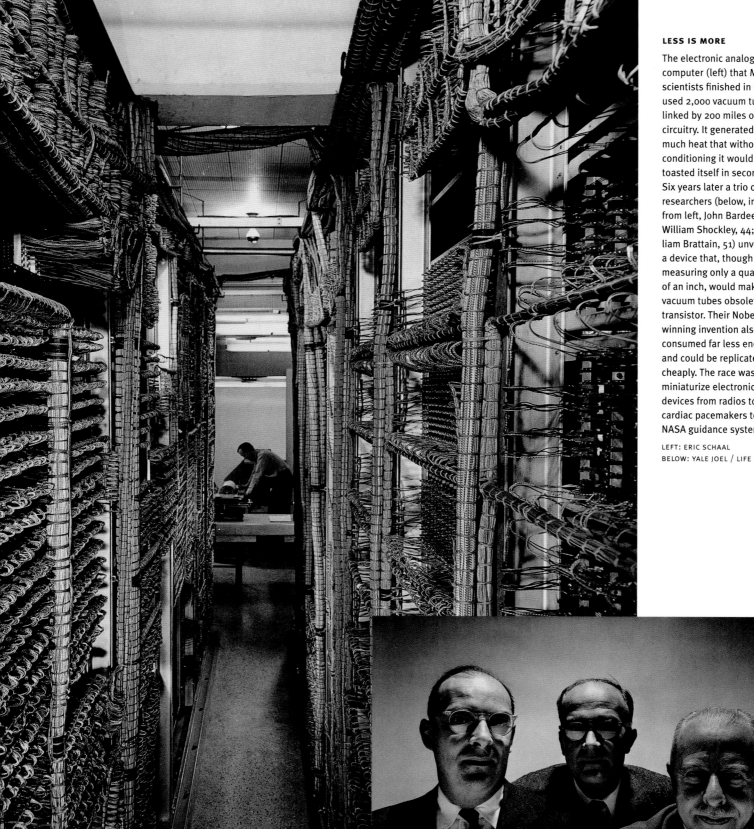

LESS IS MORE

The electronic analog computer (left) that MIT scientists finished in 1942 used 2,000 vacuum tubes linked by 200 miles of circuitry. It generated so much heat that without air conditioning it would have toasted itself in seconds. Six years later a trio of Bell researchers (below, in 1954; from left, John Bardeen, 45; William Shockley, 44; William Brattain, 51) unveiled a device that, though measuring only a quarter of an inch, would make vacuum tubes obsolete: the transistor. Their Nobel-winning invention also consumed far less energy and could be replicated cheaply. The race was on to miniaturize electronic devices from radios to cardiac pacemakers to NASA guidance systems.

LEFT: ERIC SCHAAL
BELOW: YALE JOEL / LIFE

PAGING LUKE SKYWALKER

Long before the empire struck back in the first *Star Wars* sequel, Ralph Mosher, a GE engineer known as the father of robotics, built a 3,000-pound mechanical walker. In this 1969 test, he tried using hand and foot signals to control the machine's gait. The task proved too complex. Enter the computer: Today, one chip-controlled, two-limbed robot can even spring somersaults.

THE NEW YORK TIMES

POINT THAT ELSEWHERE

The beam from a Maryland laser generator in 1968 was tracking a satellite. Light Amplification by Stimulated Emission of Radiation was proposed in 1958; it took only two years to build a working prototype. In addition to guiding missiles and playing CDs, lasers have become surgical tools that allow doctors to make more precise incisions.

TONY LINCK / TIME

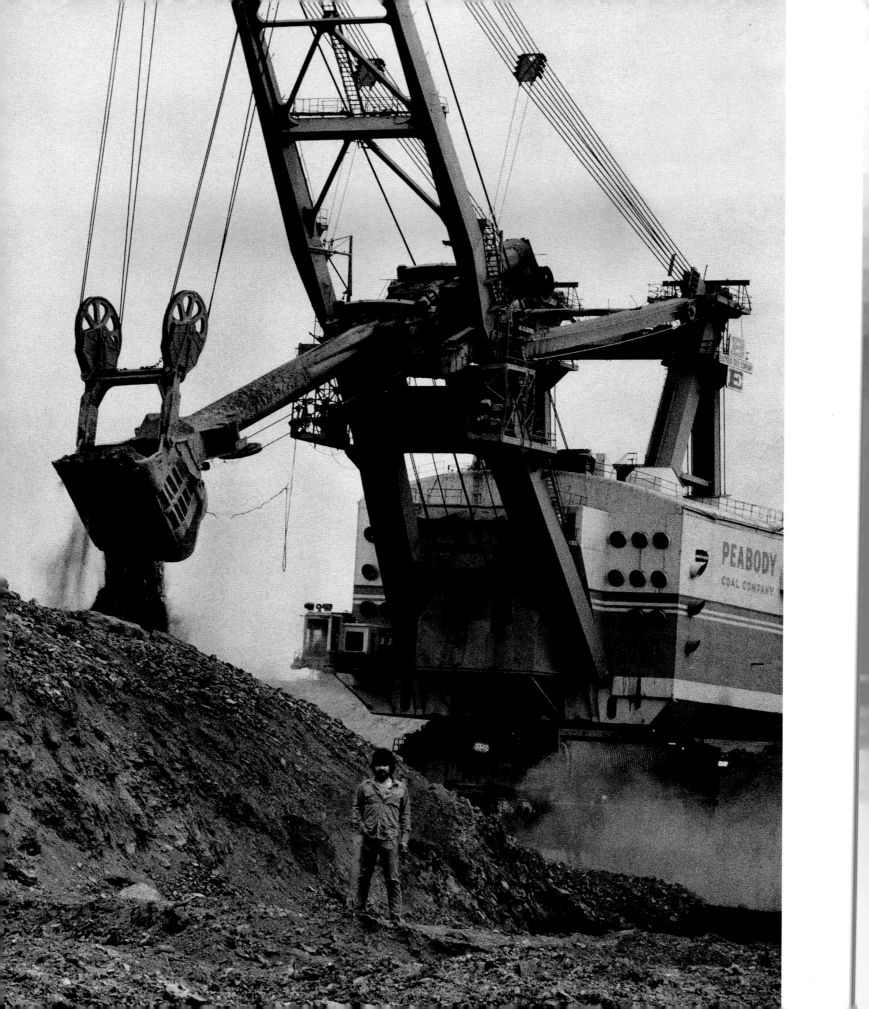

<

DIG THIS

In 1974, singer John Prine, 27, whose "Paradise" condemned the strip-mining of coal, watched as another bit of Paradise (Kentucky, pop. 0) was lost to a 10-story shovel. Earth-movers like this can scoop up 110 cubic yards of soil at a time. That's more than enough to fill a one-car garage up to the roof.

LEE BALTERMAN / LIFE

CYBERPIONEERS

A dozen hackers reunited in a Cambridge, Massa-chussetts, lab in 1973 (right) to celebrate what they'd done two years earlier: patch the East Coast into Arpanet, a tele-phonic network over which computers could talk to each other digitally. The machines using this fore-runner of the Internet were mainframes. The genesis of the PC lay in the 1971 introduction of the first microprocessor, the Intel 4004 (almost eight times actual size, below near right). Among the hobby-ists who arrayed these early chips into a working computer were two pals from Cupertino, California, who began selling the Apple I in 1976. Six years later, Steve Wozniak, 31 (beaming, far right), and Steve Jobs, 27, held up one of their revolutionary motherboards.

CLOCKWISE FROM TOP: HUTCHINS PHOTOGRAPHY, INC.; COURTESY APPLE COMPUTER, INC.; ERICH HARTMANN / MAGNUM

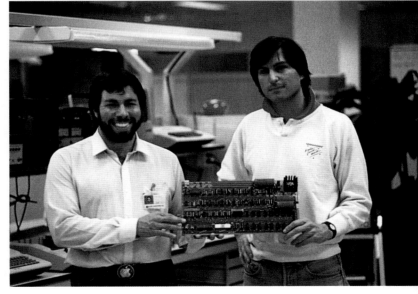

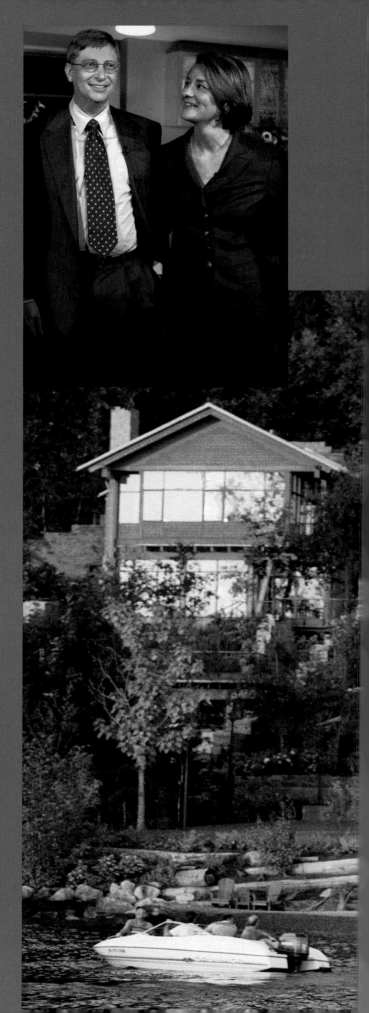

BILL GATES

Mr. $oftware

Boot up a personal computer. Without an operating system, basic software to control the hardware, it displays only a cursor. You can't run programs, play games, dial up the Internet. Bill Gates and Paul Allen, boyhood pals (above) and co-founders of Microsoft, were not the first to market an operating system. But in 1980, their MS-DOS was picked by IBM for its new PCs. While rival Apple kept its superior system proprietary, IBM licensed out its architecture, and each clone needed MS-DOS (or today, Windows). By developing new products for a captive audience — 90 percent of all PCs run on a Microsoft platform — Gates, in 1992, became, at 36, America's richest man.

In 1968, at a Seattle prep school (left), Bill Gates, 12, watched fellow computer enthusiast Paul Allen, 15, type code. Allen resigned from Microsoft in 1983 on contracting Hodgkin's disease (now in remission); he remains the firm's second-largest share-holder. In 1994, Gates, 38, and aide Melinda French, 29, were wed; she helps run his philanthropies (in 1999, above right, announcing a $1 billion fund to aid minority scholars). They live with their two kids in a $55 million, 45-room high-tech palace (right) on Seattle's Lake Washington.

TOP LEFT: LAKESIDE SCHOOL / MICROSOFT
ABOVE RIGHT: REUTERS / JEFF CHRISTENSEN / ARCHIVE PHOTOS
RIGHT: MIKE SIEGEL

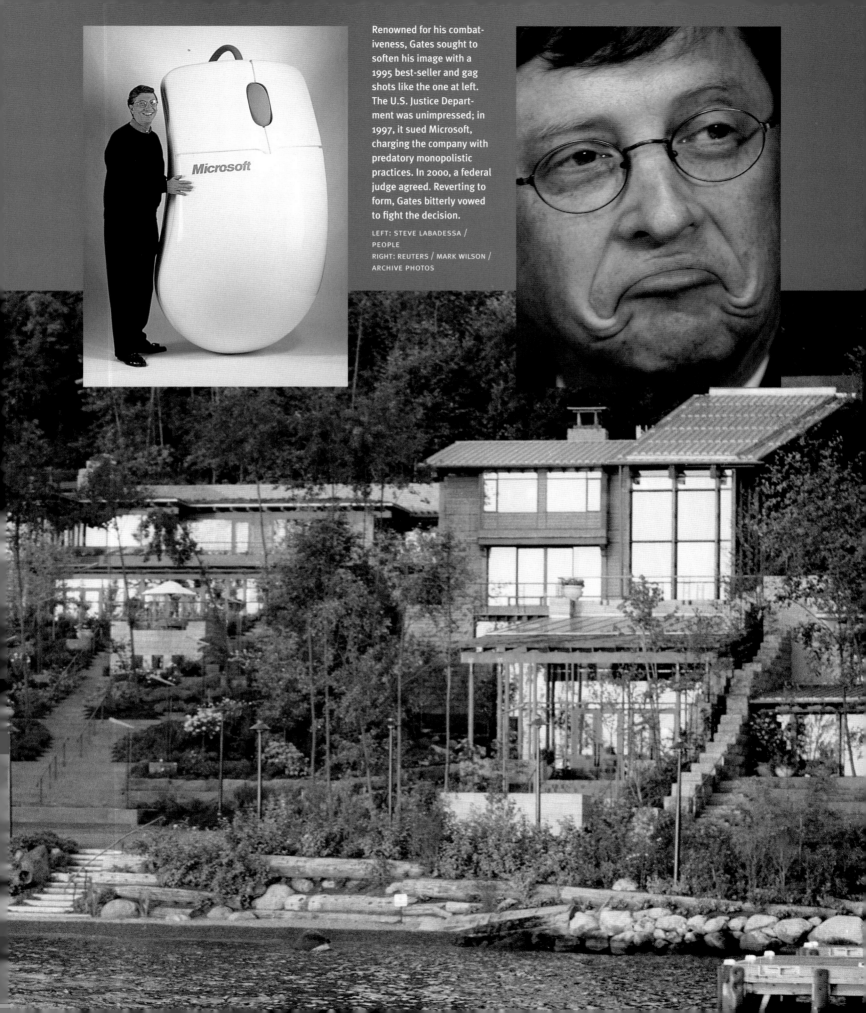

Renowned for his combativeness, Gates sought to soften his image with a 1995 best-seller and gag shots like the one at left. The U.S. Justice Department was unimpressed; in 1997, it sued Microsoft, charging the company with predatory monopolistic practices. In 2000, a federal judge agreed. Reverting to form, Gates bitterly vowed to fight the decision.

LEFT: STEVE LABADESSA / PEOPLE
RIGHT: REUTERS / MARK WILSON / ARCHIVE PHOTOS

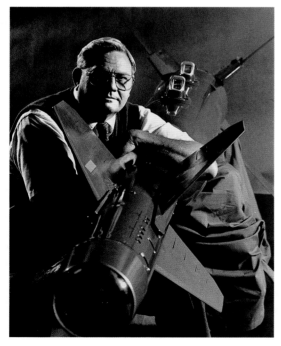

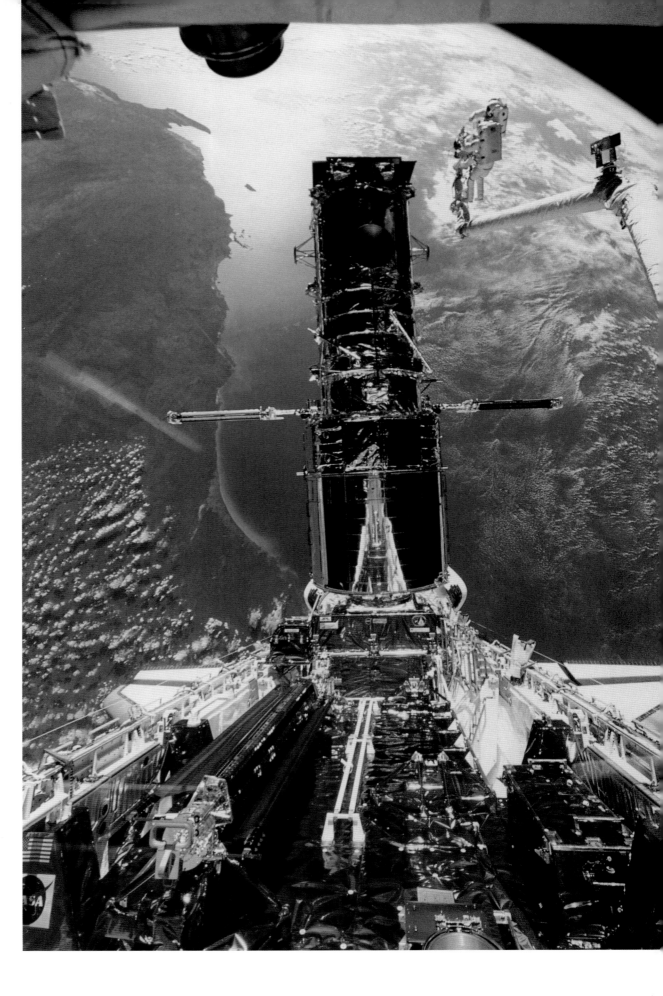

DOWNSIZED PLEASURES

Thanks to the invention in 1948 of the long-playing record by Peter Goldmark, 42 (far left), all the music on that stack of wax 78s now fit on the vinyl 33⅓s under his arm. Data compression did not stop there. Each 4¾-inch plastic CD being burned in 1993 (near left) held the music contained on one of Goldmark's 12-inch LPs.

FAR LEFT: ERIC SCHAAL / LIFE
LEFT: KEVIN R. MORRIS / CORBIS

> ## SCANNING DEEP SPACE

The space telescope named for U.S. astronomer Edwin Hubble was placed in orbit in 1990. At first the $2.2 billion instrument acted like Mr. Magoo. But in 1993, scientists overcame an improperly ground lens; since then, gliding high above earth's distorting atmosphere, it has captured light produced by the creation of the universe some 11 billion years ago.

NASA

< ## ... BUT YOU CAN'T HIDE

A quarter century after engineer Weldon Word (far left, at age 60, in 1991) helped develop a missile that could hit a laser-illuminated bull's-eye, the weapon proved its worth in Desert Storm. In the sequence at left, a Paveway III creams an Iraqi target the pilot had lit with a laser. An even "smarter" bomb debuted in the Persian Gulf war: the self-guiding Tomahawk cruise missile.

FAR LEFT: MARK PERLSTEIN
LEFT: AP / WIDE WORLD PHOTOS

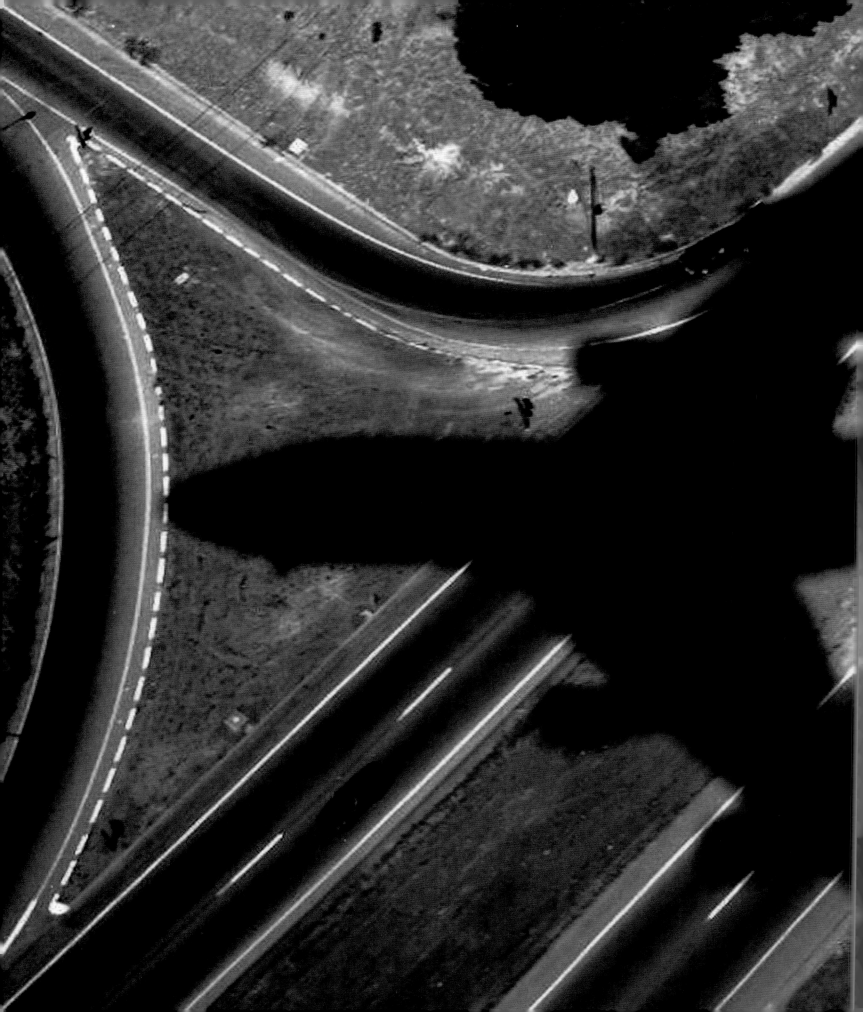

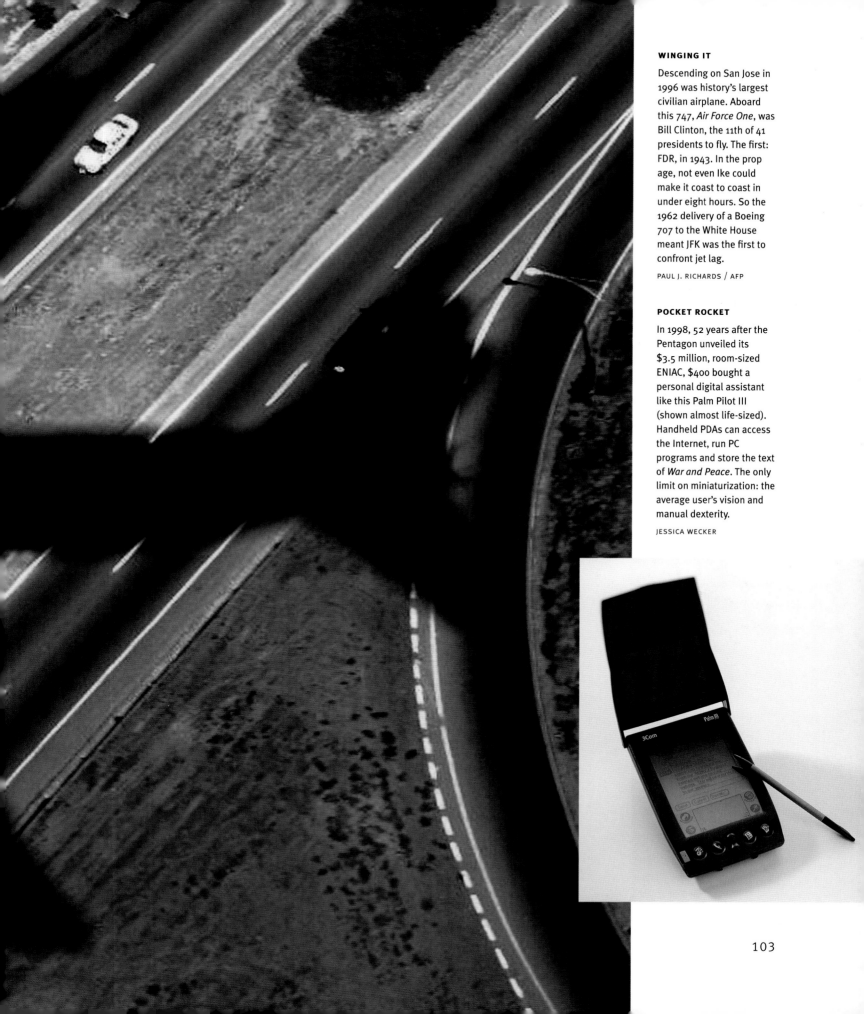

WINGING IT

Descending on San Jose in 1996 was history's largest civilian airplane. Aboard this 747, *Air Force One*, was Bill Clinton, the 11th of 41 presidents to fly. The first: FDR, in 1943. In the prop age, not even Ike could make it coast to coast in under eight hours. So the 1962 delivery of a Boeing 707 to the White House meant JFK was the first to confront jet lag.

PAUL J. RICHARDS / AFP

POCKET ROCKET

In 1998, 52 years after the Pentagon unveiled its $3.5 million, room-sized ENIAC, $400 bought a personal digital assistant like this Palm Pilot III (shown almost life-sized). Handheld PDAs can access the Internet, run PC programs and store the text of *War and Peace*. The only limit on miniaturization: the average user's vision and manual dexterity.

JESSICA WECKER

entertainment

Combining grandiose narratives with cinemagical techniques, D.W. Griffith (at 39, directing 1914's *Home Sweet Home*) elevated movies from nickelodeon novelty to Main Street staple. Combining visual wizardry with resonant storytelling, Steven Spielberg (at 50, directing 1998's *Saving Private Ryan*) ushered in the age of the modern must-see blockbuster.

LEFT: KEYSTONE / FPG

ABOVE: DAVID JAMES / COURTESY DREAMWORKS SKG

SHOW BIZ
TURNS BIG BIZ

We Kick Back and Enjoy

BY LEO BRAUDY

How many among us can remember when entertainment wasn't available at the turn of a dial or the click of a remote? And how many except the very young haven't experienced the rapid technological change that has so enormously multiplied the ways we can be entertained? My wife told our 11-year-old grandson the other day that she was going to buy him a special record. "What's a record?" he asked.

In the course of the 20th Century, entertainment, which once occupied a small amount of daily life, has become inescapably pervasive. This inundation started as a trickle. The end of the Civil War saw the rise of team sports — especially baseball, later football and basketball — as a pastime primarily for audiences of men in cities and small towns. Vaudeville furnished, for those who could afford to go and whose towns were on the circuit, a wealth of highbrow and lowbrow entertainment from jugglers to opera singers. And there was no dearth of promoters, from P.T. Barnum on down, who brought traveling foreign celebrities like Charles Dickens and Oscar Wilde, Jenny Lind and Sarah Bernhardt to audiences eager for a taste of "culture."

But perhaps only the circus left the 20th Century in anything resembling the shape in which it entered. Already by 1900 new kinds of entertainment had begun to make their first tentative inroads into the leisure time of Americans, changing what had been special events into everyday realities.

The 1890s and early 1900s saw the opening of a wealth of new public spaces for entertainment. With the establishment of baseball's American League in 1900 to join the National League, the stage was set not only for the World Series to capture the attention of the nation, but also for the construction of elaborate sports stadiums as embodiments of local pride. Meanwhile, in those same big cities, sumptuous department stores — complete with orchestras, fashion shows and special holiday decorations — made the previously simple and practical act of shopping into entertainment as well.

Technology did its part. Alexander Graham Bell produced the first microphone in 1876 and Thomas Edison the phonograph in 1877. George Eastman's box camera (1888) allowed people to become impresarios on their own, turning the world into memory for pleasure. By the early 1900s, the movies were taking their first steps with the nickelodeon. Its name promised fancy, but cheap, entertainment that was aimed directly at the surging population of immigrants.

Even the idea of leisure was cutting loose from its origins in the monied and well-born classes to become part of the expectation that being entertained was a natural right of all Americans, right up there with life, liberty and the pursuit of happiness.

Live from New York — an experimental 1937 NBC TV broadcast that used the model's dress as a test pattern. Back then, there were all of 100 TV sets within viewing range; most belonged to NBC executives and engineers.

NBC PHOTO

Thorstein Veblen's *Theory of the Leisure Class* (1899), with its idea of "conspicuous consumption," appeared at just the moment when the doors of consumption were opening more widely than ever before.

Leisure brought dreams that consumption tried to satisfy. The advent of advertising, along with mass-market newspapers and picture-filled magazines, turned aspiring manufacturers into sponsors of popular entertainment and sports. Famous faces were in demand to sell products, just as stars like Charlie Chaplin and Douglas Fairbanks Sr. were pressed into service by Woodrow Wilson to sell war bonds.

Early in the century, you still had to leave the house to see a movie or play or ballet. Going to a baseball game, watching a vaudeville show and even shopping at a department store were all immediate experiences. But the new entertainment technology began a tug of war between immediacy and distance in entertainment. (Television and the Internet have raised the tension a quantum leap or two.) The crystal set, the phonograph and the fan magazine brought the otherwise distant faces and voices of performers and athletes into the immediacy of the home. They also shunted to one side the older pleasures of playing the piano for friends, competing over board games or reading aloud to the children. Magnified by their larger audiences as much as by the repeated stories about them in the media, these bigger-than-life figures now invading the living room shaped a new world of entertainment, replacing the homey pleasures of the past with glimpses of a world of vicarious excitement.

Names sold to these huge domestic audiences, and the lesson wasn't lost on other promoters looking for a crowd. The presence of Babe Ruth was crucial to the creation of baseball as a big business that went beyond the hard-core fan, never more so than when he hit 60 home runs in 1927, the same year that Lindbergh, yet another symbolic American, flew the Atlantic.

Ruth was a homegrown figure with homegrown fans, but through the movies as well as through music like ragtime, jazz and musical theater, American entertainment was reaching out to the world at the same time that it was appealing to its own national audience. For much of the 19th Century, the traffic had been mainly in the other direction, from Europe toward America. If you wanted high culture — ballet, theater, classical music — you looked across the ocean.

Not the King, nor Dylan, nor the Fab Four accomplished what Bruce Springsteen, 26, did in 1975: land on the cover of the two top news magazines in the same week. Maybe the editors were just sick of disco?
KIM WHITESIDES / TIME; MARY ALFIERI, 1975/ NEWSWEEK, INC.

But by the 1920s and 1930s, more purely American traditions were being established. Some, such as the Broadway musical, were based on European forms like the operetta. Some, like jazz or film comedy (slapstick and screwball), seemed unique. The influx of immigrants of all kinds also helped fashion the new synthesis of high and low entertainment, in the movies of John Ford and Alfred Hitchcock, in the music of Irving Berlin and Aaron Copeland.

With the Hollywood studios, the radio and television networks, and the sports leagues (not to mention *Your Hit Parade*) instinctively colluding in the creation of a common culture, it almost seemed as if there were such a thing as "America" — where minority voices and especially faces were either excluded, caricatured or homogenized; performers

of varying ethnicity had their names changed to appear more "normal"; and the occasional black baseball player in the majors was called a "Puerto Rican."

When I was a teenager in the 1950s, there were still race movies and race records, though it was cool to know that Pat Boone's "Ain't That a Shame" was a pale cover of Fats Domino's original. It wasn't until the late Fifties that *Billboard*, the bible of popular music, stopped dividing hit songs into either mainstream or ethnic categories. The high arts, especially theater, did somewhat better in mirroring the variety of America, but we were near the end of the century before black and Asian opera singers and dancers did not have to follow the jazz musicians of the 1920s and go to Europe to create their careers.

Billboard's 1958 switch to the Hot 100 was a crucial moment in the evolution of American entertainment, at least to me. A year or two before, my salesman uncle took me along his route. We left Philadelphia, and a few hours later we were some-

where in Delaware when I heard on the car radio a Washington station playing a song I really liked. I think it was "At My Front Door" by the El Dorados. Back in Philadelphia no one had heard of it, and I was ahead of my time for about three weeks.

That kind of regional diffusion of new music ended in the early 1960s with the advent of the Beatles. All of a sudden, everyone in the country was listening at the same time to "I Want to Hold Your Hand." Like the highway system, entertainment had gone national. At the same time, with transistor radios and headsets, it was getting more portable and ostensibly more personal as well.

Entertainment is now in the gym, in the courtroom, in the museum, in the theme restaurant; we can be entertained while we jog, while we think and probably while we sleep. Publishing houses, TV networks, movie studios and sports teams even join together to become parts of the same mega-company.

But entertainment conglomerates are hardly the only ones to blame that little news gets served up without a dollop of entertainment. That 19th Century home, where reading aloud and playing the piano whiled away the few leisure hours, has been replaced by the 24/7 wired household of today. Not all of it is gain. We have access to entertainment at any hour, but also a decreasing need to be involved as a member of an audience of more than one. We have a new democracy of taste and interactivity, but also the narcissism of surfing the Internet in regal solitude. We have a rich cornucopia of choice, but also an overpowering flood of the trivial and the transient.

I could point to the rising number of people who go to operas and plays and concerts, as well as the interest in extreme sports and environmental travel, to suggest that our technological romance with the detached and the virtual in entertainment may be slackening a bit. What used to be elitist is available to everyone, and what used to be a minority taste has a better chance than ever of defining the main-

When he joined the tour in 1955, not a single event was nationally telecast. But Arnold Palmer's go-for-broke style captured the public's fancy, as well as 92 titles (including, above, the 1960 U.S. Open, when he was 30). By 1975, Arnie's Army could watch 20 tournaments a year on TV.
JOHN G. ZIMMERMAN / SPORTS ILLUSTRATED

stream. The price we have paid is that almost everything has been turned into performance, and even the most serious ideas and events are wrapped in entertainment's glossy embrace.

But those are probably the same worries my great-grandfather had when he saw his first player piano.

Leo Braudy, the Leo S. Bing Professor at the University of Southern California, teaches Restoration and 18th Century literature and film and popular culture. Among his books are The Frenzy of Renown: Fame and Its History *and* The World in a Frame: What We See in Films.

TAKE THE MONEY AND RUN

Ten years after Thomas Edison exhibited, in 1893, the first motion picture scene — assistant Fred Ott sneezing — came director Edwin Porter's *The Great Train Robbery*. In 12 minutes, 14 scenes, it re-created in New Jersey and Delaware the Wild West crime that made Butch Cassidy's gang famous. Story, drama, action. How could movies miss?

ACADEMY OF MOTION PICTURE ARTS & SCIENCES

PAST AND FUTURE

The garishly suited clowns posing under a Broadway marquee in the mid-1910s were the nonpareil vaudeville team of Joe Weber (near right) and Lew Fields. But the art form they headlined would soon be an endangered species; the 3,500-seat Strand was already gaining fame as America's premier motion-picture palace.

CORBIS / BETTMANN

NATIONAL PASTIME

On October 1, 1903, in Boston, 16,242 fans saw the first modern World Series game. It was, in fact, the 13th postseason showdown between rival pro leagues in a sport that Abner Doubleday did not invent (though he did fire the first shot of the Civil War, at Fort Sumter, in South Carolina). Back to 1903: Boston's Pilgrims beat Pittsburgh's Pirates five games to three.

NATIONAL BASEBALL HALL OF FAME, COOPERSTOWN, NEW YORK

THE MASTER'S VOICE

Gambling on a new medium, the most acclaimed singer of his time became its most heard. In 1903, Enrico Caruso signed to cut 78s in the U.S. on the fledgling Victrola label (a 1907 disc, far right). By 1914, when he and his Metropolitan Opera backups critiqued their latest release (right), the Neapolitan tenor, 41, was banking $100,000-plus a year in record royalties.

RIGHT: RCA VICTOR
FAR RIGHT: HENRY GROSKINSKY

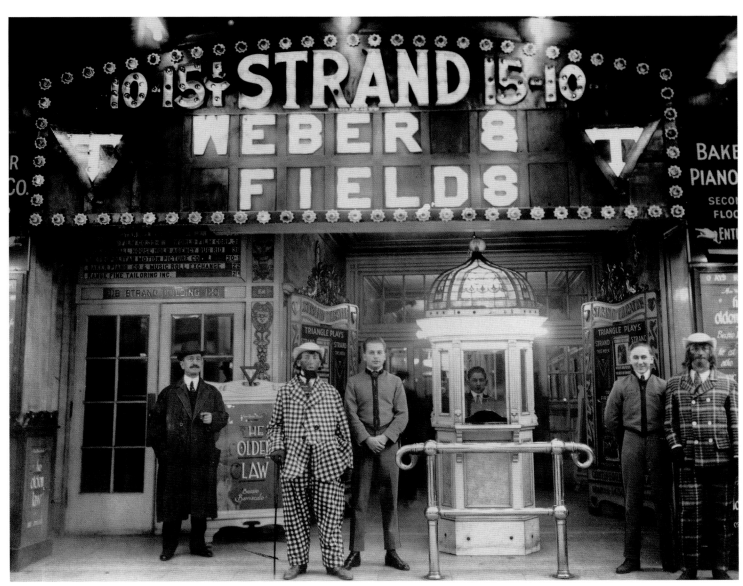

IN YOUR TOWN! LIVE!

The only exposure that most 19th Century Americans had to professional entertainment was when touring shows came to town. Then, in 1881, at his 14th Street Theater in New York City, Tony Pastor began to offer multi-act reviews fit for the entire family. Vaudeville quickly took hold. Impresarios acquired venues in burgs large and small. They signed name acts to play the circuit. In 1928, the country's 1,000 houses counted 730 million admissions. It was the industry's high-water mark. Hollywood was retooling from silent movies to talkies, and a nationwide economic depression waited in the wings.

THE DOLLY SISTERS

Eva and Zsa Zsa? Downright Ga-boring next to Yansci and Roszika Dolly, twins who emigrated from Hungary as kids (left, in 1908, at 16). Among the duo's hits was a 1918 song — based on Chopin's *Fantasie Impromptu* — titled "I'm Always Chasing Rainbows." When the Betty Grable–June Haver bioflick, *The Dolly Sisters*, came out in 1946, Yansci was dead, a suicide. Rosie lived another 24 years.

WITKIN GALLERY

BERT WILLIAMS

Not many black artists today would don blackface, but the Caribbean-born, California-raised Williams was just following a minstrel tradition that dated back to the Civil War. By 1910 (left), the singer-pantomimist, 34, was a featured member of the *Ziegfeld Follies* and known for his bizarre costumes. In 1920, with the aid of pal W.C. Fields, he became the first black to join Actor's Equity.

CULVER PICTURES

JULIAN ELTINGE

From his New York debut in 1907 well into the 1930s, Eltinge was vaudeville's most acclaimed female impersonator (right, at 32, in a scene from the 1915 farce *Cousin Lucy*, with music by Jerome Kern). He also made silent movies — one with a then unknown Rudolf Valentino — and had a theater on Broadway named after him. RuPaul, eat your heart out.

CULVER PICTURES

W.C. FIELDS

Start every day with a smile, and get it over with. During his first two decades in showbiz, William Claude Dukenfield never cracked wise, just juggled. Comically and brilliantly. In 1915, as a *Ziegfeld Follies* regular (above), he began breaking up audiences with his sly wit. After *Poppy,* a hit 1923 stage comedy, Fields quit vaudeville to become Hollywood's resident curmudgeon: *I like children. If they're properly cooked.*

CULVER PICTURES

THE ASTAIRES

Adele Austerlitz was 13 in 1911 when she mock-scolded baby brother Fred, 11. The Omaha natives had already been on the circuit for five years. After Anglicizing their surname, the dancing Astaires appeared in 10 Broadway shows. In 1932, Adele retired to marry Lord Charles Cavendish. Fred did one more musical, *The Gay Divorcée*, then glided onto the big screen; a good and graceful move — witness his résumé of 40 movies.

RKO RADIO PICTURES, INC.

The Rude Descending a Staircase
(Rush Hour at the Subway)

THE INFAMOUS EXHIBIT

Modern art made its U.S. debut at the 1913 Armory Show in Manhattan (left), which gathered 1,300 works by Europe's best. New York responded with a Bronx cheer. *Nude Descending a Staircase* (above), Marcel Duchamp's Cubist landmark, was parodied by editorial cartoonists (above right) and scorned by critics (one was reminded of "an explosion in a shingle factory"). In 1952, Duchamp, 65, posed for the multiple-exposure shot at right that re-created on film the effect he had achieved on canvas four decades earlier.

CLOCKWISE FROM LEFT:
THE MUSEUM OF MODERN ART;
PHILADELPHIA MUSEUM OF
ART / THE LOUISE AND WALTER
ARENSBERG COLLECTION;
THE MUSEUM OF MODERN ART;
ELIOT ELISOFON / LIFE

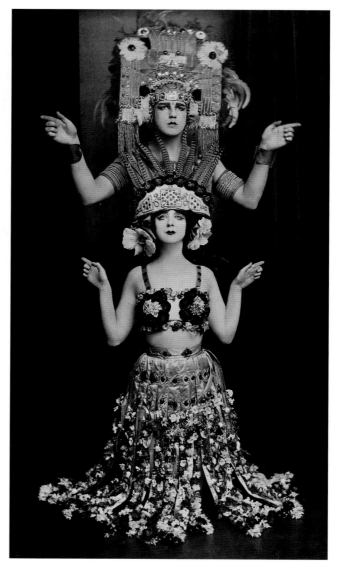

A REAL TROOPER

World War I saw U.S. show folks stage patriotic productions and sell war bonds. One of the few actually to go Over There was vaudeville superstar Elsie Janis, who took her one-woman show to the American Expeditionary Force soldiers posted on the western front. Breaking into showbiz in 1897, at age eight, Janis later co-wrote screen musicals like 1930's *Paramount on Parade*.

JURASSIC LARK

After two experimental shorts, newspaper cartoonist Winsor *(Little Nemo)* McCay in 1914 spliced 10,000 hand-drawn frames into a knockout animated one-reeler (above). And the movie was "interactive" — at the vaudeville houses where it was shown, McCay appeared in person to give commands that big-screen Gertie obeyed. One fan: Walt Disney.

THE SHOCK OF THE NEW

Modern dance took root in America when Ruth St. Denis, 36, and husband Ted Shawn, 24, founded an academy in Los Angeles in 1915. (Martha Graham was one of the first pupils at Denishawn.) St. Denis had choreographed nonballetic works with Asian and Egyptian overtones as early as 1906. The school closed in 1934, six years after the couple separated.

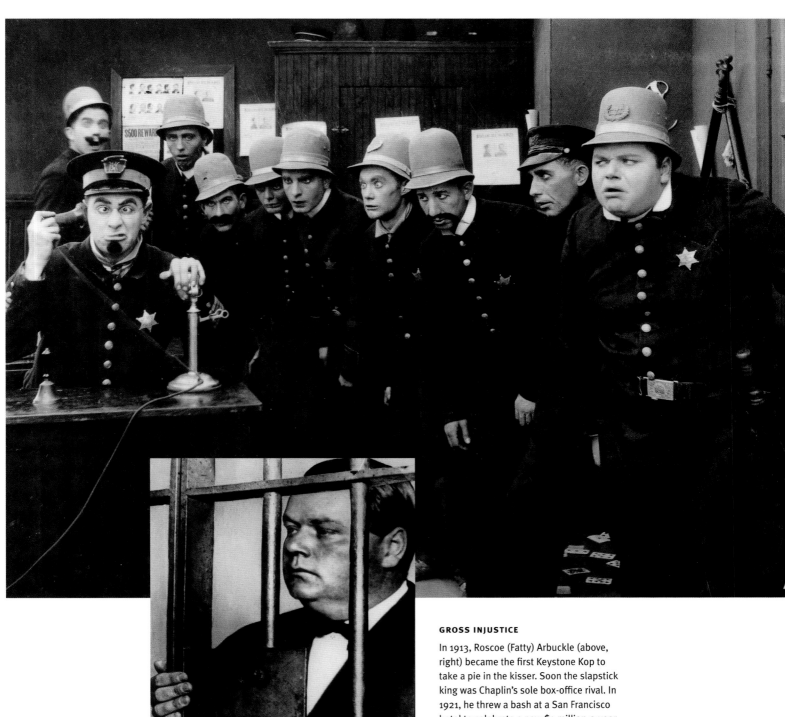

GROSS INJUSTICE

In 1913, Roscoe (Fatty) Arbuckle (above, right) became the first Keystone Kop to take a pie in the kisser. Soon the slapstick king was Chaplin's sole box-office rival. In 1921, he threw a bash at a San Francisco hotel to celebrate a new $1-million-a-year pact. Party girl Virginia Rappe, 25, died four days later of peritonitis; Arbuckle, 34, was held for manslaughter (left). When the DA leaked unsupported tales of rape by bottle, the comic became the poster boy for Hollywood debauchery. He endured two hung juries before winning exoneration. It came too late to save his career.

THE GRANGER COLLECTION
INSET: CORBIS / BETTMANN-UPI

<
A SIGN IS BORN

No, those weren't motion-picture pioneers breaking ground for a studio in 1923. They were land developers turning Harvey Wilcox's 120-acre citrus farm into L.A.'s latest subdivision, Hollywoodland. In 1949, the last four letters of the sign on Mount Lee were razed. In 1978, the movie industry anted up $2.5 million to refurbish the remaining nine 50-foot-tall letters.

BRUCE TORRENCE / HISTORICAL COLLECTION

>
SCALPER'S DELIGHT

Until July 2, 1921, no single event in history had sold $1 million in tickets. That day, 90,000 fight fans made their way to Jersey City, New Jersey. The title bout: America's Jack Dempsey, 26, the world heavyweight champ, against France's Georges Carpentier, 27. It took promoters longer to count the receipts ($1.75 million) than it took Dempsey to KO his foe (11 minutes).

AP / WIDE WORLD PHOTOS

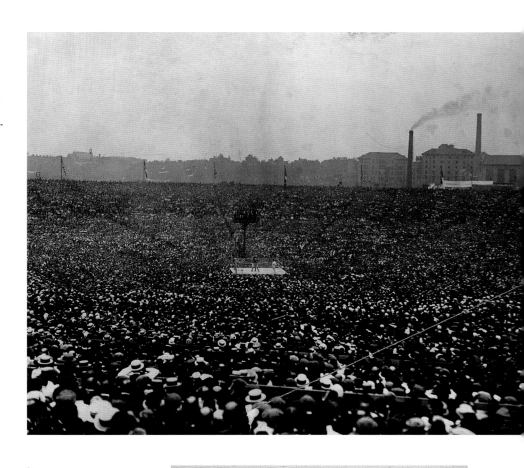

>
KING RAT

A mouse sired by a hare? This being Hollywood, why not? In 1928, after Walt Disney lost a contract to continue animating the popular Oswald the Lucky Rabbit series, he ordered his staff to morph the bunny into a rodent (below). In Mickey's third short, *Steamboat Willie*, he became the first cartoon character to talk.

RIGHT: EVERETT COLLECTION
BELOW: WALT DISNEY PRODUCTIONS

CLOSE UP

GEORGE SQUIER

The Muzak Man

To the list of World War I's oddest legacies, add elevator music. In 1922, George Squier, who was the Army's chief signal officer, patented some transmission techniques that he had helped develop during wartime. Twelve years later his company began piping phonograph music into Cleveland-area homes via utility lines (prefiguring cable TV by a half century). But Muzak — a word coined by Squier himself — did not stop there. Instead, the treacly background tunes were also touted as a way to motivate shoppers and workers and calm those trapped in waiting rooms or on telephonic hold. The sounds of silence? In your dreams.

120

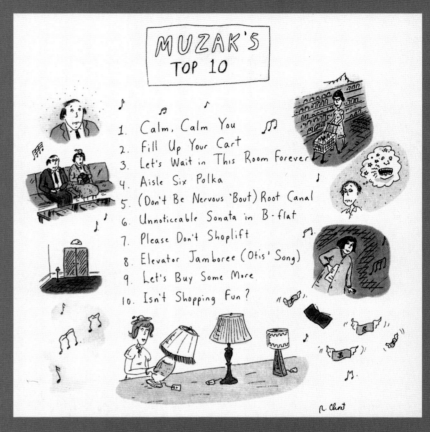

MUZAK'S TOP 10

1. Calm, Calm You
2. Fill Up Your Cart
3. Let's Wait in This Room Forever
4. Aisle Six Polka
5. (Don't Be Nervous 'Bout) Root Canal
6. Unnoticeable Sonata in B-flat
7. Please Don't Shoplift
8. Elevator Jamboree (Otis' Song)
9. Let's Buy Some More
10. Isn't Shopping Fun?

R. Chast

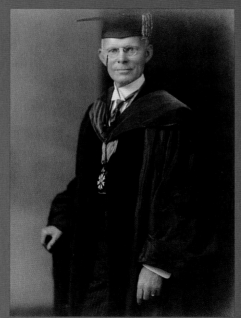

In a 36-year Army career, West Point grad Squier (top left, circa 1920) rose to the rank of major general. He also held the title of doctor, having earned a Ph.D. in science from Johns Hopkins. Despite the achievements in aviation, telegraphy and telephony by the Michigan native (left, in 1931), his most public innovation is also the most dissed (above).

On September 12, 1908, at Fort Myer, Virginia, Squier, 43 (below, number 6), became one of Orville Wright's first passengers. The major made the nine-minute flight to gauge whether the Signal Corps could use a heavier-than-air flying machine. (He voted yes.) Later in the field trials, Orville crashed when his propeller splintered. He survived. Army observer Lieutenant Thomas Selfridge did not.

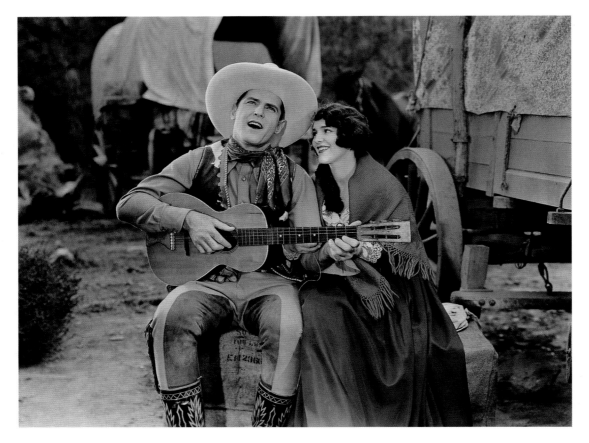

HORSE OPERA

After Al Jolson's *The Jazz Singer*, even Hollywood cowboys began speaking lines. The first to sing, in 1929's *The Wagon Master*, was Ken Maynard, 34, here serenading Edith Roberts. Another early prairie warbler: B-star John Wayne, who in 1933 played Singin' Sandy in *Riders of Destiny*. Enrico Caruso he wasn't.

CULVER PICTURES

DANCE WITH ME, HENRY

Modern all-night raves are warm-up drills next to the "sport" of marathon dancing that swept America in the 1920s (at right, a Depression-era contest in Chicago). The last couple standing typically pocketed $1,000. One marathon ran 22½ weeks. In 1935, the spectacle became the backdrop for Horace McCoy's existential novel *They Shoot Horses, Don't They?*

THE GRANGER COLLECTION

MONSTER HIT

Two decades after Thomas Edison produced a one-reel *Frankenstein*, James Whale directed the 1931 classic starring Boris Karloff, 44, here with victim-to-be Marilyn Harris. In its wake came such beastly anti-heroes as King Kong, Dracula and the wolfman. Karloff was forever typecast, but his lurching turn became the blueprint for TV's Herman Munster and Arnold Schwarzenegger's Terminator.

PHOTOFEST

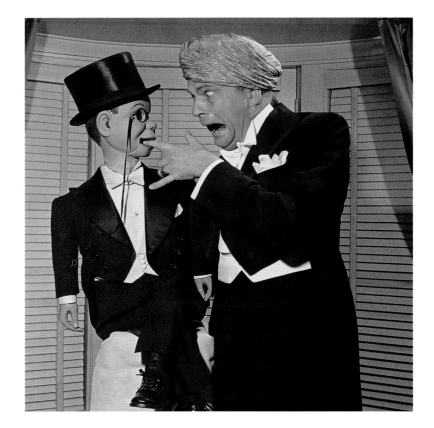

NO FREE LUNCH

Why would a 1920s family spend a month's wages to buy a newfangled radio set? To enjoy drama, music, comedy and news from home. But what was in it for those producing the programs? Once a signal enters the ether, there's no way to charge a listener for receiving it. The English imposed an annual tax on radios (and later, TVs), with the revenue subsidizing the BBC. That was not the American way. In 1922, New York radio station WEAF aired a 10-minute, $100 announcement extolling an apartment house in Queens. Soon, the medium was the message — commercial, that is.

HE'S NO DUMMY

Read my lips? Home listeners couldn't, so *Chase & Sanborn Hour* star Edgar Bergen never became a technically brilliant ventriloquist. He was, though, a perfect straight man for his acerbic mouthpiece, the toffish Charlie McCarthy. Inheriting Bergen's funny gene was daughter Candice, who in 10 years as TV's *Murphy Brown* copped five best comedienne Emmys.

RALPH CRANE / BLACK STAR

<
TAKE A BOW

At 35, Evelyn (Kaye) and Her Magic Violin was the top act on *The Hour of Charm*, featuring Phil Spitalny's all-female orchestra. Girl bands were in vogue in the 1930s: the International Sweethearts of Rhythm, Peggy Gilbert and Her Coeds, Ina Ray and Her Melodears. During Spitalny's 14-year gig on two networks, he and Evelyn became man and wife.

CORBIS

THE SHAMATEURS

Five ringers sneaked onto Tommy Dorsey's star-search show, *The Amateur Swing Hour*, in 1938. From right: the host himself, 32, on trombone; Shirley Ross, 29; Bing Crosby, 34; Ken Murray, 35; Dick Powell, 33; and Jack Benny, 39 (for the fifth year in a row). It didn't hurt that all the guests except big-band thrush Ross had their own NBC shows in the 1930s.

NBC PHOTO

ETERNAL HOPE

At 12, an English-born lad named Leslie won a comedy contest in his new hometown, Cleveland. At 25 and a vaudie quipster, he changed his handle to Bob. At 34, after a breakthrough radio guest shot, Hope landed his own show. Still to come were seven *Road* movies with Bing Crosby, four wars' worth of USO shows and a long run on TV. Thanks for the memories.

NBC PHOTO

<

A CRANKY OPERATOR

His puss was sour, but his one-liners were sweet: "If the grass is greener in the other fellow's yard, let him worry about cutting it." Fred Allen didn't switch from vaudeville to radio until 1932, at age 38, but he would remain a weekly fixture until 1949. His early take on TV: "A device that permits people who haven't anything to do to watch people who can't do anything."

WABC-CBS

CUE THE CLOSET

Domestic comedy was the game, *Fibber McGee & Molly* the name. In 1935, Marian and Jim Jordan created a couple from Anytown, USA. He told tall tales that she rarely bought ("T'ain't funny, McGee"). And what was in that closet at 79 Wistful Vista? A sound-effects gag that continued until McGee had been bonked by the last wedged-in kettle.

CORBIS / BETTMANN-UPI

SAINT HOLLYWOOD

Returning from a 1933 holiday to Europe were MGM production chief Irving Thalberg, 34, actress wife Norma Shearer, 32, and son Irving, 2. Younger and more polished than other studio czars, Thalberg also had a knack for delivering winners (*Mutiny on the Bounty*, the Marx Brothers, *The Good Earth*). So the year after his death, at 37, of pneumonia, the industry inaugurated the Oscar that halos his name.

AP

A RIVER WIDE

To nurture the arts during the Depression, governments both federal and local assumed the role of patron. Missouri's legislature commissioned native son Thomas Hart Benton to paint a 1,519-square-foot mural in the statehouse in Jefferson City. (The detail at right portrays Huck Finn and his pal Jim.) Benton went on to become a noted teacher, though one student was to boldly break from representationalism: Jackson Pollock.

ZEAL S. WRIGHT

WEE WORKHORSE

Yes, Shirley Temple was paid $2,500 per week in the depths of the Depression, but she earned every penny. *The Little Colonel* of 1935, in which the moppet, 6, bucked-and-winged with master hoofer Bill (Bojangles) Robinson, 56, was her 13th full-length picture. She would crank out 16 more before reaching her teens.

EVERETT COLLECTION

WATCH YOUR STEP

Top billing in Hollywood's 1939 version of the Broadway hit *On Your Toes* went to ballerina Vera Zorina, 22, the second Mrs. George Balanchine (of four). Mr. B, 35, choreographed it. Still, the movie tripped at the box office. One survivor: James Wong Howe, 40 (manning the camera), who later won Best Cinematography Oscars for *The Rose Tattoo* and *Hud*.

HANS KNOPF / TIME INC.

>

FOOTLOOSE

From Harlem's Savoy Ballroom in the late 1920s hopped the Lindy, named (or so the story goes) for the first aviator to solo the Atlantic. Dancers themselves began to fly when Frankie (Musclehead) Manning invented the air step in 1935. As the swing of Ellington, Goodman and Basie went global, so did the Lindy, under a new name, the jitterbug.

GJON MILI / LIFE

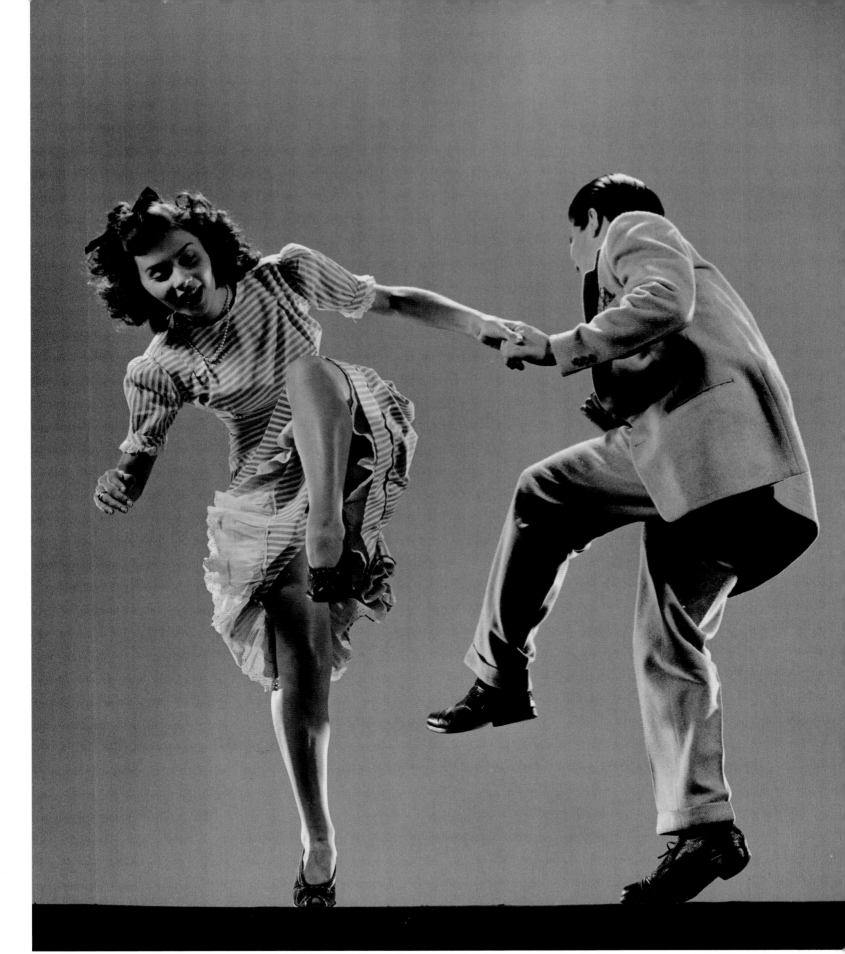

CLOSE UP

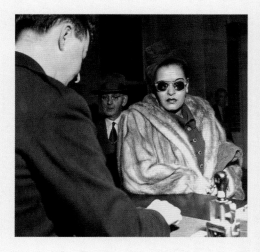

BILLIE HOLIDAY

The Jazz Diva

Born out of wedlock, raped as a girl, Eleanora Fagan spent her early teens turning tricks. Then, at 17, she began turning musical phrases at a Harlem nightclub. A year later, in 1933, her first Columbia 78 came out. Billie Holiday learned to style lyrics, to sell the song, by way of Louis Armstrong records. Soon others (like a Jersey kid named Sinatra) were wearing out the grooves of their Lady Day discs. The magic she brought to music, alas, did not work offstage. Three abusive husbands were ditched but not heroin; she died at 44 of drug-related causes. Holiday is still studied by young pop artists. Her final (and saddest) lesson has not been heeded enough.

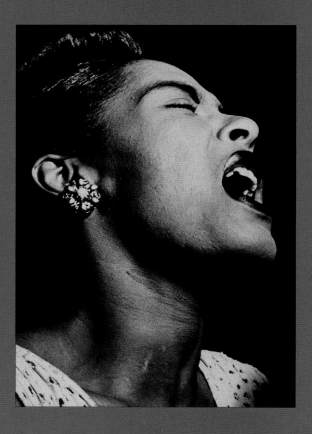

Though her 1956 autobiography was titled *Lady Sings the Blues*, Holiday's métier was jazz (far right, recording in 1943 with stride legend James P. Johnson on piano and Cozy Cole on drums). It was probably Husband No. 2, Joe Guy (from 1945 to 1947), who switched her from opium to heroin; by her 1949 bust in San Francisco for possession (left), Holiday had a rap sheet and had tried rehab. Mourners at her 1959 funeral included Benny Goodman (below, fourth from right) and longtime pianist Teddy Wilson (second from left). Nineteen CDs have been made of Lady Day's music.

CLOCKWISE FROM TOP LEFT: AP; WILLIAM GOTTLIEB / RETNA; GJON MILI / LIFE ; CORBIS / UPI

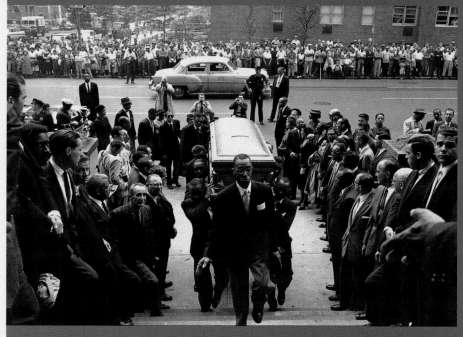

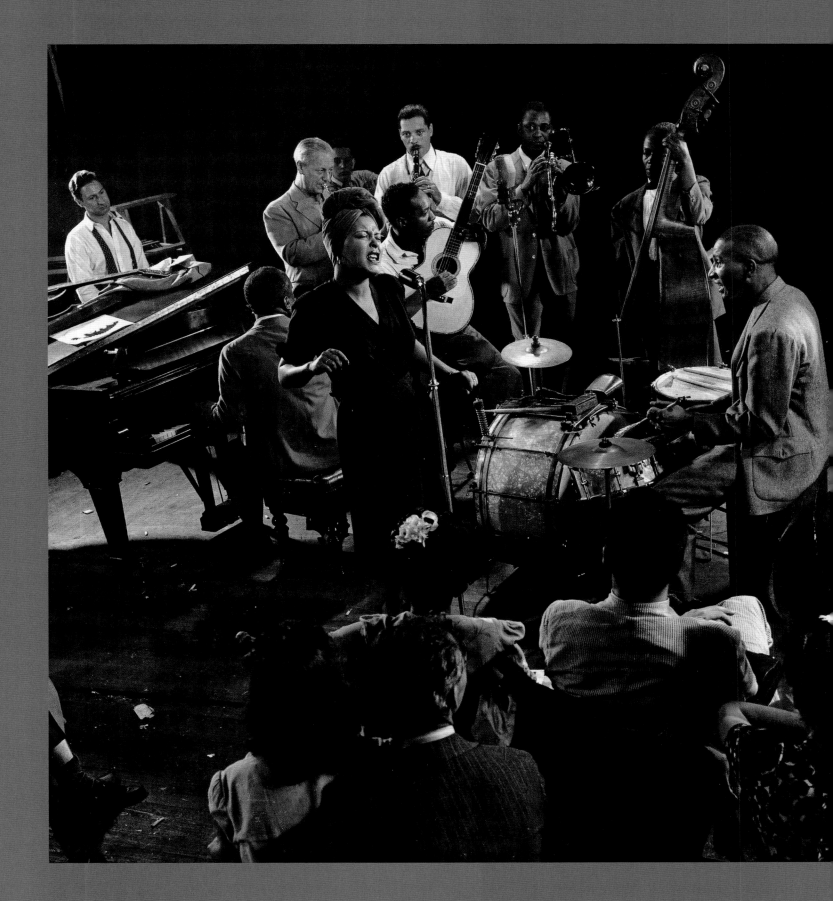

NO SMILE, NO SHOESHINE

The postwar recovery was going full tilt in 1949 when *Death of a Salesman* opened on Broadway. The drama was disquieting: Title character Willie Loman (Lee J. Cobb, 37, seated) has just been fired. His sons (Arthur Kennedy, kneeling, and Cameron Mitchell) do not console; rather, they mock him and his grovel-before-clients career. Why does the play reverberate still? Maybe because author Arthur Miller, 33, put his finger on that thin line between success and sellout.

JOHN SPRINGER /
CORBIS / BETTMANN

CAN'T PLEASE 'EM ALL

What to call a self-taught artist who begins to sell at age 78? Anna Mary Robertson Moses (left, in 1948, at 88) was instantly dubbed Grandma. A servant at 12, a wife at 27 to a farmer with whom she had 10 kids, Moses began painting her trademark rustic canvases in 1938. Her art, grumped critics, was "primitive." Granny couldn't care less, and she brush-stroked away almost until her death, in 1961, at 101.

GLEN S. COOK & SON

DUMB AND DUMBER

And the first national TV star was . . . Howdy Doody? You bet your cowabunga — the kids' show began on NBC in late 1947 (with a different marionette; Ol' Freckle Face, near left, was carved the next year). "Doody" alone could set off the Peanut Gallery, so host Buffalo Bob Smith said it often. Cheap yuks were also the forte of TV's first prime time star, Milton Berle (far left). Given a Tuesday-night slot on NBC in 1948, the comic, then 40, filled it with shtick from vaudeville (he had debuted at age 5). America couldn't get enough; Uncle Miltie grabbed 80 percent of the nation's viewers.

FAR LEFT: RALPH MORSE / LIFE
LEFT: NBC PHOTO

> **I REMEMBER POPPA**

Father Knows Best was not an ironic title. In the series, which began in 1954, no one questioned the wisdom of star Robert Young (with, from near right, Billy Gray, Elinor Donahue, Lauren Chapin and Jane Wyatt). American families continued to be portrayed in prime time as wholesome and winning until January 12, 1971. That's when dysfunctionalism opened its mouth in the persona of Archie Bunker.

JERRY OHLINGER

< **HONEY, WE'RE HOME**

Lucille Ball gave birth twice on January 19, 1953. *I Love Lucy*'s second season had been built around her real-life pregnancy, with the delivery episode filmed the previous November. On the day it aired, Ball, 42, actually bore son Desi. Mother and child were natural choices to grace the first cover of a new weekly devoted to program listings.

TV GUIDE INC.

<

A SITCOM'S GROWING PAINS

Kramden and Norton we recognize, but who are those women? The first wives in *The Honeymooners*, a sketch created in 1950 by Jackie Gleason, 34, for the DuMont network's *Cavalcade of Stars*. From right: Art Carney, Gleason, Pert Kelton (Alice Kramden) and Elaine Stritch (Trixie Norton). Moving to CBS in 1952, Gleason cast Audrey Meadows as Alice and Joyce Randolph as Trixie. And away they went. . . .

>

FRONT ROW COUCH

Giving early TV a buzzy edge were original live dramas like 1954's *Twelve Angry Men* (starring Robert Cummings, back row, second from left). The Golden Age arose out of necessity: Hollywood refused to make shows for the upstart medium. Jack Warner was the first to reconsider, in 1955. By decade's end, live drama was down to one prime time hour a week.

CBS PHOTO ARCHIVE

<

HIS GUN WAS QUICK

The actor who played Marshall Matt Dillon on CBS Radio's long-running *Gunsmoke* was shaped like a pear, so in 1955 the TV role was offered to John Wayne. Who declined but recommended B-movie star James (*The Thing*) Arness, 32. Who ended up patrolling Dodge City for 20 seasons, four of them atop the Nielsens. And that radio actor? In 1971, William Conrad got his own TV series, *Cannon*.

PHOTOFEST

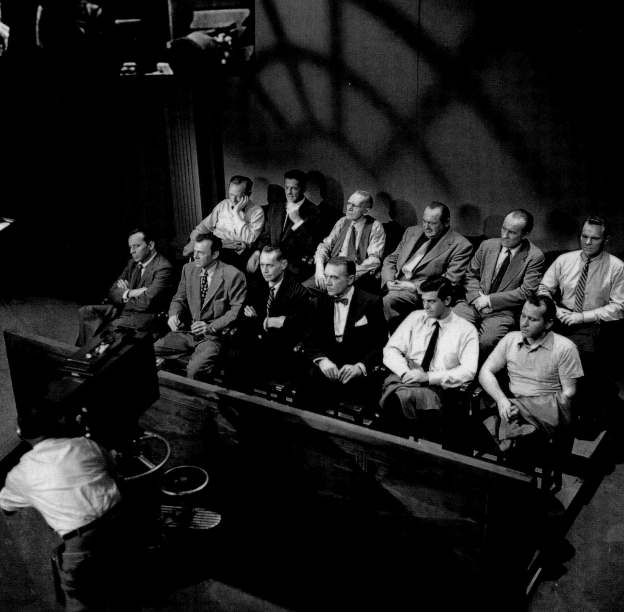

TURNING POINT

The Beat Goes On

Newcomers to America often arrived without many material goods. But they could, and did, bring along their native music; by 1900, when the census counted immigrants from three dozen lands, our nation buzzed with cross-pollinated melodies. Jazz, blues, bluegrass, R&B and C&W grew as fast as the recording industry. Each genre contributed a lick or more to what became rock 'n' roll. Mirroring a society flush with its World War II triumph, this new form strutted and preened — just like its King (below). Never trust an attitude over 30? Even after half a century, rock, not Coke or Levis, is America's most influential export.

W.C. Handy, Conductor

<

IT WAS A VERY GOOD YEAR

Memphis producer Sam Phillips knew a way in 1954 to cash in on this new rock 'n' roll: find a white boy who sang black. In walked Elvis Presley. The 19-year-old scored five regional hits. Then his 1956 "Heartbreak Hotel" went gold; new label RCA rushed out an LP (left) whose cuts included "Tutti Frutti," "I Got a Woman," "Money Honey" and "Blue Suede Shoes."

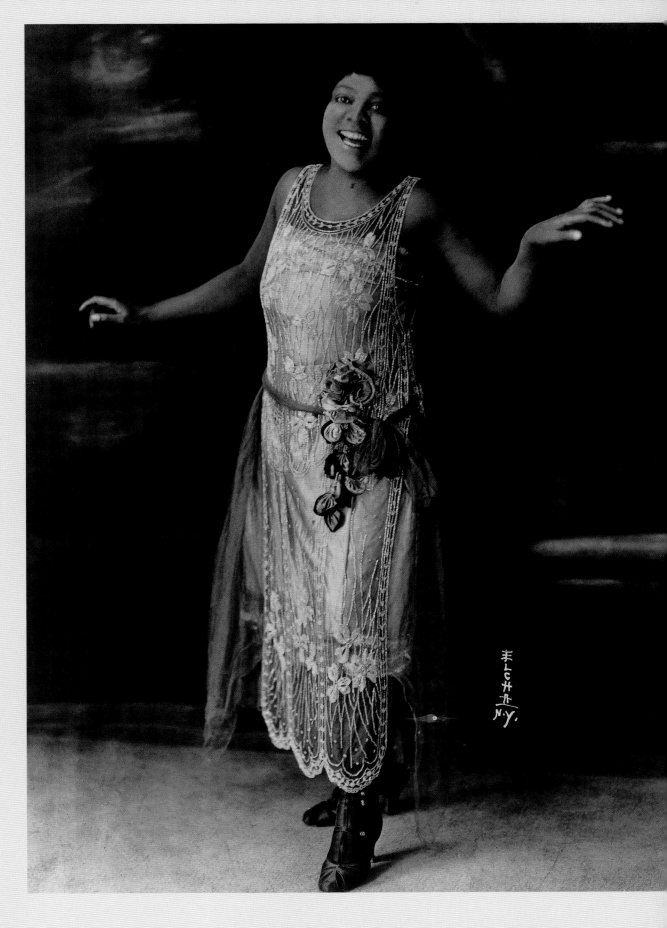

< BLUES BROTHER

W.C. Handy didn't invent the blues. But as a composer, conductor and teacher (left, in 1900, at 27, with an Alabama college band), he helped meld Southern black folk music with ragtime. The result was mournful ruminations on life and love to simple, 12-bar tunes. Among the best: Handy's 1914 "St. Louis Blues."

MICHAEL OCHS ARCHIVES

SECOND BANANAS

It's doubtful that the Original Dixieland Jazz Band, here in 1917, played many of the top bordellos in New Orleans's Storyville, where the upbeat, trumpet-led form was born. After all, Sidney Bechet, King Oliver and Louis Armstrong were still in town. Instead, the original average white band moved to New York and became the first combo to cut Dixieland records.

SOUCHON COLLECTION / NEW ORLEANS

> YOU IS OUR WOMAN

The first disc by Bessie Smith, 29, a 1923 cover of Alberta Hunter's "Down Hearted Blues," sold two-million-plus copies. Soon the deep-voiced Chattanooga native was earning $2,000 a week (and spending most of it). In 1937, Smith was injured in a car crash in Mississippi. Folks still swear that had she been white, the blues diva would not have been allowed to bleed to death.

EDDIE ELCHA / COLLECTION OF OLE BRASK

A GREAT MAN

To fans like these in Chicago in 1940, Benny Goodman, 31 (above), was the King of Swing. The clarinetist from Chicago, who began touring with 13 sidemen in 1935, introduced jazz to mainstream America. Goodman was also the first noted white musician to play in public with blacks, most famously at Carnegie Hall in 1938 with Count Basie.

HART PRESTON / LIFE

MAGNA CARTERS

Country's original super-group, the Carter Family, broke up in 1943, but the kinfolk kept making music. Mother Maybelle and the Carter Sisters featured Maybelle Carter on guitar, with daughters Anita (bass), Helen (accordion) and June. In 1968, June broadened the bloodline by marrying another C&W headliner, Johnny Cash.

BMI PHOTO ARCHIVES / MICHAEL OCHS ARCHIVES

NEXT, THE AIR GUITAR?

By 1947, Les Paul, 32, had fretted together the instrument that would soon rock the music world: the solid-bodied electric guitar. Now a musician could pump up the volume and distort notes. Paul also pioneered multitrack recording, another rock essential. Not bad for a jazz guitarist who made his mark playing unplugged.

MICHAEL OCHS ARCHIVES

BUSS STOP

First came Frankiemania. In 1943, the 28-year-old crooner gave bobby-soxers ample opportunity to swoon. In addition to his recently launched solo act, he notched his first million-copy single, "All or Nothing at All." Sinatra would overwork that ring-a-ding-ding baritone all too soon. But he never lost that magical ability to phrase lyrics, not even in the autumn of his years.

PETER MARTIN

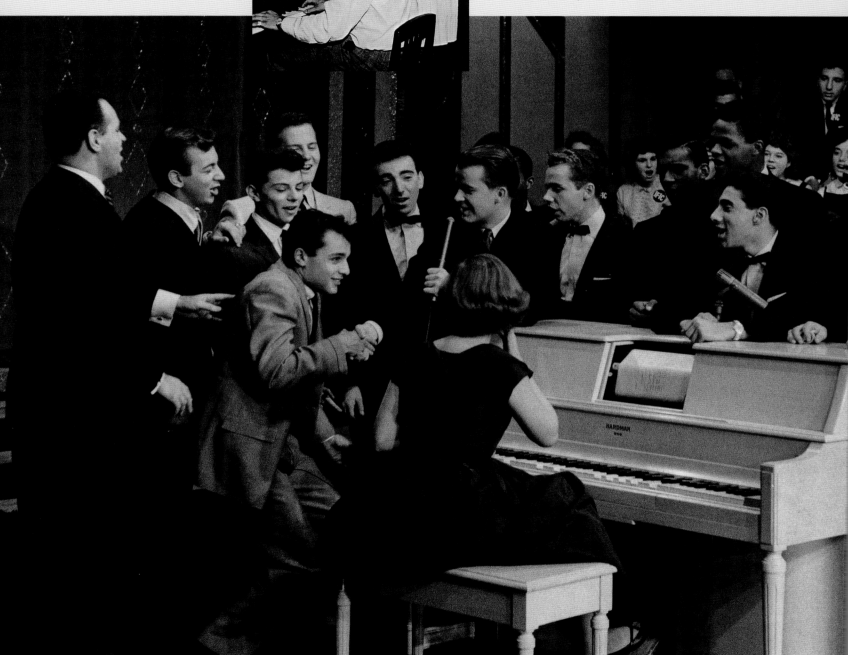

THEY WROTE THE SONGS

Carole King, far right, Barry Mann and Cynthia Weil were among the writers who composed rock songs for music publishers. Weil and Mann's early hits included "On Broadway." King, who started in her teens, helped pen titles like "Up on the Roof" and "One Fine Day" before she began performing her own lyrics (1971's *Tapestry* LP).

FRANK DRIGGS / ARCHIVE PHOTOS

SPLISH-SPLASH SOME TEARS ON MY PILLOW

In 1957, ABC turned *American Bandstand* from a Philadelphia phenomenon into a national study break. The next year, host Dick Clark, 29 (with mike, surrounded by local band Danny and the Juniors), welcomed, from left, J.P. (the Big Bopper) Richardson, 28; Bobby Darin, 22; Frankie Avalon, 18; Pat Boone, 24; Sal Mineo, 19; and flanking Connie Francis, 19 (to right of piano), the black doo-wop group Little Anthony and the Imperials. Boss tunes, the chat was so-so, the studio audience danced like dorks. We gave it an 83.

PAUL SCHUTZER / LIFE

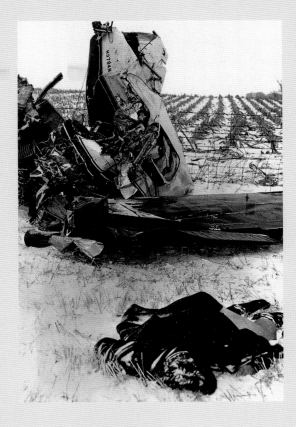

THE DAY THE MUSIC DIED

That is probably Ritchie ("La Bamba") Valens, 17, in an Iowa cornfield on February 3, 1959. Also lost in the crash: Buddy ("Peggy Sue") Holly, 22, and J.P. ("Chantilly Lace") Richardson, 28. Holly, headlining a 24-day Midwestern barnstorm, had grown sick of buses and chartered a plane to fly to Fargo, North Dakota. Tour members who passed up a seat included Waylon Jennings and Dion (then still a Belmont).

CORBIS / BETTMANN

QUEENS OF BEEHIVE

The Shirelles made No. 1 first, but the Ronettes (below, from right, Ronnie Bennett, 21, her sister Estelle, 20, and their cousin Nedra Talley, 18) were the top girl group, pre-Supremes. Hits like 1963's "Be My Baby" were stoked by the Wall of Sound pyrotechnics of producer Phil Spector, 23 (below). Phil's 1968 marriage to Ronnie lasted six years. Later, a judge ruled, Phil pocketed $2.6 million in royalties due his ex and her backups.

RAY AVERY /
MICHAEL OCHS ARCHIVES

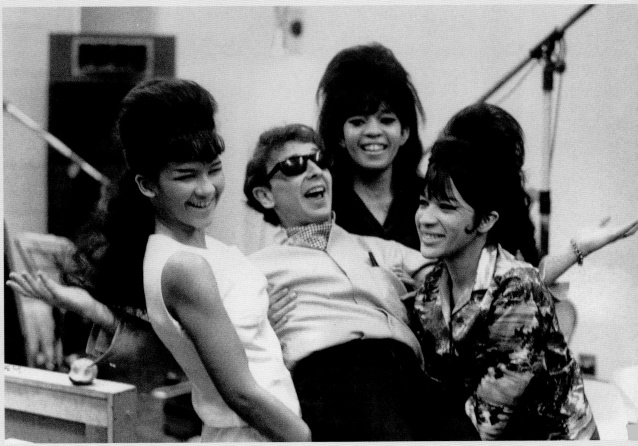

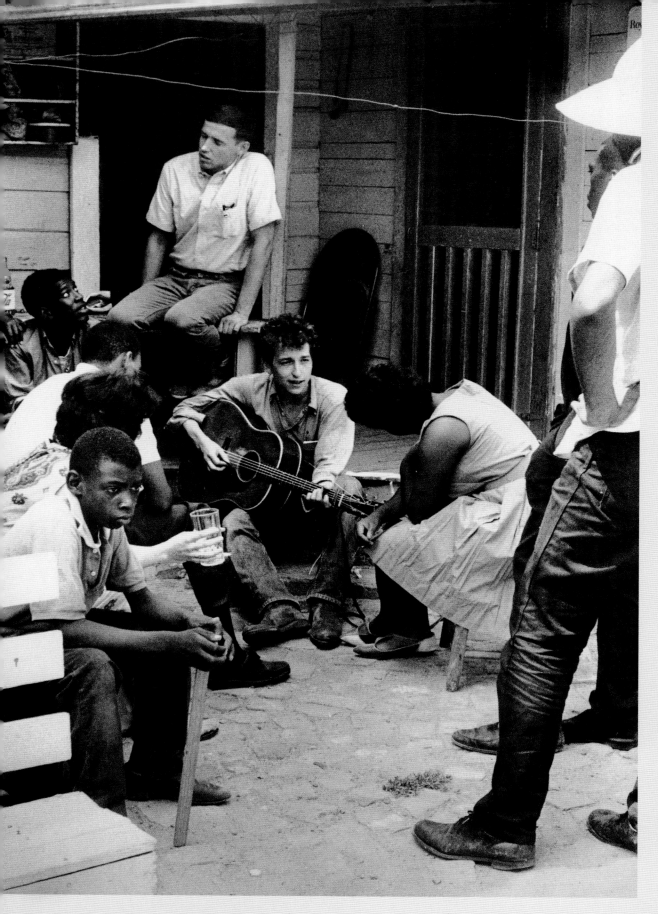

<

RETURN TO ROOTS

In 1963, Bob Dylan, 22, soloed at a civil rights office in Greenwood, Mississippi. At the time, folk music had strayed from social protest (Woody Guthrie, Pete Seeger) to feel-good banjo strumming (the Kingston Trio). Dylan and Joan Baez helped steer the genre back to its tradition as musical ombudsman for America's underclasses.

DANNY LYON / MAGNUM

>

HOT, HOT, HOT

As Liverpool lads, they aped Elvis and Fats and Buddy and Little Richard and Roy Orbison. By 1964, when they undertook their first triumphant tour of the Colonies, the Beatles had remade rock (in Miami Beach, from near right, John, 23; George, 20; Paul, 21; and Ringo, 23). More important than craft and charm: the self-composed tunes that rank with the best in all popular music.

ROBERT GOMEL

>

THE HIGH ROAD

The headliners for this 1967 concert shared more than a stage; both sprang from San Francisco's days of wine and overdoses, and both survived handsomely. When Jefferson Airplane stalled, the group white-rabbited itself into a Starship. And even after the death of leader Jerry Garcia in 1995, the Grateful Dead kept pleasing veterans of Woodstock I.

BGP AND SFX.COM COLLECTIBLES

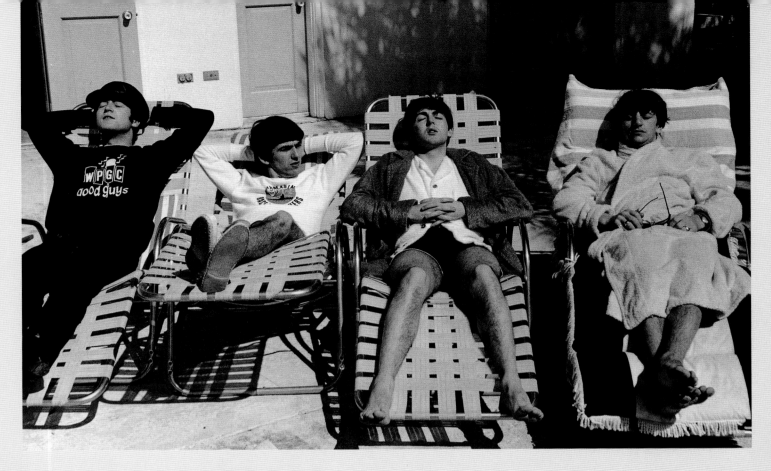

THEIR VIBRATIONS WERE GOOD

Dick Dale fathered the staccato, reverb-heavy sound, and Jan (Berry) and Dean (Torrence) furthered it. But surf's big kahunas were the Beach Boys (in 1962, from left: Carl Wilson, 16; Dennis Wilson, 18; Mike Love, 21; Brian Wilson, 20; and David Marks, 14). Four Boys could hang 10. Brian, who composed the group's evocative hits, didn't even swim.

MICHAEL OCHS ARCHIVES

FEEL THE NOISE

Bombast met the blues in Led Zeppelin's 1971 "Stairway to Heaven," an early heavy metal chart-climber. Vocalist Robert Plant, 23 (above, left), and guitarist Jimmy Page, 27, cared less about melody than power riffs. Led Zep begat Iron Maiden, which begat Metallica. Eventually, the genre begat laughs by way of Bill and Ted, who so excellently saved the universe with some headbanging chords.

FAMILY BUSINESS

Motown's Jackson 5, which used the talents of all six brothers, was history in 1977 when 80 percent of the Jacksons said "cheese." From far left: mom Katherine, 46; Michael, 18; Jermaine, 22; Janet, 10; Marlon, 19; Randy, 14; La Toya, 20; and Tito, 23. (Dad Joseph, 47, Rebbie, 26, and Jackie, 15, were elsewhere.) Seven of the sibs also tried solo careers; only Michael's and Janet's had any impact.

O.K., SO FAKE IT

The band's sound was crude because the quartet Joey Ramone assembled in 1974 could not play musical instruments. Who cared? Basic three-chord punk rock was oxygen to an audience drowning in over-produced studio albums. Among fans of the Ramones (below, a 1980 poster) were future Pearl Jammers and Soundgardeners.

SU SUTTLE / NEKO STUDIOS

I DON'T DO "YMCA"!

In 1978, who at Studio 54 needed amyl nitrite during a gig by Grace Jones, 26? Unlike Donna ("Love to Love You Baby") Summer or those captains of camp, the Village People, Jones's disco was in your face. When the synthesizers that drove Saturday night fever wore out, the Jamaica-born ex–runway model went Hollywood; she was rarely cast as a submissive cupcake.

ROBIN PLATZER / TWIN IMAGES

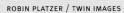

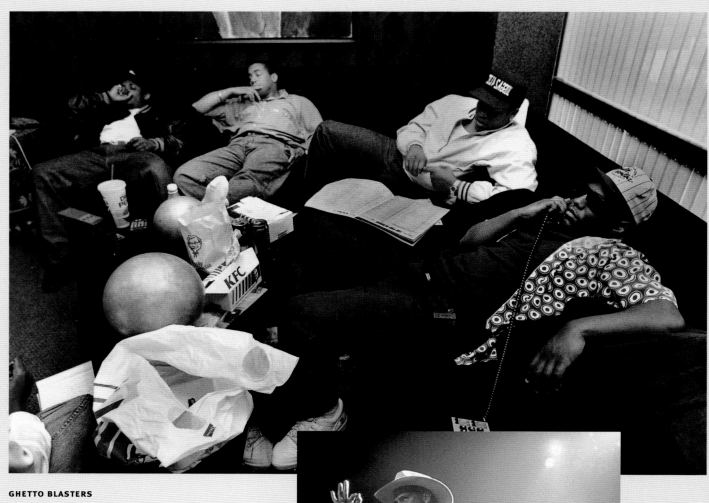

GHETTO BLASTERS

N.W.A (Niggaz With Attitude) emerged from the mean streets of South Central L.A. with the notorious 1989 single "F--- tha Police." But when not performing the defiant and misogynistic brand of rap they called gangsta, the homeboys could chill. In 1991, from left: Eazy E (who would die four years later of AIDS, at 31), DJ Yella, MC Ren and Dr. Dre.

MICHAEL GRECCO / CORBIS / OUTLINE

BIG HAT BECOMES BIGFOOT

In 1991, Garth Brooks, 29, smashed the wall between country and pop when his third album, *Ropin' the Wind*, became the first to top both charts. The Tulsa native got a helping hand from new technology that more accurately tabulated music sales across America. For decades, it seems, country had been short-changed. Shoot, Johnny, Loretta, Willie and Dolly had known that all along.

PAUL NATKIN / CORBIS / OUTLINE

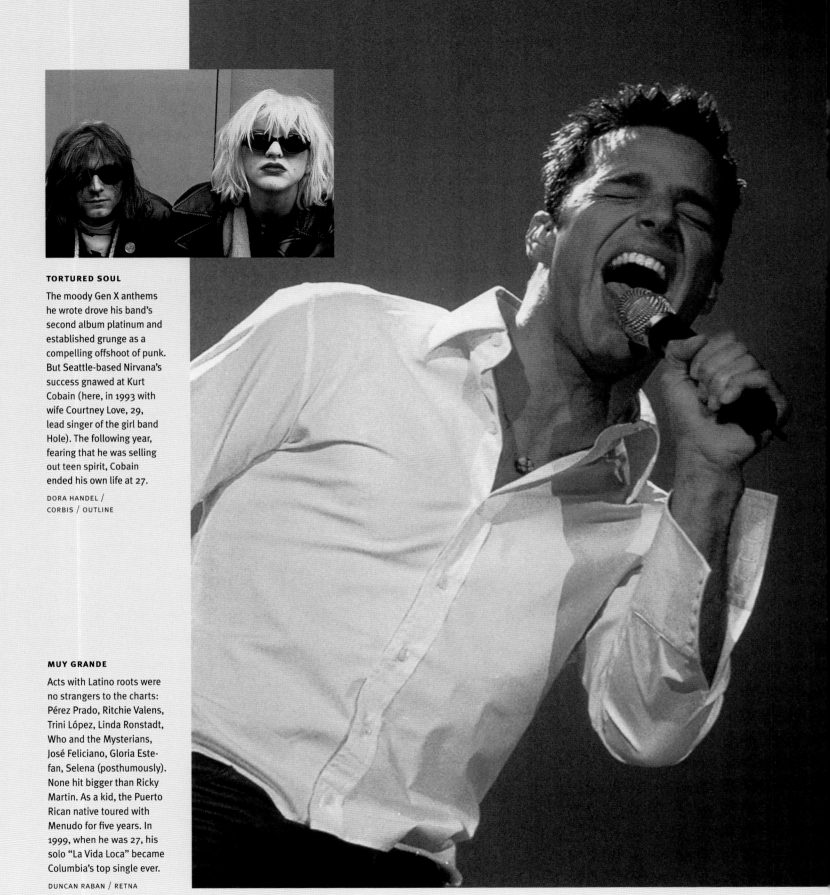

TORTURED SOUL

The moody Gen X anthems he wrote drove his band's second album platinum and established grunge as a compelling offshoot of punk. But Seattle-based Nirvana's success gnawed at Kurt Cobain (here, in 1993 with wife Courtney Love, 29, lead singer of the girl band Hole). The following year, fearing that he was selling out teen spirit, Cobain ended his own life at 27.

DORA HANDEL /
CORBIS / OUTLINE

MUY GRANDE

Acts with Latino roots were no strangers to the charts: Pérez Prado, Ritchie Valens, Trini López, Linda Ronstadt, Who and the Mysterians, José Feliciano, Gloria Estefan, Selena (posthumously). None hit bigger than Ricky Martin. As a kid, the Puerto Rican native toured with Menudo for five years. In 1999, when he was 27, his solo "La Vida Loca" became Columbia's top single ever.

DUNCAN RABAN / RETNA

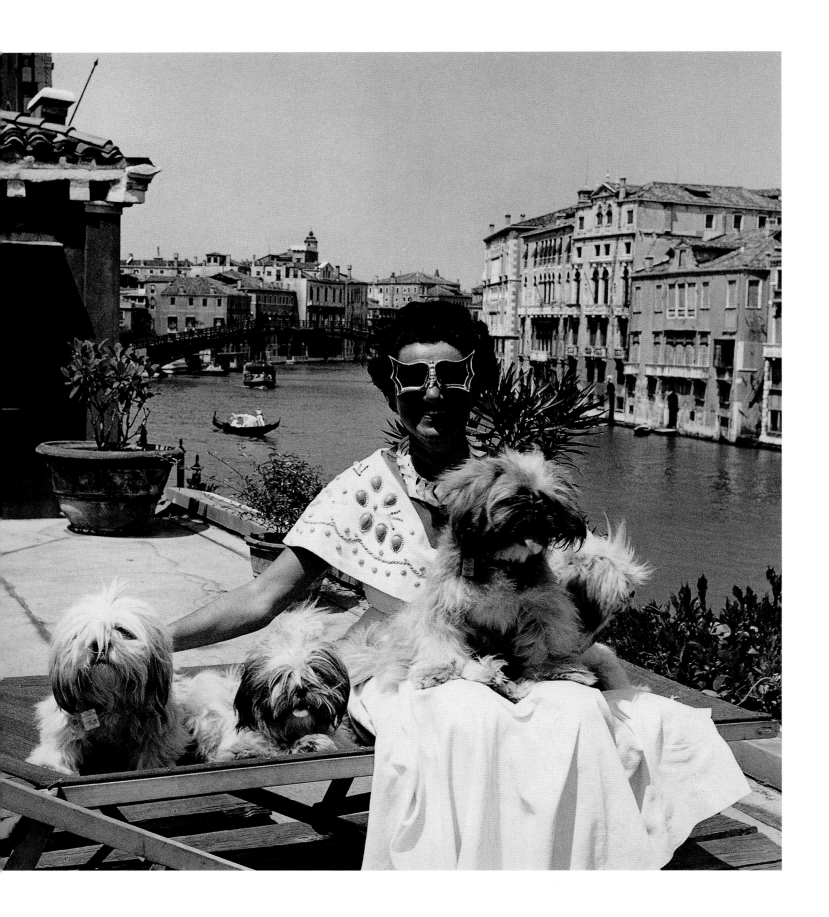

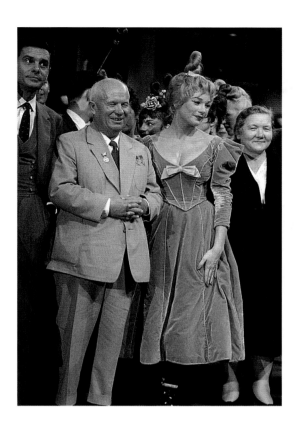

COMMIES IN HOLLYWOOD

In 1959 Hollywood, Shirley MacLaine, 25, and Louis Jourdan, 40, interrupted filming *Can-Can* to greet VIPs Nikita Khrushchev, 65, and his wife, Nina, 59. The Soviet premier, in the U.S. to confab with Ike, was doing a little sightseeing. The short-fused Khrushchev's smile vanished when he was told that, for security reasons, he could not take the missus to nearby Disneyland.

RALPH CRANE / LIFE

NO FLEAS ON THIS DOGE

Mining heiress Marguerite (Peggy) Guggenheim (left, in Venice in 1950, at 52) began befriending cutting-edge European artists in the 1920s. And becoming their patron. Some of her acquisitions are now in the New York City museum founded by uncle Solomon Guggenheim. The bulk hang in Peg's canalside Palazzo Venier dei Leoni.

DAVID SEYMOUR / MAGNUM

POLLOCK VIA ROCKWELL

In 1962, the artist known as our squarest paid tribute to the man known as our most avant-garde. Jackson Pollock had died (in a car crash) six years before Norman Rockwell, 68, painted *The Connoisseur* for *The Saturday Evening Post*. Yes, the middle-aged museum-goer seems baffled. But the canvas he studies is not a Pollock — it's Rockwell's try at abstract expressionism.

NORMAN ROCKWELL FAMILY TRUST

TOUGH, BUT SO GENTLE

On film, not on Broadway: Marlon Brando in 1951's *Streetcar Named Desire*. The movie showed the rest of America why New York was deifying an actor from Omaha. But forget the Method act. Whether Fifties slim (as in *Streetcar*, *On the Waterfront* and *The Wild Ones*) or porky later on (*The Godfather*, *Apocalypse Now* and *The Freshman*), Brando had a unique gift. On camera, he was vulnerable.

BFI STILLS, POSTERS AND DESIGNS

READY TO RUMBLE

Program-starved networks carried wrestling in prime time until the mid-1950s. The biggest star, by sheer tonnage: Haystacks Calhoun (below, in 1965, at 31), whom promoters touted as weighing up to 625 pounds. In the 1990s, program-starved cable channels in search of gross profits found them in such WWF suet hogs as Mankind and The Rock.

CORBIS / BETTMANN-UPI

THE BOOB TUBE

On turning 13 in 1961, network TV received from the chairman of the FCC not a bouquet but a brickbat. The medium, charged Newton Minow, 34, was "a vast wasteland." Time would not mellow that view. In 1991, Minow warned "of more media with fewer messages, of tiny sound bites without large thoughts."

WALTER BENNETT

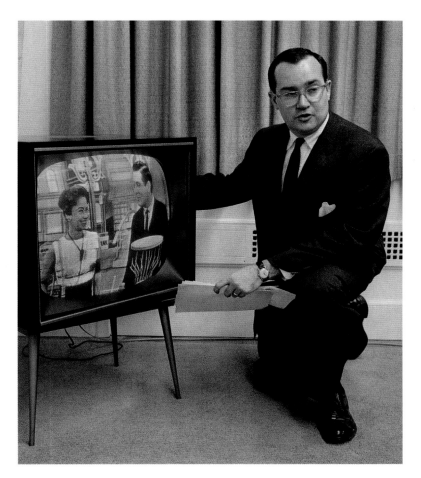

THE KITSCHEN SCHOOL

Roy Lichtenstein, 39, was a pop artist, so he titled this 1963 canvas *Image Duplicator*. Ironic literalism fueled the school, which reacted against abstract expressionism by turning such everyday objects as comic strips and ads into art. Critics yelped, but hadn't Cezanne painted wine bottles? (In 1990, a Lichtenstein sold for a record $6 million.)

JOHN LOENGARD

WE WANT BUCK ROGERS

Audiences in 1968 were unsettled by *2001: A Space Odyssey*. Sure, special effects like a zero-G walk (right) dazzled the eye. But what exactly was Stanley Kubrick's movie about? Sci-fi would remain a minor Hollywood genre until 1977, when George Lucas returned it to its Saturday-matinee roots with his space opera *Star Wars*.

DMITRI KESSEL

GREENER . . . BUT WISER

In 1969, tots who had dozed to Captain Kangaroo and Mr. Rogers got a wake-up call: *Sesame Street*. The public television hour sought to teach disadvantaged kids their 1-2-3s and A-B-Cs. The show was so hip that it soon acquired an over-five following. In 1976, Kermit T. Frog and other Jim Henson Muppets wangled a series of their own.

JIM HENSON PRODUCTIONS

MAID IN MINNESOTA

As first conceived, our spunky heroine needed a job because she had split from her hubby. Uh-uh, said CBS; divorce was no laughing matter. So when *The Mary Tyler Moore* show debuted in 1970, the star, 34, needed a job because she had split from her beau. Either way, it's a good thing that the job Mare took was in the newsroom of WJM-TV in Minneapolis.

CBS PHOTO ARCHIVE

SUPER BOWL I

When the NFL and the upstart American Football League made peace, they agreed to an interleague title game. The first, in 1967, at the 94,000-seat Los Angeles Coliseum, drew only 61,946, and the game was a bore (Green Bay 35, Kansas City 10). Didn't matter; a January sports tradition was launched.

CORBIS / UPI

MAKING HIS DAY

What were American TV star Clint *(Rawhide)* Eastwood, 33, and German actress Marianne Koch, 31, doing in 1963 on the plains of Spain? Filming Italian director Sergio Leone's rip-off of *Yojimbo*, the Japanese classic by Akira Kurosawa. It all translated into *A Fistful of Dollars*, the spaghetti Western that propelled Eastwood to action stardom.

THE KOBAL COLLECTION

CURT FLOOD

Sacrifice Play

Pro baseball was integrated in 1947 by Jackie Robinson yet stayed a virtual plantation: A team signing a kid owned him for life. (The "reserve clause" dated to 1922, when the Supreme Court shielded the game from antitrust laws by deciding it was not a business.) In 1969, All-Star center fielder Curt Flood, 31, refused to accept a trade and, by suing for the right to pick his own team, in essence committed career suicide. Again the Supreme Court agreed with baseball, but its 5-3 ruling was so ambiguous that in 1975 arbitrators let two players decide for whom they wanted to play. Thus came free agency to professional team sports.

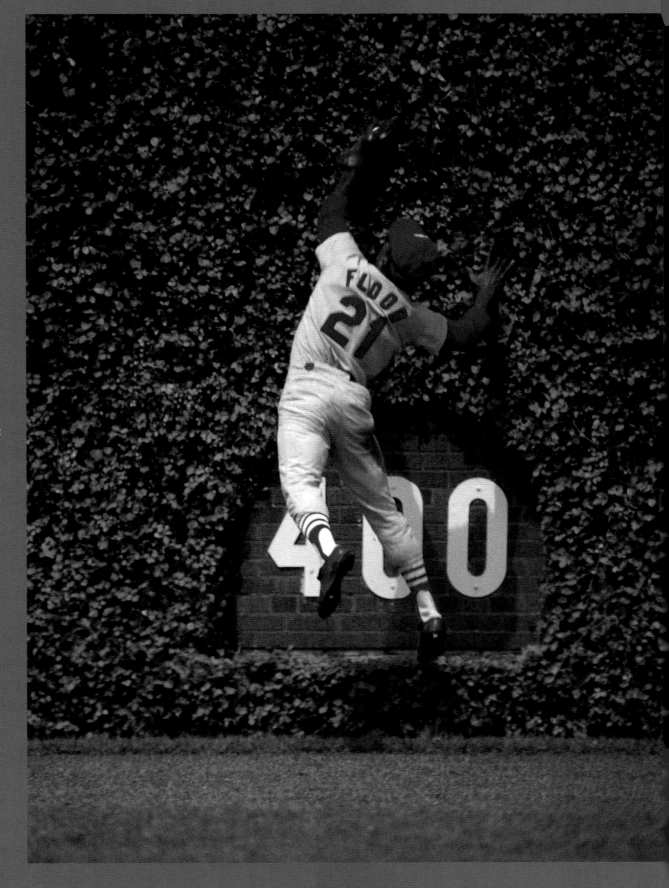

Breaking in with Cincinnati, Flood joined St. Louis in 1958 (far left). By 1969, the three-time All Star and seven-time Gold Glover (right, a 1968 grab at Wrigley Field in Chicago) was making $90,000 a year and working up potential Hall of Fame numbers. His challenge of the reserve clause was backed by baseball union head Marvin Miller, top left, in 1970 with Flood and sportscaster Howard Cosell (middle). Miller later used the split Supreme Court decision to break baseball's chattel hold on players. His career over, Flood tried to support himself as an artist. (His 1968 portrait of Martin Luther King Jr. is owned by the assassinated civil rights leader's widow, Coretta.) Flood eventually returned to sports, serving as recreation commissioner of his native Oakland before dying in 1997, at age 59.

CLOCKWISE FROM TOP LEFT:
CORBIS / UPI;
HERB SCHARFMAN / SPORTS
ILLUSTRATED; AP;
THE TOPPS COMPANY, INC.

THOSE WERE THE DAYS

When Archie Bunker (Carroll O'Connor, 48) ranted about "dose people" on *All in the Family*, everyone knew whom he meant. Second-season guest Sammy Davis Jr., 47, used some old black magic to stifle the blowhard. The sitcom, breathtaking in its political incorrectness, premiered in 1971 and for the first five (of 12) years ruled as No. 1 in the Nielsens.

CBS PHOTO ARCHIVE

>

WRAP ARTIST

The first artwork needing environmental approval: 1976's *Running Fence*, by Christo (Javacheff) and his wife, Jeanne-Claude (de Guillebon), both 41. They joined 2,050 panels of nylon fabric into an 18.5-foot-high, 24.5-mile-long wall stretching from Cotati, California, to the Pacific Ocean. Two weeks after finishing, they had to knock it down.

GIANFRANCO GORGONI / CONTACT

>

MUG SHOTS

An adolescent girl throws up pea soup because . . . the devil made her do it! *The Exorcist*, that stylish 1973 screamfest, starred Linda Blair, 14. (At near right, the special-effects head that did the dizzying trick spins.) The 1976 slugfest *Rocky* required no legerdemain, just vats of ketchup. Journeyman actor Sylvester Stallone, 30, wrote the boxing tale in three days, then sold it cheap on condition he play the title role. Yo, nice career move.

STUPID HUMAN TRICKS

If you've seen even one episode of *Saturday Night Live*, you know the drill. If not, these are Killer Bees. Portraying them in a 1978 sketch (during the late-night NBC show's fourth season) are, from left, Bill Murray, 28; John Belushi, 29; Al Franken, 27; Garrett Morris, 41; Dan Aykroyd, 25; and 12-year-old Charlie Matthau (whose actor father Walter hosted this show).

NBC PHOTO

WOOKIE OF THE YEAR

Co-star Harrison Ford (far right, 34) was, in 1976, a Hollywood who-he and his pal Chewbacca was from another galaxy. Thus could George Lucas make *Star Wars* for $9.5 million (26.7 mil, adjusted for inflation). Profits from the movie and three sequels (so far) are big. Even bigger: the licensing fees — action figures, lunch boxes, pj's — that 20th Century Fox so nonchalantly let Lucas keep.

20TH CENTURY FOX

OUT OF AFRICA

The blockbuster miniseries of the century was based on Alex Haley's novel about his family's history from slave-ship days to the present. You didn't have to be black to be gripped by the cross-generational saga; in 1977, more than half the country caught at least a portion of *Roots*, which ABC aired in 12 hours over eight straight nights.

EVERETT COLLECTION

STEPPING IT UP

Mikhail Baryshnikov was 26 when he jetéd over the Iron Curtain in 1974. Unlike earlier defecting Soviet superstars Rudolf Nureyev and Natalia Makarova, Misha (here in 1978 with Gelsey Kirkland, once his offstage partner as well) didn't just stick to ballet. While doing movies, TV and Broadway, he also became a modern-dance innovator.

KEN REGAN / CAMERA 5

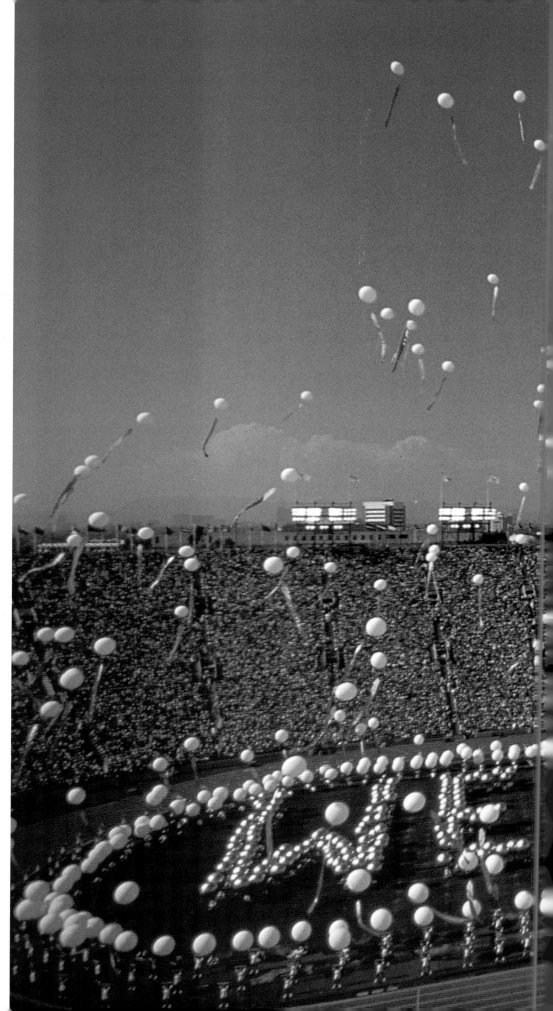

AND THE ANSWER IS . . .

. . . printed below. In May 1980, the prime time soap *Dallas* cribbed a gimmick from the movie serials of yore by ending its season with anti-hero J.R. Ewing (Larry Hagman, 48) felled by a bullet — then making fans wait six months to learn whodunit. The tease worked; in the interim, the show rose three notches to No. 1.

A: Sister-in-law Kristin, played by Mary Crosby, daughter of Bing.

BARRY STAVER / PEOPLE

FIVE-RING CIRCUS

Spectacular was the ceremony that opened the 1984 Los Angeles Games. Even more so were the outcomes. For the first time since the modern Olympics were founded in 1896 by French aristocrat Pierre de Coubertin, the host city earned a profit. And with Team USSR absent (as payback for America's boycott of the 1980 Moscow Games), Team USA won its most medals ever.

DAVID BURNETT / CONTACT

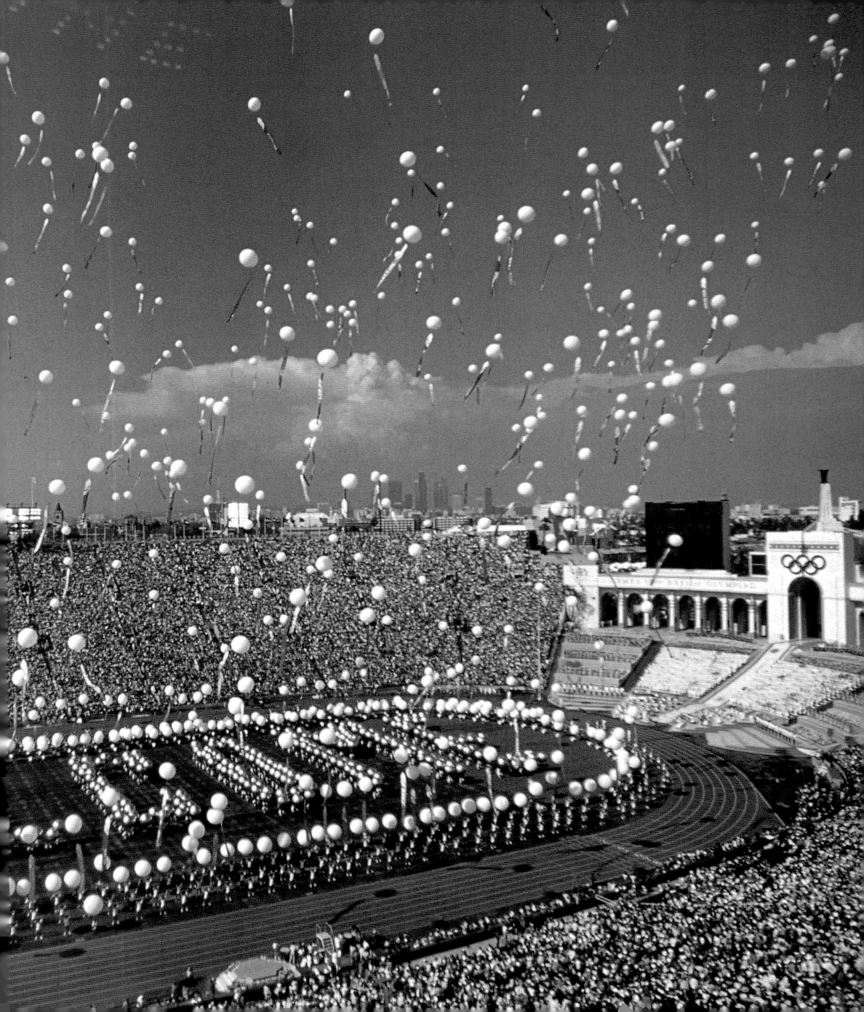

A FAREWELL TO ARMS

TV series based on big-screen hits rarely work. In 1973, *M*A*S*H* — drawn from Robert Altman's 1970 antiwar comedy — was almost axed after a season. Instead, CBS moved it to Saturday night, where it stayed in the Top 15 for the next decade. And episode 251, its 150-minute finale (below), was the most-watched entertainment show ever.

AP

YOUR BEST FRIEND DID WHAT?

The Mississippi native had been a radio and TV gypsy for 12 years before landing a local Chicago talk show. Soon, she was out-Nielsening daytime king Phil Donahue. Oprah Winfrey went national in 1986, at 32 (above). Was talk cheap? Not hers; from that syndicated show grew an empire that has expanded from TV and movies into publishing.

HARRISON JONES

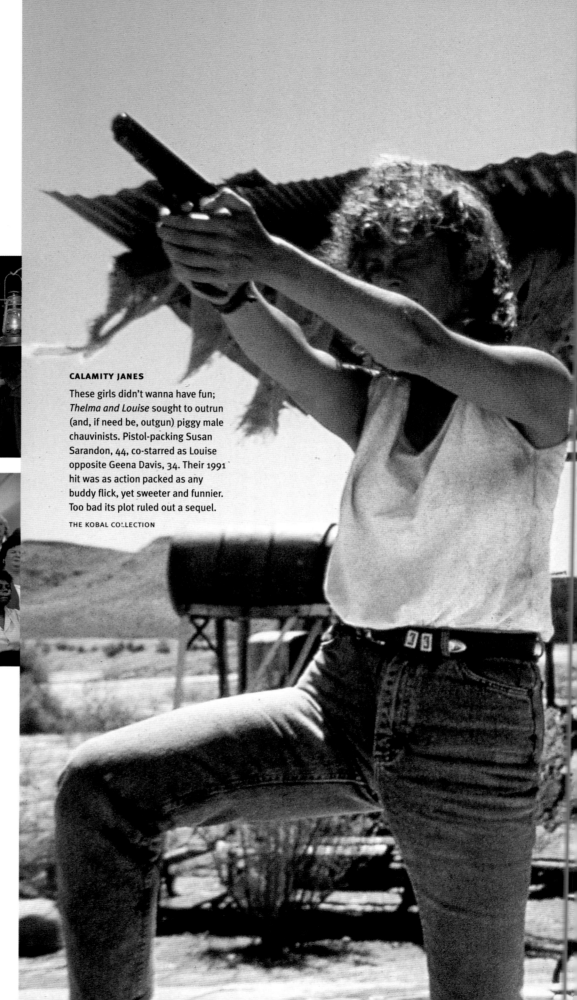

CALAMITY JANES

These girls didn't wanna have fun; *Thelma and Louise* sought to outrun (and, if need be, outgun) piggy male chauvinists. Pistol-packing Susan Sarandon, 44, co-starred as Louise opposite Geena Davis, 34. Their 1991 hit was as action packed as any buddy flick, yet sweeter and funnier. Too bad its plot ruled out a sequel.

THE KOBAL COLLECTION

CAROL ROSEGG

NEEDED: ANOTHER SHELF

In 1991, Quincy Jones, 57, won six of his industry-high 26 Grammys. It was a record built on durability (he broke in as a trumpeter with Lionel Hampton in 1951) and versatility (from bebop performer to rock and hip-hop producer). Jones also found time to write 35 movie scores, including that of *In the Heat of the Night*, and create the sitcom *Fresh Prince of Bel-Air*.

SUSAN RAGAN / AP

<
PRIME PEDIGREE

Cats frisked past *A Chorus Line*'s mark for most Broadway performances (6,137) in 1997. The purr-fect musical was adapted by Andrew Lloyd Webber from T.S. Eliot's *Old Possum's Book of Practical Cats*. The New York production seemed fated to run out of lives; but rest assured, the show will be revived — now and forever.

CAROL ROSEGG

>
NOTHING BUT NET

Michael Jordan aired his last jumper (right) in June 1998. It went in to give the Chicago Bulls their second NBA three-peat in eight years. When the star then retired, at 35, the league's TV ratings tanked. Small wonder; fans were spoiled by the game's most charis-matic and best player. Take issue with "best"? Whom would you send against Mr. Jordan, one-on-one?

JOHN BIEVER /
SPORTS ILLUSTRATED

<
AN EPIC TO REMEMBER

In a five-million-gallon tank in Rosarito, Mexico, *Titanic* director James Cameron, 42, told stars Kate Winslet, 20, and Leonardo DiCaprio, 21, what he wanted. It was the right advice. The special-effects-laden 1997 movie was the most costly ever ($215 million). And the highest grossing ever ($1.8 billion worldwide).
20TH CENTURY FOX

>
ANALYZE THIS

Do not drop your cigar in this guy's pool — unless you plan on swimming with the fishes. In 1999, HBO unveiled *The Sopranos*, about a violent and profane Jersey wiseguy (James Gandolfini, 37). Tony Soprano's crime family was oafish. Tony's own family was thermonuclear. No wonder Tony needed a shrink. By lacing its melodrama with unlikely laughs, the show became, er, a Mob hit.
ANTHONY NESTE

<
FEARFUL SYMMETRY

Even in trouble up to his young neck, Tiger Woods was head and shoulders above the planet's other golfers. In 1996, at 20, he left Stanford to turn pro. Woods quickly topped $16 million in official purses (No. 1 all-time) and in 2000 became only the fifth player to bag all four major tournaments. At age 24, Tiger was the youngest ever.

W.A. FUNCHES JR. /
NEW YORK POST

lifespan

Vera Cornell was born on February 17, 1900, in Portland, Oregon, and at a winsome 19 months posed for this portrait. Her expected longevity: 48.7 years. She foiled the numbers. A century later Cornell celebrated with a cake in her Corvallis home. As she blew out the candles, she joked to friends, "If my teeth fly out, will you catch them?"

LASTING LONGER,
LIVING BETTER

Shaking Off Nature's Threats

BY SHERWIN B. NULAND

IN THE ECONOMY OF NATURE, there is no need for an animal to live beyond its reproductive years. When the DNA has been transmitted, the offspring brought forth and, in some cases, a period of rearing passed, the parental generation serves no useful purpose to the preservation of the species. Its hour of strutting and fretting upon the stage of history is over. By every criterion of biological reason, it should be "heard no more."

And that is precisely the way things are for all but us *Homo sapiens* and the relatively few forms of life we have chosen to domesticate. Men and women try to live on, and we do what we can to help our pets and certain of our farm and laboratory animals do the same. Longevity, in fact, is widely considered one of the valid measures of a civilization's progress.

Our earliest ancestors are estimated to have lived an average of only 18 years, and it would take dozens of millennia before that figure was stretched out to approximately two score and five at the beginning of the 20th Century. Today, just a hundred years later, we are able to predict that newborn children in the developed world will very likely live into their middle or late 70s.

In the form of immunizations and the widespread availability of antibiotics, medical advances have played a large role in the changing picture, but public health measures such as water purification and improved sanitation and housing have had an even greater influence. In all ways, prevention of disease has been more important than treatment, and by a wide margin. Therapeutic technology like open heart surgery, kidney dialysis and chemotherapy hardly make a dent in the statistics when compared with prophylactic factors. Even the great reduction in mortality from coronary heart disease of recent decades owes at least as much to changes in lifestyle and emergency transportation and the development of intensive care units as it does to drugs and surgery. There are lessons here for all of us, but especially for the health planners and those charged with allocating precious resources — like money.

Scientists debate the question of just how far longevity can be increased within the maximum lifespan of our species, which appears to be no longer than 120 years. Even that figure is seemingly up for grabs, as biologists have recently begun manipulating the small structures at the end of chromosomes — called telomeres — and predicting a soon-to-be-acquired ability to otherwise alter the genetic factors that limit the possibilities of natural survival. The moral and ethical considerations and the implications for our planet and for each of us as individuals of such far-ranging technologies are just beginning to be explored. Until they become the subject of wide-ranging discussion, decisions about the future of such research are best left in abeyance.

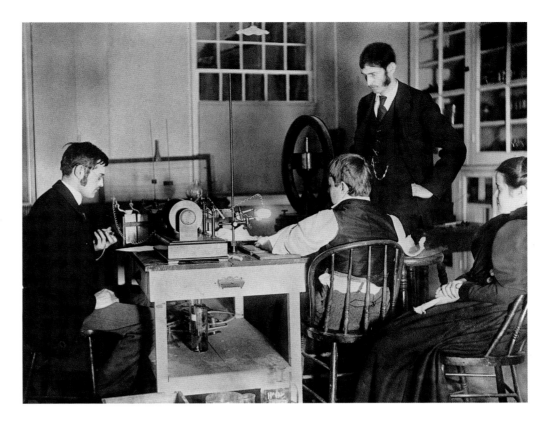

The first medical X-ray in the U.S., in 1896, revealed that patient Eddie McCarthy, 14, had a broken arm. Present at this historic moment in Hanover, New Hampshire, were Gilman Frost, a physician (at left); his wife, Margaret, a nurse; and his brother Edwin.

DARTMOUTH PHOTO ARCHIVES

What is of far greater importance now is the matter of longevity, how long we may reasonably expect to live. But as magnificent as are the changes wrought by medical science in the 20th Century's fight against disease and as striking as the resultant lengthened periods of our lives may be, another transformation has occurred that is at least as impressive as the additions to the number of years we have been granted — and that is the additions to their quality.

Most of this kind of change has taken place in the second half of the century, but traces of it were becoming evident earlier. In fact, the new outlook can be viewed as a progression that started slowly and then began to accelerate during the 1960s, as the hazards of tobacco, alcohol and certain kinds of diet became increasingly well known to the American public, accompanied by an expanding awareness of the baneful effects of sedentary habits.

It is no coincidence that attention paid to the quality of life should have magnified at exactly the same time as additions were being made ever more rapidly to its quantity. The added years of survival gave younger people the opportunity to observe firsthand and in large numbers the way their bodies were programmed to deteriorate with the passage of the augmented time. Not only did degenerative processes like arthritis and osteoporosis become far more common as life lengthened, but so did major

pathologies like cancer, heart disease and dementia, all of them far more prevalent in an aging population than in one whose members usually do not live past their late 40s.

Earlier in the century, the elderly used to die with a lot less preamble than they were later forced to endure once life was extended beyond its previous limits. Even today, by the time people reach their 50s, the heart has long since lost its ability to respond effortlessly to stress, the lungs exchange oxygen without their previous youthful efficiency, and the abdominal organs — particularly liver, spleen and kidneys — are missing some of their zip. In 1900, the waning of powers meant the loss of the body's ability to fight off nature's inevitable small attacks, most notably when they required that the increasingly creaky immune system mount a defense against infection. When bacteria or a virus gained a foothold in a body no longer optimally prepared to fight it off, death usually came within days.

But by the last third of the 20th Century, most of nature's threats could be shaken off with barely a bit

Prevention beats cure. Here, a New York City public-health nurse in the 1930s quarantines an apartment, forbidding casual entrance. It was a common practice to stop the spread of diseases like tuberculosis.

JAMES CONNAUGHTON JR. / BUREAU OF PUBLIC HEALTH EDUCATION / PHOTORESEARCHERS

of notice. A visit to the doctor, a prescription, occasionally an operation, and the aging body is soon back at its desk or even on the slopes. A growing pharmacopoeia, in fact, prevents many of the quickly lethal dangers of aging from manifesting themselves at all. It is impossible to calculate how many men and women now living would be dead but for the daily taking of a blood pressure pill or a capsule to regulate cardiac rhythm. Most of the common infectious diseases that 75 years ago would have expeditiously killed so many of their victims are vanquished at their very onset with a phoned order for antibiotics, the sixtysomething having barely broken stride.

At the end of the 19th Century, it took hardiness to be very old; now, at the beginning of the 21st, a good medical-insurance plan may accomplish the same thing. When we reach a healthy 65th birthday these days, the statisticians can predict that we stand an excellent chance of attaining the hoary age of 81, thanks to the lifestyle changes and medical advances of the past six or seven decades.

And so we live well beyond the time when nature would have called us away in an earlier era, and we pay as little heed as possible to the small changes that are gradually rusting our joints, eroding our bones, scarring our hearts, decimating the strength of our muscles, plugging up our waterworks and killing off our brain cells. For many, the quick drop of yesteryear has been turned into the lingering decline of today. Nursing homes and similar facilities for the aged are filled with men and women slowly passing into physical and mental oblivion.

But we have known for much of the past century that it doesn't have to be that way. Ever larger numbers of men and women are changing a pattern that many others still believe to be inevitable. Granted that the same major offenders that led the horsemen of death for most of the 20th Century — heart disease, cancer and stroke — will continue to be the leading killers in the 21st, a large proportion of people now in middle age and younger can look forward to later years that will be quite different from the grim scenario that so many of our most aged are experiencing today. Plenty of Americans decades older than their 50s are already living pleasurable lives because they have learned the lessons of healthy longevity.

Thoracic surgeon Henry Heimlich, 54 (right), conducts a 1974 session in Cincinnati teaching his method for dislodging food from a person's windpipe. The Heimlich maneuver has saved an estimated 60,000 people.
HENRY GROSSMAN

These changes have come about not as a result of the efforts of pie-in-the-sky researchers who tell us that they will extend the human lifespan to 200 or more years but from more reasonable scientists who have long realized that the foremost factor preventing independent living by the elderly is physical frailty. Gerontological research has concentrated on a concept called "compression of morbidity," by which is meant improving the quality of life so that we will not die with the dwindles but rather expeditiously, following a relatively short period of worsening health.

Effective and safe antidepressants, drugs to combat osteoporosis and individualized hormone-replacement therapy — these were among the first of the wide array of medications now commonly used to reverse or control the ravages of aging. The new therapies and the wide availability of such surgical procedures as joint replacement and the implantation of artificial lenses are the heralds of the burgeoning research that is already increasing the quality of life during those added years.

But even these are only treatments for degenerative processes that have already begun. Exercise, steady habits, attention paid to food and drink and abstinence from smoking lessen the depredations of time. Psychological and attitudinal factors too have come to play a major role: The realization that curiosity, work and creativity are part of healthy aging have added immeasurably to the lives of the vital septa-, octo- and nonagenarians whose numbers multiply with each passing year.

Studies of the effects of vigorous exercise have yielded findings that amaze even its most enthusiastic proponents. It prevents frailty among the oldest of the old, delays and even reverses osteoporosis, improves the tone of the heart and the lungs, lessens the frequency of certain cancers, fights depression and has even been found to strengthen the immune system. Every day, more older Americans learn about such

Space hero John Glenn, 78, suits up for the Gridiron Club's 1999 show honoring him as the world's oldest astronaut (with club president Tom Braziatis). Because of his shuttle flight at age 77 in 1998, he's exactly that.
MARIANNE MEANS

things; every day, hundreds if not thousands start on the road toward vigorous and productive aging.

Of all the miracles of the 20th Century, there is only one in which each of us can have a direct and determinative hand: to act on the evidence that healthy and rewarding longevity depends at least as much on our individual decisions and actions as it does on biomedical science, the cards dealt in the genetic draw or the unpredictable currents of life's experience.

Sherwin B. Nuland is Clinical Professor of Surgery at the Yale School of Medicine and author of How We Die, *winner of the 1994 National Book Award. His most recent book is* The Mysteries Within: A Surgeon Reflects on Medical Myths.

DANGEROUS SHADOW

This 1895 cartoon poked fun at X-ray imaging — invented that year by German scientist Wilhelm Roentgen — by turning a genial farmer into the Grim Reaper. The hazards of cumulative exposure were known almost immediately since X-ray machine operators and researchers suffered from burns, skin ulcers, lost limbs and sickness. By 1906, at least four X-ray deaths had been reported.

CORBIS

FOLKS ON THE RUN

Add to boiling water and stir: That was the beauty of Jell-O, available in four flavors and, in 1897, the country's first convenience food. Eight years later came more culinary progress. The Lombardi family opened the first pizza parlor in New York City. Before long, rip-offs appeared everywhere. Eating on the go began taking over U.S. cuisine.

BELOW: KRAFT FOODS
RIGHT: MAURICE LEVINE

THE NEW ROENTGEN PHOTOGRAPHY.
" Look pleasant, please."

>
SURGEON AT WORK

This photo shows a medical pioneer in action. By 1900, surgeon Charles McBurney, 55 (bald, at center, surrounded by staff and students), had simplified the operation for appendicitis, which was claiming thousands of lives a year. His diagonal "McBurney's incision" exposed the appendix by splitting, rather than cutting through, abdominal muscles.

THE BYRON COLLECTION /
MUSEUM OF THE CITY OF
NEW YORK

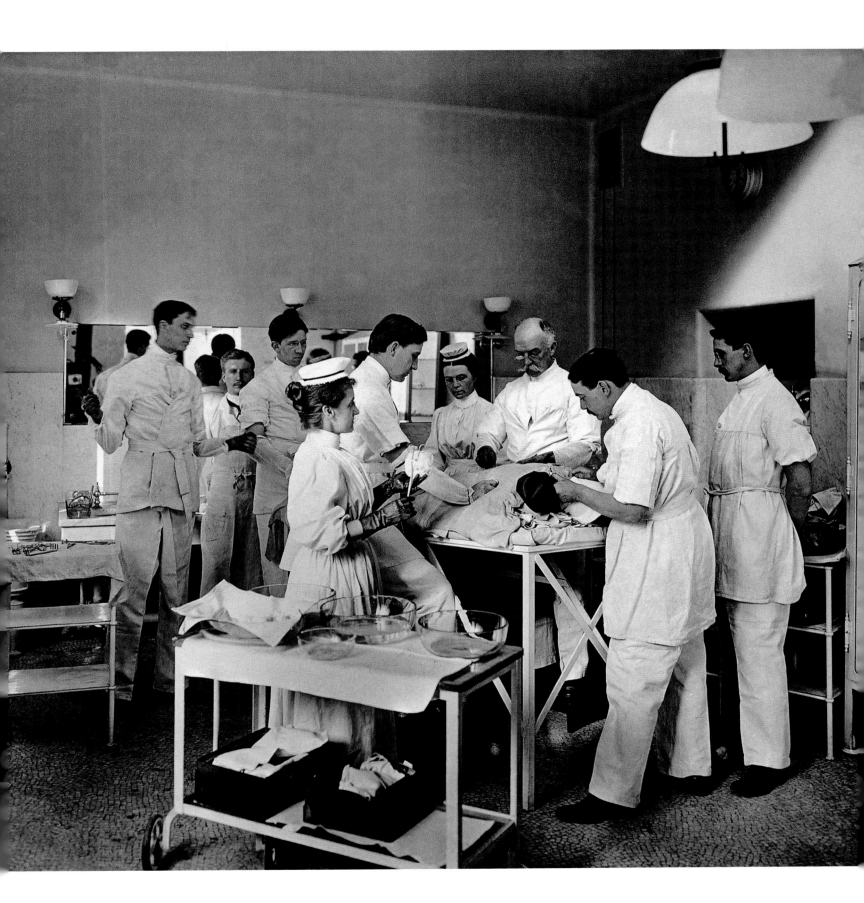

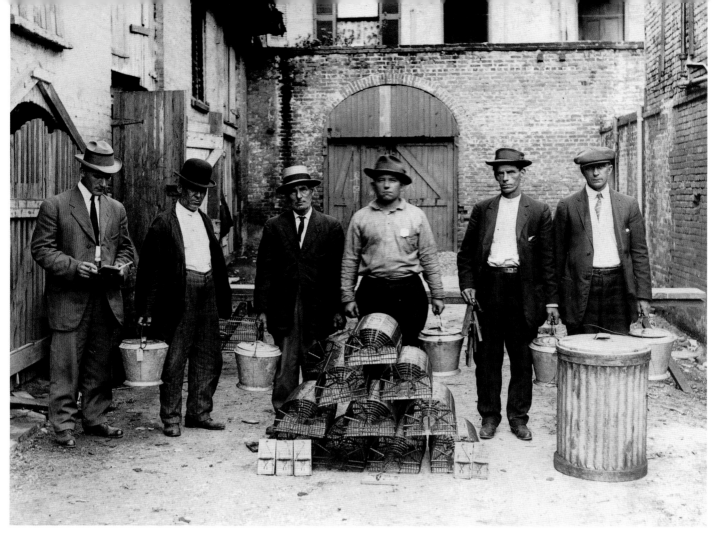

SMELLING A RAT

Disease control in a growing nation required collective effort, so the U.S. created the Public Health Service in 1902. It helped suppress an outbreak of deadly bubonic plague in San Francisco in 1907 and 1908 and six years later in New Orleans. There a team mobilized to catch rats, which spread the disease.

DEPARTMENT OF HEALTH AND HUMAN SERVICES

>

TOILET TRAINING

Only the wealthiest enjoyed indoor plumbing. For the rest, the outhouse posed the threat of cholera and typhoid fever from poor hygiene and drainage. Posters like this, which appeared in neighborhoods where every backyard had a privy, offered practical advice on basic sanitation. Disinfectants had not yet caught on.

DEPARTMENT OF HEALTH AND HUMAN SERVICES

(To Be Tacked Inside of the Privy and NOT Torn Down.)

Sanitary Privies Are Cheaper Than Coffins

For Health's Sake let's keep this Privy CLEAN. Bad privies (and no privies at all) are our greatest cause of Disease. Clean people or families will help us keep this place clean. It should be kept as clean as the house because it spreads more diseases.

The User Must Keep It Clean Inside. Wash the Seat Occasionally

How to Keep a Safe Privy:

1. Have the back perfectly screened against flies and animals.
2. Have a hinged door over the seat and keep it CLOSED when not in use.
3. Have a bucket beneath to catch the Excreta.
4. VENTILATE THE VAULT.
5. See that the privy is kept clean inside and out, or take the blame on yourself if some member of your family dies of Typhoid Fever.

Some of the Diseases Spread by Filthy Privies:

Typhoid Fever, Bowel Troubles of Children, Dysenteries, Hookworms, Cholera, some Tuberculosis. The Flies that You See in the Privy Will Soon Be in the Dining Room.

Walker County Board of Health

>

RUM DEAL

On the eve of Prohibition in 1920, partygoers in New York City gathered around John Barleycorn's coffin for a last, mournful toast. A dry nation drank less at first; then consumption actually increased. And that meant other hazards to health — poisonous home brews and Mob violence over liquor smuggling. The 18th Amendment was repealed in 1933.

CORBIS / ACME

TURNING POINT

Giant Steps

At the dawn of the 20th Century, families were often big because birth control was scarce and unreliable and fertility rates were high. But so was infant mortality: 10 percent of all infants died within a year. It is surprising that the figure was not higher. The importance of prenatal nutrition and care were little recognized. Mothers tended to be young and unsophisticated about the needs of the babies they were carrying. Most births took place at home, attended by midwives. Over the past hundred years, in no other area of medicine have there been such dramatic advances as in the birthing of healthy babies.

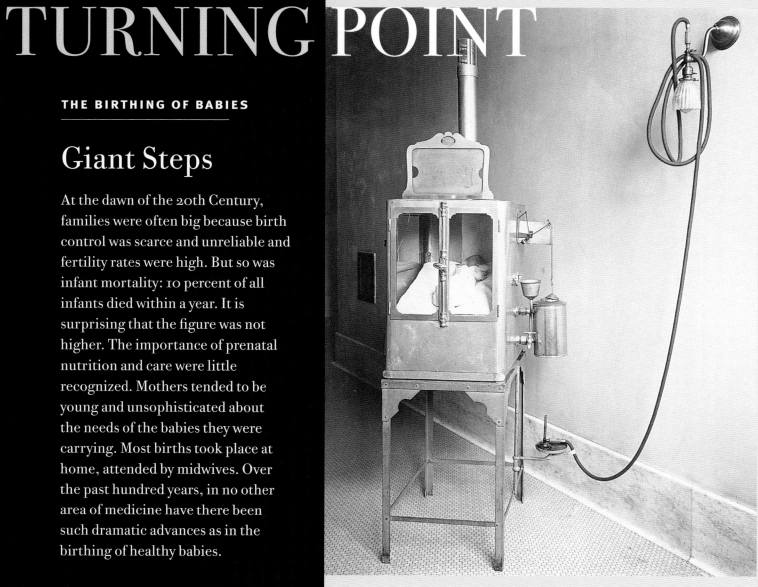

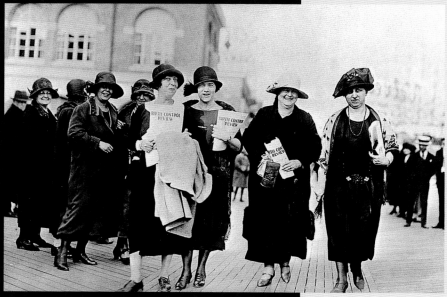

SPREADING THE NEWS

Defying laws that prohibited the release of information about contraception as obscene, these well-dressed volunteers hit the streets of New York City in 1925 to peddle copies of *The Birth Control Review*, edited by Margaret Sanger. Long before this, she had handed out condoms and diaphragms to the women of Brooklyn. As a result, her birth control clinic, the first in the U.S., was closed by authorities in 1916.

SOPHIA SMITH COLLECTION / SMITH COLLEGE

INTERVENTION

Nestled in a Sloane Maternity Hospital incubator in 1899, this tiny New Yorker was an anomaly for the period. Babies were incubated at the time to provide warmth and to stave off infection. The first American obstetric institutions were founded in Boston in 1912 to address the medical complications of labor. Until about 1939, more babies were born at home than in hospitals.

MUSEUM OF THE CITY OF NEW YORK / ARCHIVE PHOTOS

LABOR MARKET

Doctors were often reluctant to make house calls in low income areas. That left the birthing field open to midwives, one of whom operated in 1905 out of this building in a New York City slum. Some midwives also doubled as abortionists for girls "in trouble." Midwives today, highly trained in new techniques and equipment, are back in fashion.

LEWIS W. HINE / GEORGE EASTMAN HOUSE / ARCHIVE PHOTOS

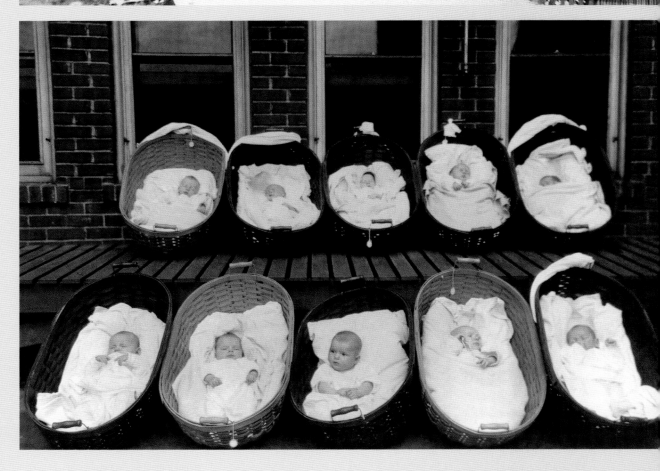

BASKET CASES

Ten bundles of joy breathed fresh air on the porch of a Minneapolis maternity ward in 1925. In cities, more affluent, better educated women increasingly preferred to give birth in hospitals. Mothers and babies stayed up to two weeks before going home. Unlike today, fathers were never allowed in the delivery room or the recovery area.

CORBIS / MINNESOTA HISTORICAL SOCIETY

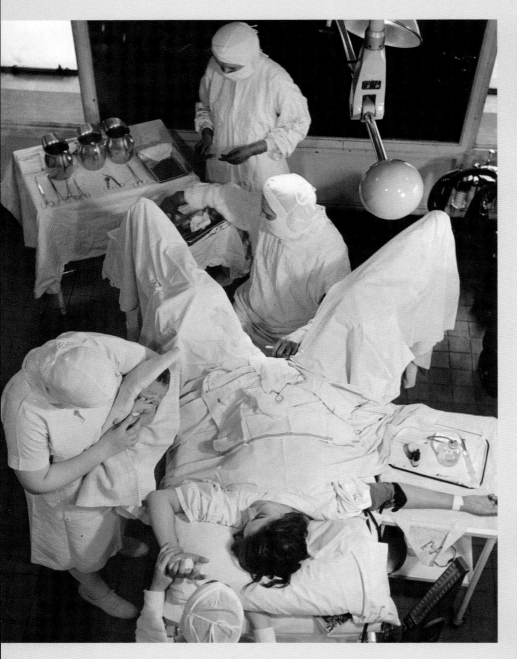

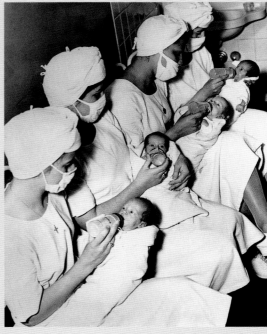

HAVE A DRINK

Nurses at Lebanon Hospital in the Bronx helped the Collins quadruplets hit the bottle. Born in May 1949, the two boys and two girls spent 22 days in the hospital before going home. Their mom, Ethel Collins, 27, was expecting triplets when she went into labor. Such multiple births were rare then. In recent times, the use of fertility drugs has increased the incidence of births of three or more babies by 400 percent.

CORBIS / BETTMANN

TWILIGHT ZONE

Subdued by exhaustion — and anesthesia — a new mother gets a first look at her baby boy in 1944. To achieve "painless child-birth," doctors at Philadelphia's Lying-in Hospital administered a combination of morphine and sedative, which sometimes affected the baby's first efforts to breathe. Today, an injection diminishes pain below the waist but leaves the patient alert.

ALFRED EISENSTAEDT / LIFE

IT'S A GIRL!

In 1954, people had to rely on dubious methods to learn their baby's sex. At a Northbrook, Illinois, lab, Jane Dill sucked on a chemical-soaked paper, then watched as a technician exposed it to another mysterious chemical. The result purportedly showed that she would have a daughter. Jane did, but even without all the hocus-pocus, the technician had a 50 percent chance of being right.

WALLACE KIRKLAND / LIFE

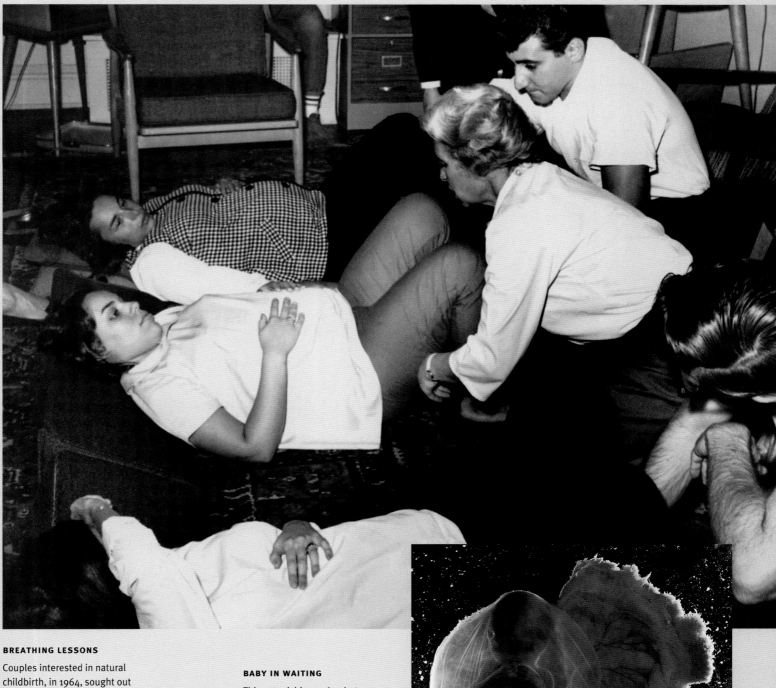

BREATHING LESSONS

Couples interested in natural childbirth, in 1964, sought out Elisabeth Bing, 49 (above, center). She was a physical therapist and the method's leading proponent in New York City. Now it's standard prenatal practice to refer parents to Lamaze classes, named for the French doctor who adapted breathing exercises he had seen used in understaffed Russian delivery rooms.

CORBIS / UPI

BABY IN WAITING

This astonishing 1965 photograph captured an 18-week-old fetus floating within its amniotic sac. Measuring 6 1/4 inches from "crown to rump", the baby was just slightly taller than its placenta (at right), the tissue that anchored it to the uterus. With another five months of normal development, the fetus would more than double in size.

LENNART NILSSON

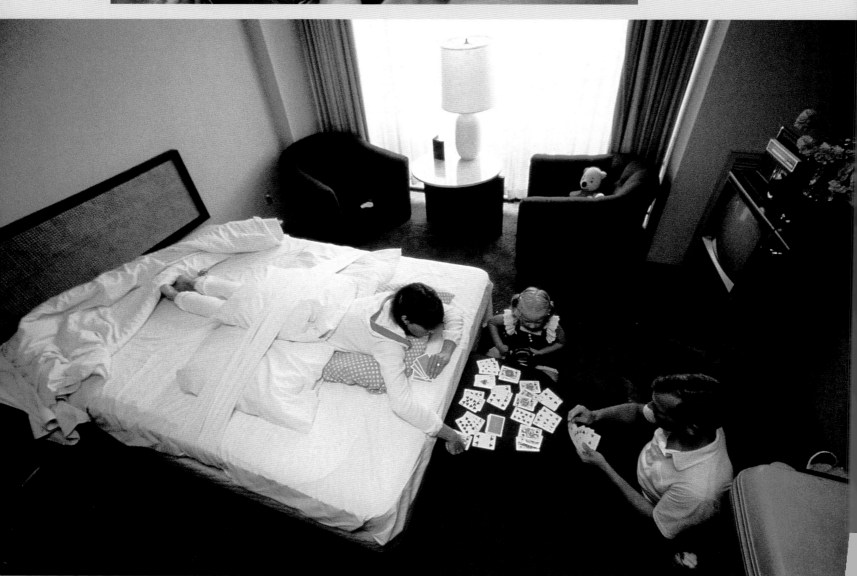

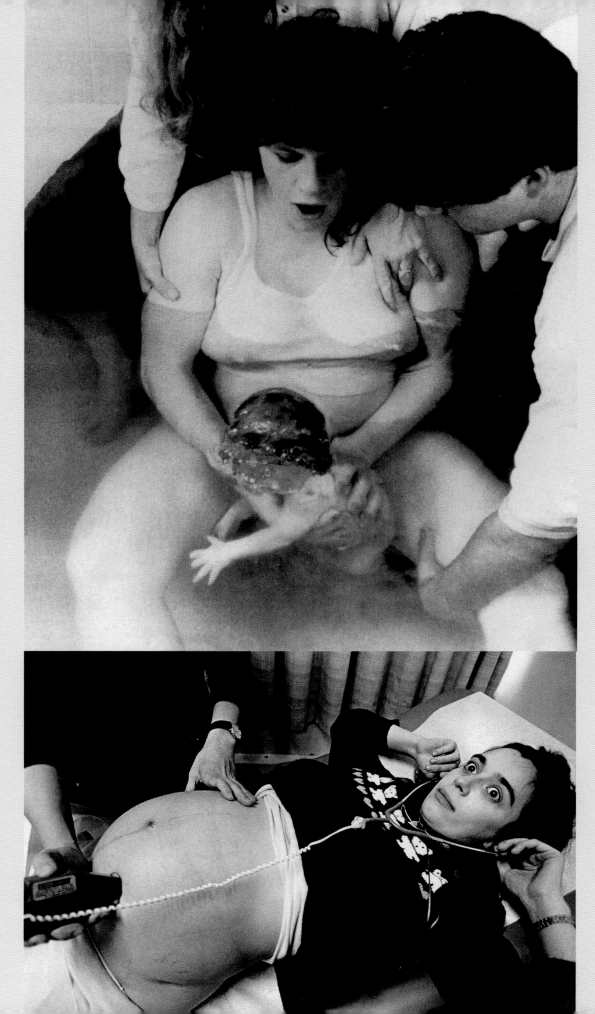

> ### MAKING WAVES

In 1990, an Upland, California, birthing pool served as a delivery room for Cindy Comstock and her baby. They were attended by husband John and sister Kami Lee Beyer. Water birthing was introduced in the U.S. in the 1980s from Russia and France. Advocates claimed that it lessened the mother's pain and gave the baby a gentler transition into the world.

CORBIS / BETTMANN-UPI

< ### THE WAITING GAME

Two of her eggs had been impregnated and then implanted in Judy Kosiba at the Eastern Virginia Medical School (now called the Jones Institute) in Norfolk, Virginia. Then her husband tied her to the bed in their hotel room lest any movement dislodge the eggs. Unfortunately, she failed to get pregnant. In 1982, the success rate was only 20 percent. In 2000, at Jones and other clinics, it was 50 percent.

ALEXANDER TSIARAS

> ### MUSIC TO HER EARS

Over an ultrasonic scanner held by a midwife, Sara Vogt, 28, of Arlington, Virginia, was hearing her baby's heartbeat for the first time, in 1991. Such sonograms were administered frequently to check on fetal health and development. They could reveal such problems as abnormal growth, ectopic pregnancy and toxemia, a form of high blood pressure.

EUGENE RICHARDS

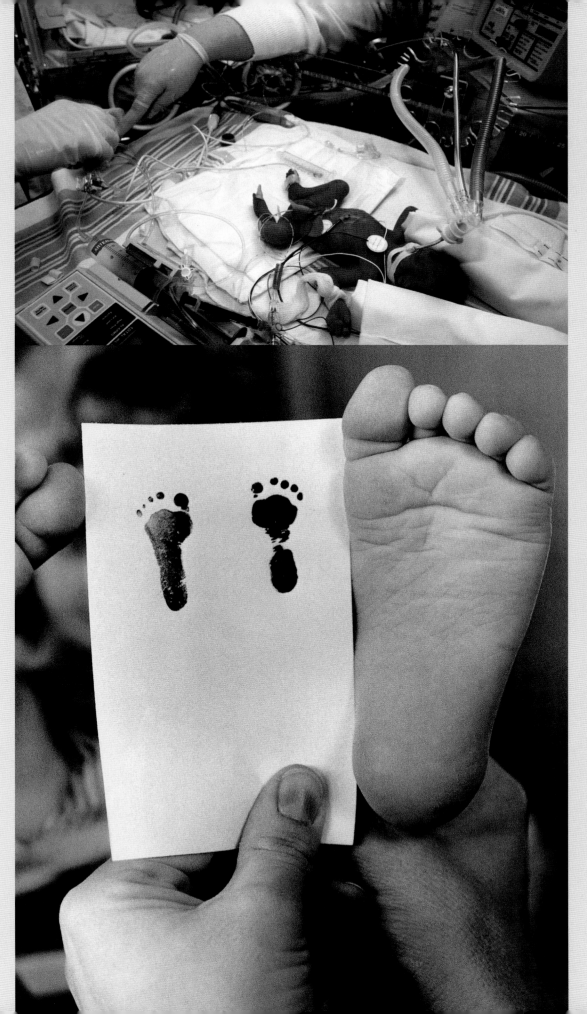

BORN TOO SOON

Medical advances allowed doctors to improve the odds for babies born as many as 12 to 14 weeks premature. At this Washington, D.C., hospital in 1992, poor prenatal care caused most preemie births. This infant (top left) survived. As did Trent Petrie, 3 (below left), whose foot dwarfed the tiny footprint taken when he was born four months early in 1985 at St. Luke's Children's Hospital in Fargo, North Dakota. At 12 ounces, Trent was the smallest preemie ever to survive at the time.

ANNIE GRIFFITHS BELT / CORBIS

REACHING FOR HELP

Tests showed that her unborn daughter had crippling spina bifida. Trish Switzer, 34, of Maryland authorized Dr. Joseph Bruner of the Vanderbilt University Medical Center to operate on the six-month fetus (right) and close a lesion on its spinal cord. The procedure had been performed successfully fewer than 50 times. At Sarah Marie's birth in 1999, the little girl was expected to walk normally.

MAX AGUILERA-HELLWEG

SIGN LANGUAGE

A hostile demonstration greeted a visit by President Clinton to Glendale Community College in California in 1996. "We are protesting illegal immigration," said Carol Keeler (inset, right), a member of a nativist group called Voice of Citizens Together. "We are not racists." Her real objection was that babies born on U.S. soil automatically become citizens.

DAMIAN DOVARGANES / AP

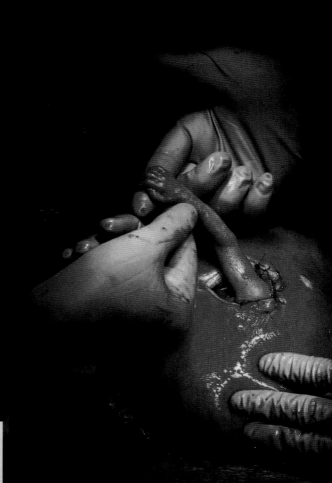

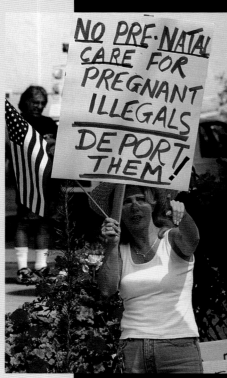

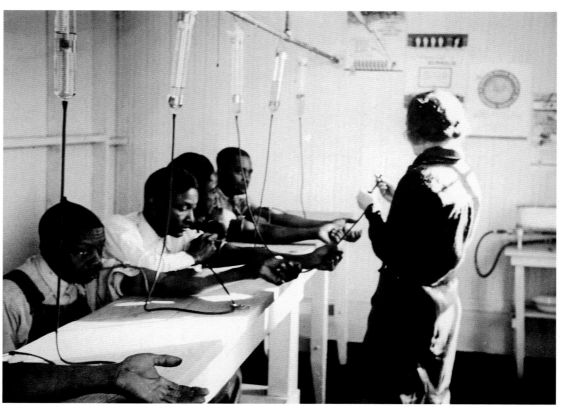

<

IT'S IN THE CAN

Processed meat went mass market in 1937 with Spam (a contraction of *spiced ham*), promoted by Hormel as an affordable lunch food. A mixture of pork shoulder and ham, it became a popular government addition to GI field rations. A contemporary if twisted homage to Spam: It's the name bestowed by the Internet generation on annoying, unsolicited e-mail.

COURTESY HORMEL FOODS CORPORATION

>

MAKING A DEPOSIT

In 1937, borrowing an idea developed in the Soviet Union, Chicago doctor Bernard Fantus established America's first "blood bank," as he called it, for public use. Two years later, local American Legionnaires (right) rolled up their sleeves to make a donation. Within a few years, blood banks had spread to the rest of the country.

UNDERWOOD PHOTO ARCHIVES

>

FRUITS OF HIS LABOR

Since personally grown produce was exempt from World War II rationing, Americans rallied to plant what were dubbed "victory gardens." Here, Harry Ducote tends a plot next to his downtown New Orleans parking lot in 1943. For four dollars and a lot of sweat, he harvested 30 pounds of tomatoes, 100 ears of corn, 150 radishes, 75 cabbages and 35 heads of lettuce.

AP / WIDE WORLD PHOTOS

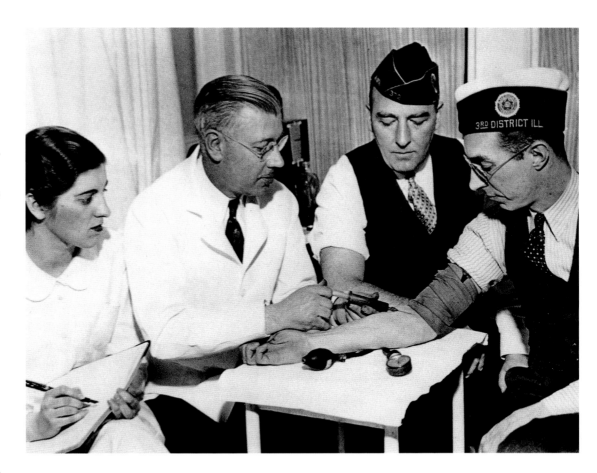

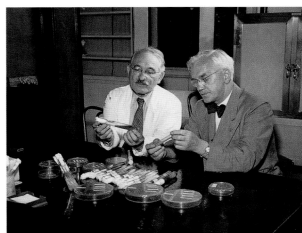

WONDER DRUGGISTS

Two giants of medicine met at Rutgers University in 1949: at right, Alexander Fleming, the British scientist who discovered penicillin in 1928, and Selman Waksman, the American who isolated streptomycin and neomycin and coined the term *antibiotic*. An experiment (below right) showed that two piglets fed aureomycin (on the right) grew larger than the three on the left. But overuse of miracle medicines on farms can lead to drug-resistant microbes.

TOP RIGHT: AP
RIGHT: AP / WIDE WORLD PHOTOS

<
TEMPORARY ORGAN

Spliced into this young patient's artery, a mechanical kidney filtered poisonous wastes from her circulatory system and fed clean blood back into a vein. Dutch physician Willem Johan Kolff designed the world's first kidney dialysis machine in 1943 and four years later donated it to Mount Sinai Hospital in New York City for short-term support of patients suffering from illness or shock.

FRITZ GORO / LIFE

THE ENEMY WITHIN

Women gained a weapon in their fight against breast cancer after radiology professor Jacob Gershon-Cohen demonstrated the benefits of X-ray screening in the Fifties. Because malignancies are visible on X-rays (the spot on right), they can be detected when they are small and curable. Women over 40 are urged to have a mammogram every year.

CHRIS BJORNBERG /
PHOTORESEARCHERS

CLOSE UP

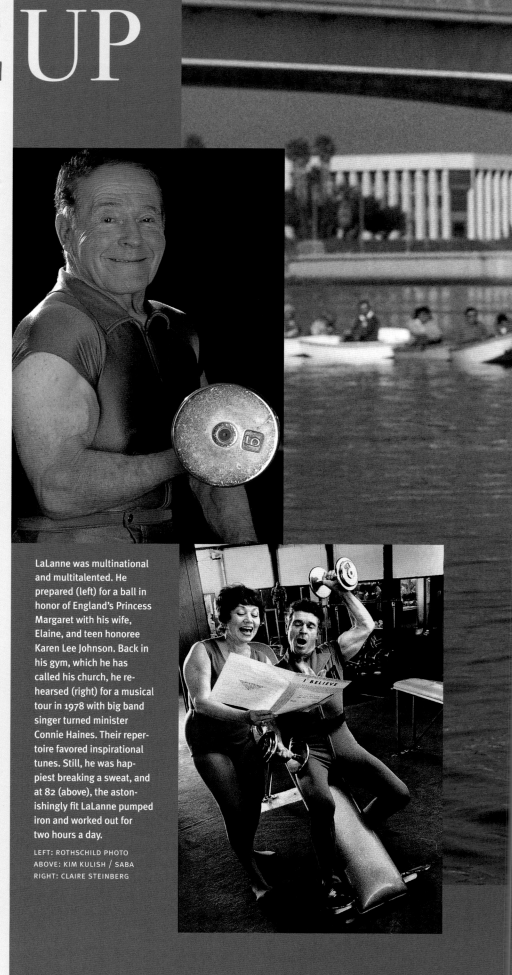

JACK LALANNE

Body Beautiful

Long before Richard Simmons and Susan Powter were born, Jack LaLanne was flexing his marketing muscle. A 90-pound weakling, he discovered his true outer self at 14, swore off processed food and began lifting weights. Within four years, San Francisco police and firemen were paying the high school dropout five dollars a month for access to the backyard gym he had built himself. Sensing a niche, he opened the country's first modern health club in Oakland, eventually expanding the business across the country. His influence over a sedentary nation broadened even more in 1951 when he went on TV; his syndicated program ran for 25 years.

LaLanne was multinational and multitalented. He prepared (left) for a ball in honor of England's Princess Margaret with his wife, Elaine, and teen honoree Karen Lee Johnson. Back in his gym, which he has called his church, he rehearsed (right) for a musical tour in 1978 with big band singer turned minister Connie Haines. Their repertoire favored inspirational tunes. Still, he was happiest breaking a sweat, and at 82 (above), the astonishingly fit LaLanne pumped iron and worked out for two hours a day.

LEFT: ROTHSCHILD PHOTO
ABOVE: KIM KULISH / SABA
RIGHT: CLAIRE STEINBERG

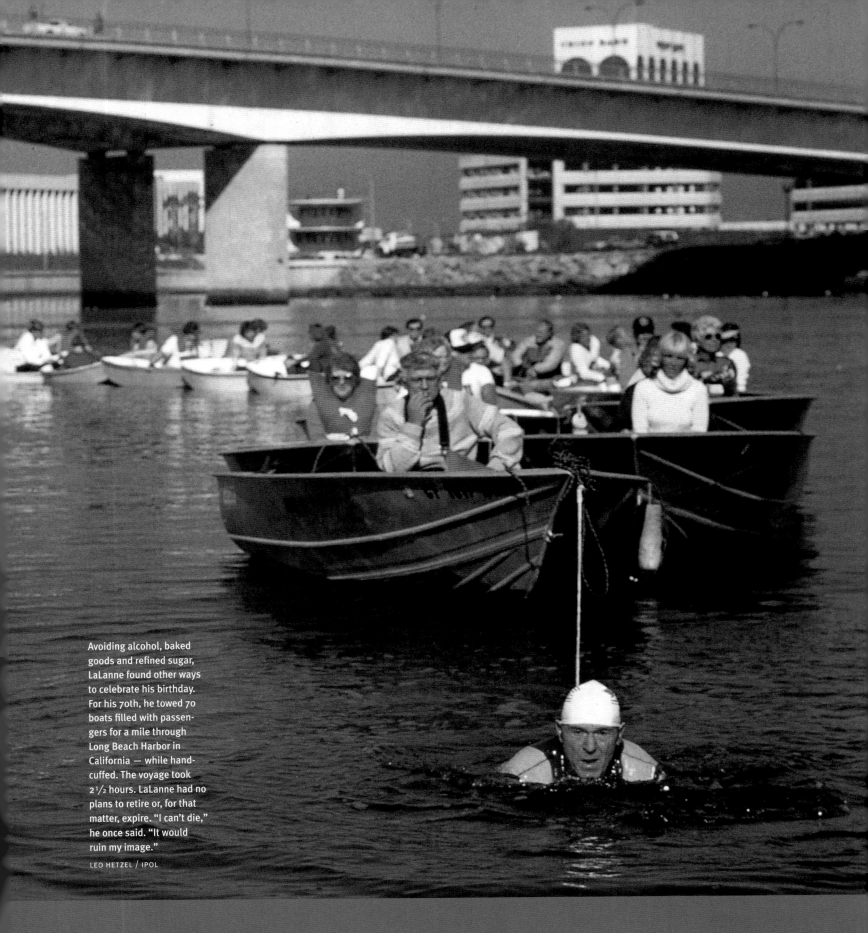

Avoiding alcohol, baked goods and refined sugar, LaLanne found other ways to celebrate his birthday. For his 70th, he towed 70 boats filled with passengers for a mile through Long Beach Harbor in California — while handcuffed. The voyage took 2½ hours. LaLanne had no plans to retire or, for that matter, expire. "I can't die," he once said. "It would ruin my image."

LEO HETZEL / IPOL

< LOOK MOM . . .

Adding fluoride to public water systems began in 1945 but was not always met with approval. In 1961, Seattle radiologist Frederick B. Exner, 60, contended that tiny amounts of the chemical could cause damage to teeth (left). Nonetheless, most cities went ahead with fluoridation. The result: a nationwide reduction in cavities among kids and adults.

ROY SCULLY / THE SEATTLE TIMES

FROZEN IN TIME

Although Clarence Birdseye founded the frozen-food industry in 1924, the market would not develop until refrigerators became common in the Thirties. After that, many companies entered the cold war over housewives' dollars. In 1962, Libby, McNeill & Libby (below) packaged green beans at its Sunnyvale, California, plant; the produce was exposed to 30-mph gusts of air chilled to −40°.

ART RICKERBY

> SMOKE IN HIS EYE

In 1963, a year before the surgeon general's warning, these executives were taught not to stop, but to smoke smart. A cigar manufacturer, Stephano Brothers, gave lessons in how to enjoy a stogie without inhaling. The forlorn student at right had flunked. Smoking was offered as a sophisticated habit that would help these men advance their careers.

GORDON TENNEY / LIFE

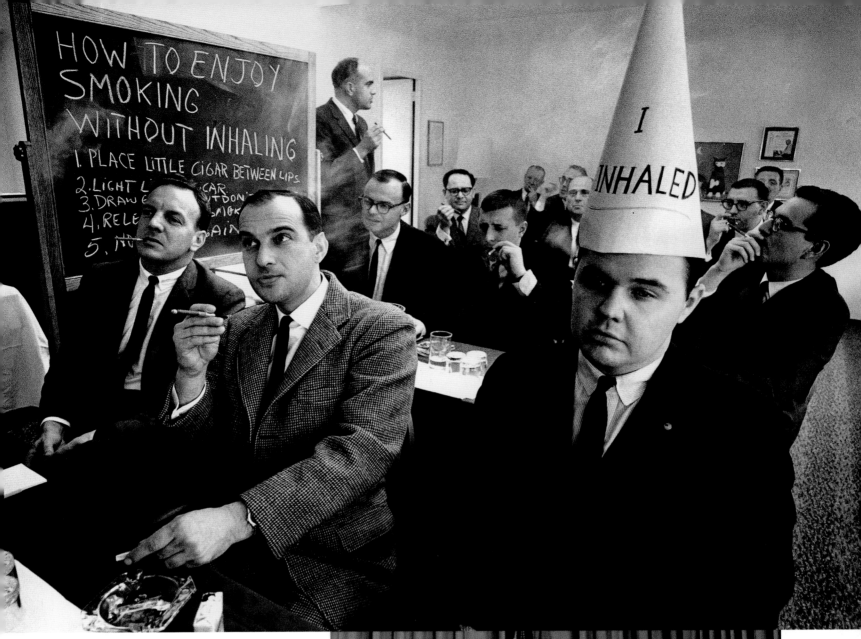

>

MEDICARE KICKS IN

With the encouragement of Vice President Hubert Humphrey, former president Harry Truman (who proposed the idea in 1945), Ladybird Johnson and Bess Truman, LBJ used 72 pens to sign the Medicare bill in 1965. It was national medical insurance, which for years had been stigmatized as "socialized medicine," for those over age 65. Medicaid was also set up to cover the poor and disabled.

CORBIS / BETTMANN

<

BIRDS OF A FEATHER

No doubt Dave Thomas of Wendy's (left) modeled himself after Colonel Sanders of Kentucky Fried Chicken — fast food, white suits and all. Thomas had a KFC franchise in 1964 when he accepted this trophy from the founder. In 1969, he sold his restaurants and opened a hamburger joint named for his daughter. Today KFC has more than 10,800 outlets, Wendy's more than 5,500.

COURTESY DAVE THOMAS

>

BEST OF BREED

Farmers — and the rest of the world — reaped the benefits of Norman Borlaug's Nobel Prize–winning work. On his farm in Mexico, the American scientist, 56 (inset, with wheat), bred disease-resistant grain to maximize yields. Results were especially dramatic in Third World countries like the Philippines, where sturdier rice hybrids (right, brighter green) produced more kernels.

RICHARD SWANSON
INSET: ART RICKERBY / LIFE

<

LESS IS MORE

Relying on a diet plan from the New York City Board of Health and weekly gatherings with other overweight women, she dropped 72 pounds (from 214) by 1962. Five years later, a still-svelte Jean Nidetch, 43, showed her "before" picture as she spoke to other happy losers. Her Weight Watchers has 25 million clients worldwide and estimated annual sales of $400 million.

MARTHA HOLMES

CLOSE UP

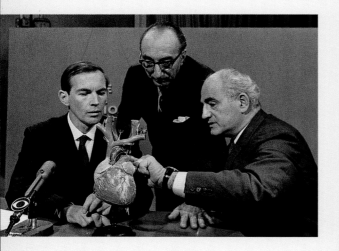

THE HUMAN HEART

Healing Hands

To poets, it's the soul's home. To doctors, the heart is a pump, and like any piece of equipment, it is prone to failure. When that happens today, patients have options unimaginable at mid-century. Erratic heartbeats can be regulated, clogged arteries bypassed and, most astonishingly, worn-out organs replaced. After South African surgeon Christiaan Barnard, 44 (above, left), performed the first human-heart transplant, in 1967, he talked about the operation with American cardiac specialists Michael de Bakey, 59 (above, center), and Adrian Kantrowitz, 49. Early transplant patients rarely survived for long, but by the 1980s, antirejection drugs were extending lives significantly.

To speed up Rose Cohen's heart in 1960, doctors wired the Brooklyn housewife to an early battery-operated pacemaker, worn first on the outside, then implanted (right). The second model allowed Cohen to swim again and take up bowling. In 1982 (below), Barney Clark, 61, was visited by his wife, Una Loy, while tethered to an artificial heart machine. Clark was not a transplant candidate because of his age; the cutoff was 50. Though the machine kept him alive, Clark, despondent at his immobility, died four months later of "multi-organ failure."

ABOVE LEFT: CORBIS / BETTMANN
RIGHT: YALE JOEL / LIFE
BELOW: UNIVERSITY OF UTAH HEALTH SCIENCE CENTER

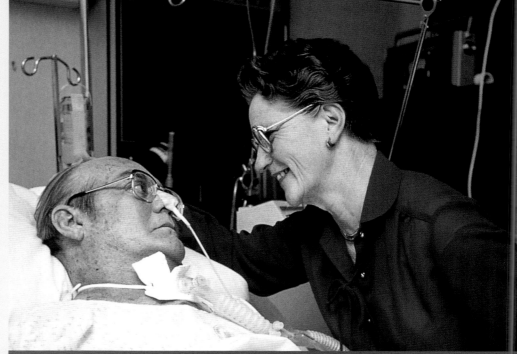

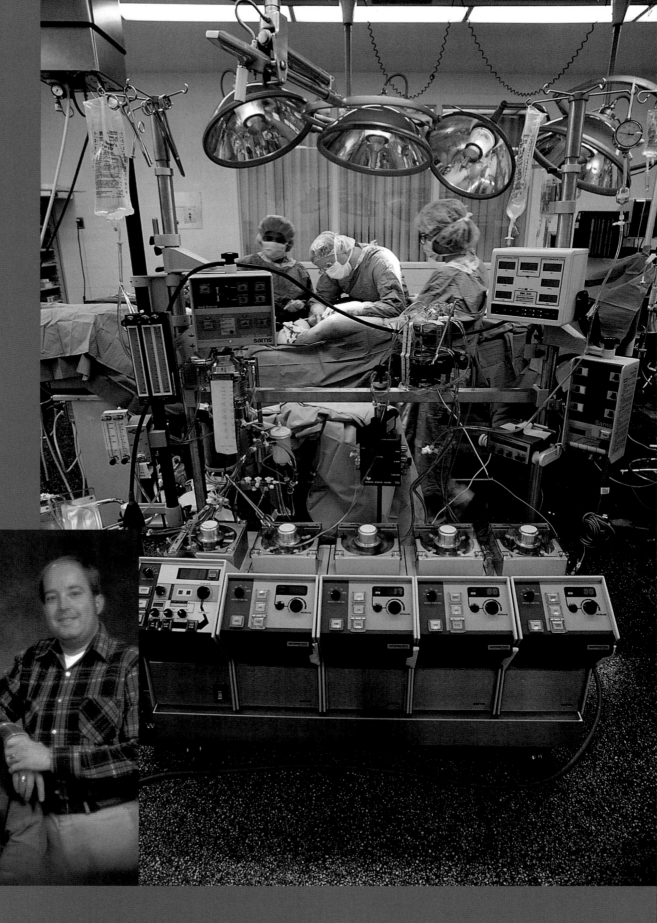

Introduced in 1967, coronary bypass — taking veins from the leg and sewing them in place of clogged blood vessels near the heart — was common by 1988 (at right, bypass surgeons at work in Detroit's Sinai Hospital). Meanwhile, heart transplants became more common: an estimated 2,300 a year in the U.S. Two of the most successful cases involved brothers, Bruce, 30 (left), and Randy Dailey, 34, of Nashville. As teenagers with dim prospects because of enlarged hearts, they received donor organs in the late 1970s. In early 2000, both were fine.

RICHARD HIRNEISEN /
MEDICHROME
INSET: COURTESY DAILEY FAMILY

<

BY SEA AND LAND

In Hawaii, participants in the 1984 Ironman — the nation's most grueling triathlon, first held in 1978 — had to complete a 2.4-mile swim, a 112-mile bike ride and a marathon in one day. Originally limited to men, the event was opened to women in 1979. Corporate sponsorship has raised the winner's jackpot to $250,000.

KEN SAKAMOTO / BLACK STAR

>

RIGHT TO DIE

A significant but sorrowful precedent was set in 1976, when attorney Paul W. Armstrong (in back) won the right for Joseph Quinlan and his wife, Julia, to take their comatose daughter Karen Ann off a respirator. The 22-year-old factory worker had fallen into a permanent vegetative state in 1975 after taking a mixture of alcohol and tranquilizers. She died in 1985.

AP

>

IN THE MOOD

Approved by the FDA in 1987, Prozac was hailed as the ultimate feel-better drug without side effects. Doctors prescribed it for conditions ranging from depression to compulsive behavior; managed care plans authorized it in lieu of costly psychotherapy. Doubts about Prozac emerged in 1990 when one patient said to be under its influence committed murder and another tried to kill herself.

PHOTO ILLUSTRATION BY
BUTCH BELAIRE

A NEW MACHINE AGE

R2D2 to the OR! Before a cardiac procedure at Ohio State University in March 2000, surgeons inserted tiny telerobotic arms into the patient's chest to test whether the machines could cut with more precision than the doctors. In Germany, complete coronary bypass operations have been done by robots. Their use in brain and eye surgery also seems promising.

JACK KUSTON / PHOTOJ.COM

GEEK FRUIT

Thinking outside the box, scientists around 1983 began introducing the DNA of one fruit or vegetable into a different species, changing its growing period or resistance to disease and pests. To dramatize the potential of genetic engineering, here is a digital squaring of a strawberry, orange and apple. Supporters called it simply the equivalent of crossbreeding. Opponents called the result Frankenfood.

VICTOR HABBICK VISIONS /
SCIENCE PHOTO LIBRARY /
PHOTORESEARCHERS

ARRESTING A KILLER

Magnified 1,000 times by a 3-D microscope, a green-tinted sample of HIV, the virus that causes AIDS, advanced toward the blue-shaded nucleus of a human cell. This scene, captured in 1999 at the Salk Institute in California, could help researchers come up with new strategies for fighting the lethal virus. Drugs had already greatly helped patients who could afford them.

DAVID MCDONALD AND THOMAS
HOPE / THE SALK INSTITUTE

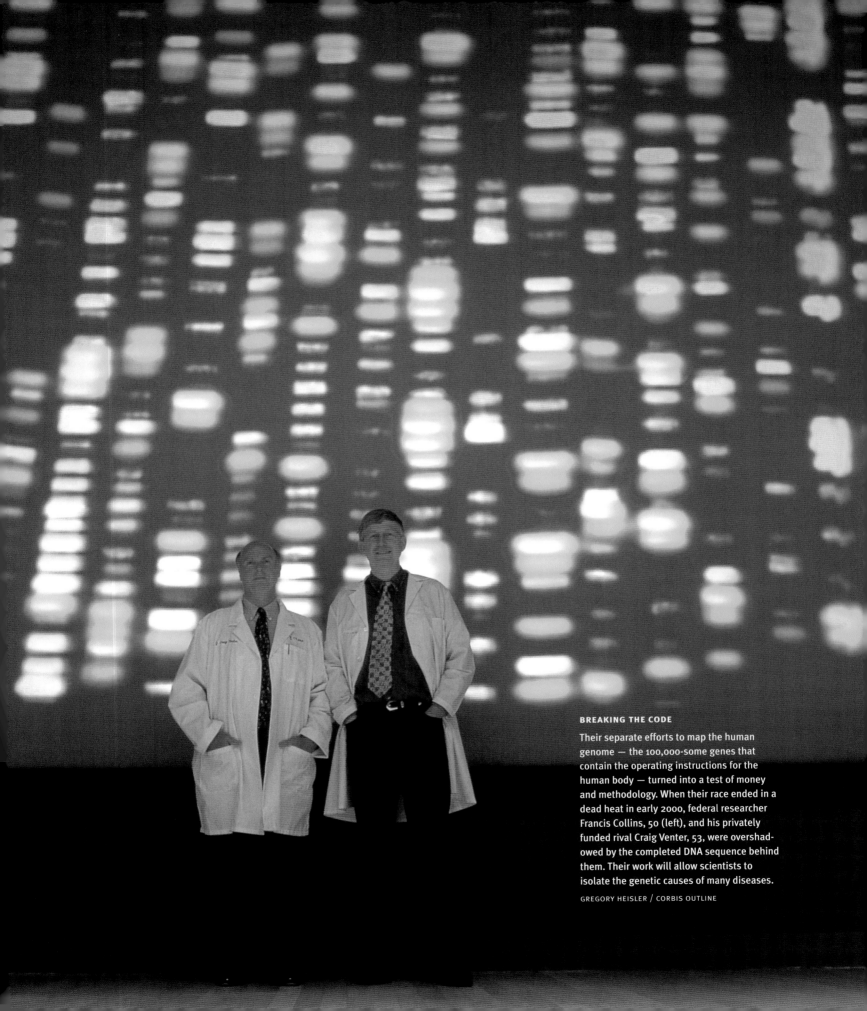

BREAKING THE CODE

Their separate efforts to map the human
genome — the 100,000-some genes that
contain the operating instructions for the
human body — turned into a test of money
and methodology. When their race ended in a
dead heat in early 2000, federal researcher
Francis Collins, 50 (left), and his privately
funded rival Craig Venter, 53, were overshad-
owed by the completed DNA sequence behind
them. Their work will allow scientists to
isolate the genetic causes of many diseases.

GREGORY HEISLER / CORBIS OUTLINE

we the people

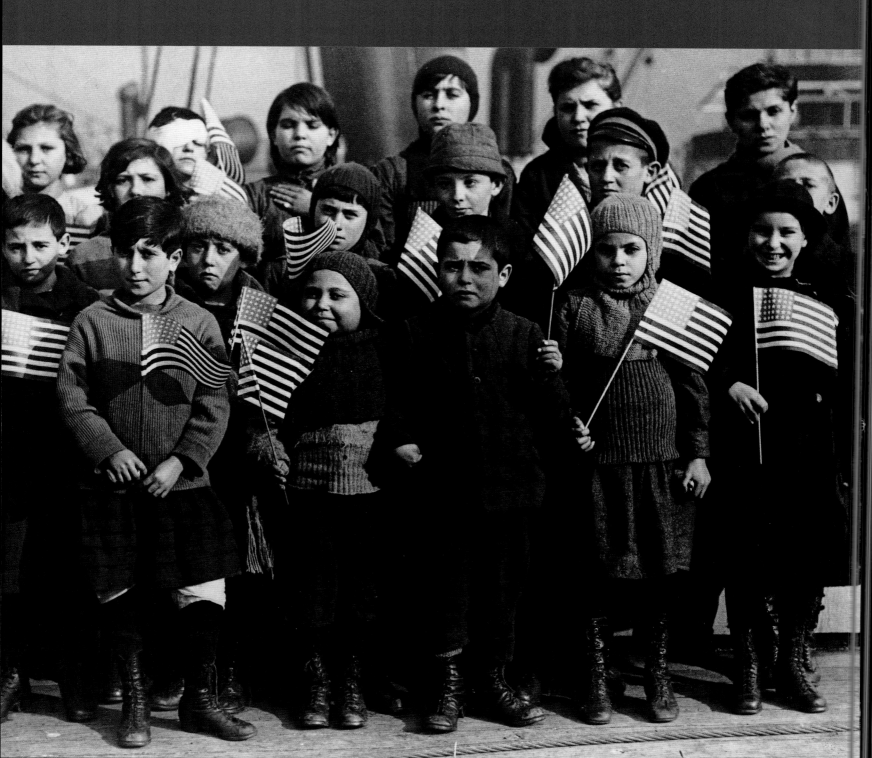

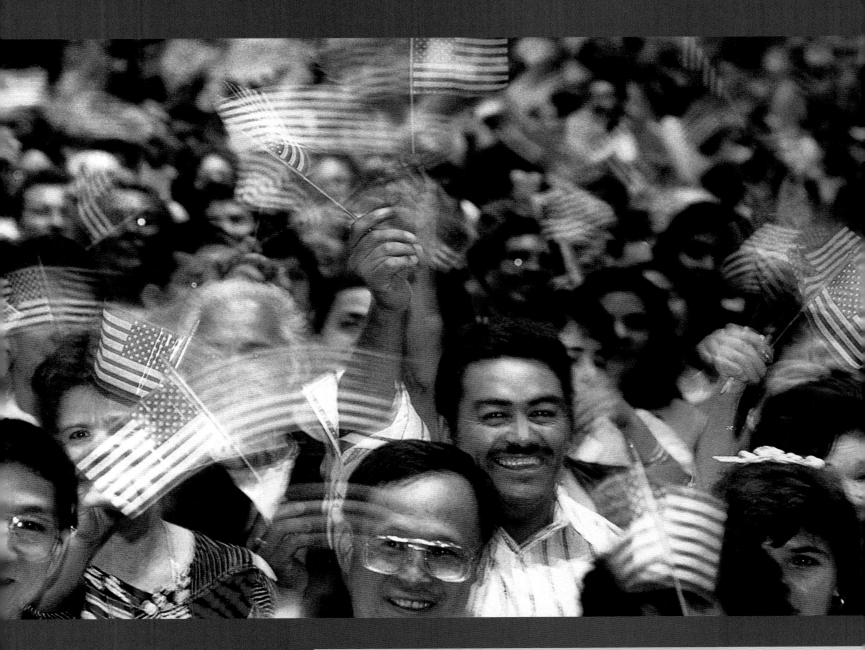

Hooray for the red, white and blue! These Eastern European orphans from World War I were given flags to wave — some dubiously — as they approached the U.S. in 1921. More than 800,000 immigrants arrived that year. Newly naturalized citizens in Los Angeles were more enthusiastic as they joined the million-plus people who became Americans in 1996.

LEFT: THE AMERICAN JEWISH JOINT
DISTRIBUTION COMMITTEE
ABOVE: FRANK WEISEL / AP

A NEW CHORUS OF CULTURES

Black, White and Chaotic Color

BY RICHARD RODRIGUEZ

IT IS A SPRING DAY — that makes no differ-ence — in the 1950s, in Sacramento. I am seven years old. I am standing with my class-mates, outside. We are posed for our class picture. My face is the exception in the as-sembly. Otherwise, I am one among others; compo-sition is by height. I am the only one reminding him-self not to smile. My reticence is due to what I know about the future. What I know is that the instant the camera shutter opens and our young lives are turned upside down, I will be the only one translated to a positive. Chemicals will do the rest.

Among my classmates I will be the smudge — not because I moved, but because I am dark-skinned. Only my smile will show. The other thing I know is that the eventual photograph will already be the past — a future regret, perhaps, but not serious. It will be easy for my mother to spot me when I take the photograph home. She will sigh: I would know that smile anywhere.

The human race has some need for anniversa-ries. We compose ourselves as classes, marriages, centuries — comprehensible romances of fixed du-ration — to mark our inclusion and, eventually, our deliverance. I am the 20th Century.

To borrow the brilliant line from Sondheim: *If it happened, I was there.*

What is memorable? Many of my personal, my most sacred memories are borrowed — they must be; I wasn't there — from stories I've heard, pictures I've seen. They are nevertheless boxed in some sort of nucleic acid and labeled "memories." My memo-ries. I recall them. At my age, I do not mistrust, but only cherish. Whereas I have photographs of myself in places and in company with persons I cannot re-member at all.

So I will say, in the artificial spirit of fin de siè-cle: I was born midway in a century that begins in black and white and ends in color. By century's end, my brown skin would no longer be eccentric in a school photograph. There are many Mexican kids at Sacred Heart School now, and Vietnamese and African-Americans. Nowadays, probably, a child of color sees herself in color as color, rather than as a "darkening rod," which is the term I coined for myself, behind my eyes, in high school, facing yet another camera.

In the late 1950s, nearly everyone I knew had a white stove, a white refrigerator. (Hygienic.) Every-one I knew had a black telephone. (Not a toy.)

It is difficult to know to what extent technology, by lagging behind the real light of day, or by exceed-ing the real light of day, composes or restricts our memory.

Despite the number of times I have been to New York, I do not think I have ever reached Manhattan. The city is only real for me as it approaches the

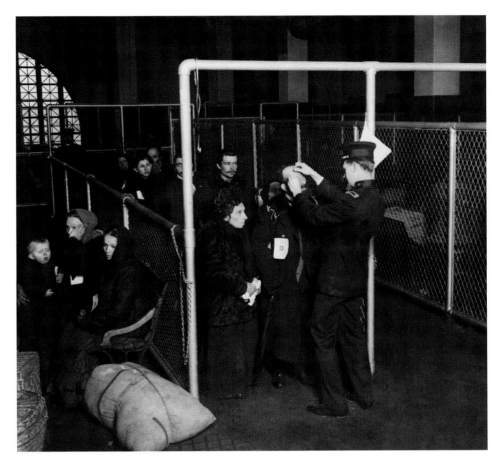

Affluent immigrants from the Old World disembarked in New York with ease. Those in steerage went to Ellis Island for tests like this search for eye disease. If it was found, the poor soul was sent back.

CORBIS / UNDERWOOD & UNDERWOOD

daydreams of my youth, as real as its black-and-white capture in the magazines and newspapers and television shows of the Fifties. I cannot imagine, I don't want to reimagine Leonard Bernstein in color or Grand Central Station or the verse of Auden or the Great White Way.

Already in the 1950s, when I surveyed America in the pages of *Life*, I saw color. I honestly cannot remember if the colors seemed vivid to me at the time or if they seemed washed out and primitive, as they seem to me now, issues bundled with twine or in bins at secondhand stores. Newspaper photographs of the era were black and white. Newspapers portrayed themselves then as serious business.

The world that appeared on my family's small Emerson television was only black and white. Sacramento had two channels. There were blanks in the broadcasting day. During such blanks, a tone chart of grays and blacks would appear on the screen to hold the signal. Otherwise, snow.

The drama of race in America was similarly described by a primitive chart: similarly held in abeyance. There was black. And there was white. Otherwise, chaos.

Our Emerson was not technically capable of any more sophisticated deliberation. In the movies there were stories of Negroes born light-skinned who "passed" as white. This would have blown the tubes of our Emerson, though it did not require a precocious child to recognize the oversimplification, the poverty of language of America on this point. Most "Negroes" I saw as a child were, in truth, brown; some were lighter than me.

On their immigration papers, my Mexican parents were officially described as "white." (I asked.) The encyclopedia I consulted in those years (in which there was no color beyond Art, Birds' Eggs, Precious Stones, Flags of the World and, for some reason, Poisonous Plants) corrected this. My family was of the Mongoloid race — "from saffron-yellow to dark brown." My uncle from India, who married my aunt, was twice called nigger by strangers downtown. The encyclopedia said my uncle was Caucasoid — "pinkish white to brown." The encyclopedia went on to say that the world had 2,666,000,000 people, none pure.

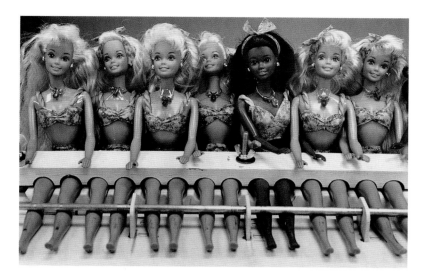

Interracial Barbies underwent factory testing in 1993, the same year that a Native American version hit stores. Mattel introduced a black playmate, Christie, in 1968 and now has Kenyan, Chinese and Eskimo versions.
ACEY HARPER

My introduction to American racial theory came on the late movie, after the 11 o'clock news. In the musical *Showboat*, the sheriff boards *Cotton Blossom* to declaim, "One drop of Negro blood 'sall it takes. . . ." To make a Negro.

I looked down at my own arm.

Experts, pasters of electrodes, tell us that humans, like cats and dogs, butterflies, even parakeets, do not dream in color. (I remember having seen yellows and blues in my sleep. Are these simply neurological cognates of yellows and blues?) Watching television, we had no trouble distinguishing blood from blueberry pie, even though blood, Ricky Ricardo's hair, Zorro's cape, Lassie's nose — all were as black as Khrushchev's shoe. On Sunday nights, we felt the advent of color. *The Wonderful World of Disney* was tantalizingly awash in theoretical hues. We knew Tinkerbell's sparkling wand was transforming other living rooms. Not yet ours. And on *The Ed Sullivan Show*, Elvis Presley's act managed to be astonishingly mulatto — a redneck impersonation of black blues. Change was coming.

Domestically, by the late Fifties and early Six-ties, the medium met its message: The focus was the Negro civil rights movement. I watched it every night at six o'clock. I was aware, as never before, of "watching history." I attended to the Protestant hymns; the deep, wet voices; the sweating faces (black faces flecked with white); processions perfectly composed. The German shepherds, state troopers, the white water from fire hoses aimed at serious men and women who linked arms to withstand an assault.

Tinkerbell was nowhere in sight, and yet, by the time American Negroes had defiantly translated themselves into English as "black," making a virtue of the limits of technology, other Americans — not black — began to colorize by analogy: feminists, Gray Panthers, Brown Berets, pink triangles.

Rosa Parks seats herself at the front of a gray bus. Selma is a black-and-white day; the sky is white. Martin Luther King Jr. is ashen. And George Wallace — in white mask with jet eyebrows — takes a last stand against color. But by the time the stoic Negro movement moved north, color had entered into American memory. Beneath her widow's veil, Coretta Scott King is brown.

The 20th Century is divided in its memory.

Roger Moore and Liv Ullman expected to give 1973's Best Actor Oscar to Marlon Brando for *The Godfather*. To protest bias against Native Americans, Brando sent Sacheen Littlefeather, 26, to refuse the award.
CORBIS / UPI

There are two potent images of dawn. The first, a black-and-white image, is the gray "new dawn" of the Russian Revolution; crowds in winter, tracks in snow. The second dawn, the American image, is the second reel of *The Wizard of Oz*: Dorothy steps out of the whirlwind into color. The American Century flickers fitfully in our memory — the pink suit of Jacqueline Kennedy, tongues of flame in Watts. Then, in the mid-Sixties, when my family buys our first color TV, a conflagration: A lime and magenta war burns upon the screen day and night. Every memory of Vietnam is in color. Telephones turn red, refrigerators green, ovens yellow. The federal government rewrites immigration laws that had discriminated against Asians.

In the 1970s, Richard Nixon, the dark man of American politics, who had made his career by forbidding red, became our first colorized president. Because of the Nixon administration, and during the era of affirmative action, America for the first time described itself as comprising not only black and white and Native American, but also "Hispanic" and "Asian." The Latin South and the Far East were bureaucratically impressed upon the American imagination. Thus did five-color separation revolutionize the memory of America, even before color photographs appeared in the pages of daily newspapers.

The astonishing idea that America is a global society — the first in history — is an easy one for today's seven-year-old. By the 1990s, American teenagers were dying their hair green, and Michael Jackson, a sexual and racial chameleon, made a video of his face morphing from male to female to Asian to male to Mexican — a pop resolution of the future. (Technology once again pulls ahead.)

By century's end, we were not yet free of black-and-white history. Our prison population was disproportionately black. But outside the prison of our memory stood a graceful, new American ideal — a

A bilingual sign near San Ysidro, California, in 1993, warned motorists to beware of illegal immigrants from Mexico and Latin America who sometimes dashed across highways to escape authorities and enter the U.S.
STEVE RUBIN / THE IMAGE WORKS

brown man on a green field. Tiger Woods refused either/or, choosing instead Thai-African-American-Indian.

"You in the back," ordered the photographer.

I won't smile. He could not have known the implication of asking me to smile. Everyone turned.

O.K. I smiled. In spite of myself, I smiled, standing there that day, a day now completely irrecoverable beyond the edges of the creased photograph I hold in my hand. Somewhere in America my parents are young. Dr. King is alive. Jacqueline has not yet met Jack. *I Love Lucy* is on tonight.

The boy was right. The camera did render him a smudge, more a fingerprint than a face. Still, he had no idea that this photo might one day make him smile.

A journalist and essayist, Richard Rodriguez has written Hunger of Memory: The Education of Richard Rodriguez *and* Days of Obligation: An Argument with My Mexican Father. *With the forthcoming* Brown, *he will complete a trilogy on class, race and ethnicity in America.*

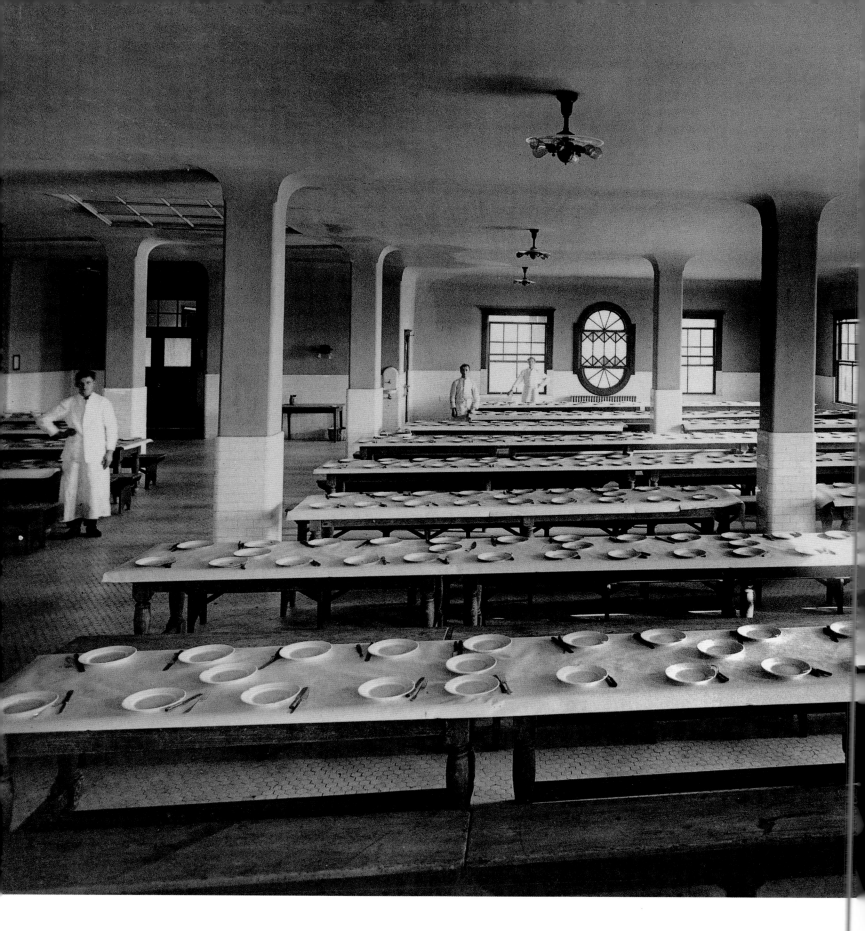

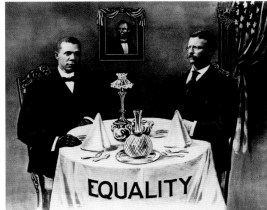

>

TABLE FOR TWO

Abraham Lincoln had entertained black visitors in the White House, but back then there was a war on. When President Teddy Roosevelt invited educator Booker T. Washington for a meal in 1901 (served by white waiters), the tête-à-tête ignited controversy. TR was surprised. Six months later, he hosted an interracial reception that attracted no attention at all.

CORBIS

>

A WELCOME FOR SOME

Despite the sentiment pictured in this early 1900s greeting card, many Americans feared immigrants, blaming them for rising crime and falling wages. Laws passed by Congress limiting access to the U.S. (paupers and idiots were among the "undesirables") tragically denied refugee status to millions of Europeans fleeing World War II.

KENNARD / NEW YORK BOUND BOOKSHOP

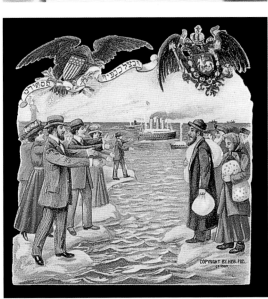

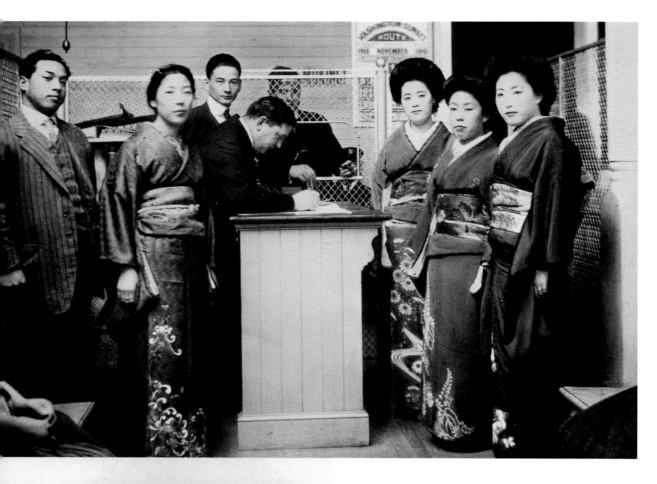

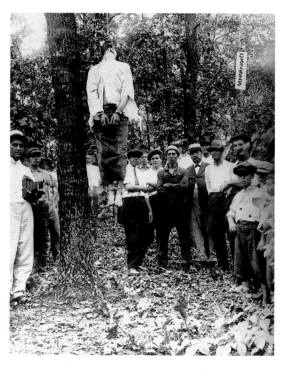

PACIFIC OVERTURES

Japanese laborers allowed into the U.S. after 1907 wanted wives. So they picked them from back-home photographs, and the "picture brides" (left) began arriving at Angel Island, the isolated, notorious San Francisco immigrant center (below left). The Immigration Act of 1924 halted the bizarre trade in young Japanese women.

COURTESY CALIFORNIA STATE PARKS (2)

EINSTEIN ARRIVES

On his first trip to the U.S., Albert Einstein, 42, rode in a 1921 New York motorcade to raise funds for Hebrew University in Jerusalem. Twelve years later, the distinguished physicist fled newly Nazified Berlin. He became a U.S. citizen in 1940 only a few months after he had signed a famous letter to FDR urging this country to develop an atomic bomb. We did, and it won World War II.

BROWN BROTHERS

THE HANGING TREE

An Atlanta jury found pencil-factory manager Leo Frank guilty of murdering a 14-year-old former employee, Mary Phagan. Governor John Slaton had his doubts and commuted Frank's death sentence in 1915. An enraged anti-Semitic mob broke into the jail and lynched him. After a surviving witness implicated another man in 1986, Georgia pardoned Frank.

CORBIS / UPI

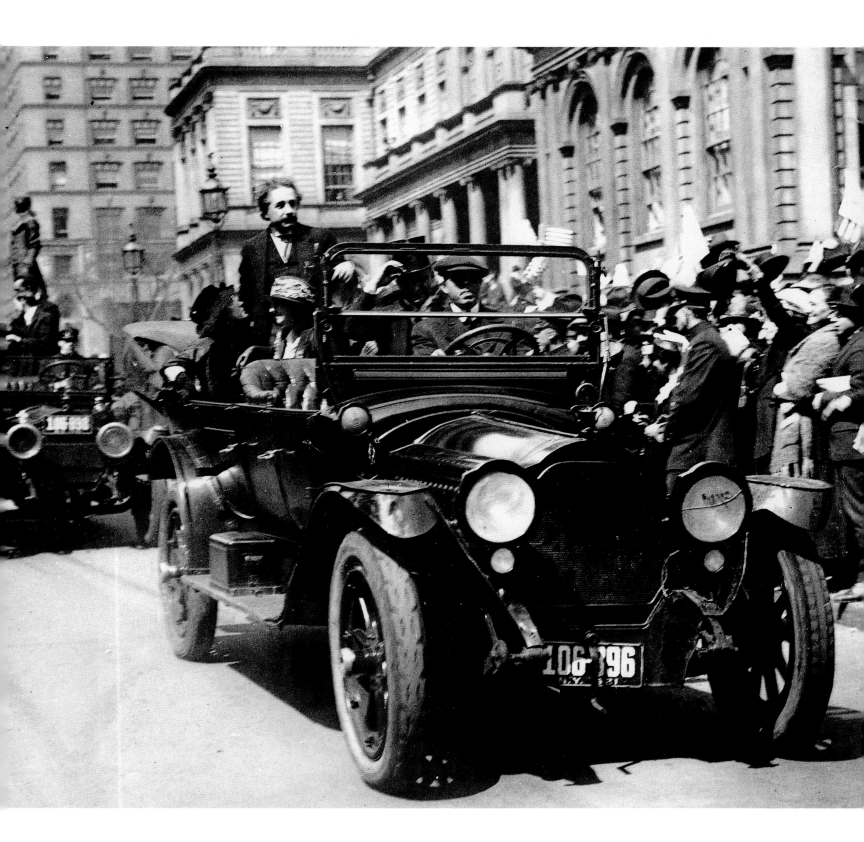

CLOSE UP

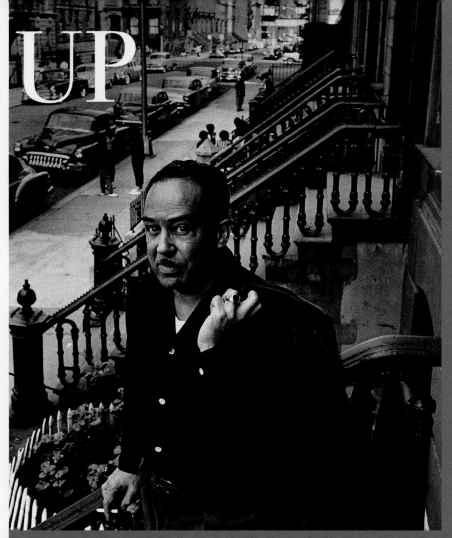

Renaissance Man

To fill vacancies, in 1901, white landlords in upper Manhattan began renting apartments to black tenants (at significantly higher rates). In two decades, that neighborhood, 55 city blocks known by the Dutch name of Harlem, became the largest African-American community in the U.S. Among its ranks: writers, performers and activists eager to celebrate their heritage without apology. Their movement was called the Harlem Renaissance; its poet laureate was Missouri-born Langston Hughes. His style was plain and tough. "I, too, sing America," he wrote, "I am the darker brother. They send me to eat in the kitchen when company comes."

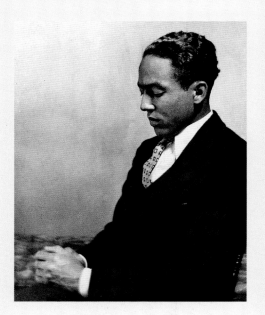

Hughes (left, in 1930) came to New York to attend Columbia in 1921. Dropping out the next year, he supported himself as a busboy in Washington, D.C. (right). One day in the restaurant, he gave some writing samples to American poet Vachel Lindsay. With Lindsay's help, Hughes graduated from college and soon published two verse collections and a novel. By 1958, Hughes (above, standing in front of his Harlem town house) had written for the stage, opera and television. After his death in 1967, his home became a New York City landmark.

LEFT: NEW YORK PUBLIC LIBRARY / SCHOMBURG CENTER
ABOVE: ROBERT KELLEY / LIFE
RIGHT: CORBIS / BETTMANN-UPI

As he wrote about the black experience in America, Hughes grew increasingly radical. He traveled to Haiti and the Soviet Union to befriend the working class. In Spain, in the late 1930s, he wrote about the Civil War from the leftist Republican side. Hughes (at right, second from left) met there with a soldier in the all-American Abraham Lincoln Brigade, a Spanish officer and Louise Alone Thompson Patterson. She was a Harlem-based civil rights and labor activist. Her nickname: Madame Moscow.

AP / PATTERSON FAMILY

For "Strollin' Twenties," a 1966 Emmy Award–winning CBS-TV special, Hughes wrote a script about the lively Harlem he had moved to 40 years earlier and loved. "Every Sunday was Easter Sunday," he recalled. He joined the stellar cast in the studio, from left, back row, Sidney Poitier, Hughes, Harry Belafonte (who produced the show), Joe Williams, Nipsey Russell; front row, George Kirby, Gloria Lynne, Diahan Carroll, Paula Kelly and Duke Ellington.

ROWLAND SCHERMAN

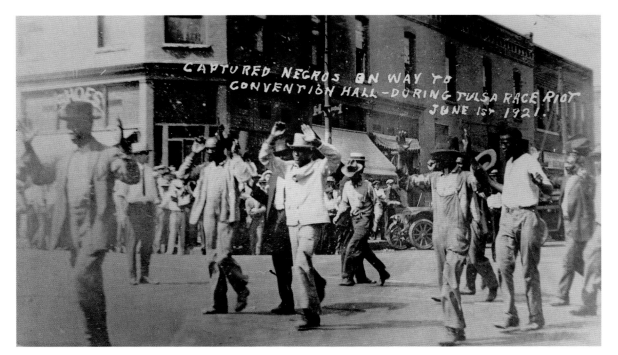

WHITE RAGE

These Tulsa men were rounded up by the National Guard for their own protection in June 1921 after a white mob had burned a thriving, 35-block business district run by blacks. The riot was sparked by rumors that a black shoeshine boy had attacked a white female elevator operator. In 1997, Oklahoma got around to recommending that victims and heirs be compensated.

TULSA HISTORICAL SOCIETY

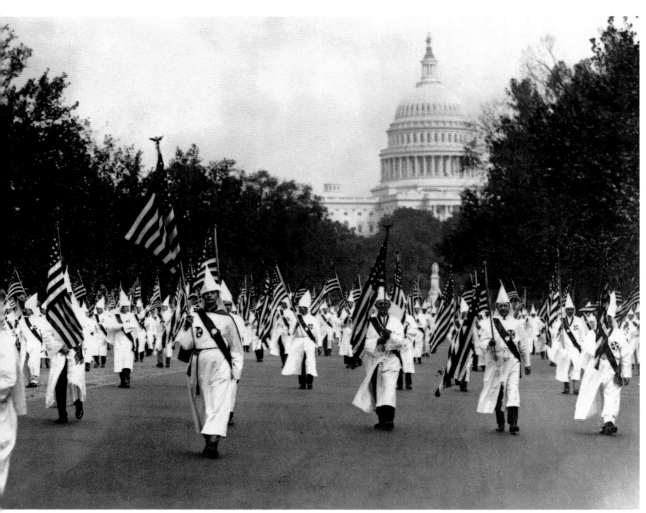

CAPED FEAR

Sufficiently powerful to parade unmasked in the shadow of the Capitol in Washington, D.C., in the 1920s, the Ku Klux Klan claimed more than three million members nationwide, including future Supreme Court Justice Hugo Black of Alabama. Despite the KKK's hand in murder, lynching and assault, it was not put under FBI surveillance until 1964.

CORBIS /
NATIONAL PHOTO COMPANY

THE WAR AT HOME

As this 1944 postcard shows, American propaganda in World War II could take an ugly racial turn. Fewer than 300,000 Japanese lived in the U.S. when hostilities commenced, half the estimated Italian population. Germans numbered 5.2 million. Yet, more than 100,000 Japanese (and no Italians and Germans) were sent to internment camps to guard against potential "sabotage."

CORBIS / LAKE COUNTY MUSEUM

BOYS FROM BAVARIA

Only 150,000 European Jews were admitted to the U.S. from 1935 to 1941. Among the lucky families in 1938 were the Kissingers, including Heinz, 11 (far left), a future Secretary of State known as Henry, and his brother Walter, 10. Their parents scrambled to make a living. Father, a respected teacher, had to switch to bookkeeping; Mother worked as a cook.

CORBIS / BETTMANN-UPI

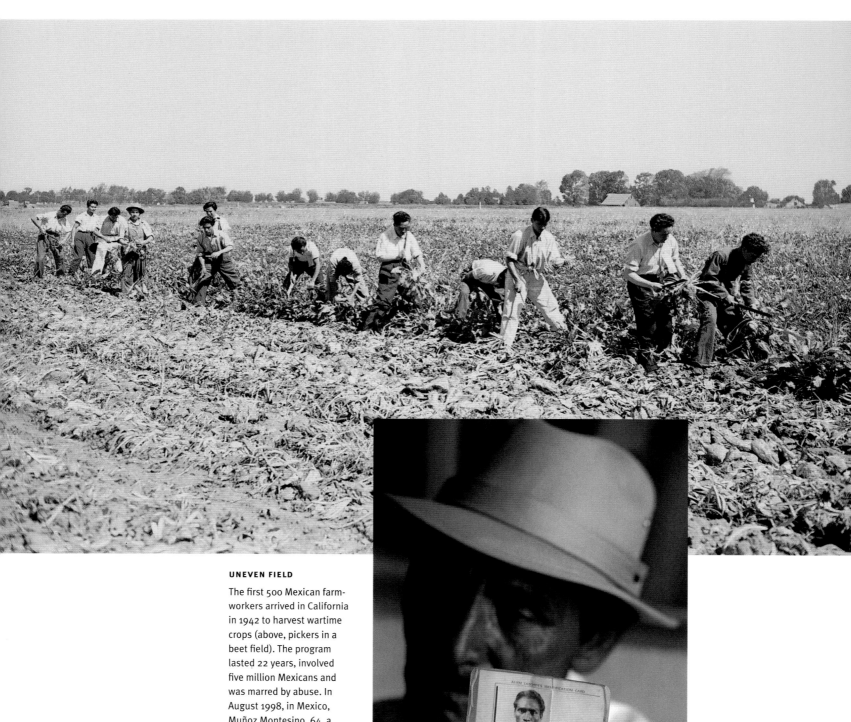

UNEVEN FIELD

The first 500 Mexican farm-workers arrived in California in 1942 to harvest wartime crops (above, pickers in a beet field). The program lasted 22 years, involved five million Mexicans and was marred by abuse. In August 1998, in Mexico, Muñoz Montesino, 64, a former bracero (right), discovered no one could account for the 10 percent of his wages his own government had deducted for "investment."

ABOVE: AP / EHK
RIGHT: ELIZABETH DALZIEL / AP

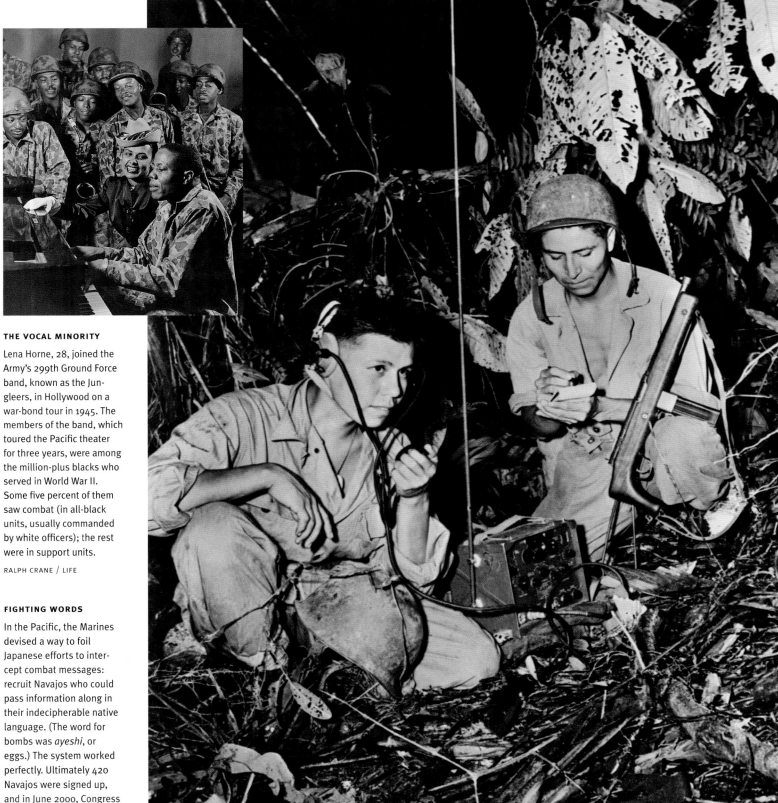

THE VOCAL MINORITY

Lena Horne, 28, joined the Army's 299th Ground Force band, known as the Jungleers, in Hollywood on a war-bond tour in 1945. The members of the band, which toured the Pacific theater for three years, were among the million-plus blacks who served in World War II. Some five percent of them saw combat (in all-black units, usually commanded by white officers); the rest were in support units.

RALPH CRANE / LIFE

FIGHTING WORDS

In the Pacific, the Marines devised a way to foil Japanese efforts to intercept combat messages: recruit Navajos who could pass information along in their indecipherable native language. (The word for bombs was *ayeshi*, or eggs.) The system worked perfectly. Ultimately 420 Navajos were signed up, and in June 2000, Congress awarded medals to the first 29 "code talkers."

CORBIS

TURNING POINT

Justice for All

Presidents are temporary fixtures in Washington with a maximum eight-year shelf life. Their ability to change laws and institutions is limited. By contrast, Supreme Court justices serve until they retire or die, an average of 16 years, and ultimately have greater impact on American society. In the past century, their decisions ranged from the classroom to the bedroom and beyond, determining how we educated our children and, indeed, whether we had to give birth to them at all. Every ruling adjusted the boundaries of freedom. Here are some particularly crucial decisions from the past 100 years.

EAST LOUISIANA RAILROAD CO.

EXCURSIONS $1.00. — TO THE — GREAT ABITA SPRINGS. E. S. FERGUSON, G.P.A.

WRONG TRACK

In 1896, the Court approved race-based seating on the East Louisiana Railroad, and thus on all public transportation, in the famous *Plessy* (a black shoemaker) v. *Ferguson* (a white judge in New Orleans). It said "separate but equal" facilities were legal, a ruling that essentially stood until 1954.

HISTORIC NEW ORLEANS COLLECTION

<
HAIL TO THE CHIEF

Chief Justice Earl Warren, 63, was in his first term, in 1954, when he persuaded the Court to outlaw school segregation by a surprising unanimous decision. Their argument, overturning the *Plessy* case, was that separate is "inherently unequal." The Warren Court was considered to be "liberal," yet few of its rulings were overturned by later justices.

FABIAN BACHRACH / COLLECTION OF THE SUPREME COURT OF THE UNITED STATES

ROOSEVELT LANDSLIDE WRECKS HILL MACHINE, G.O.P. FORCES LOSE OUT IN COUNTY VOTE DRIVE

Oscar DePriest Wins; Another Pro-Parker Senator Beaten

OUR NEXT PRESIDENT

Pittsburgh Courier
AMERICA'S ★ BEST ★ WEEKLY

Live Features, Latest News Leader in Advertising, Circulation and News Clean and Progressive

ELECTION EXTRA

GUARDING OUR BALLOT

VOL. XXIII—No. 45 PITTSBURGH, PA., SATURDAY, NOVEMBER 12, 1932 PRICE TEN CENTS

SEVEN SCOTTSBORO BOYS WILL BE GIVEN NEW TRIAL

FRANKLIN D. ROOSEVELT

VANN SAYS: 'THANK YOU'

BULLETIN!
STEPHENS WINS IN NEW YORK

LOOKS LIKE A WINNER

PRETTY FLOSSIE PARKER

HIGHEST COURT ACTS

M. L. BENEDUM

CONTROL IN FIFTH WARD IS JOLTED

NEGROES IMPORTANT FACTOR AS DEMOCRATS SWEEP INTO POWER

Negro Vote Not 'On Sale', Pride Was The Price, As Roosevelt Won Out

< JUDICIAL PRECEDENT

First in his Harvard Law School class, Louis Brandeis was known as "the people's attorney." He sued banks and businesses and won special protection for working women in *Muller* v. *Oregon* in 1908. In spite of opposition from his legal targets, he became, at 60, the first Jewish justice on the Supreme Court.

STOCK MONTAGE INC. / HARRIS & EWING

SAD SCOTTSBORO

Two white women said they were raped on a freight train in 1931; doctors said they weren't. Nine Alabama blacks were convicted nonetheless and seven sentenced to death. The Supreme Court overturned the verdict. The case dragged on; the defendants spent from six to 19 years in prison. The last one was finally pardoned in 1976.

LIBRARY OF CONGRESS

< SCHOOL CLOSURE

Denied admission to the University of Missouri law school in 1936, Lloyd Gaines, 24, sued. The Supreme Court supported him, ruling that each state must provide its own citizens with equal opportunities for education. Missouri's response was to establish an all-black law school. Gaines moved to Michigan.

CORBIS / INTERNATIONAL NEWS PHOTOS

JUSTICE DELAYED

When West Coast Japanese-Americans were ordered into primitive World War II internment camps like California's Manzanar (above) in 1942, Fred Korematsu refused. Plastic surgery enabled him to escape arrest for several months. Captured, he eventually was sent to a camp in Utah. Korematsu, who unsuccessfully appealed all the way to the Supreme Court, was finally cleared of charges in 1983 (left).

ABOVE: DOROTHEA LANGE / NATIONAL ARCHIVES
LEFT: GARY FONG / SAN FRANCISCO CHRONICLE

>
BRAVE FAMILY

In 1951, Leola and Oliver Brown of Topeka, Kansas, thought their daughter Linda, then 8 (here with little sister Terry), should be admitted to a white school seven blocks away instead of walking a mile to a black school. The parents brought suit. Three years later, the Supreme Court agreed, outlawing school segregation — and changing America for all time.

CARL IWASAKI / LIFE

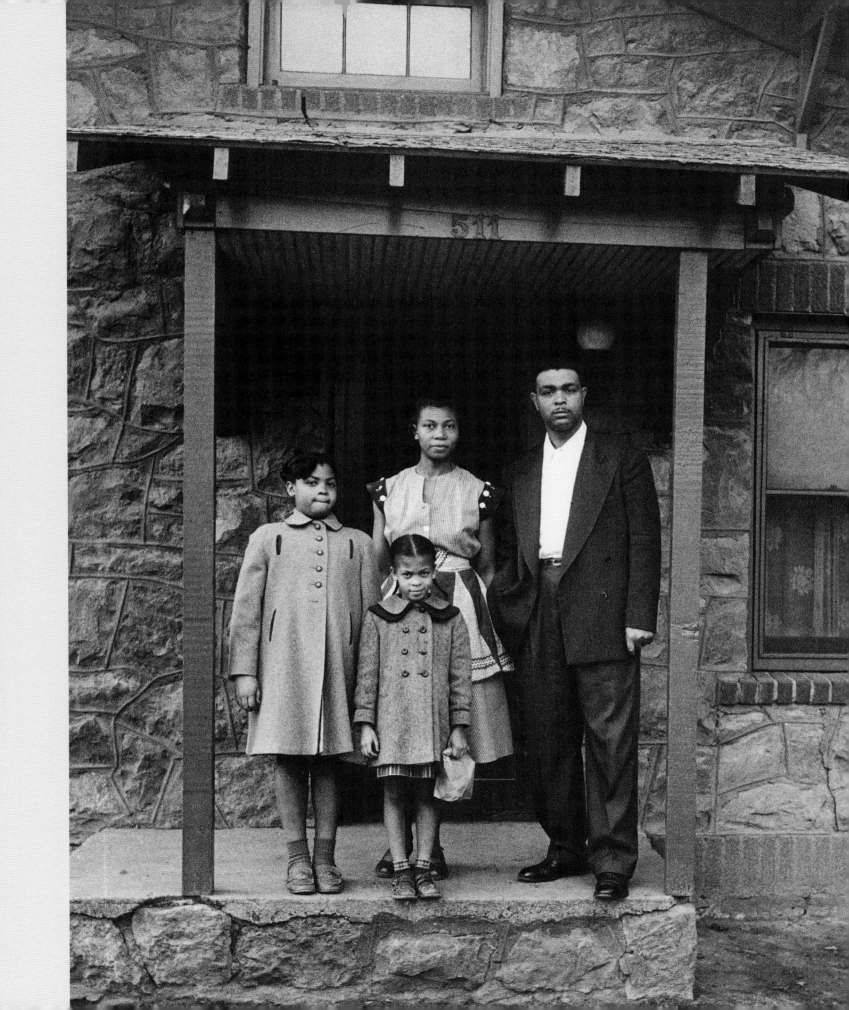

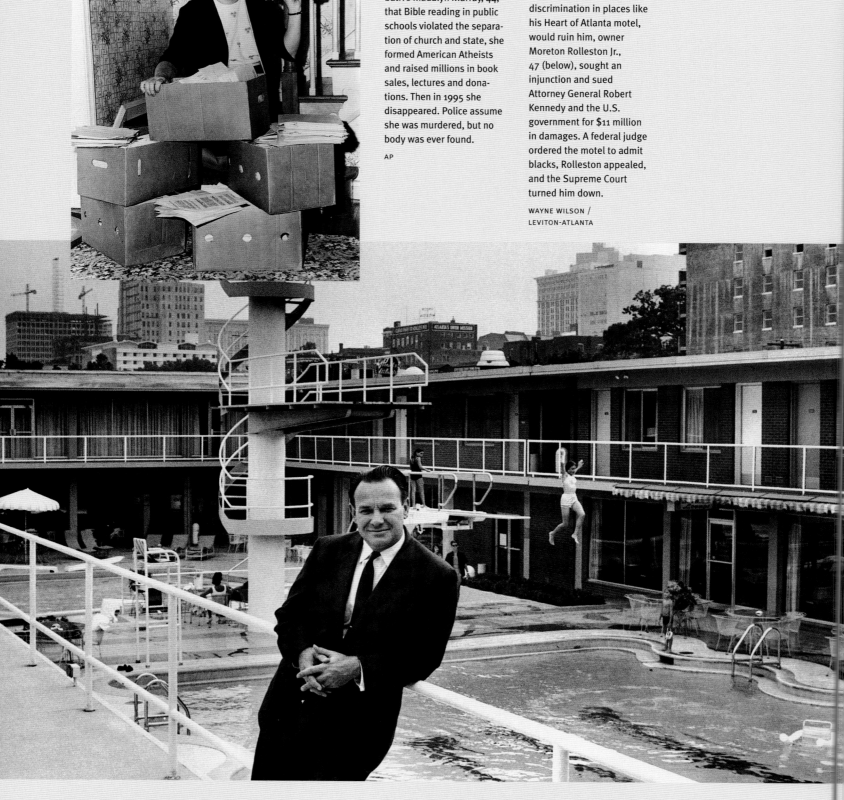

WITHOUT A PRAYER

After the Supreme Court, in 1963, agreed with combative Madalyn Murray, 44, that Bible reading in public schools violated the separation of church and state, she formed American Atheists and raised millions in book sales, lectures and donations. Then in 1995 she disappeared. Police assume she was murdered, but no body was ever found.

AP

REVIVING JIM CROW

Claiming that the 1964 Civil Rights Act, outlawing discrimination in places like his Heart of Atlanta motel, would ruin him, owner Moreton Rolleston Jr., 47 (below), sought an injunction and sued Attorney General Robert Kennedy and the U.S. government for $11 million in damages. A federal judge ordered the motel to admit blacks, Rolleston appealed, and the Supreme Court turned him down.

WAYNE WILSON / LEVITON-ATLANTA

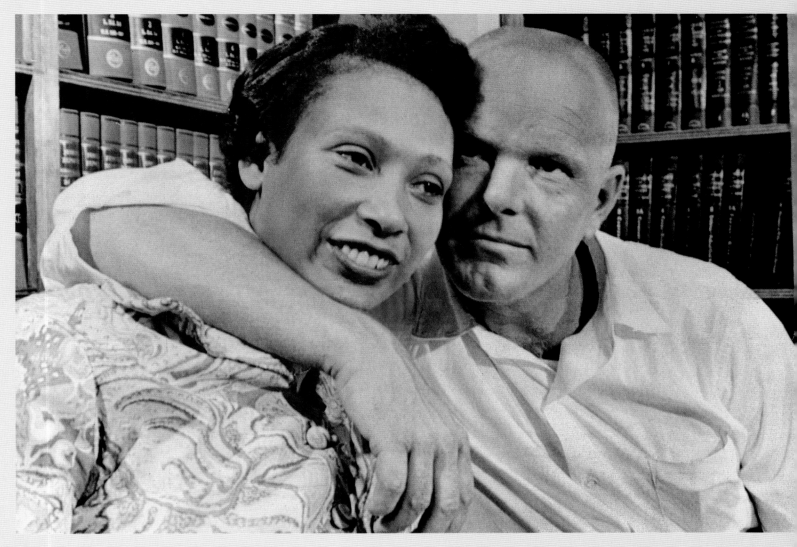

SAVING A MARRIAGE

Richard, 24, and Mildred Loving, 18, who exchanged vows in Washington, D.C., in 1958, were arrested when they returned to their native Virginia for breaking that state's law against black-white marriage. Nine years later, the Supreme Court nullified Virginia's miscegenation statute and, in effect, those still on the books in 15 other states.

CORBIS / UPI

<
CHANGE OF HEART

Roe v. *Wade* legalized abortion in the U.S. in 1973. The anonymous "Jane Roe" was Norma McCorvey (left, at 44, in front of the Supreme Court building in 1989), and "Wade" was the district attorney in Dallas. Today, with some restrictions, abortion is allowed in all 50 states. But McCorvey, now a fundamentalist Christian, has turned from pro-choice and campaigns against it.

DONNA FERRATO / BLACK STAR

PRO-LIFERS WIN

Antiabortion forces regrouped after *Roe* v. *Wade*. In 1989, the Court granted Missouri the right to limit abortions by requiring mandatory waiting periods and parental notification for teenagers. Three months later a judge cited that decision in acquitting protesters who had been arrested at this St. Louis abortion clinic.

ED LALLO

THE DOCTOR IS IN

The University of California's Davis Medical School had quotas for minority applicants. Allan Bakke, who was white, was rejected and sued on the grounds of reverse discrimination. The Court agreed. Bakke, 42, graduated in 1982 (as his son, Ed, watched), and schools all over the country took a hard look at their affirmative action programs.

ROGER RESSMEYER / CORBIS

SCOUT'S HONOR

James Dale reached the highest rank possible, Eagle Scout, at age 18. Only 3.5 percent of all Boy Scouts get there each year. He seemed the perfect candidate for troop leader and served in Matawan, New Jersey, until 1990. Then Scout officials learned that he was gay. Dismissed, Dale went to court. Ten years later, the justices decided 5–4 that the Scouts were a private group and could exclude him.

RON THOMAS / AP

STAY THE COURSE

A chronic blood disorder weakened his legs, so pro golfer Casey Martin, 25, asked in 1998 to ride in a cart during tournaments. The Professional Golf Association said no, that it was an unfair advantage. Casey sued, citing the 1990 Americans with Disabilities Act. The PGA has asked the Court to decide.

ALLEN EYESTONE /
PALM BEACH POST

HALLELUJAH CHORUS

In 1960, John F. Kennedy was the second Catholic to run for president. Al Smith tried in 1928 and was sunk by anti-Vatican sentiment in the South and West. JFK dealt with the issue directly in a historic meeting with Houston ministers on September 12, assuring them he would not take orders from the Pope. Kennedy (right, in St. Louis, two days later) won the election in a squeaker.

PAUL SCHUTZER / LIFE

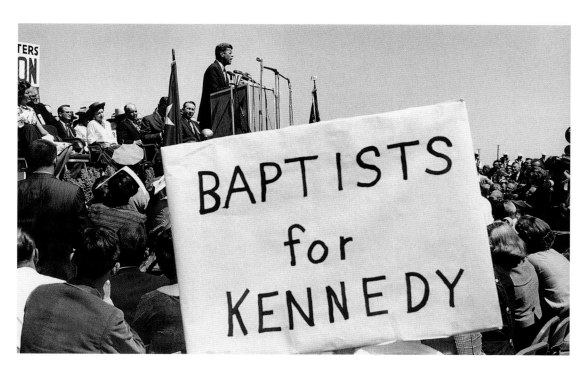

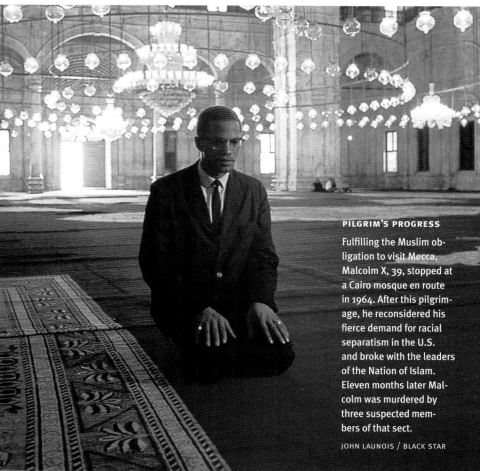

PILGRIM'S PROGRESS

Fulfilling the Muslim obligation to visit Mecca, Malcolm X, 39, stopped at a Cairo mosque en route in 1964. After this pilgrimage, he reconsidered his fierce demand for racial separatism in the U.S. and broke with the leaders of the Nation of Islam. Eleven months later Malcolm was murdered by three suspected members of that sect.

JOHN LAUNOIS / BLACK STAR

STAR PECK

It was a bold first for TV: Nichelle Nichols, 32, and William Shatner, 37, exchanged an interracial kiss on *Star Trek* in 1968. (The movies had beaten the tube to black-white smooching by a decade.) But wait; turns out Lieutenant Uhura and Captain Kirk did it only because they were under alien control at the time. Beam me down!

PARAMOUNT / FOTO FANTASIES

>
CLOSED-DOOR POLICY

As he vowed publicly to do, Governor George Wallace, 43, stood in the schoolroom door to prevent two blacks from entering the University of Alabama in 1963. Protesting at left was Deputy Attorney General Nicholas Katzenbach, 41. Once the photos were snapped, the grandstanding governor walked away and the students were registered. After he was shot in 1972, Wallace softened his racial views.

CORBIS / BETTMANN-UPI

HEADED FOR STARDOM

Title IX leveled the playing field for women. It was the 1973 federal law that said women's sports should get the same financial support as men's. Little Mia Hamm, seen here at age six in Wichita Falls, Texas, was a soccer whiz early on. She went on to star at the University of North Carolina and on the U.S. national team that won the world championship in 1999.

HAMM FAMILY PHOTO

MISTAKEN IDENTITY

Two Detroit autoworkers called Vincent Chin, 27, a "Jap" and blamed him for the Japanese imports that had cost them their jobs. Outside a bar, they beat him to death in June 1982. Chin was a Chinese-American engineer. His mother, Lily, was near collapse after asking the court to sentence the men to more than three years' probation and a fine. The judge refused.

IRA STRICKSTEIN / CORBIS

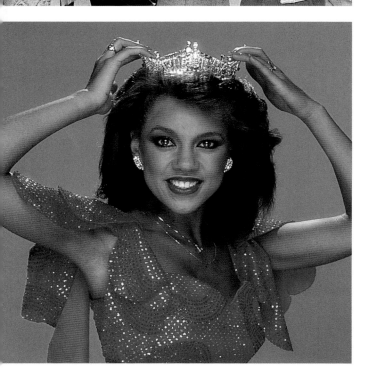

THERE SHE WENT

The first black Miss America enjoyed only a 10-month reign in 1984. Then Vanessa Williams, 20, was featured nude in *Penthouse* photos she had posed for a year earlier. Devastated, she turned in her tiara, but her life had a dramatic second act. A skilled singer, she made five albums, won 11 Grammy nominations, married twice, starred in movies, had four children and was happy.

CHRISTOPHER LITTLE

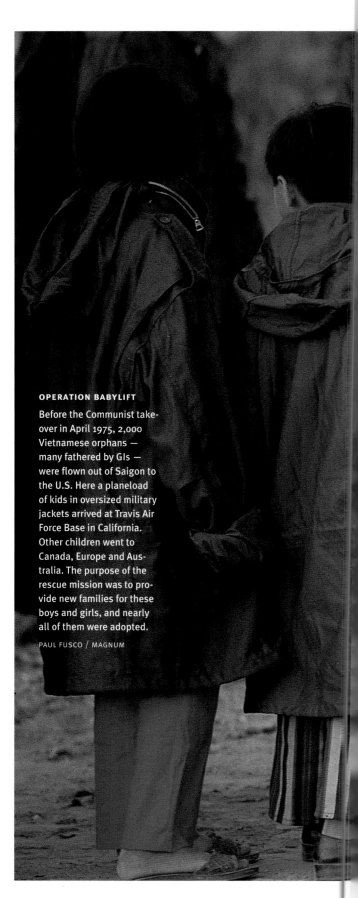

OPERATION BABYLIFT

Before the Communist take-over in April 1975, 2,000 Vietnamese orphans — many fathered by GIs — were flown out of Saigon to the U.S. Here a planeload of kids in oversized military jackets arrived at Travis Air Force Base in California. Other children went to Canada, Europe and Australia. The purpose of the rescue mission was to provide new families for these boys and girls, and nearly all of them were adopted.

PAUL FUSCO / MAGNUM

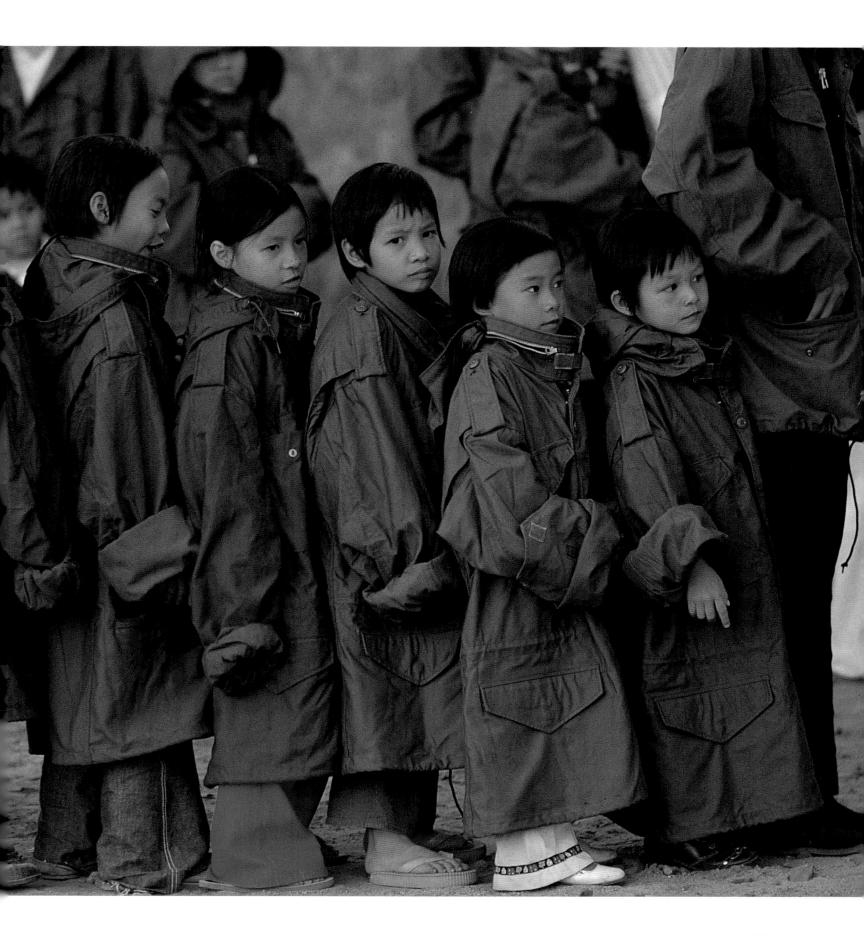

CLOSE UP

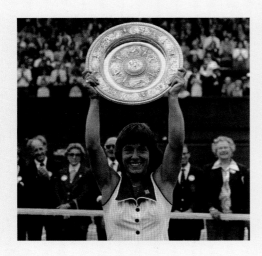

MARTINA NAVRATILOVA

Tradition Breaker

Women's tennis used to be a stately lob-and-volley affair, a sideline to the real event, played by men. Then Martina Navratilova blew in. Her 1975 defection from Czechoslovakia at age 18 seemed to sharpen her game; within three years, she was the top-ranked female in the world. Before retiring in 1994, she had won 167 singles titles, more than anyone else in tennis history. She had also earned new respect for all female athletes, boosting women's tournament and endorsement fees. Navratilova broke social mores as well. Her acknowledgement that she was a lesbian humanized gays and won her a victory in another court — that of public opinion.

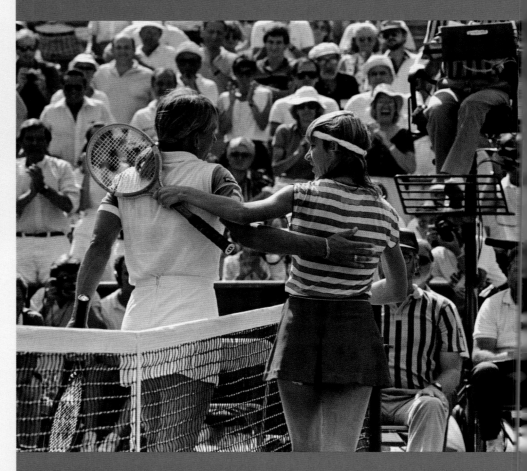

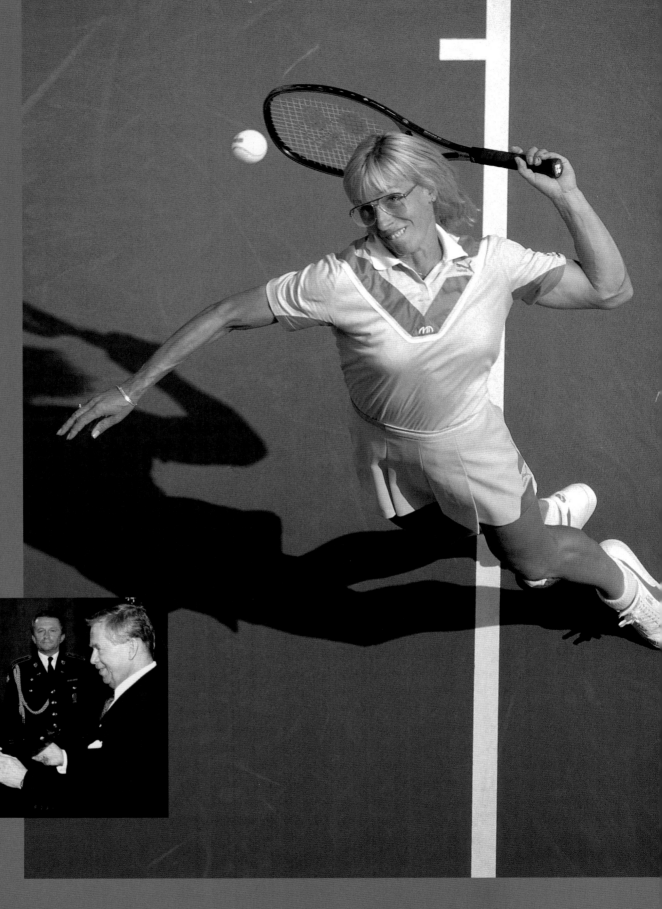

Behind a 90-mile-an-hour serve (right), Navratilova won her first of nine Wimbledon trophies in 1978 (far left). Her chief rival was Chris Evert, 28, who offered congratulations after losing in the finals of the U.S. Open five years later (near left). Off-court, Navratilova partnered with Judy Nelson, 40, a married former Texas beauty queen, and they lived with a kennelful of dogs in Fort Worth (lower left, in 1985). The relationship ended in 1991. After Navratilova left Czechoslovakia, that country erased her name from its record books. Amends were made in 1998 when she received the Medal of Merit from President Vaclav Havel in Prague.

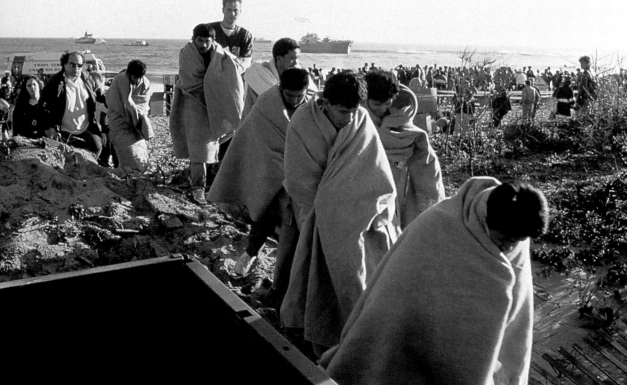

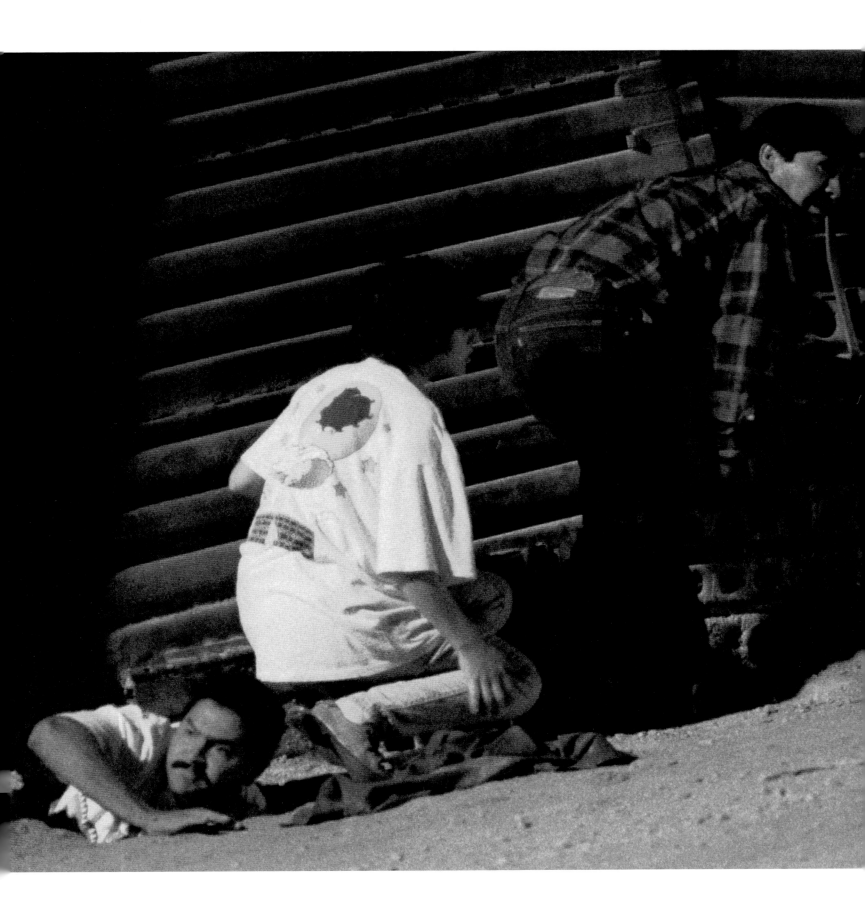

MAKING RESERVATIONS

Congress passed a law in 1988 authorizing Indian tribes to set up casinos if their states allowed gambling (31 do, like New Mexico, site of this 1997 Pojoaque Pueblo billboard). Today some 260 casinos rake in $8 billion a year, more than Atlantic City. Earnings are supposed to be spent improving life on historically impoverished reservations, with any surplus going to the Native Americans themselves.

MIGUEL GANDERT / CORBIS

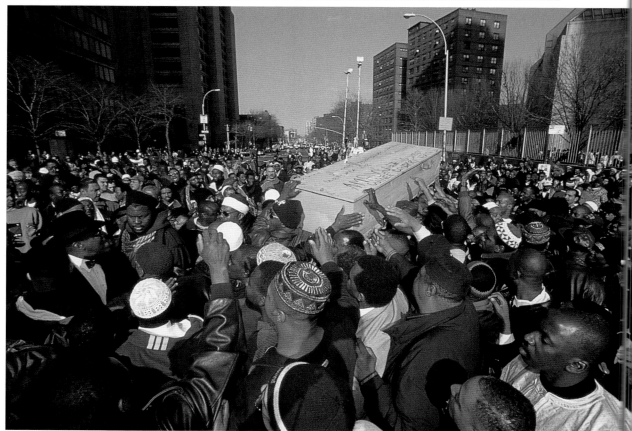

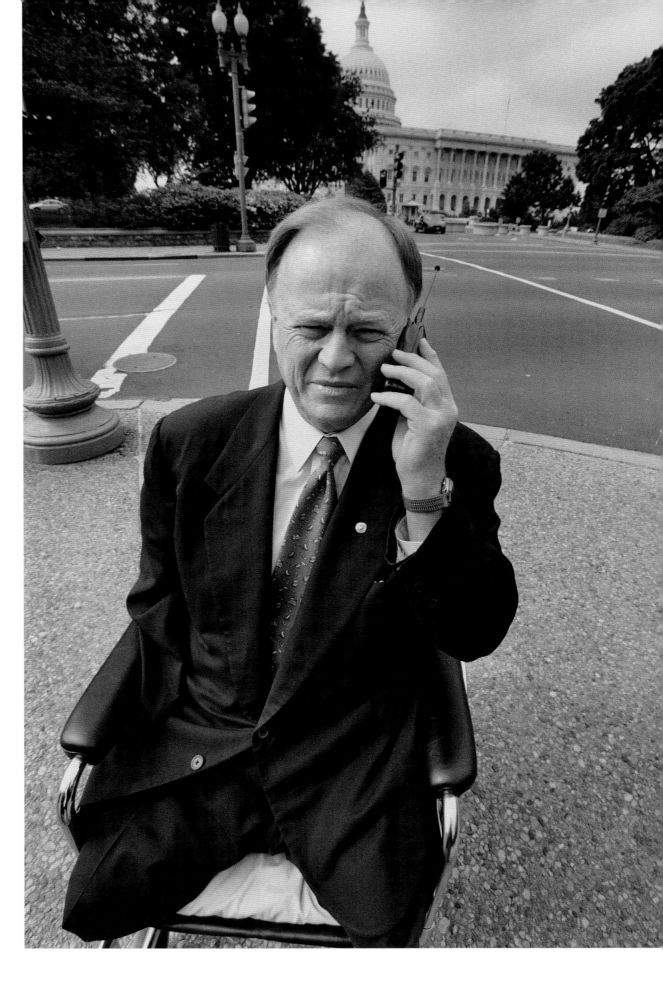

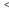

shopping

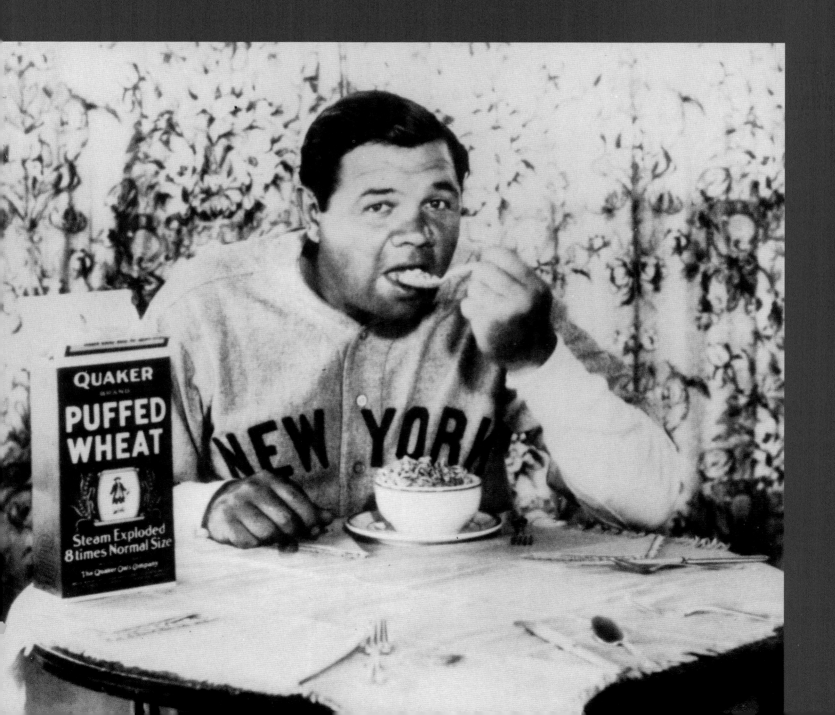

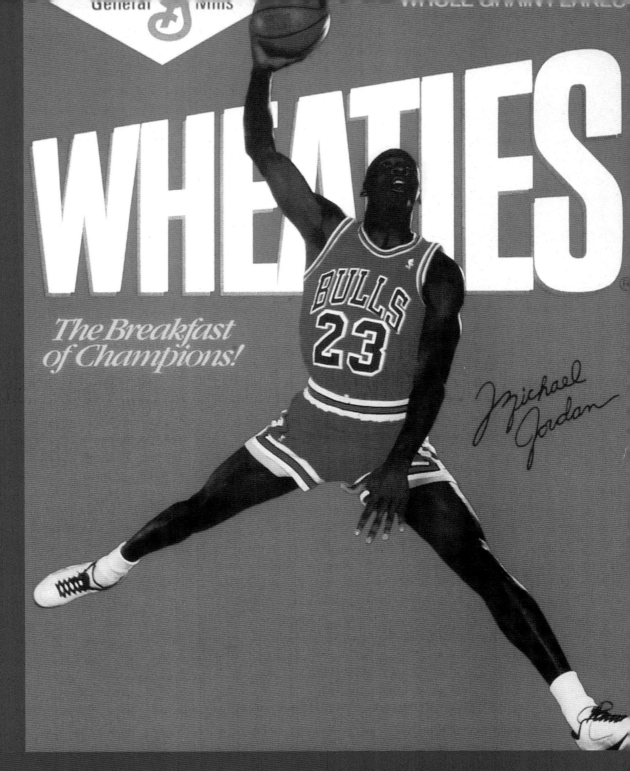

Who better to sell a product than America's best-known and highest-salaried athlete? In 1927, Babe Ruth, 32, padded his $70,000 paycheck by spooning breakfast food. (Coincidence or not, that year he swatted 60 home runs.) In 1988, Michael Jordan, 25, padded his $3 million paycheck by fronting breakfast food. (Coincidence or not, that year he won his second straight scoring title.)

LEFT: TRANSCENDENTAL GRAPHICS
RIGHT: COURTESY GENERAL MILLS, INC.

WHERE THE CONSUMER RULES

So Many Goods, So Little Time

BY BARBARA EHRENREICH

IN A CENTURY DARKENED by so much human savagery, there emerged one bright new source of light and color, fantasy and frivolity. The number of things to buy — or at least to imagine buying — increased, as did the reasons for buying them and the pleasures of going out and shopping. This new consumer culture, as scholars would term it toward the end of the 20th Century, grew most spectacularly in America, transforming people's leisure time and subtly challenging their most traditional values. While the old voices of authority kept barking orders like work, kill, die, the 20th Century consumer culture issued a far more enticing command. "It does not say, 'Pray, obey, sacrifice thyself, respect the King, fear thy master,' " an American retailing merchant observed in 1912. "It whispers, 'Amuse thyself, take care of yourself.' " The power of this message can be measured by the magnitude of the changes that have been variously attributed to, or blamed on, the consumer culture: the secularization of Western society, the taming of American labor, the fall of Communism.

The new culture made its appearance on the eve of the new century, in the 1890s, when the first department stores opened in American cities, replacing rows of tiny, cluttered shops. With their high, vaulted ceilings, their imaginatively designed show windows and dazzling displays of goods, department stores were meant to evoke palaces and even cathedrals. Shoppers crowded in to enjoy the stores' changing decorative themes, Egyptian, Oriental, French Salon; and took in a fashion show (the first one was staged in 1903) and perhaps lunch at the store's restaurant. More than any other institution, the department store accustomed Americans to the idea that shopping is a rewarding pastime whether you buy anything or not. By the Teens and the Twenties, entirely new items — radios and cars — were showing up on the nation's collective shopping list: The one to convey ads urging you to buy; the other to take you to the store.

Shopping has, of course, seldom been a straightforward matter of acquiring necessary objects. In preindustrial societies, people looked forward to their annual or seasonal markets as occasions for flirtation, gossip and the renewal of community bonds. Until about 200 years ago, for example, English fairs featured not only practical things to purchase, like cattle and sugar, but also long days of dancing and carousing. So too in America's consumer culture: Buying is associated with a special mood of festivity and self-indulgence, set off from the daily grind. The difference is that America's consumer marketplace neither offers nor requires much human interaction. In our stores and malls, shoppers pursue their private dreams of status and luxury, barely aware of each other except as competitors for sale items and parking spots. You can even shop in solitude, via a

The first self-service market: this Piggly Wiggly in Memphis. So radical was the concept, patented in 1917, that the store put up turnstiles to ensure that shoppers who served themselves didn't also help themselves.

catalog or, today, the Web. The appeal is to the individual, not to the community or even, in most cases, the family.

Women were the first group of Americans to find their lives drastically changed by the consumer culture, and the word *shopping* retains its feminine ring to this day. In the first half of the century, women discovered the stores filled with items like clothing that they — or at least their mothers — had once manufactured in their homes. A few, more conservative, women complained of being robbed by the removal of *creative* work from the home and worried that homemakers would soon be left with nothing to do. But most women, especially those with money to spend, found that shopping itself filled the void, and even before there were cars to put bumper stickers on, "shop till you drop" defined an acceptable female lifestyle. The only problem was that if shopping was supposed to be about pleasure and self-indulgence — as the advertisers and

merchants insisted — it could hardly be a respectable adult occupation. Hence the caustic question raised by Betty Friedan in 1963: "Why is it never said that the really crucial function, the really important role that women serve as housewives, is *to buy things for the house*?"

By Friedan's time, the consumer culture had outgrown the downtown department store and was expanding its grip on the American landscape, not to mention the American psyche. Malls started eating up suburban acreage in the Fifties, offering huge weatherless interior spaces dedicated to the consumerist dream life. At the same time, marketing began to acquire a new psychological sophistication, with one mid-century "motivation researcher," for example, telling businessmen, "We are now confronted with the problem of permitting the average

Insanely low prices were one gimmick used by Earl (Madman) Muntz (in 1945, at 31) to lure car buyers to his Southern California lot. Another was to vow on-air that he would chop up the featured bargain of the day if it did not sell by closing time.

American to feel moral even when he is spending, even when he is not saving. One of the basic problems of prosperity, then, is to demonstrate that the hedonistic approach to his life is a moral, not an immoral, one." Americans' vaunted capacity for hard work and "deferred gratification" was to have no place in the mall.

Men were the next group to be seduced by the expanding cornucopia of consumer goods. At mid-century most American men still tended to see shopping as a sissified pursuit, too much interest in clothing or home furnishing as a sign of effeminacy. James Bond helped reform this backward attitude, providing living, or at least celluloid, proof that a man could cherish fine wines and fabrics without compromising his masculinity. New magazines like *Playboy* offered a widening spectrum of male-oriented consumer goods in their advertisements — liquor, casual clothing, hi-fis — along with the editorial message that you'd be a sucker to support a female shopper when you could be spending your

wages on yourself. In response to this new pitch the American male began to develop his well-known "fear of commitment": Men married later, and both sexes showed a new willingness to divorce.

But the consumer culture of the Fifties and Sixties probably had its most disruptive effect on the young. The word *teenager* came into use only in the Forties; by the late Fifties this newly discovered group was spending, or persuading parents to spend, a record $10 billion a year on things like records, cameras, cars and clothes. They had become, in short, a market, entitled to tastes, like blue jeans and rock 'n' roll, that were repellent to the grown-up majority. It should have been no surprise, then, that the young began to think of themselves as a distinct group, set apart from and potentially hostile to anyone over 30. When a rebellious youth culture broke out in the mid-Sixties, adult critics were quick to blame parental permissiveness. But it wasn't Dr. Spock who had tempted Americans into the new values of self-indulgence and impulsiveness; it was the consumer culture created by respectable American businessmen.

So, willy-nilly and without anyone's conscious intention, the consumer culture helped drive a wedge between the genders and the generations. Women questioned their role as full-time homemakers, meaning, largely, shoppers. Men began to chafe at their responsibility as breadwinners. Teenagers challenged the authority of clueless adults. In our own time, even the smallest children help account for

what is now an estimated $550 billion youth market in everything from sneakers to Pokémon — again, sometimes to the detriment of the family as a whole. According to economist Juliet Schor, 30 percent of parents say they are working longer hours than they would like in order buy things their children say they need.

We worry, of course, about our addiction to shopping. One distinguished intellectual after another has complained about its deleterious effects on the polity: that it pits neighbor against neighbor in the game of conspicuous consumption, that it burdens families with debt, that it distracts children from their studies and adults from their responsibilities as parents and citizens. But perhaps the most striking critiques are the lived ones. Ever since the Fifties, you could always find, if you looked hard enough, a counterculture designed to oppose the dominant consumer culture. The Beats mocked the idea of working " for the privilege of consuming all that crap they didn't really want anyway" and seemed content enough with their jug wine and orange-crate furniture. A decade later, Yippie leader Jerry Rubin spoke for a disaffected generation when he wrote, "We didn't dig why we needed to work toward owning bigger houses? Bigger cars? Bigger manicured lawns?" His admirers lived in frugal communes or took up subsistence farming in Vermont. In our own time, environmental activists are the chief proponents of a less materialistic, less shopping-centered, way of life. "Live simply," one bumper sticker advises, "so that others may simply live." Add to this a growing concern about the sweatshop sources of some of our consumer goods, and you have the startling sound, first heard in Seattle in late 1999, of rocks crashing through the windows of popular, consumer-friendly, chain stores.

But to most Americans, the critics of the consumer culture have usually seemed cranky and marginal. Organized religion, after all, has long since made its peace with the prevailing materialism, and no politician would get very far by promising less. For better or worse — and at least until someone comes up with a more appealing focus for our fantasies — the consumer culture *is* American culture.

Barbara Ehrenreich is the author of Fear of Falling: The Inner Life of the Middle Class *and* The Hearts of Men: American Dreams and the Flight from Commitment. *She writes for* Time *and other magazines, lives in the Florida Keys and shops mostly by catalog and e-mail.*

AVON CALLING

Actually, the first ding-dong lady — Mrs. Persis F.E. Albee, 50, of Winchester, New Hampshire, in 1886 — made door-to-door sales of scents and creams for a New York City–based firm that would not be renamed Avon until 1939. She went on to recruit and train 5,000 saleswomen like herself.

COURTESY AVON PRODUCTS, INC.

ROOT BEER FLOAT, PLEASE

In 1902, the 4,502 citizens of Junction City, Kansas, could enjoy the latest in refreshments by visiting the soda fountain at Loeb & Hollis Drug Store. First to carbonate water: English immigrant John Matthews, in 1832. First to mix carbonated water with a flavored syrup (lemon): French immigrant Eugene Roussel, in 1838. And Massachusetts native G.D. Dows patented the soda fountain in 1863.

PENNELL COLLECTION / UNIVERSITY OF KANSAS

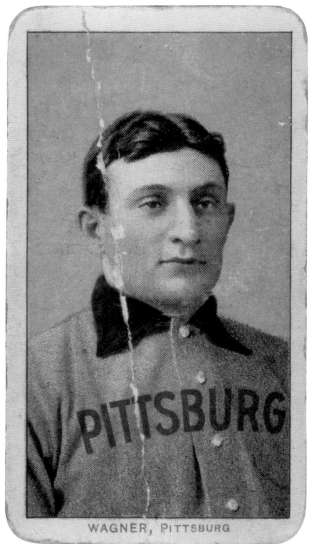

WAGNER, PITTSBURG

BASE BALL SERIES

150 SUBJECTS

Piedmont

The CIGARETTE *of* QUALITY

FACTORY No.25, 2° DIST. VA.

PREMIUM PLAYER

This baseball card, free to cigarette purchasers in 1909, sold for $1.27 million at an online auction in July 2000. Honus Wagner, 35, was the first pro jock to endorse a product (Louisville Slugger bats, in 1905). But when Piedmont began using his image, the All-Star shortstop, an ardent nonsmoker, made the company stop. That's why fewer than 60 "1909 T206 Wagners" were printed.

CHRISTIE'S IMAGES, LTD. (2)

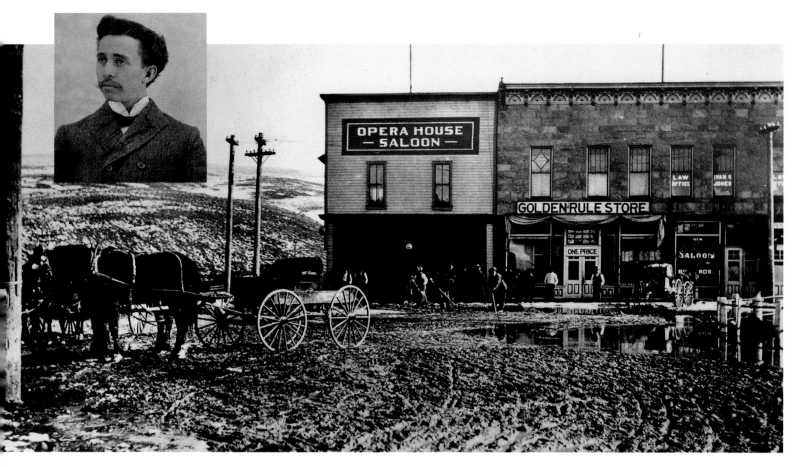

PRAIRIE ENTREPRENEUR

In 1902, store clerk James Cash Penney, 26 (inset), borrowed $1,500 to buy into a new dry goods store in the mining town of Kemmerer, Wyoming (above, in 1904). In 1913, now the owner of 48 stores, most in the Rockies, he renamed them after himself. The chain peaked at 2,053 outlets in 1973, two years after his death; despite heavy competition, 1,100 JC Penneys remain open.

ABOVE: BROWN BROTHERS
INSET: COURTESY JC PENNEY ARCHIVES

> **L.L. BOOTSTRAPPER**

Freeport, Maine, merchant
Leon Leonwood Bean
mailed out a modest
circular in 1912. It drew 100
orders for rubber boots.
Though 90 pairs were
returned because they
leaked, Bean saw a niche in
the catalog industry. Giants
like Sears and Montgomery
Ward literally offered the
kitchen sink; he would
specialize and offer only
outdoor-related gear.

COURTESY DAN HARLOW /
L.L. BEAN, INC.

<
STORE-TO-DOOR SERVICE

By the early 1920s, riders
like these were augment-
ing the brown trucks of a
new outfit competing with
the U.S. Post Office. At
the time, Seattle-based
United Parcel Service deliv-
ered packages in a handful
of West Coast cities; its
growth paralleled that of
the mail-order industry.
The next advance in distrib-
ution services came in
1973, with the launch of
Federal Express.

COURTESY UPS

UNCLE SAM WILL *ENFORCE* PROHIBITION

BUY NOW!

This is the time to acquire your Wines and Liquors. Prices are advancing daily and will continue to advance whether Prohibition becomes effective July 1, 1919, or January 20, 1920. No Wines or Liquors may now be manufactured or imported—and existing stocks of good merchandise are almost extinct. Even if the ban on manufacture were lifted it would require years to mature the new product.

Specials This Week

	Per Case.	Per Bottle.
Imperial Gin	$24.50	$2.15
Dove Gin	27.00	2.30
Gordon Gin	29.00	2.45
Cocktail Rum (H. H. Dove Brand)	32.00	2.75
Bacardi Rum	37.00	3.20
Allash Kummel	30.00	2.60
Old Bridgeport Whiskey	36.00	3.10
(Six years old; bottled in bond)		
Green Creme de Menthe	34.00	3.00
(Imported in glass from Mouchotte Freres)		

Special inducements given to those buying Ports, Sherries, Clarets, Rhine and Moselle Wines in quantity.

HENRY HOLLANDER

Importers of Wines and Whiskies for the Connoisseur

ESTABLISHED 1877.

Telephone: Greeley 3218-3219 149-151 West 36th St. (Just West of B'way.)

DIMPLED DUMPLINGS

The Campbell Kids, drawn in 1904 by Grace Gebbie Drayton, first appeared in trolley-car ads to promote canned goods. Their occasional makeovers have been M'm! M'm! marginal (above left, acing a science quiz in the 1920s and, above, skating in 1983). As the Kids near 100, they remain unnamed. How about Porky and Beansie?

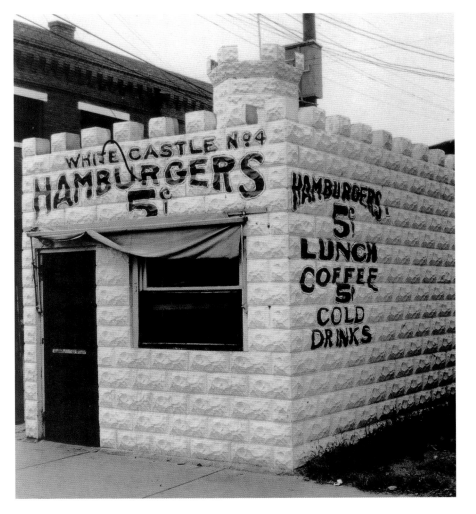

<
LAST CALL . . .

Prohibition, which took effect in January 1920, turned us into a nation of do-it-yourselfaholics. We befriended immigrants who knew how to ferment the juice of fruits (especially grapes), a legal activity. We bought half-brewed wort, produced in making near beer, and added yeast to get real beer. We spiked raw alcohol with essence of juniper to arrive at "bathtub gin." And with Repeal in 1933, we gratefully turned those jobs back to the pros.

A SQUARE MEAL, CHEAP

The McDonald brothers were still teens in 1921 when Wichita burger king Walter Anderson and backer E.W. Ingram, both 40, opened the first White Castle (left; Anderson ran three other stands, so this one was called No. 4). The 345-outlet chain still serves the patties Walt designed: square, with five holes to allow faster, more even cooking.

COURTESY WHITE CASTLE, INC.

In 1902, Macy's co-owner Isidor Straus, 57 (seated, with sons Percy, 26, far left, and Jesse, 30), awaited opening day of their gamble on 34th Street. After Isidor and wife Ida went down aboard *Titanic* in 1912, control of the store passed to their sons and nephews. The last of that generation to be associated with Macy's was Percy, who died in 1944.
COURTESY MACY'S EAST, INC.

MACY'S

The Big Store

Breaking the first three rules of retail — location, location, location — a Manhattan merchant family decided, as the 19th Century wound down, to leave bustling 14th Street for the wilds of midtown. Good move. In 1902, the dry goods establishment founded 44 years earlier by ex-seaman Rowland H. Macy opened on Herald Square as the world's largest store (current size after expansions: 2.15 million square feet). The emporium became a national institution, with as many as 15 branches in 1950. With the emergence of discount superstores, the chain filed for bankruptcy in 1992. Two years later, Macy's was acquired by a department store conglomerate.

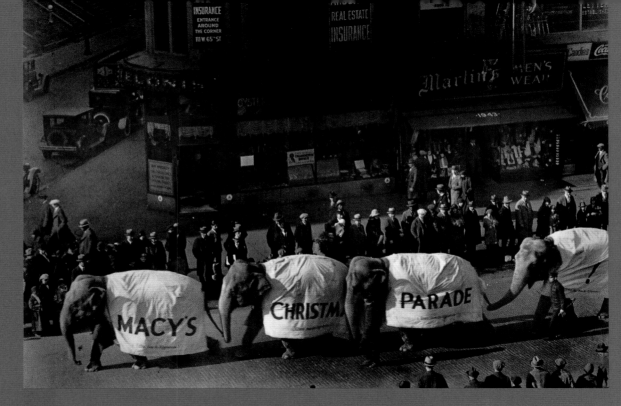

Long before moving uptown (below right, the store in 1909), Macy's was known for innovative retailing. In 1859, it became one of the first to run prices in newspaper ads. In 1873, it created the first Christmas window display. Its parade, a tradition begun in 1924 with real animals (right) instead of giant balloons, was often staged in December, until 1939, when FDR moved Thanksgiving back a week to lengthen the holiday shopping season. By 1947, the store's fame was such that the movie *Miracle on 34th Street* (above left, Edmund Gwenn and Natalie Wood, 8) could have been set nowhere else. What Hollywood didn't show was the aftermath of a day of shopping (left, in 1948).

CLOCKWISE FROM TOP LEFT: 20TH CENTURY FOX / NEAL PETERS COLLECTION; COURTESY MACY'S EAST, INC.; COURTESY ANDREW ALPERN; NINA LEEN / LIFE

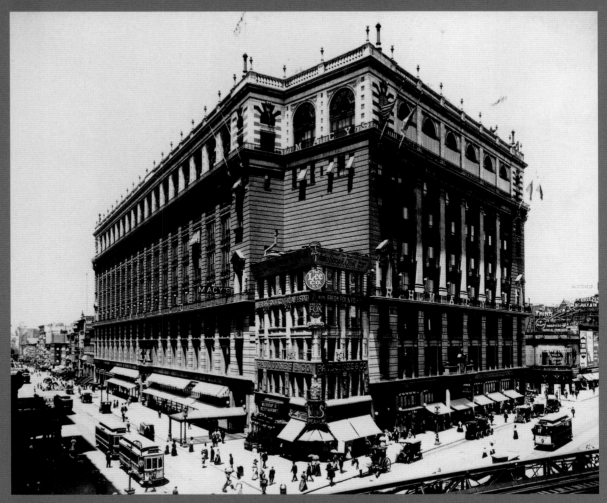

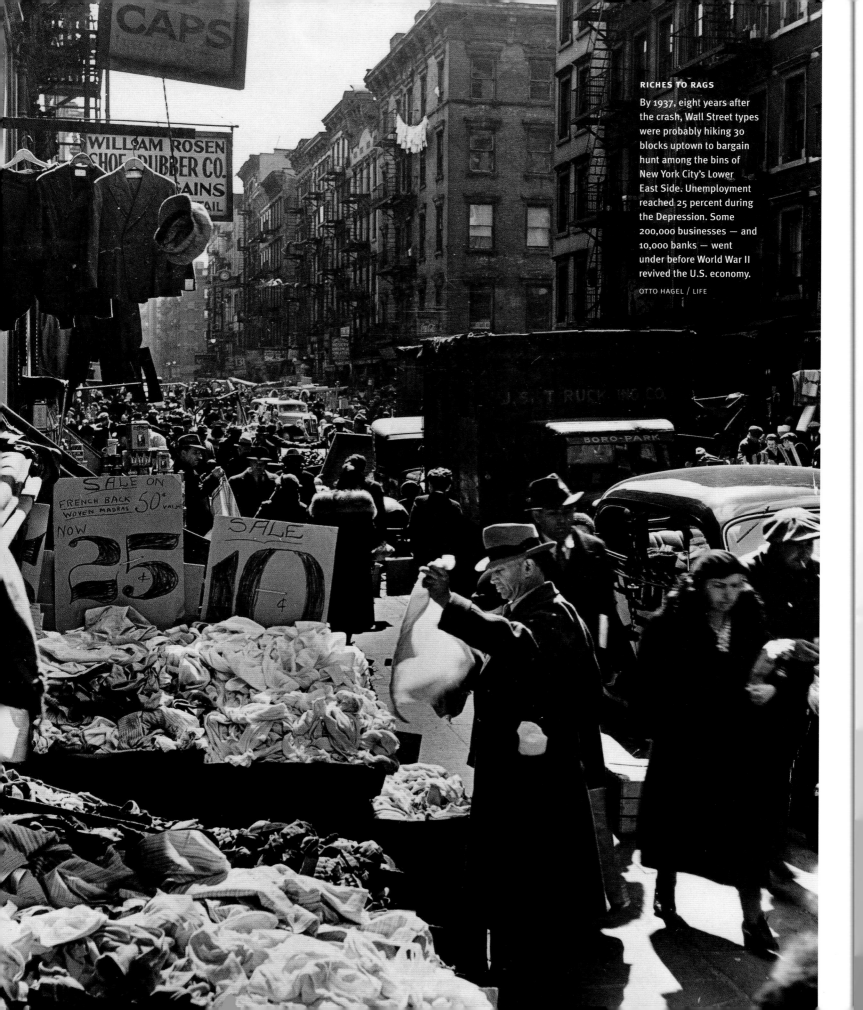

RICHES TO RAGS

By 1937, eight years after the crash, Wall Street types were probably hiking 30 blocks uptown to bargain hunt among the bins of New York City's Lower East Side. Unemployment reached 25 percent during the Depression. Some 200,000 businesses — and 10,000 banks — went under before World War II revived the U.S. economy.

OTTO HAGEL / LIFE

SMOKE GETS IN YOUR EARS

A short-lived 1919 cigarette campaign showed a bellhop wailing, "Call for Philip Morris!" In 1933, with radio maturing as a commercial medium, Madison Avenue decided to recycle the concept with a live callboy. Thus did Brooklyn midget Johnny Roventini, 22, collect Philip Morris paychecks until his death in 1998.

MURRAY KORMAN

NO WISE-QUACKS

Inspired by a California coffee shop shaped like a percolator, Martin and Jeule Maurer built, in 1931, a store in Riverhead, New York, that left no doubt about what they bred and sold: Pekin ducks. The structure was declared a historic landmark in 1997. The Big Duck now roosts in a county park (above).

ROBERT LIPPER

POWDER-PUFF DERBY

Is there a correct way to dab on cosmetics? Helena Rubinstein thought so, as did these aspiring counter girls in 1941 (when 2,500 took her one-week training course). Today's in-store salespeople are as often as not lab-coated "epidermal consultants," but it's still the old skin game. With men now active players, 1999 vanity-industry sales hit $40 billion.

EUROPEAN PICTURE SERVICE

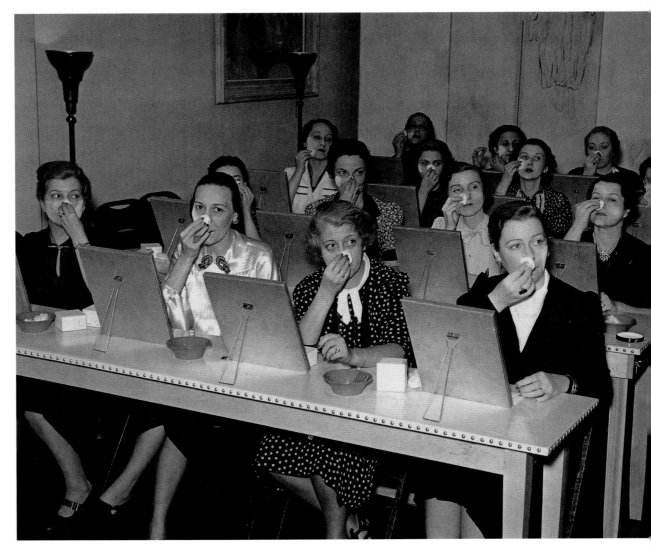

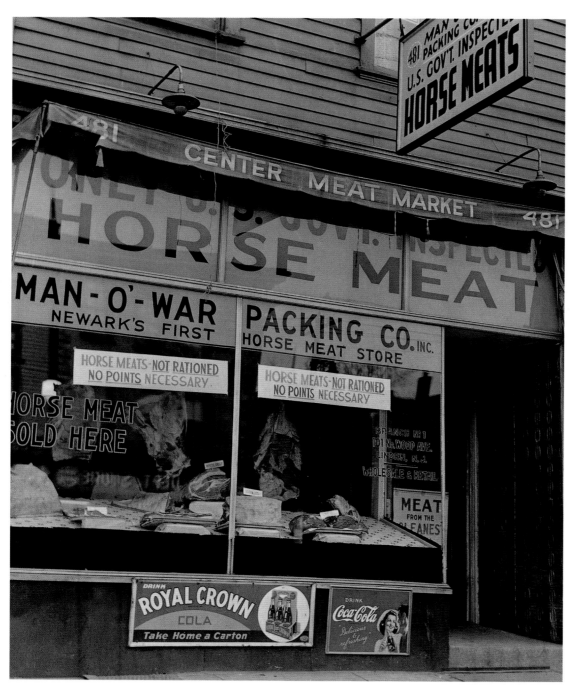

<

THE OLD GRAY MARE . . .

Filly mignon (left, a New Jersey butcher shop in 1943) was not an American staple until World War II, when each home front family member got 112 ration-coupon points per month. A pound of porterhouse cost 12 points, a pound of chuck nine. Suddenly, Flicka was a meal, not a friend. But since V-J Day, bronco burgers have been hard to find.

ELIZABETH TIMBERMAN

>

SHEER MADNESS

DuPont threw up a two-ton gam at the 1939 San Francisco Exposition to tout nylon stockings. The day that the synthetic hosiery went on general sale, in 1940, some 780,000 pairs were sold. After Pearl Harbor, the military had dibs (to make everything from parachutes to medical sutures). Still, nylons could be had on the home front black market — at $10 a pair.

DUPONT COMPANY

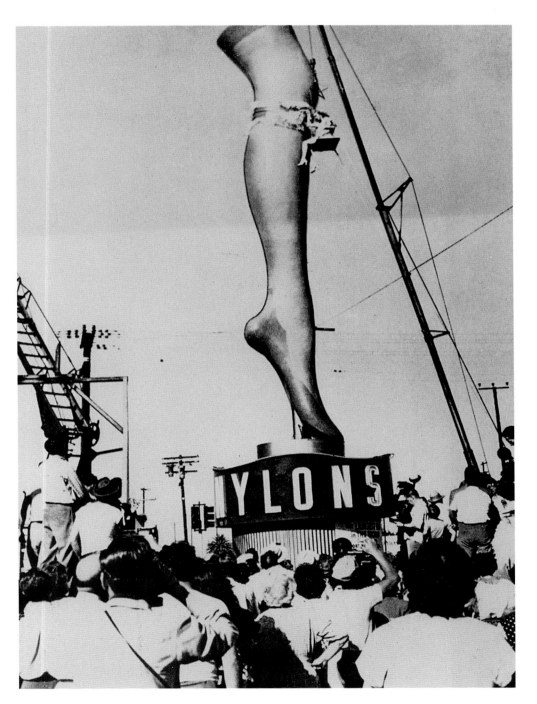

SIGNS OF THE TIMES

Motorists first encountered Burma Shave's rhyming roadside verses in 1925. The Odell family of Minnesota wrote the initial jingles, which pitched a shaving cream, but soon ran dry; for the next 30 years, the rhymes came from frustrated poets, at $100 a pop. The campaign ended in 1963 because drivers were going too fast to read the doggerel.

JOE SCHERSCHEL (6)

HELLO, DAMAGE CONTROL?

In 1947's *The Hucksters*, war vet Clark Gable (far left) needs all his combat skills to survive in the treacherous world of advertising. The movie and the Frederick Wakeman novel on which it was based weren't the only hits the industry took; in 1957 came sociologist Vance Packard's scathing exposé of manipulation and greed, *The Hidden Persuaders*.

PETER STACKPOLE / LIFE

THE PERSUASION INDUSTRY

Admen Cometh

The word *advertisement* traces to the 1500s, when Gutenberg's press made it feasible to print handbills and circulars. In the 17th Century, London newspapers began running ads. But not until America reached two critical masses — in producing consumer goods and media — did an industry emerge. Its early soft sell grew hard on radio and TV (though even in the electronic age, some campaigns were print only; see pages 262–263). Are ads all sizzle and no steak? As early as mid-century (above), we suspected that Madison Avenue was taking us on Gullible's Travels. Too late now. Researchers gauge that we see or hear 400 to 600 commercial messages a day.

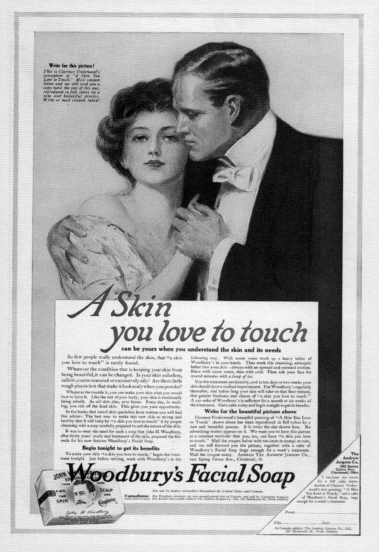

FULL OF STARCH

Men's shirts and collars were still sold separately in 1914. That 19th Century fashion was soon ended by a haberdasher named Uncle Sam. Doughboys returning from World War I wanted soft sewn-on collars like those on their government-issue uniform shirts.

REFRESHING PAUSES

At century's dawn, Coca-Cola's secret formula (devised as a hangover remedy by Atlanta pharmacist John Pemberton in 1886) still contained minute traces of cocaine. They were removed in 1903. Sales did not suffer.

CONTACT SPORT

Chaste though it seems now, this 1915 magazine ad was a trailblazer. Never before had a nationwide campaign dared hint that tactile pleasure is an essential ingredient in romance. Madison Avenue had discovered sex.

Coca-Cola IS A DELICIOUS BEVERAGE Delightfully In Harmony With the Spirit of ALL OUTINGS

Sold at all Founts and Carbonated in Bottles 5¢

"Can he really play?" a girl whispered. "Heavens, no!" Arthur exclaimed. "He never played a note in his life."

They Laughed When I Sat Down At the Piano But When I Started to Play!—

ARTHUR had just played "The Rosary." The room rang with applause. I decided that this would be a dramatic moment for me to make my debut. To the amazement of all my friends I strode confidently over to the piano and sat down.

"Jack is up to his old tricks," somebody chuckled. The crowd laughed. They were all certain that I couldn't play a single note.

"Can he really play?" I heard a girl whisper to Arthur. "Heavens, no!" Arthur exclaimed. "He never played a note in all his life...But just you watch him. This is going to be good."

I decided to make the most of the situation. With mock dignity I drew out a silk handkerchief and lightly dusted off the keys. Then I rose and gave the revolving piano stool a quarter of a turn, just as I had seen an imitator of Paderewski do in a vaudeville sketch.

"What do you think of his execution?" called a voice from the rear.

"We're in favor of it!" came back the answer, and the crowd rocked with laughter.

Then I Started to Play

Instantly a tense silence fell on the guests. The laughter died on their lips as if by magic. I played through the first bars of Liszt's immortal Liebesträume. I heard gasps of amazement. My friends sat breathless—spellbound.

I played on and as I played I forgot the people around me. I forgot the hour, the place, the breathless listeners. The little world I lived in seemed to fade—seemed to grow dim—unreal. Only the music was real. Only the music and the visions it brought me. Visions as beautiful and as changing as the wind-blown clouds and drifting moonlight, that long ago inspired the master composer. It seemed as if the master musician himself were speaking to me—speaking through the medium of music—not in words but in chords. Not in sentences but in exquisite melodies.

A Complete Triumph!

As the last notes of the Liebesträume died away, the room resounded with a sudden roar of applause. I found myself surrounded by excited faces. How my friends carried on! Men shook my hand—wildly congratulated me—pounded me on the back in their enthusiasm! Everybody was exclaiming with delight—plying me with rapid questions.... "Jack! Why didn't you tell us you could play like that?" ..."Where *did* you learn?"—"How long have you studied?"—"Who *was* your teacher?"

"I have never even *seen* my teacher," I replied. "And just a short while ago I couldn't play a note."

"Quit your kidding," laughed Arthur, himself an accomplished pianist. "You've been studying for years. I can tell."

"I have been studying only a short while," I insisted. "I decided to keep it a secret so that I could surprise all you folks."

Then I told them the whole story.

"Have you ever heard of the U. S. School of Music?" I asked. A few of my friends nodded. "That's a correspondence school, isn't it?" they exclaimed.

"Exactly," I replied. "They have a new simplified method that can teach you to play any instrument *by note* in just a few months."

How I Learned to Play Without a Teacher

And then I explained how for years I had longed to play the piano.

"It seems just a short while ago," I continued, "that I saw an interesting ad of the U. S. School of Music mentioning a new method of learning to play which only cost a few cents a day! The ad told how a woman had mastered the piano in her spare time at home—and *without a teacher!* Best of all, the wonderful new method she used required no laborious scales—no heartless exercises—no tiresome practising. It sounded so convincing that I filled out the coupon requesting the Free Demonstration Lesson.

"The free book arrived promptly and I started in that very night to study the Demonstration Lesson. I was amazed to see how easy it was to play this new way. Then I sent for the course.

"When the course arrived I found it was just as the ad said—as easy as A. B. C.! And as the lessons continued they got easier and easier. Before I knew it I was playing all the pieces I liked best. Nothing stopped me. I could play ballads or classical numbers or jazz, with equal ease. And I never did have any special talent for music."

Play Any Instrument

You, too, can now *teach yourself* to be an accomplished musician—right at home—in half the usual time. You can't go wrong with this simple new method which has already shown almost half a million people how to play their favorite instruments *by note*. Forget that old-fashioned idea that you need special "talent." Just read the list of instruments in the panel, decide which one you want to play and the U. S. School will do the rest. And bear in mind no matter which instrument you choose, the cost in each case will be the same—just a few cents a day. No matter whether you are a mere beginner or already a good performer, you will be interested in learning about this new and wonderful method.

Send for Our Free Booklet and Demonstration Lesson

Thousands of successful students never dreamed they possessed musical ability until it was revealed to them by a remarkable "Musical Ability Test" which we send entirely without cost with our interesting free booklet.

If you are in earnest about wanting to play your favorite instrument—if you really want to gain happiness and increase your popularity—send at once for the free booklet and Demonstration Lesson. No cost—no obligation. Sign and send the convenient coupon now. Instruments supplied when needed, cash or credit. **U. S. School of Music, 812 Brunswick Bldg., New York City.**

Pick Your Instrument

Piano
Organ
Violin
Drums and Traps
Mandolin
Clarinet
Flute
Saxophone
'Cello

Harmony and Composition
Sight Singing
Ukulele
Guitar
Hawaiian Steel Guitar
Harp
Cornet
Piccolo
Trombone

Voice and Speech Culture
Automatic Finger Control
Piano Accordion
Banjo (5-String, Plectrum or Tenor)

U. S. School of Music,
812 Brunswick Bldg., New York City.

Please send me your free book, "Music Lessons in Your Own Home," with introduction by Dr. Frank Crane. Demonstration Lesson and particulars of your offer. I am interested in the following course:

Have you above instrument?......................

Name................................
 (Please write plainly)

Address................................

City................State................

Time to Re-tire?
(Buy Fisk)

We Hold Our Trade

ONLY *permanent customers* can make permanent success. Only *satisfaction* can make *permanent customers*. On this belief we base our manufacturing and selling policies.

We do not aim to sell to the million car owners. We do aim to please continuously our constantly increasing part of that million to whom we sell whenever tires are needed. *We hold our trade.*

Year after year, for car after car, we sell to the same customers. Members of the same family, business associates and friends recommend our tires and service one to another.

WE OFFER tires of demonstrated quality, the courteous and far-reaching service of an unusually efficient organization, a sincere effort on our part to hold our customers through their satisfaction with Fisk Tires and our methods of doing business.

THE FISK RUBBER COMPANY

Factory and Home Office: Chicopee Falls, Mass.
18,000 Dealers Everywhere and Fisk Branches in Principal Cities

DON'T FOOL YOURSELF

Halitosis makes *you unpopular*

It is unexcusable . . . can be instantly remedied

No matter how charming you may be or how fond of your friends are, you cannot expect them to put up with halitosis (unpleasant breath) forever. They may be nice to you—but it is an effort.

Don't fool yourself that you never have halitosis as do so many self-assured people who constantly offend this way.

Read the facts in the lower right hand corner and you will see that your chance of escape is slight. Nor should you count on being able to detect this ailment in yourself. Halitosis doesn't announce itself. You are seldom aware you have it.

Recognizing these truths, nice people end any chance of offending by systematically rinsing the mouth with Listerine. Every morning. Every night. And between times when necessary, especially before meeting others.

Keep a bottle handy in home and office for this purpose.

Listerine ends halitosis instantly. Being antiseptic, it strikes at its commonest cause—fermentation in the oral cavity. Then, being a powerful deodorant, it destroys the odors themselves.

If you have any doubt of Listerine's powerful deodorant properties, make this test: Rub a slice of onion on your hand. Then apply Listerine clear. Immediately, every trace of onion odor is gone, even the strong odor of fish yields to it.—Lambert Pharmacal Company, St. Louis, Mo., U.S.A.

The new baby—
LISTERINE SHAVING CREAM
—you've got a treat ahead of you.
TRY IT!

READ THE FACTS
⅓ had halitosis

66 hairdressers state that about every third woman, many of them from the wealthy class, is halitoxic. Who should know better than they?

LISTERINE
The safe antiseptic

I'M SENDING CHESTERFIELDS to all my friends. That's the merriest Christmas any smoker can have — Chesterfield mildness plus no unpleasant after-taste

Ronald Reagan

see RONALD REAGAN starring in "HONG KONG" a Pine-Thomas Paramount Production Color by Technicolor

CHESTERFIELD *Buy the beautiful "Christmas-card" carton*

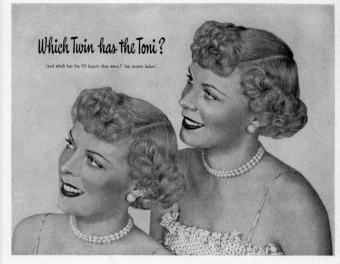

BARE NEW WORLD

What would Freud have made of young women who fantasized about showing their bras in public, as in this 1954 ad? The campaign that lifted Maidenform atop the industry ended in 1969 (when Madonna was at the impressionable age of 11).

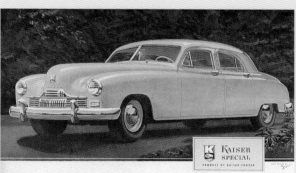

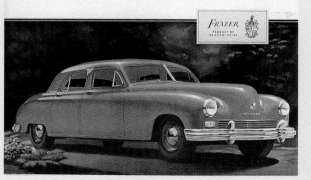

MIRROR, MIRROR

You wouldn't know from ads that only four of 1,000 births lead to identical twins. Above, the Toni look-alikes started in 1949; Wrigley has showcased some 40 sets of doubles in its Doublemint gum campaign, running since 1939.

LIGHT ONE FOR THE GIPPER

In 1950, at 39, he seemed to be just another B-star cashing in. Yet DiMaggio and Dietrich also shilled smokes, and not until 1964 did the Surgeon General link cigarettes to cancer. So in 1980, an untarred Ronald Reagan got to mount a grand second act.

< POINT OF NO RETURN

By 1947, the U.S. auto industry had shrunk from a high of 88 makers to the Big Three (GM, Ford, Chrysler) and seven independents. Recently merged Kaiser and Frazer proved beyond Madison Avenue's help; by 1954, these Little Two were history.

< SWEET BIRDS OF YOUTH

Nymphetomania was the charge in 1980 when Brooke Shields, 15, confided that nothing came between her and her Calvins. Calvin shrugged and ran print ads ever more cheesecakey (Christy Turlington), beef-cakey (Marky Mark) or nocakey (Kate Moss).

< PIED PIPER WITH HUMPS

Tobacco had been banned from TV for 17 years when Joe Camel made his print debut in 1988. Did the cartoon target kids, as critics insisted (and polls confirmed)? Sure. Though governments cracked down on sales to minors, the FDA's attempt to forbid all ads was, in 2000, judged unconstitutional.

> HUMAN KINDESS

At least these 1996 rivals for the White House agreed on something. Or did they? Turns out that these were stock photographs doctored with computer-generated mustaches — but neither Bill Clinton nor Bob Dole had a beef with the public-service ad.

Vote. Strengthen America's Backbone.

MILK
Where's *your* mustache?℠

<

INDULGE NOW, PAY LATER

When it came time in 1949 to pay the tab for entertaining clients, Frank McNamara, 32, found himself short. (Mrs. McNamara had to go bail him out with cash.) Soon after, the New York City credit specialist invented Diners Club, the country's first charge card. At last count, there were a billion pieces of plastic out there — or four for every American.

ROY STEVENS

BRING HOME THE BACON

In 1954, the Kroger Food Foundation sponsored a freewheeling focus group by turning 54 grade-schoolers loose in a Cincinnati supermarket. Sociologists and marketing experts were sure the kids would load up on ice cream, candy and comic books. Instead (no doubt prepped by their parents), they filled their carts with staples.

FRANCIS MILLER / LIFE

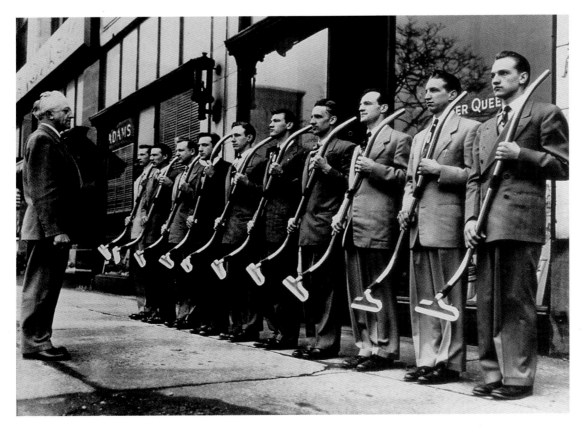

<

OUR PRODUCT SUCKS

Dust bunnies were an endangered species in Clio, Michigan, in 1952. That's Paul Kolenda, 59, inspecting his sales force of 10 sons. Family businesses like Kolenda's vacuum cleaner distributorship became an endangered species with the rise of national chain stores.

CORBIS / BETTMANN-UPI

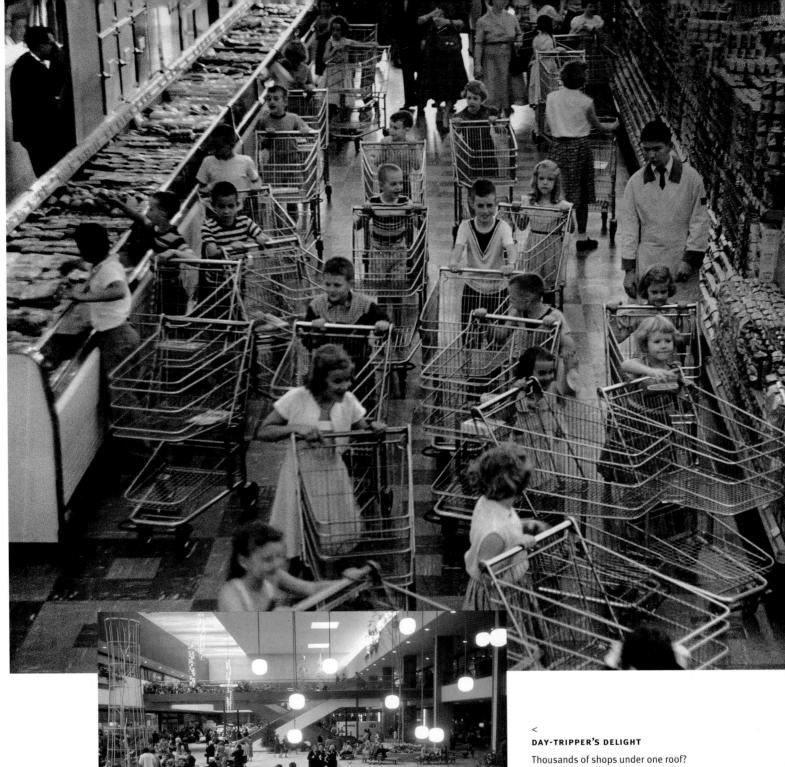

DAY-TRIPPER'S DELIGHT

Thousands of shops under one roof?
Istanbul's Grand Bazaar has been open
for business since the mid–15th Century.
The first major American indoor mall was
Southdale Regional Shopping Center in
Minneapolis, built in 1956. It had 72
retailers, including two department
stores, amenities like an aviary and
Muzak, and 45 acres of parking.

GREY VILLET / LIFE

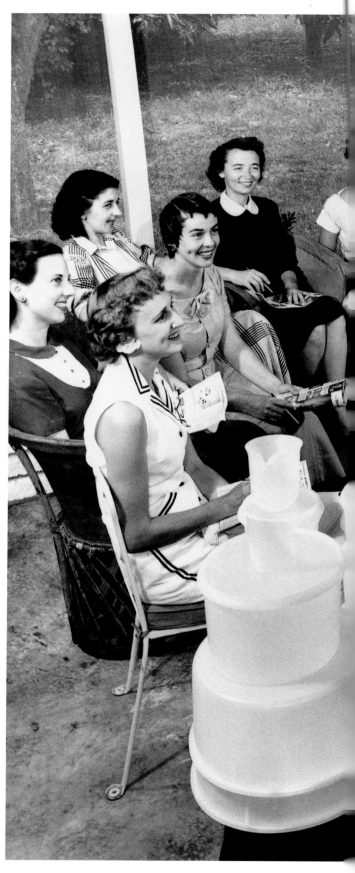

KINGS OF THE COOP

In 1957, Salisbury, Maryland, chicken farmer Arthur Perdue, 62 (above, with son Frank, 37, and grandson James, 7), sold his birds locally. Thanks to a clever TV ad campaign begun by Frank in 1971, Perdue poultry products — the first brand-name raw meat — were available on four continents in 1992, a year after James became the CEO.

COURTESY PERDUE FARMS

<

WANNA SHARE?

Why were these guys trooping around rural Kansas in 1958? Bringing Wall Street to Main Street (from far left, Bache salesmen Bob Muir, Kelly Slaughter, Lyle Fackler and Harry Nickelson). Back then, some 10 million Americans owned securities. The number doubled by 1965, and today some 80 million of us are keeping up with the Dow Joneses.

STAN WAYMAN / LIFE

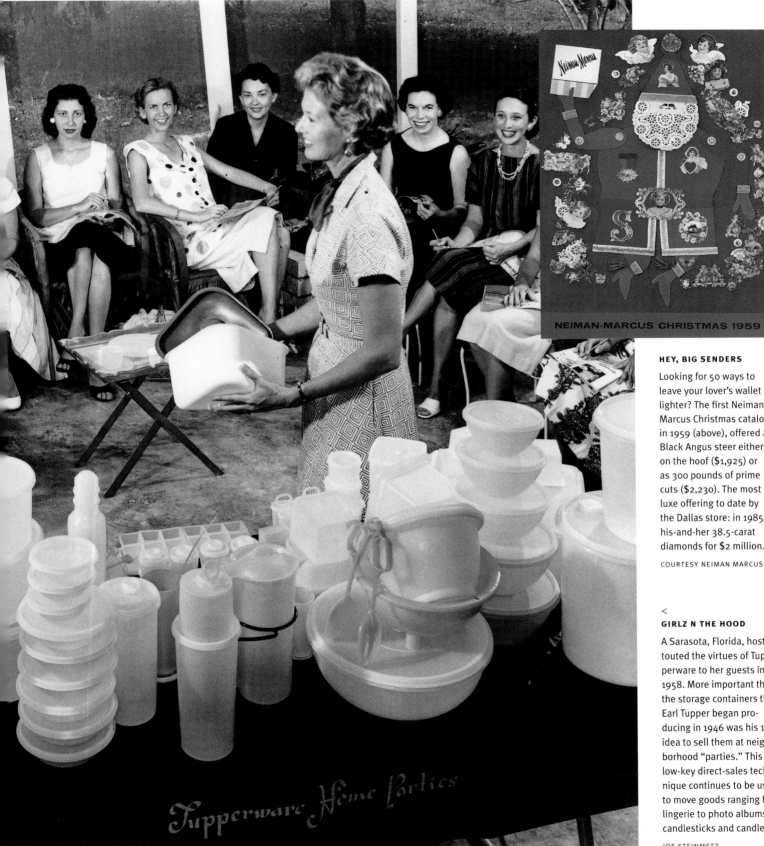

NEIMAN-MARCUS CHRISTMAS 1959

Tupperware Home Parties

HEY, BIG SENDERS

Looking for 50 ways to leave your lover's wallet lighter? The first Neiman Marcus Christmas catalog, in 1959 (above), offered a Black Angus steer either on the hoof ($1,925) or as 300 pounds of prime cuts ($2,230). The most luxe offering to date by the Dallas store: in 1985, his-and-her 38.5-carat diamonds for $2 million.

COURTESY NEIMAN MARCUS

<

GIRLZ N THE HOOD

A Sarasota, Florida, hostess touted the virtues of Tupperware to her guests in 1958. More important than the storage containers that Earl Tupper began producing in 1946 was his 1951 idea to sell them at neighborhood "parties." This low-key direct-sales technique continues to be used to move goods ranging from lingerie to photo albums to candlesticks and candles.

JOE STEINMETZ

TOO LITTLE, TOO LATE

Itinerant peddlers are as old as America itself. In 1962, some New York City merchandisers came up with a five-and-dime on wheels to cater to suburban housewives. They didn't notice that with 79 million cars registered and 32.7 million women licensed to drive, the little lady was no longer housebound. Nor did they notice that malls were a-building.

MCCRORY CORPORATION

<

STICK-TO-ITIVENESS

In 1960, after parishioners had spent $1.1 million with merchants issuing Green Stamps, St. Francis Parish School in Provo, Utah, redeemed enough booklets for three new school buses. Sperry & Hutchinson introduced the premium — forerunner of the frequent-flyer mile — in 1896. The concept has been retooled for e-commerce; some 100 online merchants now offer S&H "greenpoints."

CARL IWASAKI

WETTING THE BED

Water beds were invented to help arthritics, but even high-end stores like Bloomingdale's in New York stocked them in the 1970s. But the lava-lamp generation soon found that not every floor could support the units, which weighed a ton when filled. And that Dramamine was not an aphrodisiac.

SY FRIEDMAN / ZODIAC

LEI'D-BACK MOGUL

What prompted Sam Walton, 65, to shake a grass skirt in 1984? He had bet fellow Wal-Mart execs on the size of pretax profits. Mr. Sam guessed too low and settled up by doing a hula on Wall Street. That year, the discount chain he founded in 1962 numbered 745 stores. In 2000, eight years after his death, it had grown to 4,000 stores and 1,140,000 employees.

JOHN MCGRAIL

A PENNY SAVED . . .

The attention of Kmart shoppers in Pottstown, Pennsylvania, was captured in 1991 by three city slickers. Donald Trump Jr., 13, enrolled at a nearby boarding school, needed some supplies. Mom Ivana, 42, survived the outing. Dad Donald, 45, the real estate and casino developer, almost didn't. The store refused to take the credit card he flashed and insisted on cash.

JOHN STRICKLER /
MERCURY PICTURES

THE FUTURE IS NOW

Forget the Star Wars anti-missile system; in 1992, at a grocers' convention in Orlando, the high-tech device that awed infrequent shopper George Bush, 67, was a scanner that read a product's bar code and rang up its price. "Amazed by some of the technology," confessed the president, unaware that the system, introduced in 1974, was by then already in a majority of U.S. supermarkets.

ORLANDO SENTINEL / LIAISON

PERFECT PITCHMAN

By 1992, when Ron Popeil, 57, began spritzing GLH-9, the TV spielmeister had already sold to late-night audiences such gadgets as Veg-O-Matic, the Pocket Fisherman, the Smokeless Ashtray and the Inside-the-Shell Egg Scrambler. And he had helped invent infomercials. (Watch Suzanne Somers work a Thigh Master!) So what was GLH-9? A "hair spray" to knock the shine off bald spots.

STEVEN LABADESSA

MEG WHITMAN

The Web Mistress

To join America's first Gold Rush, you trekked to California. To join its second, you just put up a Website. No one knows if dot commerce will one day yield mother lodes or pyrite — buying plane tickets and books on the Net, O.K., but fresh produce? Among the first virtual businesses to turn an actual profit: eBay. In two years, CEO Meg Whitman upgraded an online flea market (used CDs for a buck) into an auction site visited by 1.8 million daily. Nearly a billionaire after taking eBay public, she earns her keep policing it against varmints who rig bids and misrepresent goods. It seems cyberspace is as wild and woolly as the Old West.

As a high school senior on Long Island, New York, in 1973 (far left), Whitman, 16, planned to go into business; at Princeton, she had the *Wall Street Journal* delivered to her dorm. In 1998, while running Hasbro's Playskool division, she was recruited by eBay founder Pierre Omidyar, 33 (above). Whitman's job includes some kitschy perks (right). But the mother of two spends many of her 70-plus-hour workweeks as eBay's media face (left) — and crystal-balling the uncertain future of doing business on the electronic frontier.

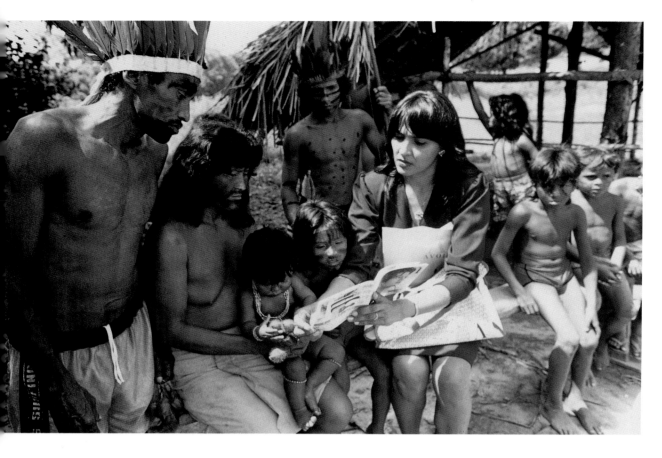

>
TEMPLE OF RETAIL

To the Mall of America in Bloomington, Minnesota, go 40 million shoppers a year (some on buy-polar flights from Europe and Japan). Opened in 1992, the 78-acre complex boasts 520-plus stores, 80-plus eateries, amusement park rides, an aquarium with sharks, and a wedding chapel. For the record, a mall in West Edmonton, Canada, is even bigger.

BOB SACHA

<
CAN WE HAWK?

If comedy isn't pretty, what about flogging paste jewelry on a 24/7 shopping channel (left, Joan Rivers, 61, in 1994)? But HSN, which went national in 1985, and QVC, which debuted the next year, knew their couch potato audience. In 1999, the rivals combined to ship $3.5 billion in goods that ranged from AA batteries to zircon rings.

LIAISON

sex

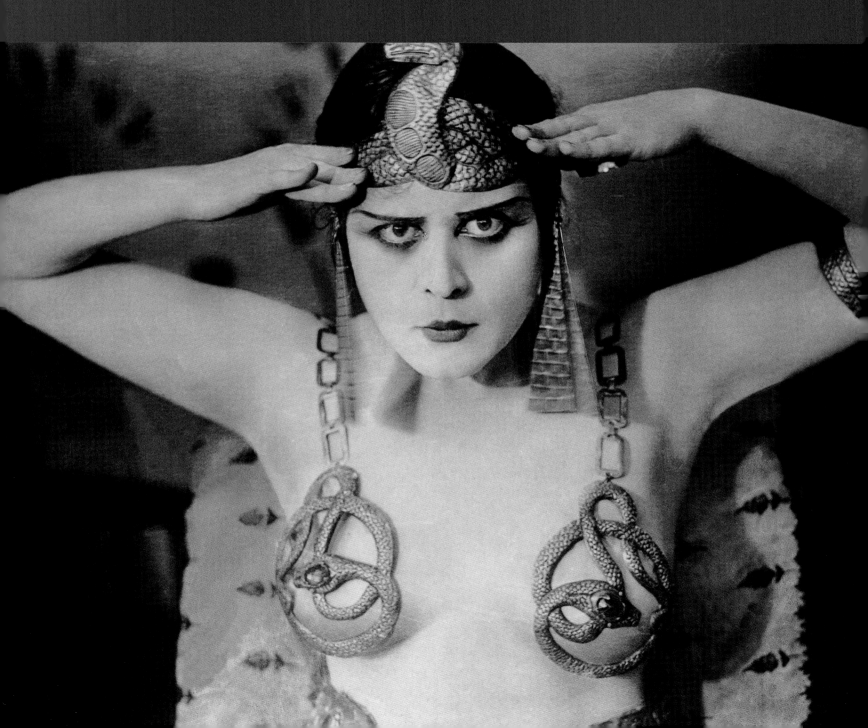

A Hollywood director in the Forties called the three-letter word Topic A. Long before that, it was the reason for Theda Bara's mascaraed ticket to stardom as a predator in 1915's *A Fool There Was*. Long after, the game was the same in 1996 when Demi Moore played a single mom reduced to topless employment in *Striptease*.

FROM NO-NO'S TO ANYTHING GOES

How to Put the Mystery Back

BY ERICA JONG

WHEN THE cultural history of the 20th Century is written by our dispassionate great-great-great-grandchildren, they will have a hard time describing the revolution in sexual mores that took place between 1900 and 2000. Even those of us who lived through the so-called sexual revolution have difficulty describing it. How did we go from "down there" to *The Vagina Monologues*? How did we go from "self-abuse will make you blind" to "oral sex isn't really sex"? From the propriety of Woodrow Wilson to the randiness of Bill Clinton? Clearly a vast change in the nature of privacy took place and with it all sorts of changes in the language we speak, the way we raise children and the mating rituals we practice.

At the root of it all is the triumph of birth control. Until women had control over their own fertility, there could be no sexual revolution. And the sexual revolution itself happened in two waves — in the Twenties and in the Sixties. The Twenties brought cropped hair, short skirts, rumble seats and diaphragms. The Sixties brought unisex blue jeans and long hair, love-ins and the pill. Both were periods of great prosperity, innovative music and feminism. Both were followed by cultural backlash, yet the changes they brought were gradually absorbed by the culture even as they seemed to be repudiated.

I went to college in the Sixties — before the Sixties really became the Sixties, a transformation that actually occurred circa 1968. Girls were thrown out of Barnard in my day for having boys in their rooms — and, coincidentally, for wearing Bermuda shorts. The female members of the class of 1963 were still apt to marry their first lovers, have children early and often and delay their career gratifications till their kids were grown.

By 1973, when my first novel, *Fear of Flying*, was published, all that had changed. Wide sexual experience was the rule not the exception, marriage was delayed by both men and women, and it seemed for a brief period that there were no wages to be paid for sin. Between 1968 and 1980, youth really flamed. It was only in the Eighties that AIDS and other sexually transmitted diseases dampened the culture's enthusiasm for guiltless sex. And yet despite all the proselytizing for safe sex and disease prevention lavished on kids born in that scary decade, they have not turned back the clock to the Fifties. They are more blasé about sex than we ever were; they seem to be comfortable with the idea of oral sex before they even hit double digits. Some of them, we're told, are even doing it without thinking they are having sex. Like Bill Clinton, they believe that if penetration doesn't occur, they are still virgins. Even when penetration does occur, the condom seems to have taken the place of the bundling board as a guarantor of purity.

This orgy appeared on screen in the Twenties, clearly influenced by that decade's sexual revolution. It was a last-gasp effort by Hollywood before scandalized conservatives quashed such licentiousness in the Thirties.
PARAMOUNT PICTURES

These are changes that would astound our grandparents. And they all coalesced rather late in that amazing century. Perhaps it's too early to say that we have abandoned puritanism and reverted to paganism, but sexual attitudes really are different than they were when the century began. They are certainly different than they were halfway through the century when I first encountered them. The distinction between private and public has been abolished.

Can sex survive all this publicity? Has its mystery and danger been lost or will new forms of mystery and danger arise? It does seem harder to shock people sexually than ever before — but when hormones rage, people are no less interested in sex. Have we all become so overstimulated by sexual publicity that we will demand ever bloodier and more violent forms of sexual entertainment? Or will sexual hypocrisy metamorphose into new forms? Occa-

sionally sexual conservatives like Wendy Shalit rediscover the intrigue of premarital virginity. This longing for virginity may really be a longing for mystery and romance, for a new form of love that dares not speak its name.

My own generation seemed just as quaint and misguided in its way. Raised in the fearful Fifties, we believed that freedom to fornicate, to use four-letter words and possibly to put a drop of LSD in the water supply would bring not only nirvana but also world peace. We had to experience the disappointments of sexual freedom to understand that it did not, in and of itself, usher in paradise. It was not just the problem of sexually transmitted diseases that cooled the sexual revolution, but the discovery that sex without inti-

For nine inhibition-free years, between 1977 and 1986, the New York swingers' club Plato's Retreat symbolized sexual license. Patrons whipped each other (sometimes literally) into ever wilder exhibitionistic displays; legal skirmishes and fear of AIDS cooled everyone down.

CORBIS / BETTMANN

macy can be downright depressing. We had dealt with our guilt, but we had not dealt with our romanticism. For the dreaming, fantasizing creature that is *Homo sapiens*, sex is always better when it is part of a quest.

What new quests will future generations devise? What new prohibitions will enhance eros for them? There has never been a time in history when eros was altogether without restrictions. Will our grandchildren and great-grandchildren rediscover virginity, arranged marriages, stoning as a punishment for adultery — just to put the danger back into sex? Stranger things have happened in human history. Certainly the rise of fundamentalism in our time bespeaks a nostalgia for the bad old days of sexual prohibition. And the popularity of cybersex tells us that disguise and distance are more powerful aphrodisiacs than familiarity and comfort.

People who tabulate these things tell us that the typical sex-addict — is there such a person? — spends an average of 11 hours a week exploring sex online. Supposedly this has a disastrous effect on

marriages as spouses sneak out of bed in the middle of the night to hook up with mysterious lovers in the ether. "Just tell your partner what's going on," therapists urge, "if you want to preserve your marriage." But of course if you tell your partner what's going on, the wicked edge of risk is lost. What these cyberspace lovers long for is exactly this sense of risk in a world where sex has become ever more mundane. The truth is that we long to invent and idealize our lovers every bit as much as Petrarch and Dante did. That good old pal in a baggy T-shirt who helps us unload the groceries or unclog the toilet will never be as alluring as the lover we know only by wisps of ambiguous description on the screen. Is cyberspace teaching us what the poets always knew — that sexual words are sexier than sex itself?

At the beginning of this new century, we seem to be longing for a return to sexual secrecy. Bring back the veils and smoked mirrors, the forbidden partners, the vamps flickering through the beaded curtain of cyberspace. Make up a name, any name, with a sexual connotation and chances are it exists online and wants your credit card number. Type in *sex-chat* or *animal-lovers* or *trans-sex talk* and something like it is sure to exist on the Web. The Web needs your billing information, but it does not need your real name or address. (Apparently sex sites are the only ones that consistently make money.) There are still plenty of people who are too ashamed of their desires to use their real names. But not too ashamed to describe in detail their perversions and the fantasy lovers they hope to share them with. Sex slaves seem to be perennially sought by men who call themselves "masters." But are they really men or are they women who want to be men? You can never trust gender in cyberspace. Or identity. This is part of the allure. Browsing through the sex chat rooms in search of insights about sex in the 21st Century, I am struck by the hardiness of sexual perversions — animals, excrement, submission, dominance, kiddie porn. Is

How did she keep it on? Was it legal? Everybody wanted to know after actress Jennifer Lopez stepped out for the 1999 Grammy Awards in a strategically pinned, oversize scarf by designer Donatella Versace. The best guess: invisible tape at the top, built-in panties below.

brains with sexual signals; in the midst of the sensual static they are starving for soul. Now that I find myself with a daughter in her twenties who, like her mother before her, is looking for love in all the wrong places, I wish we could bring back arranged marriages. How can a kid be expected to make the crucial decision of finding a life-partner on the basis of fickle hormones alone? Why aren't we giving them more help? How can we leave something as essential as the begetting of our grandchildren to chance?

I read back what I've written here, and I am vaguely horrified. Is sexual conservatism creeping up on me? In my twenties, it was sexual hypocrisy that obsessed me and inspired my most transgressive satires. Now that sex is everywhere, hypocrisy is beginning to look a lot more attractive to me. I've started to believe that discreet adultery is better for children than the serial monogamy and disastrous divorces I myself experienced. I have nostalgia for matchmakers and the matches they made. What's next? Am I destined to lead marches on Washington for born-again virgins? I hope not. But I am searching for ways to bring back the poetry and mystery of sex. By bringing sex so relentlessly out into the open, we have lost its essential chiaroscuro. It is less beautiful for that even if it is more democratically available to all. Do we really want sex to be so damned democratic? Isn't exclusivity part of its ineffable charm?

When Sappho wrote, "Like a mountain whirlwind / punishing the oak trees, / love shattered my heart," she was thinking of a very particular whirlwind — one that cannot easily be found online.

Erica Jong is the author of six best-selling novels, including Fear of Flying. *She also has published a memoir,* Fear of Fifty; *six collections of poetry; and books about Henry Miller and witches and witchcraft. She is currently writing a novel and a book of poems.*

there nothing new under the sexual sun? The medium changes but not the message. Tie me up! Tie me down! Fill every aperture! The loneliness behind these urgent cries is heartbreaking.

In a world in which the population explodes exponentially every year, loneliness seems to be the secret message behind sexual hunger. Sex is everywhere, it seems, but intimacy is rare. Sex slaves advertise online, but soulmates are hard to find.

Perhaps you will attribute it to the waning hormones of middle age, but I think our society is having a love crisis, not a sex crisis. We have blasted our kids'

OUR
$18.00 Giant Power Heidelberg Electric Belt

FOR $18.00 WE OFFER THE GENUINE 80-GAUGE CURRENT HEIDELBERG AL-
TERNATING, SELF-REGULATING and ADJUSTING ELECTRIC BELT
AS THE HIGHEST GRADE, VERY FINEST ELECTRIC BELT EVER MADE, AS THE ONLY SUCCESSFUL ELECTRIC BELT
TREATMENT, as the most wonderful relief and cure of all chronic and nervous diseases, all diseases, disorders and weaknesses
peculiar to men, NO MATTER FROM WHAT CAUSE OR HOW LONG STANDING.

$18.00 IS OUR LOW PRICE, based on the actual cost to manufacture, for this highest grade electric belt, a superior belt to those usually sold at $6.00 to $0.00. Our $18.00 Giant Power Belt is the result of years of scientific study and experiment. It is the very highest grade, a belt that has all the best features of other electric belts without their drawbacks, defects and discomforts, with exclusive and distinctive advantages not found in other makes. Positively wonderful in its quick cure of all nervous and organic disorders arising from any cause, whether natural weakness, excesses, indiscretions, etc. The nerve building, health giving, vigor restoring current penetrates and permeates the affected parts; every nerve, tissue and fiber responds at once to its healing, vitalizing power; health, strength, superb manliness, youthful vigor is the result.

OUR GIANT POWER 80-gauge Current Genuine Heidelberg Alternating Electric Belt at $18.00 will do you more good in one week than six months of doctoring. The Heidelberg Electric Belt for disorders of the nerves, stomach, liver and kidneys, for weakness, diseased or debilitated condition of the sexual organs from any cause whatever, is worth all the drugs and chemicals, pills, tablets, washes, injections and other remedies put together. Its strengthening, healing and vitalizing power is magical—never before equaled.

HAVE YOU DOCTORED? Have you perhaps written to some quack, so called institute or self styled men's physician, have you tried various so called remedies for your peculiar trouble without success, without getting any help, perhaps not even temporary relief. Perhaps you are discouraged; maybe hopeless. Don't give up. Don't despair. You may yet be cured. Just what you should wear. Send for our Giant Power 80-gauge Current Heidelberg Electric Belt at once, wear it according to directions. In a day you will feel a difference, in two days there will be a marked change for the better, in three days you will experience relief, in a week or two weeks your system will be filled with the grand health giving current, in a month you will be a new man.

OUR GIANT POWER 80-GAUGE HEIDELBERG ELECTRIC BELT AT $18.00 comes complete with the finest stomach attachment and most perfect, comfortable electric sack suspensory ever produced. The lower illustration shows the style of these attachments, but you must see and examine, wear them, to appreciate the comfort and convenience. The suspensory encircles the organ, carries the vitalizing, soothing current direct to these delicate nerves and fibers, strengthens and enlarges this part in a most wonderful manner. The sack suspensory forms part of the circuit. The electric current must traverse every one of the innumerable nerves and fibers. Every wearing brings the current in contact with the organ; every wearing means that part of the organ is traversed through and through with the strengthening, healing current; means a livelier impaired, a vigor induced, a tone returned, a joy restored that thousands of dollars' worth of medicine and doctors' prescriptions would never give.

DON'T SUFFER IN SILENCE. Don't endure it secret. $18.00 will buy our Giant Power 80-Gauge Current Genuine Heidelberg Electric Belt. $18.00 will enable you to face the world anew. $18.00 will bring to you health and strength, vigor, manliness and happiness, a bigger measure for your money, a greater bargain than you could ever possibly secure in any other purchase.

ARE YOU IN DOUBT? Have you tried so called remedies without avail and fear to take advantage of this great offer? Do you hesitate because some unreliable firm or doctor took advantage of you? With us you run no possible risk. Let us send you one of our Genuine Giant Power 80-gauge Heidelberg Electric Belts under the liberal condition of our offer. We will send you the belt, then after ten days' fair trial if you have any reason to be dissatisfied, if you are not greatly benefited, return the belt to us and we will refund your money.

HOW THE 80-GAUGE HEIDELBERG ELECTRIC BELT IS MADE. Every $18.00 80-Gauge Electric Belt of the Heidelberg make is the very finest belt that can be manu-actured, made of the highest grade materials money will buy, put together by scientific, skilled mechanics, hand made and finished in every part. The casing for the battery of cells is made of an extra quality very fine selected satin, a grade prepared particularly for this purpose, absolutely non-conducting, lined with a genuine Brighton insulating flannel, and then a layer of close woven non-conducting duck, forming the very best and perfect insulating case possible.

THE BATTERY in our $18.00 Giant Power Heidelberg Electric Belt we furnish the new and genuine Heidelberg battery, consisting of triple cells, producing an 80-gauge current. The battery is made of a secret, highly excitable, metal alloy and composition of silver and copper, a combination producing the quickest, most powerful and lasting current. No battery in any other make can compare in any respect to the Heidelberg. One cell of a Heidelberg battery, with its distinctive triple construction and special composition, has more strength, produces more current, than two cells of the ordinary electric belts usually advertised.

ELECTRODES. Four large and one extra large (five in all) electrodes secure a fine equal distribution of the current to the proper organs and affected parts. The electrodes are large size, splendid conducting surface, extra full and finely silver plated. The four electrodes in back are 2 inches across, the front and largest electrode is 5 inches across. Wonderful in its treatment of diseases of the stomach, liver and kidneys. Carries the life giving electric fluid straight to the affected parts. The big current bearing electrodes can be adjusted for any position, any part, any organ, bringing it in the direct route of the current. For a weak or deranged nervous system the electric treatment has splendid results. It stops losses, gives tone to every tissue and muscle. The whole body feels the good effect. No words can describe the change in health, feeling, vitality, even character, from the result of wearing a genuine Heidelberg Giant Power Electric Belt.

EVERY BELT IS PUT OUT UNDER OUR BINDING GUARANTEE for more current, more power, more and quicker relief than any belt sold at three times the price. Simple, comfortable, efficient. Wear it, nothing clumsy about the belt, nothing uncomfortable. No one can tell if you wear it. Complete instructions for use and wear with every belt.

CURRENT REGULATOR. Every 80-gauge Heidelberg Electric Belt is provided with our own special and perfect current regulator, a feature imitated (but not successfully) by every electric belt maker in the country. By means of this regulator the current can be instantly adjusted to any strength desired without removing the belt from the body. You can make it mild, medium or strong, just as you like, just as your case requires. No possibility of your receiving an unpleasant shock, no chance to get a current too strong and irritate tender parts. Six different strengths, different degrees of current are possible. A simple movement of a tiny one-inch lever does it. You get just the strength, just the gauge of current required.

THE 80-GAUGE CURRENT is marvelous, really magical in its power. Will cure any case, no matter how obstinate, how long standing. Tones up the system, drives out disease, fortifies the body against cold, against sick attacks of any kind. Perfect in its relief and cure of the peculiar diseases of men. For those sexually weak or impotent or suffering from any trouble of the sexual organs the Giant 80-gauge Belt affords relief when everything else has failed. The stimulating alternating current forces a vigorous circulation of blood into the seminal glands, enlivening them into a healthy glow. They quickly respond to this infusion of energy, dormant nerves wake up and expand, general circulation is produced, youthful vigor displaces the tired out feeling, natural power returns. In most cases of sexual weakness the full power of this belt is required, but a cure is certain. The 80-gauge current absolutely doubles the sexual force and power.

No. 8R3020 OUR 80-GAUGE CURRENT BELT..............$18.00

FOR QUICK RELIEF for an ultimate speedy cure of all weaknesses, no matter from what cause, nothing can equal, nothing, whether drugs or chemicals, approaches the 80-gauge Heidelberg Alternating Current Electric Belt at $18.00. The Heidelberg Electric Belt is the best, most reliable, most harmless yet powerful, most efficient and the cheapest cure possible. Don't let a specialist bleed you. Don't pay $25.00, $30.00 or $50.00 for an electric belt not one-half as good as the Genuine 80-gauge Giant Power Alternating Current Heidelberg Electric Belt at $18.00. Send for one of our $18.00 belts immediately. Throw physic to the dogs. Strengthen and cure yourself at once.

Sent on 10 Days' Free Trial

THE CURTAIN FALLS

"We expect the police to forbid on the stage what they would forbid on the streets and low resorts," thundered a New York newspaper about the 1900 stage debut of playwright Clyde Fitch's daring *Sapho*, starring Olga Nethersole. Cops closed the show after 29 performances. Its abiding sin? A scene in which the heroine (left) is spirited away (toward a presumed love nest) in the arms of her leading man.

CULVER PICTURES

ALL CHARGED UP

In 1901, men suffering from impotence had no recourse to heavily advertised wonder drugs endorsed by former presidential candidates. Instead, they had the Sears, Roebuck catalog, which featured the (staggeringly expensive at $18) Giant Power Heidelberg Electric Belt, a contraption that claimed to cure male inadequacy with a jolt of current to the affected parts. Oysters, anyone?

SILENT TREATMENT

Margaret Sanger was accustomed to not being heard, starting with the 1917 New York ban on *Birth Control*, a movie using scenes from her life as an advocate of contraception. (Her mother had 11 babies.) Jailings were common. And when prevented from speaking in Boston in 1929 (above), she protested being gagged in a literal way.

BIOLOGICAL WARFARE

Venereal disease in World War I was so widespread that the armed forces lost an estimated seven million days in manpower to it. The brass closed brothels near military bases and put up scary exhibits like this showing the ravages of syphilis. By World War II, the battle against STDs was fought with training films and condoms.

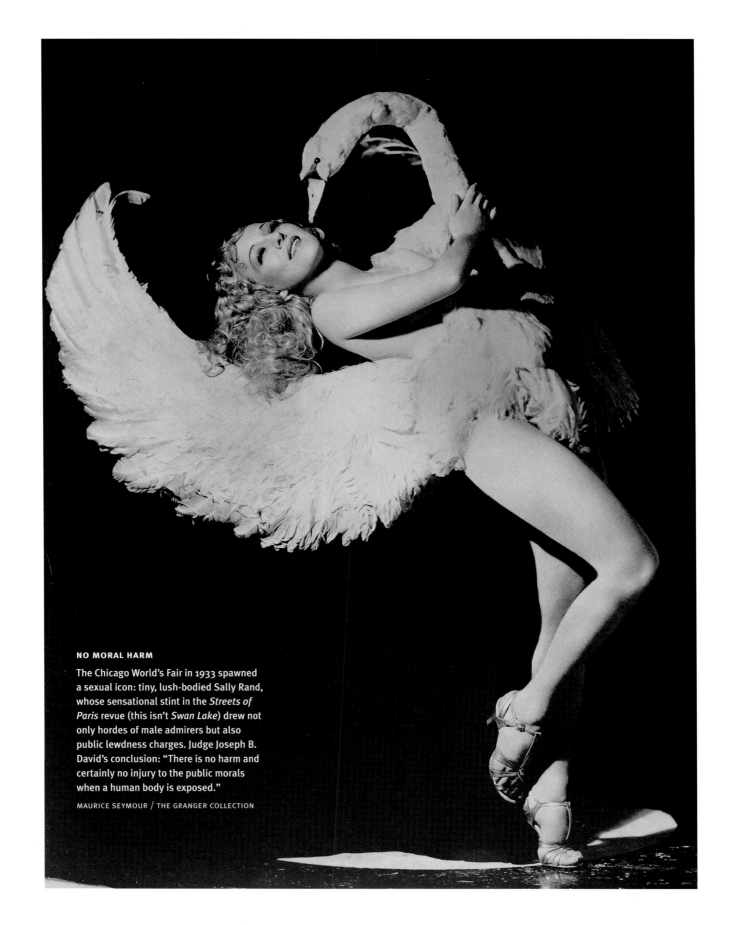

NO MORAL HARM

The Chicago World's Fair in 1933 spawned a sexual icon: tiny, lush-bodied Sally Rand, whose sensational stint in the *Streets of Paris* revue (this isn't *Swan Lake*) drew not only hordes of male admirers but also public lewdness charges. Judge Joseph B. David's conclusion: "There is no harm and certainly no injury to the public morals when a human body is exposed."

MAURICE SEYMOUR / THE GRANGER COLLECTION

>

JUNGLE FEVER

Johnny Weissmuller, 29, and Maureen O'Sullivan, 22, posed sedately in skins to promote 1934's *Tarzan and His Mate*, but on screen they swung, and not just from vines. Moviegoers thought of them as married. (Who officiated, Cheetah?) But there was no mistaking their erotic domestic life when Jane awoke beside her beefcake and murmured adoringly, "Oh, Tarzan, you're a bad boy."

THE MUSEUM OF MODERN ART
FILM STILLS ARCHIVE

<

ROMAN SCANDAL

Understatement was never director Cecil B. DeMille's calling card, but he scaled new heights of florid decadence with 1932's *Sign of the Cross*, his tribute to the voluptuaries of ancient Rome. It featured an outlandish Charles Laughton as emperor Nero and a near-nude Claudette Colbert as the wicked Poppaea, bathing in asses' milk (left). Such wretched excess led to the 1934 Hays Code crackdown on Hollywood.

THE KOBAL COLLECTION

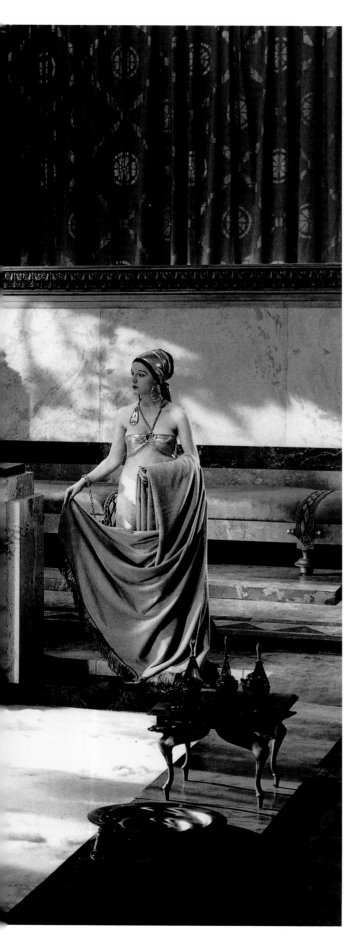

>

HOW TO TAKE IT OFF

It was a 1937 *Life* scoop. An instructor at the Allen Gilbert School of Undressing demonstrated the correct technique (far right) for getting comfortable at home, while a "typical housewife" blundered through the sloppy form that Gilbert — a Manhattan producer of burlesque shows — claimed was driving husbands to divorce court. Sure.

PETER STACKPOLE / LIFE

TURNING POINT

Bluenoses, Arise

As the 20th Century hove into view, the conservatism and piety of the previous five decades in America had begun to erode. Nowhere was this more noticeable than in the theater, where playwrights like Henrik Ibsen and George Bernard Shaw were portraying what convention saw as a rising tide of depravity and moral confusion. Into this perceived breach rode a new brand of moral crusader, the censor. Favored targets of the censorship movement were contraception and obscenity. Attempts to suppress started with the stage but soon extended to other venues of popular culture. The societal tug-of-war that started back then goes on.

"Your Honor, this woman gave birth to a naked child!"

<
GOOD WILL HUNTING
Natty Will Hays (in the double-breasted coat) was the moral czar of Hollywood from 1922 to 1945. His list of movie taboos was largely ignored until 1934, when the production code drove nudity, unpunished sex and other nastiness from the screen. For the next 30 years offending films were banned from major theater chains.
KEYSTONE VIEW CO. /
CORBIS SYGMA

JOINING JOYCE

James Joyce's sexually frank 1922 novel, *Ulysses*, was banned in the U.S. So when a magazine began to print a serialized and severely censored version in 1926, Joyce's friends mobilized. More than 150 prominent authors and intellectuals protested in ads. Among the signers: Albert Einstein, T.S. Eliot, W. Somerset Maugham, D.H. Lawrence, Ernest Hemingway.

COURTESY CYRIL P. CORRIGAN

"ULYSSES" PROTEST

(We print below some of the many signatures)

PARIS.

IT is a matter of common knowledge that the "Ulysses" of Mr. James Joyce is being republished in the United States, in a magazine edited by Samuel Roth, and that this republication is being made without authorisation by Mr. Joyce, without payment to Mr. Joyce, and with alterations which seriously corrupt the text. This appropriation and mutilation of Mr. Joyce's property is made under colour of legal protection in that the "Ulysses" which is published in France and which has been excluded from the mails in the United States is not protected by copyright in the United States. The question of justification or that exclusion is not now in issue, similar decisions have been made by government officials with reference to works of art before this. The question in issue is whether the public (including the editors and publishers to whom his advertisements are offered) will encourage Mr. Samuel Roth to take advantage of the resultant legal difficulty of the author to deprive him of his property and to mutilate the creation of his art. The undersigned protest against Mr. Roth's conduct in republishing "Ulysses" and appeal to the American public, in the name of that security of works of the intellect and the imagination without which art cannot live, to oppose to Mr. Roth's enterprise the full power of honourable and fair opinion.

JAMES JOYCE [Martinie]

THAT'S LIFE

In April 1938, a year and a half after launch, *Life* went too far. Its pictures of a child being born caused the police in Merrick, New York, and several other towns, to seize thousands of copies of the magazine from newsstands. Journalists protested this violation of freedom of the press; *Life* enjoyed the kind of publicity that money can't buy.

CORBIS / ACME

"THOU SHALT NOT"

1 LAW DEFEATED
2 INSIDE OF THIGH
3 LACE LINGERIE
4 DEAD MAN
5 NARCOTICS
6 DRINKING
7 EXPOSED BOSOM
8 GAMBLING
9 POINTING GUN
10 TOMMY GUN

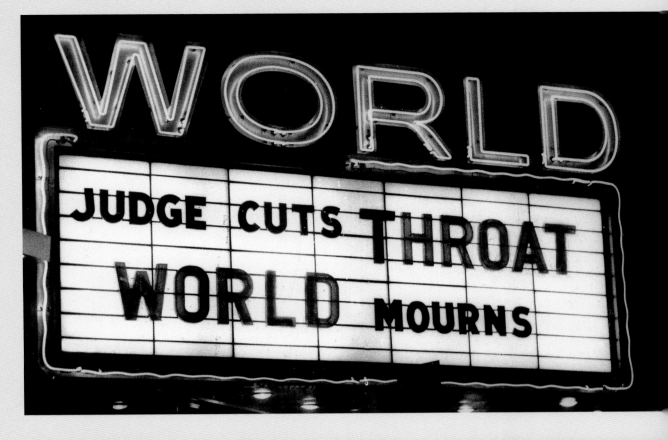

>

SO LONG, LINDA

New York State criminal court judge Joel L. Tyler deep-sixed *Deep Throat* in February 1973. He ruled that star Linda Lovelace's popular film, with its 17 explicit sexual acts, was spectacularly lacking in redeeming social value and "is one throat that deserves to be cut." At Manhattan's World Theater, reaction was predictably sober.

CORBIS / UPI

>

JUST A JOB

The Maryland Board of Censors was the last of the powerful state film authorities in the country. Its widely respected (and sought) seal of approval was withheld from movies that were "sacrilegious, obscene, immoral, or tending to debase or corrupt morals." These were the members in 1970: from left, Margery Shriver, chair Mrs. Louis E. Schecter and Mary Avara. The board was abolished in 1981.

WALTER BENNETT

IT ISN'T PORN, BUT IS IT ART?

Demonstrators gathered at Cincinnati's Contemporary Arts Center to protest criminal obscenity charges against the museum's director, Dennis Barrie. His sin was to exhibit erotic pictures by gay photographer Robert Mapplethorpe. The prestigious Corcoran Gallery in Washington, D.C., had earlier canceled the show. In this case, the anticensorship forces prevailed. Barrie was vindicated.

JIM CALLAWAY / THE CINCINNATI ENQUIRER

MIAMI VICE

A Florida judge found 2 Live Crew's 1990 rap album, *As Nasty As They Wanna Be*, including smash single "Me So Horny," a little too nasty and declared it obscene. (The album cover, above, had its own problems.) Luther Campbell, 2 Live's leader, spent the next few years touring the courts, defending his right to talk dirty. "I wish they'd respect me for the joker I am," he said.

TONE IT DOWN

Since 1977, Mississippi pastor Donald Wildmon, 40 (above), had demanded boycotts of corporations he said encouraged sex and violence on TV. The result: scant impact, huge publicity. In 1985, future Second Lady Tipper Gore and Susan Baker (right) helped convene Congressional hearings on obscene rock lyrics. Musicians howled; record companies labeled CDs.

ABOVE: SLICK LAWSON; RIGHT: DENNIS BRACK / BLACK STAR

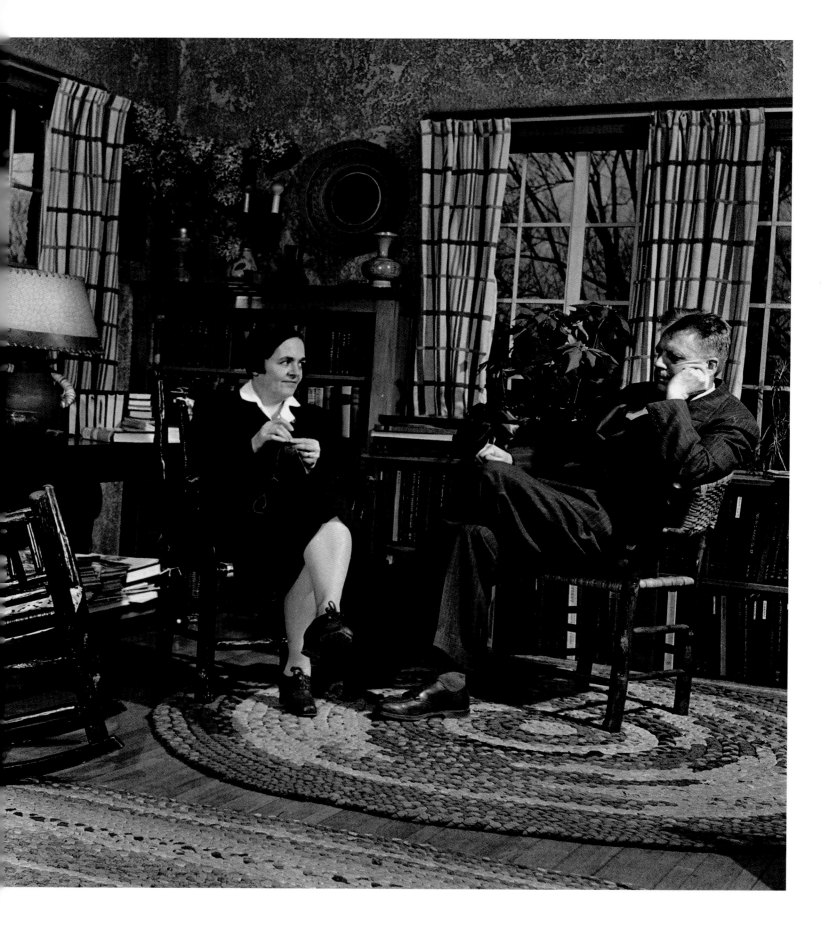

WATCH THE BIRDIE

In 1939, tenacious Sally Rand found a way to shimmy back into the headlines at another World's Fair — this one in San Francisco. The draw was her "nude ranch," where for a quarter patrons goggled at rancherettes playing badminton allegedly clad only in boots, hats and gunbelts. (There were rumors about the use of body stockings.)

HORACE BRISTOL

<

BY THE NUMBERS

It was a ponderous 1948 best-seller titled *Sexual Behavior in the Human Male* but popularly referred to as the Kinsey Report. Using pollsters' techniques to quantify erotic behavior, zoologist Alfred Kinsey of Indiana University discovered some shockers: Both bisexuality and male extramarital sex were far more common than believed. Wife Clara (left) called Kinsey's work "an unvoiced plea for tolerance."

WALLACE KIRKLAND / LIFE

DREAM GIRLS

With his luscious watercolors of *Ziegfeld's Follies* girls in the 1920s, Peruvian-born Alberto Vargas established himself as the unchallenged king of the pinup painters. His creamy, curvy, come-hithering Vargas girls appeared in *Esquire* from 1940 to 1948 and throughout GI barracks in World War II. Later Vargas hooked up with *Playboy*.

CORBIS / ACME

<

AFTER AND BEFORE

She wrote to her parents, "Nature made a mistake, which I have corrected." In February 1953, Christine Jorgensen, an American, checked out of the Copenhagen hospital that she had entered as an ex-soldier named George (inset). After two years of operations, she had changed sex (a procedure that had been available for a couple of decades). Her zest for life emboldened others; today, an estimated 4,000 in the U.S. have followed suit.

CORBIS / INTERNATIONAL NEWS PHOTO (2)

PACKING HEAT

She was the Fifties' premier bad girl, a peroxided pistol from Dallas who called herself Candy Barr. After a steamy striptease in the classic 1951 stag flick *Smart Aleck*, Barr began having trouble with the law. In 1956, shortly before this cheesecake still was snapped, she fired a .22 rifle at her estranged husband. Later, she went to jail for possessing pot.

CORBIS / BETTMANN-UPI

>

BUNNIES ON PARADE

After the 1953 launch of *Playboy*, Hugh Hefner did more than build a publishing empire. He opened clubs (here in Chicago in 1960) and spread the philosophy, radical at the time, that "sex is not the enemy." He certainly lived by his own creed. It's hard to imagine the 1960s' sexual revolution without the Hefner influence.

COURTESY PLAYBOY ENTERPRISES

CLOSE UP

A Dirty Book

A blurb on the 1956 paperback promised that *Peyton Place* lifted "the lid on a respectable New England town." Some lid; some town. The fetid goings-on — sex, sex and more sex — proved such an appealing-appalling read that despite sporadic boycotts it ranked as the biggest-selling novel of all time in 1960. Today the count is 20 million copies. Some say it presaged feminism by exposing society's sexual double standard. Author Grace Metalious, 32 when the book was published, never made extravagant claims for her maiden effort, or matched its success.

Large- and small-screen visits to Peyton Place strengthened its grip on America. The movie (right) ended 1957 as Hollywood's No. 2 grosser, earning nine Oscar nominations but no wins. On TV, the 1964 prime-time soap (below, with Ryan O'Neal, Mia Farrow and Barbara Parkins) was a smash for five seasons; by 1985's *Peyton Place: The New Generation* TV movie (below left, actress Ruth Warrick), few shocks remained.

CLOCKWISE FROM BELOW LEFT: TONY COSTA / CORBIS OUTLINE; JERRY OHLINGER; CAPITAL CITIES / ABC, INC.

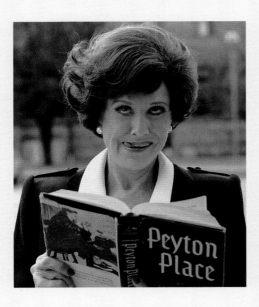

Tomboyish and book-besotted, Grace de Repentigny of Manchester, New Hampshire, was the daughter of French-Canadian mill workers. She moved to Gilmanton after she married grammar school principal George Metalious. Because of her book's notoriety, residents didn't exactly toss confetti at Grace. Still, she got rich, bought a big house in town and eventually divorced her husband. She began drinking heavily, and three later novels failed. She died in 1962 at age 39, $200,000 in the red. Gilmanton would not let her be buried in the local cemetery.

HANS CARROLL / LIFE

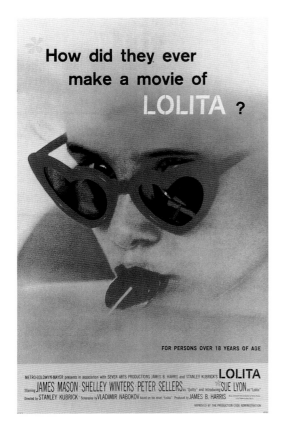

For persons over 18 years of age

< LOLI-POP

Published in 1955 but available at first in the U.S. only in a contraband French edition, *Lolita* was Vladimir Nabokov's shocking if witty tale of a professor's lust for a 12-year-old nymphet. In 1962, a film version starring Sue Lyon, 15 (left, in a movie poster), and directed by Stanley Kubrick enjoyed modest success in American theaters. Clearly, it was a different decade.

JERRY OHLINGER

> NO JOKE

Stand-up comic Lenny Bruce's first arrest for obscenity came in October 1961 in San Francisco (right). The country's best known "sick" humorist and fervent free-speech advocate beat the charge. Later in New York, he was busted again and convicted. While awaiting a Supreme Court appeal, a dispirited Bruce, who had long had trouble with drugs, died in 1966 at age 40 of a heroin overdose.

CORBIS / BETTMANN-UPI

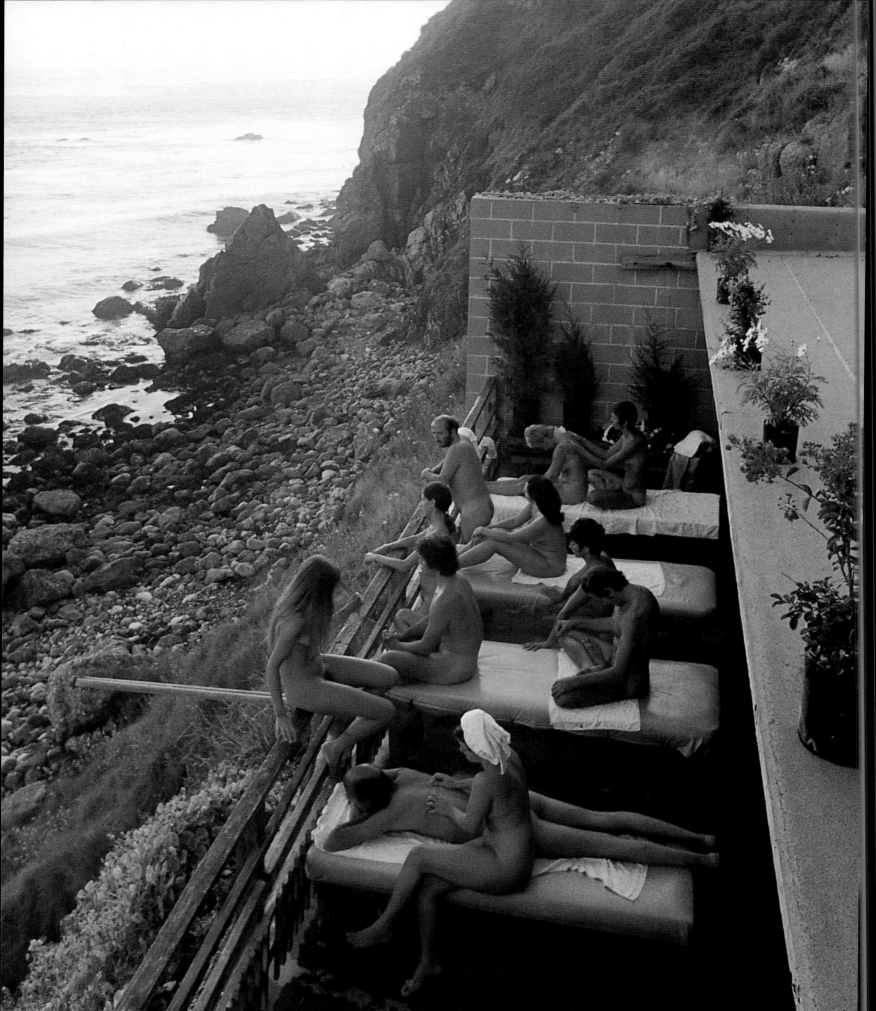

<

HANGING OUT

Hippie acolytes of the Sixties often connected the search for truth with getting naked. Foremost among the spots to do so was the Esalen Institute in Northern California, founded in 1962. This wasn't as much about sex as about shedding American "uptightness." Clients did yoga, took hot baths, had massages, pounded bongo drums and paid $65 per weekend for the liberating experience.

ARTHUR SCHATZ / LIFE

>

THAT COSMO GIRL

Cosmopolitan editor Helen Gurley Brown, 43, toasted her magazine's first million-copy month, in 1965. A one-woman consciousness-raiser, she told "mouseburgers" (her American Everywoman) how to achieve sexual and career success, something they hadn't always felt entitled to. Her teasingly titled *Sex and the Single Girl* was a 1962 best-seller.

WALTER DARAN / LIFE

<

A BARE STAGE

It was billed as an evening of "elegant erotica." *Oh! Calcutta!* (the title is a risqué French pun) opened on Broadway in 1969 to oohs and aahs but no arrests. That didn't happen until Los Angeles. The show's creator was Brit Kenneth Tynan, whose motto was "Rouse tempers, goad and lacerate, raise whirlwinds." The New York run ended in 1989; by then the show was just another tourist trap.

ORMOND GIGLI

HELLO, YELLOW

U.S. Customs, the courts and some states tried to bar Swedish director Vilgot Sjöman's 1967 film, *I Am Curious (Yellow)* — a color in the Swedish flag — but it sneaked in anyway. By 1970, it had grossed more than $8 million. Audiences saw several uninhibited, if unglamorous, sex scenes like this one (left) and listened to the director's talky, radical politics.

BOB PETERSON / LIFE

EARLY WARNING

Long before Anita Hill, *Ms.* magazine, in this 1977 cover story, warned women about sexual harassment on the job. The publication was founded in 1972 by Gloria Steinem and others as an antidote to the male-run media world. "Women's liberation" was becoming "the feminist movement."

MS. MAGAZINE /
SCULPTURE BY ELLEN RIXFORD

LIKE CLOCKWORK

With a handheld camera, director Stanley Kubrick shot the infamous rape scene in 1971's *A Clockwork Orange*, based on Anthony Burgess's novel. What many found disturbing about this depiction of sexual crime was its jokey context: Head droog Alex (actor Malcolm McDowell) violated his victim to the strains of "Singin' in the Rain."

WARNER BROS.

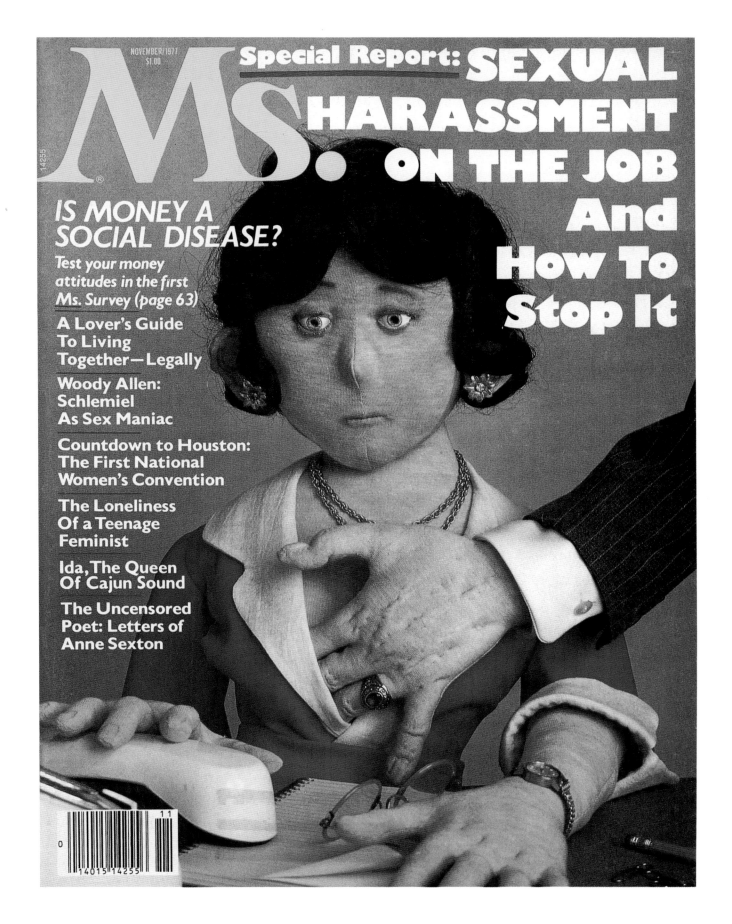

THE FINAL DOOR

As the dominant mass medium, television remained rigidly conservative in an increasingly racy world. But by 1982, the groundbreaking hospital drama *St. Elsewhere* debuted, and all bets — plus a fair bit of clothing — were off. Mark Harmon as lusty Dr. Caldwell served up prime beefcake. Virtue triumphed, however. The promiscuous medic was "punished" by dying of AIDS in 1986.

NBC

OF MEESE AND MEN

In 1985, Attorney General Edwin Meese, 54 (above), announced that his Commission on Pornography had found a provocative "causal" relationship between porn and sexual violence. Strange. A 1970 commission on the same subject had found the opposite. Reports aside, randiness persisted. One manifestation was Chippendale's, strip clubs for women. The chain opened in 1979, and nobody was quite sure what to think. By 1984, the Chippendale dancer, with dollar bills tucked into his bikini shorts (here at the original club in L.A.), had become a cultural icon.

ABOVE: CYNTHIA JOHNSON
LEFT: MARSHA TRAEGAR / 1984
LOS ANGELES TIMES

REAR WINDOW

No program dodged the censors more skillfully than *Seinfeld*. A sexual summit of sorts was reached in 1992's "The Contest," when each character bet the others that he (or she) would not succumb to self-abuse. Then, the four leads spied a naked woman in an apartment across the street (above), and JFK Jr. joined Elaine's exercise class. The loser? Who else but Kramer.

BYRON J. COHEN / COURTESY CASTLE ROCK ENTERTAINMENT

UNKINDEST CUT

Ex-Marine John Wayne Bobbit, 26 (right), held a snapshot of the woman accused of lopping off his manhood with a kitchen knife. She was, of course, his wife, Lorena, 24, and she said she had acted only after he raped her. She was found not guilty by reason of insanity. John, his part reattached, went into porn films. Lorena was called a feminist hero. The only winners were the tabloids.

MARK PETERSON / SABA

CLOSE UP

Man of Parts

Howard Stern has a face born for radio, to quote an old saw. A mouth, too. The sex-obsessed banter issuing from it made him the most popular radio personality of the last quarter century and the most heavily fined. His employer once had to pay the FCC $1.7 million for his vulgarity. Syndicated to a national audience of approximately 10 million, Stern, 46, and his on-air foil, Robin Quivers, 47 (below), greet a daily parade of porn actresses, geeky comics, transvestites and an occasional courageous celebrity. Against charges of racism, misogyny and rampant bad taste, Stern says he only wants "to talk the way guys talk sitting around a bar."

Stern brought his lesbian fixation and shock jock sensibility to the literary world with 1993's *Private Parts*, an often scatological monologue-cum-biography. Critics were unenchanted, but it sold more than a million copies. Nearly as popular was the movie version (poster above) in 1996. Intermittently successful forays into TV led Stern to call himself, only semi-seriously, King of All Media.

LEFT: TED THAI
ABOVE: PARAMOUNT / NEAL PETERS COLLECTION

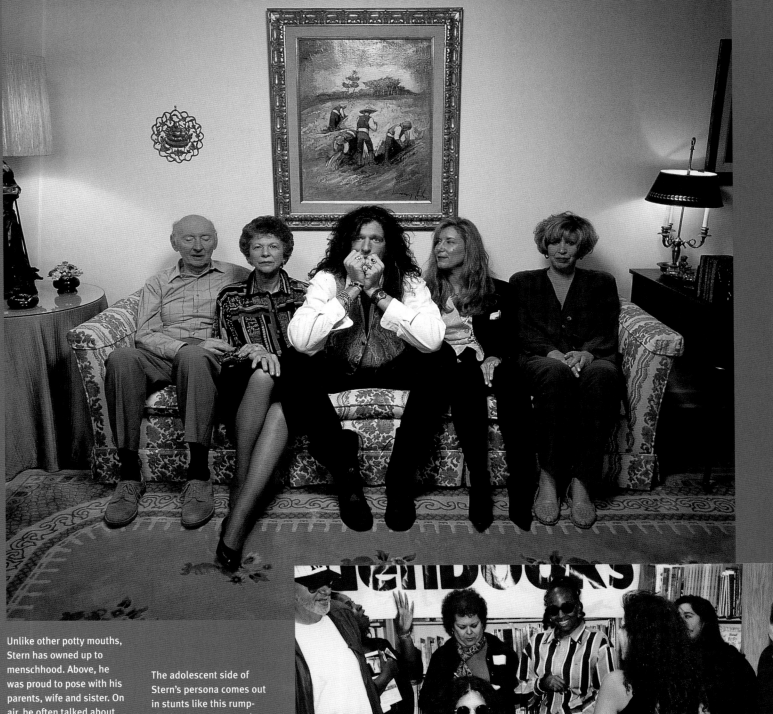

Unlike other potty mouths, Stern has owned up to menschhood. Above, he was proud to pose with his parents, wife and sister. On air, he often talked about the isolation he felt growing up Jewish in a black Long Island, New York, neighborhood. Other themes were his marital fidelity — at least until he and his wife split up in 1999 — and his doubts about his virility. "Hung like a raisin" was his self-assessment.

ANDREW BRUSSO /
CORBIS OUTLINE

The adolescent side of Stern's persona comes out in stunts like this rump-signing at an autograph session for *Private Parts*, — not to mention radio routines such as "Bestiality Dial-a-Date" and a 1988 TV pay-per-view special titled *Howard Stern's Negligee and Underpants Party*. Stern once solemnly proclaimed, "I never intentionally set out to shock anybody." Such cheek.

ROBIN BOWMAN

COUNTING DOWN

Talk about sexual politics! At a 1997 Washington dinner, Bill Clinton, 50, met the newly public lovebirds comedian Ellen DeGeneres, 39 (above, right), and actress Anne Heche, 27. In nine months, the Presidential scandal erupted. In 15 months, DeGeneres's sitcom, *Ellen*, which made history when both its main character and star announced they were gay, was canceled by ABC.

NESHAN H. NALTCHAYAN / REUTERS / ARCHIVE PHOTOS

A TANGLED WEB

Revelations of Oval Office misconduct brought forth this sexually explicit Website that was named for 1600 Pennsylvania Avenue and slyly claimed it was "proud to show you what this great nation is built upon" — not the Protestant ethic, it would seem. By 1999, Internet sex sites were generating annual revenue estimated between $700 million and $1 billion.

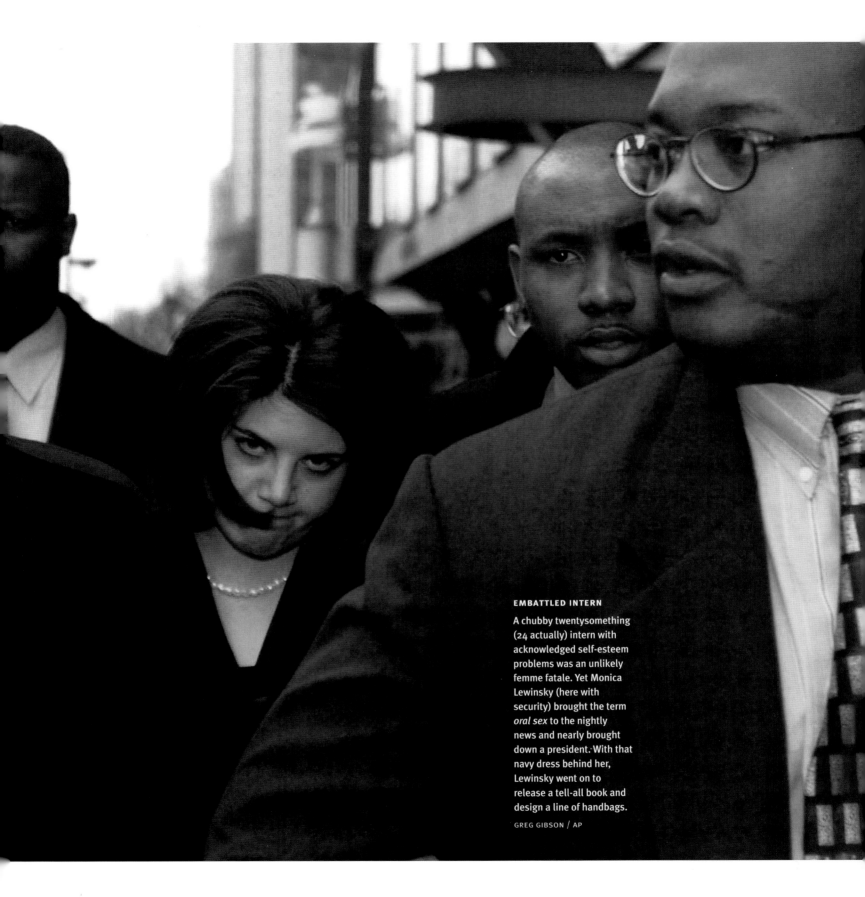

EMBATTLED INTERN

A chubby twentysomething (24 actually) intern with acknowledged self-esteem problems was an unlikely femme fatale. Yet Monica Lewinsky (here with security) brought the term *oral sex* to the nightly news and nearly brought down a president. With that navy dress behind her, Lewinsky went on to release a tell-all book and design a line of handbags.

GREG GIBSON / AP

design

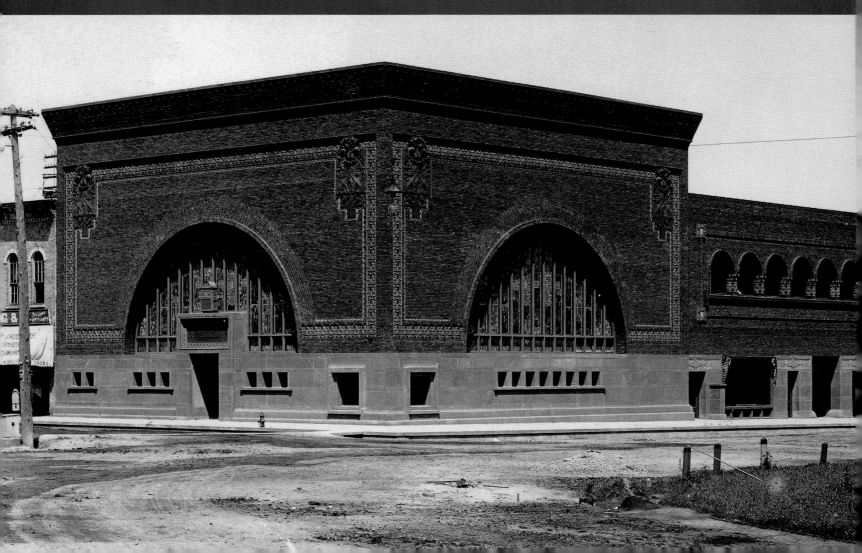

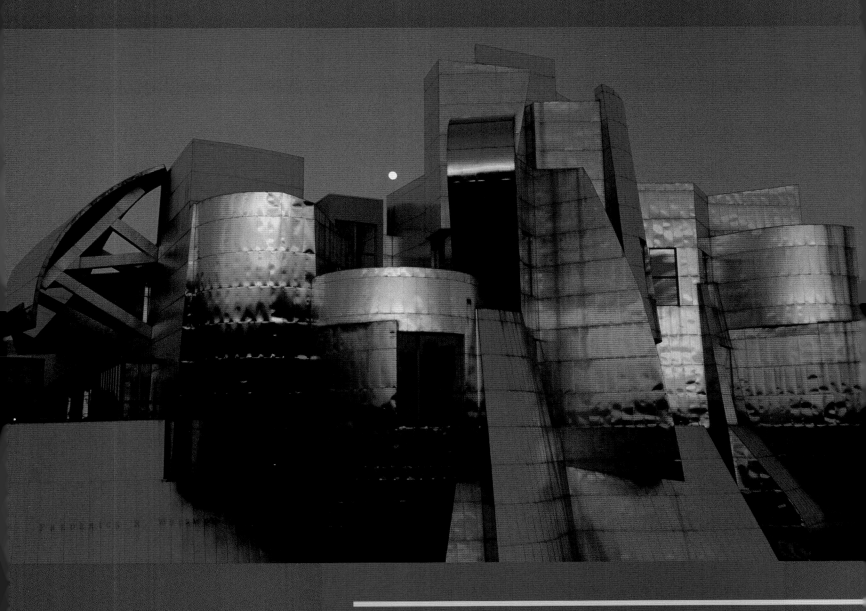

Minnesota can claim two U.S. architectural landmarks. Louis Sullivan's classically inspired National Farmers' Bank (left) was built from 1907 to 1908 in tiny Owatonna (pop. 5,000) and is still in use today. Frank Gehry's audacious stainless steel sculpture, the Frederick R. Weisman Art Museum, went up in 1993 in Minneapolis.

LEFT: CHICAGO ARCHITECTURAL PHOTOGRAPHY CO. / DAVID R. PHILLIPS COLLECTION
ABOVE: RICHARD CUMMINS / CORBIS

THE LOOK OF EVERYDAY LIFE

Outrageous Visions Realized

BY THOMAS HINE

THE MODEL T FORD, introduced in 1908, was not a beautiful thing, nor was it meant to be. Henry Ford created an elegant system to make it — the moving assembly line — but visually, the car was a lumpy mess. Like the personal computer, introduced seven decades later, the Model T wasn't so much a design as a contraption, one that required enthusiasm, patience and a measure of hard-won expertise to use. But also like the computer, it remade the way people live and work by giving new abilities to individuals.

This dowdy but revolutionary car is thus a quintessential American design, aimed not at tastemakers but at everybody else, intended not to be exquisite but accessible. Though we Americans may be materialists, our talent is not for producing fine objects, but rather for making tools that expand personal power and freedom — and for selling them too.

Taste has always been a contentious issue in our diverse and avowedly democratic society. Technology has a way of rendering taste irrelevant, while design runs along behind, bringing an aesthetic to inventions, simplifying their appearance and operation so that people feel confident using them, and adding the fantasy that helps newness sell.

At the time of the Model T, the educated, wealthy people who traditionally establish taste were rather embarrassed about the great industrial society that their parents' generation had created. They were trying to prove that America's sulfurous, coal-fired cities could produce civilization. So they patronized City Beautiful schemes to slash Parisian boulevards through monotonous urban grids and built museums that looked like temples, libraries that looked like palaces, and universities that evoked medieval cloisters. And at their homes, in leafy railroad suburbs, they sought refuge either in historical styles or in the handcrafted avant-garde, represented by glassmaker Louis Comfort Tiffany, the furniture maker Gustav Stickley and the architect Frank Lloyd Wright.

The tastemakers sought decorous permanence, while the Model T, like the movies and ragtime music, expressed a raffish and democratic zest for modernity and change. Only after World War I, however, did American buildings and objects begin to truly embody the speed and movement of modern life. Flappers' short skirts enabled a new, freer sort of woman, while buildings suddenly bristled with the zigzagging ornamentation that people at the time called "jazz modern."

And cars began to be "styled." That happened in the mid-1920s when Alfred Sloan, the creator of General Motors, hired Harley Earl, who had been customizing cars for movie stars, to help shape the company's cars. The Model T and most other cars of the time were assemblages of disparate, and rather frightening, mechanical parts. Stylists simplified the

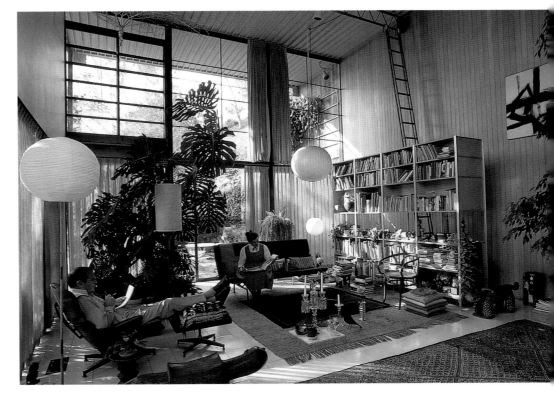

form of the automobile and cloaked most of its mechanism in sheet metal. In doing so, they signaled that it is not necessary to know how a car works, or to be able to fix one, in order to be a driver. Later, the Macintosh computer's graphic interface would do for the personal computer what sculpted sheet metal did for the car: cover up the scary technical things and make it easier to use a forbidding machine. Nearly all American industrial design has sought to make consumers comfortable with things they cannot understand and thus enable the products to reach mass acceptance.

While the most influential European architects and designers of the 1920s and 1930s embraced the steel beam and other utilitarian industrial elements to create a new artistic language of modernity, American designers sought to repackage industry as a delivery system to provide a good life for all. Form's job wasn't to follow function, but rather to increase sales. During the Great Depression, industrial designers like Raymond Loewy, Norman Bel Geddes, Walter Dorwin Teague and Henry Dreyfuss became celebrities by giving streamlined shapes to everything from railroad locomotives to pencil sharpeners. The hope was that by embodying dynamism, optimism and speed into consumer objects, these star designers would get America consuming again.

It worked — up to a point. Streamlined refrigerators appeared in many 1930s kitchens. But this fluid, curving dynamic style was mostly the stuff of dreams, experienced through the onyx and ivory interiors where Fred and Ginger danced or at exhibitions like Chicago's Century of Progress in 1933 and especially the New York World's Fair of 1939 and 1940.

Design didn't end the Depression, though. World War II did. The decisive design of the streamlined era proved not to be the Chrysler Airflow sedan but the DC-3, the workhorse airplane that carried men and equipment everywhere during the war and continued in civilian use for decades after.

The question that loomed at war's end was whether the industries that played so important a role in winning the war could quickly adapt to serving a consumer economy, or whether the country would sink back into economic torpor. For many, especially in Southern California where aircraft plants were concentrated, the solution was to adapt materials and techniques used in airplanes to make houses, appliances and other essentials for a prosperous postwar life.

The California designers Charles and Ray Eames had, during the war, manufactured plywood

Coca-Cola first came in the plain bottle at far left. That evolved into the familiar hobble skirt in 1915 (second from right), with only minor variations since then. In mid-century, famed designer Raymond Loewy called it "the most perfectly designed package in use today."

HAROLD J. TERHUNE / H & H PHOTO SERVICE

splints for wounded soldiers by adapting molding techniques they had developed for chairs. After the war, they began introducing wartime advances in adhesives and synthetic rubber into their complexly curving plywood chairs, the first great objects of the postwar era.

And in 1945, they designed a house as part of a program intended to demonstrate how modern technology could be adapted to modern living. As it turned out, the expected surpluses of steel and other industrial components did not appear, and the Eameses didn't receive the girders from which their house's frame was to be made until 1949. They then proceeded to use the steel to build a very different house from their earlier design. In doing so, they made a point. The steel structure was not a cage, but a framework for freedom, a useful tool for making a house both comfortable and full of possibilities.

As we look back from the turn of the 21st Century, the Eameses, perched halfway through the 20th, appear as central figures, visionaries and early inhabitants of a world in which we all now live. They transformed design from an exercise in engineering and marketing into an instrument of information, communication and delight. Thus, they created the multimedia experience that the computer has now rendered universal. Moreover, their lives served as a prototype for the high-intensity informality that so characterizes contemporary life. They even wore the same outfits for both work and formal occasions, and so were precursors to dress casual.

At the time, though, the matter-of-fact modernism their house exemplifies did not prevail. In 1945, the same year the Eameses published the first design for their house, General Motors designer Harley Earl persuaded the company to put tail fins on the 1948 Cadillac. Tail fins used up plenty of steel, but they provided more fantasy than utility. A decade later, Chrysler advertising would claim that fins provided "stability at speed," but Earl was more truthful when he called them, "a visible receipt for having purchased an expensive car."

Even as architecture was becoming increasingly stripped and ascetic, private possessions became more expressive, filled with swooping curves and acute angles adapted from jet fighter planes. The same year, 1958, brought the completion in New York of Ludwig Mies van der Rohe's Seagram Building, a skyscraper that virtually screams understated elegance, and the introduction of the 1959 Cadillac Eldorado, the apotheosis of auto rococo. One is a work of art, the other probably isn't; but it is the car, not the tower, that provides the most vivid glimpse of American aspirations at that moment.

The thrust of the century's design has been away from the public and toward the personal. Often, Japanese companies understood this better than American ones, as the transistor radio and the Walk-

man allowed individuals to inhabit their own sonic realms. Americans lost much of their zest for the future during the 1970s and 1980s. The "designer" wasn't viewed as a visionary. More likely it was someone whose name or initials were placed on a garment she probably didn't design. For example, Gloria Vanderbilt's name brought a gilded-age aura to blue jeans, and in this case, the visible receipt for paying a premium appeared not on the tail of your car, but on your own rear end. And while cars had become bland, the fantasy of their earlier designs was reborn and elaborated in the designs for athletic shoes. Earlier, boys had memorized the swooping shapes and overstated ornament of automobiles. Now they could wear that sort of excitement on their feet.

By century's end, the architect Michael Graves, who had once sought to develop a postmodern version of classical grandeur, was devoting much of his time to designing alarm clocks, watering cans and dustpans to be sold at discount stores. The Eameses have reemerged as heroes. Their influence derives not from any one design, but from their approach. They saw design as a way of understanding the world and of enjoying it. Their medium was less often steel or glass than information, conveyed playfully, visually and in large quantity. Their exhibitions often took the form of a web of unexpected connections between disparate artifacts and ideas. They were pioneers of the virtual world.

And in the real world, the Eameses' fascination with both the everyday and the aesthetic uses of technology has had an unexpected fulfillment in the highly public, but intensely idiosyncratic, architecture of another Southern Californian, Frank Gehry. In his early work, Gehry used some of the least attractive materials of modern life, such as chain-link fencing and corrugated cardboard, to create memorable places. Recently, he has used computer technology developed for the engineering of aircraft to design such structures as the critically acclaimed, yet

Neon signs, a French invention, leaped the Atlantic in the Twenties, and quickly began to light up our lives. By 1989, Las Vegas, the capital of gleeful excess and chaotic architecture, was bathed in their spectral glow.
ERIC SANDER / LIAISON

crowd-pleasing, Guggenheim Museum in Bilbao, Spain. These are irregular edifices, whose sculpted forms undulate and soar and whose shiny surfaces, clad in titanium and other precious forms of sheet metal, reflect the colors of the sky. They are a marriage of clouds, computers and, perhaps, Cadillacs.

Unlike the static classical strongboxes erected at the turn of the last century, Gehry's museums are celebrations of evanescence and indeterminacy. They are paradoxical monuments, personal statements on a grand scale. They show that contemporary technology enables even the most outrageous visions to be realized, and that no rules of good taste can stand in their way.

Thomas Hine writes on history, design and architecture. His books include Populuxe, The Total Package *and* The Rise and Fall of the American Teenager. *A museum consultant, he was the design and architecture critic for the* Philadelphia Inquirer *for 22 years.*

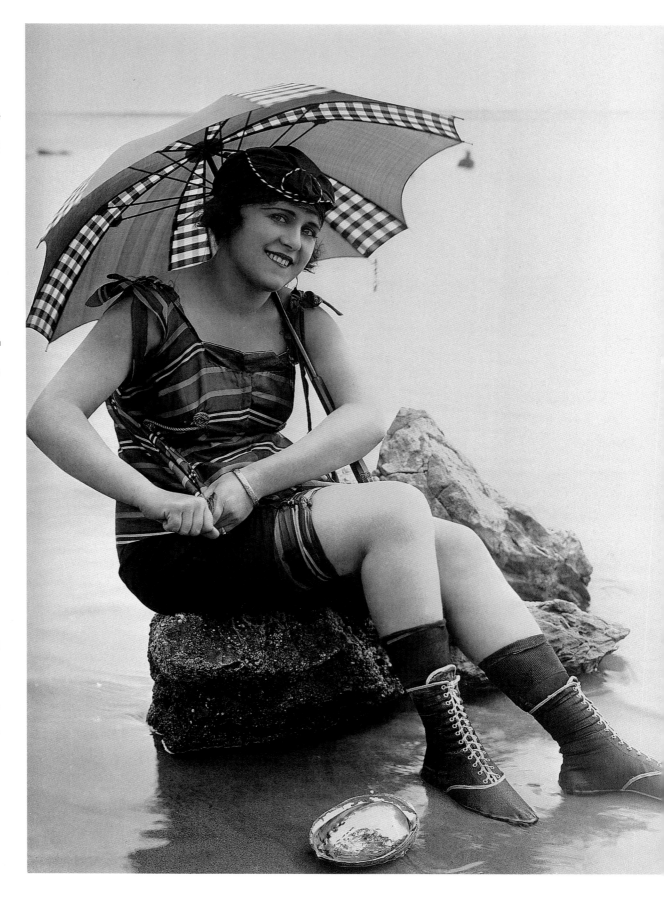

LITERARY MASTERPIECE
<

Two architects of modest renown, John Carrère and Thomas Hastings, won a competition and promptly designed the largest marble building in the U.S. After a reservoir was dismantled to make room, construction took nine years and $9 million dollars ($180 million today) before that Beaux Arts beauty, the New York Public Library, opened its doors in 1911.

BROWN BROTHERS

>
SWIMSUIT ISSUE

Between turn-of-the-century bathing gear (which swaddled its wearer in heavy wool stockings and a knee-length skirt, but left the neck and elbows fetchingly bare) and the bikini (you know what that swaddles) came this swimming costume circa 1910. Its blend of modesty and daring created excitement — and sales.

CORBIS / BETTMANN

<
THE TIFFANY TOUCH

In Louis C. Tiffany's ethereal vase (far left), the *favrile* glass he developed takes a floral shape. The Art Nouveau master appears at left, in a painting by Joaquin Sorolla, in the garden of the his Oyster Bay, New York, estate, which he designed, then donated for artists' use. Unlike his father, Louis never ran the family store; he did make jewelry for it.

FAR LEFT: CHARLES HOSMER MORSE MUSEUM OF AMERICAN ART; LEFT: HISPANIC SOCIETY OF AMERICA

WORTH HER SALT

In 1911, the Morton Salt Company advertised itself with a little girl and her umbrella and the slogan, "When it rains it pours." In 1914 (far left), the girl moved from the company's ad to its label, where she's stayed through six makeovers. Today she has morphed from pudgy toddler to miniskirted gamin, enduring almost a century of foul weather for the sake of good marketing.

<
HAT TRICK

Full corsets, full dresses and hats jammed with ribbons, flowers and stuffed birds — that was the costume of early 20th Century women. These visitors to a Midwestern park in 1911 were a decade away from abandoning their corsets, lifting their hems and pruning their hats. Perhaps the popularization of the camera helped them see what needed to be done.

BOSTWICK-FROHART COLLECTION

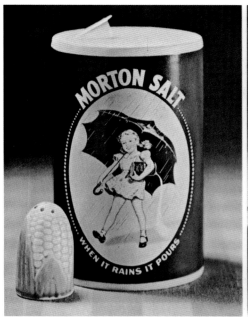

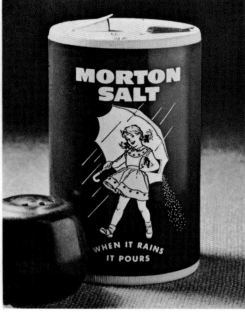

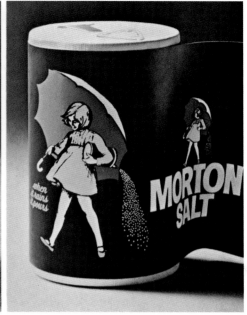

M. P. JACOB.
BRASSIÈRE.
APPLICATION FILED FEB. 12, 1914.

1,115,674.

Patented Nov. 3, 1914.
2 SHEETS—SHEET 1.

Witnesses:

Inventor:
Mary P. Jacob
by Mitchell, Chadwick & Kent
attys.

Facsimile of original brassière patent.

<

BRACE YOURSELF

The bra was not an instrument of confinement. It was an instrument of liberation, freeing women from bone corsets laced so tightly around the torso that they could shift ribs and reshape kidneys. This simple design by Mary Phelps Jacobs — two handkerchiefs secured by ribbons — was patented in 1914 and adopted with relief in the Twenties.

HULTON GETTY / LIAISON

>

GOTHIC DREAM

Architects John Mead Howells and Raymond Hood won a worldwide competition to design the Chicago Tribune Company's headquarters with this beautiful but unfashionable vision in 1925, during an era of sleek, modern high-rises. Embedded in its walls were stones from monuments like Notre Dame and the Parthenon — sly tributes to the glories of the past.

CORBIS / LAKE COUNTY MUSEUM

LOUIS SULLIVAN

His 'Living Art'

Near the end of the 19th Century, as buildings began to move upward, Chicago architect Louis Sullivan seized on the idea that these towering structures — some as high as 10 stories — required a new aesthetic. So he set out to create one. In such buildings as the Wainwright in St. Louis and Carson, Pirie, Scott's in Chicago, he practiced his "living art" and shared his philosophy — "form follows function" — with his student Frank Lloyd Wright. Sullivan helped shape the urban landscape, but the only work he could find by 1906 was designing banks in small prairie towns. The buildings, though, were works of art.

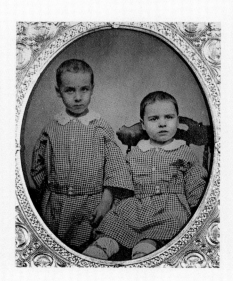

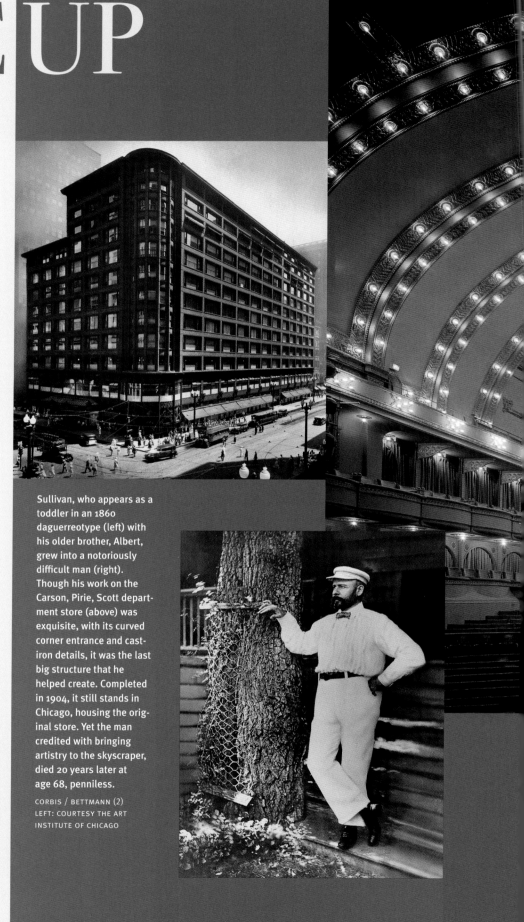

Sullivan, who appears as a toddler in an 1860 daguerreotype (left) with his older brother, Albert, grew into a notoriously difficult man (right). Though his work on the Carson, Pirie, Scott department store (above) was exquisite, with its curved corner entrance and cast-iron details, it was the last big structure that he helped create. Completed in 1904, it still stands in Chicago, housing the original store. Yet the man credited with bringing artistry to the skyscraper, died 20 years later at age 68, penniless.

CORBIS / BETTMANN (2)
LEFT: COURTESY THE ART
INSTITUTE OF CHICAGO

Sullivan's long association with engineer
Dankmar Adler yielded many landmark
buildings, including Chicago's spectacular
Auditorium Theater. Sullivan was only 30
when he designed the country's largest
theater, which had a retractable ceiling
that could hide three balconies, turning
4,000 seats into 2,500, and golden arches
lit by 10,000 lightbulbs.

HENRY GROSKINSKY

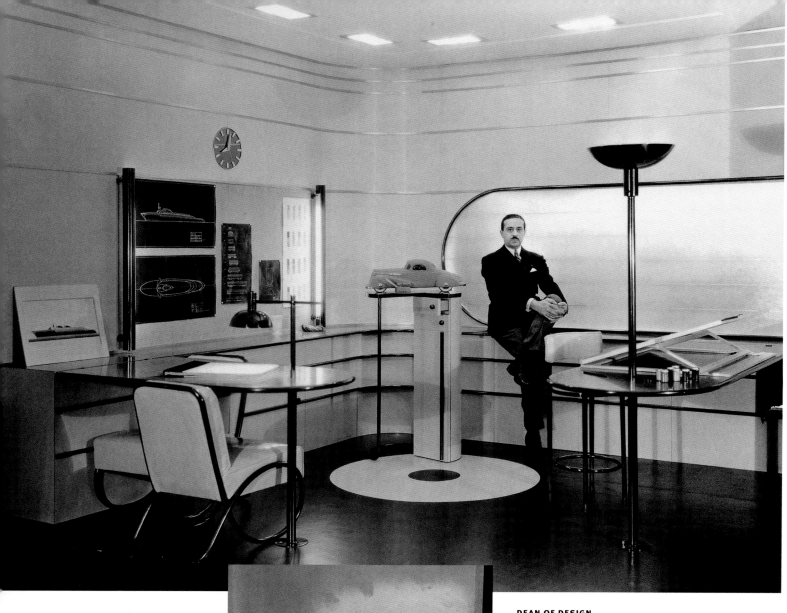

HIDE THE HOOCH

Prohibition was an inconvenience for the fashionable set — they had to find ways to conceal their flasks. This 1925 flapper used her garter. The look of the Roaring Twenties was meant for fun. Women cut their hair to accommodate the ubiquitous cloche. Some knotted its ribbons to show they were married; others tied a loose bow to signal they weren't.

CULVER PICTURES

DEAN OF DESIGN

Every object has an ideal form, declared Raymond Loewy, who gave a sleek, new shape to cars, trains, Greyhound buses, refrigerators. In the Thirties, he dominated the industrial design field he had helped invent. When the Metropolitan Museum of Art exhibited a designer's dream office in 1934, the dapper Loewy (above) was the obvious choice to be photographed in it.

RAYMOND LOEWY
INTERNATIONAL INC.

CENTERPIECE

Who: John D. Rockefeller Jr. What: Rockefeller Center. When: around 1931 for the hole in the ground, 1933 for the RCA (now GE) Building (inset). Where: 12 acres in Manhattan's midtown. Why: John D. was leasing the land when the stock market crashed in 1929, and he had to do something. You should see it now — 22 acres or so of plazas and skyscrapers.

CORBIS / ACME
INSET: MUSEUM OF THE CITY OF
NEW YORK / ARCHIVE PHOTOS

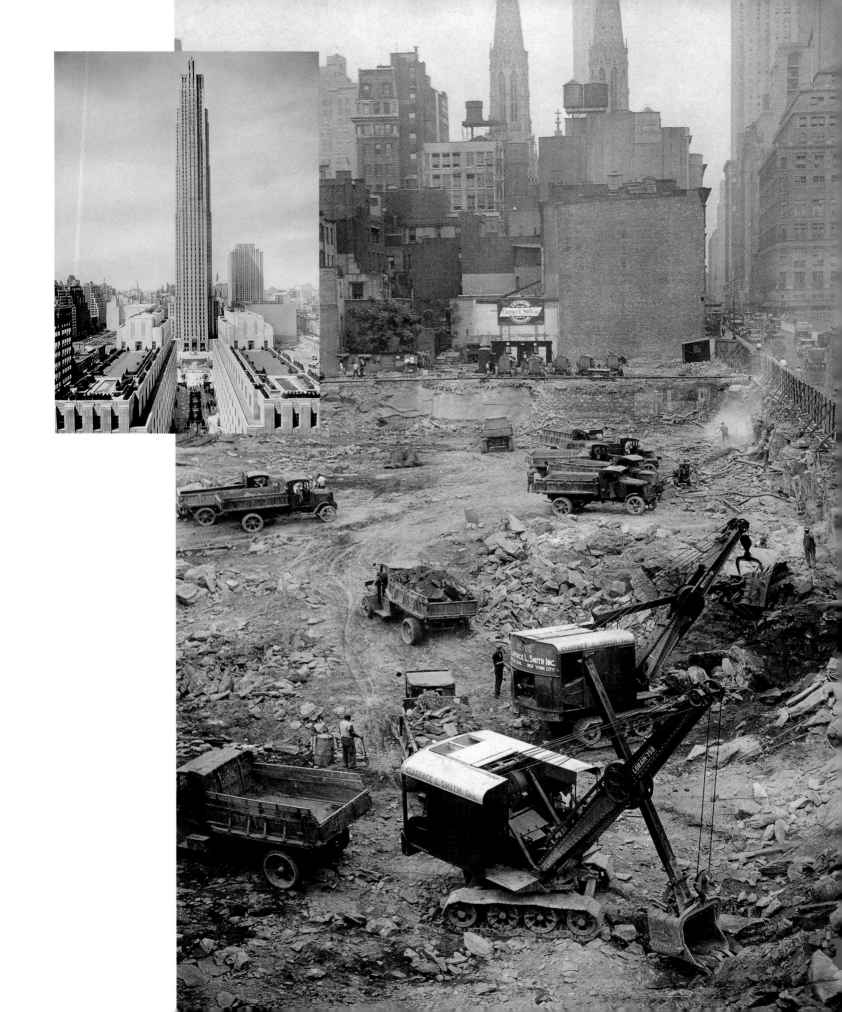

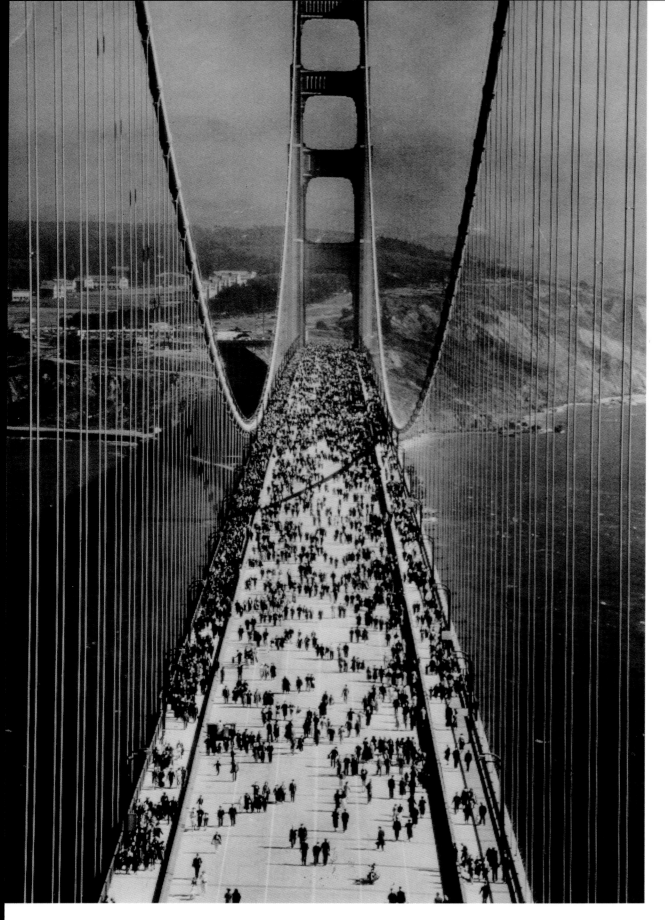

<

SUSPENDING DISBELIEF

When the Golden Gate Bridge opened on May 27, 1937 (left), 100,000 people celebrated this triumph of engineering and architecture over waters that had been deemed unbridgeable. Engineer Joseph B. Strauss had figured out how to link San Francisco and Marin County with a beautiful span that broke records for its length and swung 27 feet in a stiff wind.

>

NEATNESS COUNTS

Cheap, tough, impervious to heat and stackable, Russel Wright's American Modern ceramics were the everyday dishes of a postwar generation. Wright, raised a Quaker, was the country's best-known designer in the Forties, admired for his ability to create simple, elegant objects that brought artfulness to the process of mass-production.

>

THE LAST UNICORN

Going into battle for the 1939 World's Fair in Flushing Meadows, New York: one maiden in a hat sculpture. The bulbous object on her head was a representation of the Perisphere, the hollow 200-foot globe designed by architects at Harrison and Fouilhoux. The spear was a salute to their 700-foot-high Trylon, emblem of the fair's lofty ambitions.

<

. . . WITH A REAT PLEAT

Its extravagant use of material — the pants were 32 inches around at the knee — irritated the War Production Board, and its popularity in black and Hispanic jazz clubs made conservatives squirm. But the zoot suit, usually worn with wide-brimmed hat, pointy shoes and dangling key chain, struck a dandy note. Turns out this cautious kid was just trying one on.

MARIE HANSEN

FASHION LIKES IKE

General Dwight Eisenhower
(above left) admired the
World War II battle jackets
worn by the British in Africa
so much that he ordered a
version for himself. In 1944,
GIs fighting in Europe
picked up the style. After
the war, the Ike jacket was
cut in crepe, adorned with
jeweled buttons and a
jaunty epaulet (above), and
paraded by civilian women
back home.

ABOVE LEFT: ED CLARK / LIFE
ABOVE: PHILIPPE HALSMAN

>
THE WRIGHT DREAM

In 1943, he drew plans for
his magnum opus, a con-
crete spiral rising out of the
densely built-up neighbor-
hoods of New York City. But
it wasn't until 1959, six
months after Frank Lloyd
Wright's death, that his most
ambitious building, the
Guggenheim Museum, was
finished. With interior cork-
screw ramps, it dramatizes
abstract art as no conven-
tional museum could.

BEN SCHNALL / ARCHIVE PHOTOS

>
DIVIDE AND HIDE

This is Yankee ingenuity at
work. What does a country
do when it has 12 million
returning servicemen and
no immediate place to
house them? It expands
living space by putting up
room dividers with built-in
drawers and closets. For
only $500, as demonstrated
in a 1945 *Life* story, you
could squirrel away all that
stuff on the floor.

HERBERT GEHR / LIFE

CLOSE UP

Fashion for All

One of the first American fashion designers was a transplanted Austrian named Henrietta Kanengeiser. A turn-of-the-century immigrant, she borrowed her name from Andrew Carnegie, then the richest man in the country. Hattie Carnegie eventually became a household name in the U.S., but first she worked her way up from messenger at Macy's to proprietor of her own custom-dress shop in New York City. In 1928, she introduced ready-to-wear labels and brought fashion to the middle-class woman. Yet her couture line continued to flourish, attracting such fussy clients as the Duchess of Windsor and Joan Crawford.

With flair and instinct, Hattie Carnegie set out to clothe the women of America, all the women. She designed the habits for an order of Carmelite nuns and in 1951 rescued the Women's Army Corps (far left) from almost a decade of unflattering uniforms. Her evening wear (lower left) was lovely and expensive enough back then — $250 — for movie stars. Early in her career, she began making four trips a year to Paris, returning with news of hemlines (right, at age 31, on the deck of *Mauritania* in 1920) and couture dresses to copy. As the Depression approached, she devised a ready-made line for cost-conscious shoppers. Carnegie (upper left, in 1946) could not cut, sew or sketch, but she built a multimillion-dollar empire. It was her life. Childless, married three times, she died in 1956 at age 69.

CLOCKWISE FROM TOP LEFT:
CORBIS / BETTMANN;
ANNE ROSENER / TIME INC.;
CORBIS / BETTMANN;
GENEVIEVE NAYLOR / CORBIS

SPHERE OF INFLUENCE

The first large geodesic dome — a network of linked tubes — was built by Buckminster Fuller and his students in Canada in 1950. More than 300,000 domes have been erected since. One advantage to the shape that the visionary Fuller discovered: It's the only structure whose frame becomes stronger as it gets larger.

FULLER RESEARCH FOUNDATION

>

ONWARD AND UPWARD

A skyscraper that redefined the art form: Mies van der Rohe's Seagram Building (with the also celebrated Lever House to the right) in New York City. Built in 1958, it seemed radical with its expanse of plaza and its floor-to-ceiling windows, tinted brown — a lesson in the severe beauty of the International Style, to be copied over and over.

ANDREAS FEININGER / LIFE

NO SAD SACK

Givenchy unveiled the sack in 1957, and the man on the street (or, below, in Central Park) was dubious. But its novelty and comfort appealed to women. The loose fit and undefined waist swept Paris and New York; then the style was taken up by London designers like Mary Quant in the early Sixties. It still hangs in some form in every fashion-conscious woman's closet.

YALE JOEL / LIFE

DRESSING UP JACKIE

When Jackie Kennedy called for a designer to coordinate her White House wardrobe, Oleg Cassini, 47 (far left), stepped forward to give her the look — trim suits and sheath dresses — that came to represent Camelot. The son of a Russian diplomat, Cassini had designed costumes for Hollywood. He knew how to create drama.

COURTESY OLEG CASSINI

IS IT A BIRD?

Eero Saarinen always maintained that the swooping TWA terminal he had designed for Idlewild Airport (now JFK) in New York was not meant to suggest a bird in flight; he simply wanted to capture "the excitement of the trip." Perhaps if the Finnish-American architect had lived until its completion in 1962, he would have seen it differently.

EZRA STOLLER / ESTO

LESSONS IN PEACE

In 1964, inspired by Togolese women, who carried babies in shawls on their backs, former Peace Corps volunteer Ann Moore (with her daughters, right) had her mother sew the pouch that became the first Snugli. Experts warned that such close contact would spoil babies; Moore — and other American parents — found it kept them calm.

COURTESY ANN MOORE

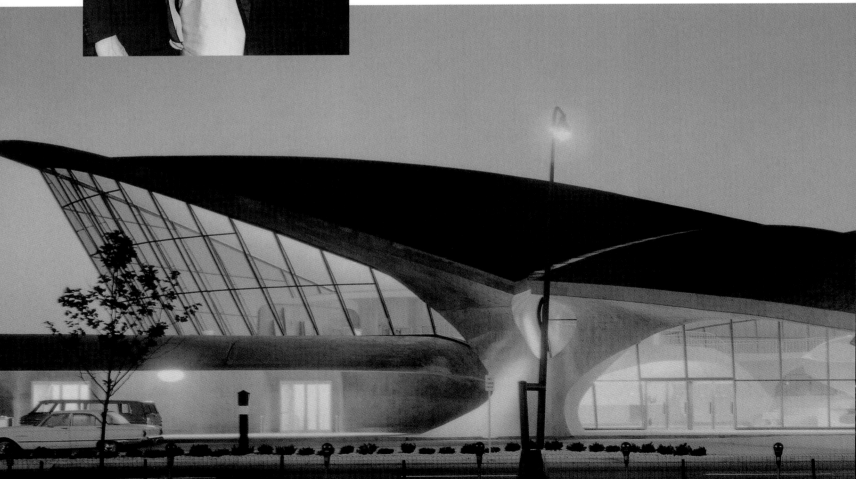

LOOKING UP

At one time, hotel lobbies were places you hurried through en route to your room. That changed in 1967, when John Portman, an architect and developer, opened the Hyatt Regency in Atlanta. Its 22-story atrium and glass-walled elevators revolutionized hotel design. Now lobbies look like tropical Edens, with waterfalls, ponds and relaxing guests.

COURTESY HYATT REGENCY ATLANTA, ATRIUM

WALKWAY

EXIT →

TURNING POINT

Ordinary Stuff

The plastics revolution started with an accident. Chemist Leo Baekeland couldn't get the resin out of a container in 1907. He wasn't the first scientist to cook up plastic, but his Bakelite was a breakthrough — 100 percent synthetic and indestructible (page 338). The race to produce and market new mutations of plastics (from the Greek *plastikos*, meaning molded or formed) was intense. In 1939 alone, nylon, Teflon, Lucite, Orlon, Dacron and Mylar were introduced. Plastics lost some of their caché in the Sixties, but 20 years later, Polar Fleece came along. Plastics were fashionable — and forever.

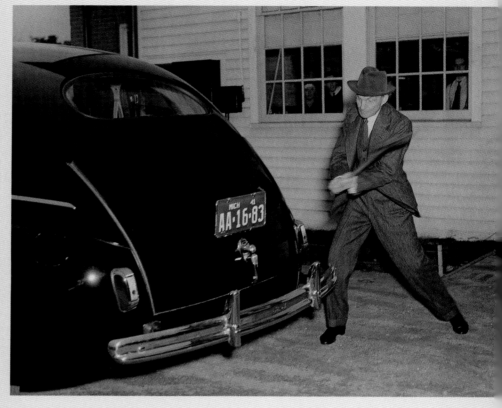

UNBREAKABLE

No matter how hard he swung that ax, Henry Ford, 77, could not nick the plastic car he had ordered built, in 1940, out of a soybean-based resin. Lightweight, tough, but expensive and unwieldy, the fiber-body car was ditched in 1949.

GEORGE EBLING

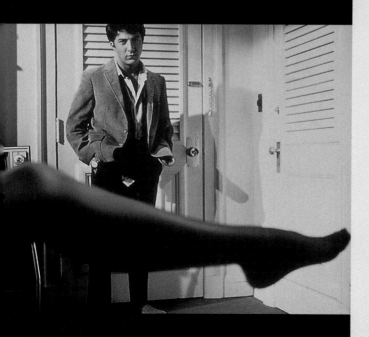

<

INADVISABLE

Dustin Hoffman had eyes for Mrs. Robinson in 1967's *The Graduate*, but best remembered from the movie was the career tip he received from a drunken neighbor: "I just want to say one word to you, just one word . . . plastics."

MEMORY SHOP

AMERIPOL

SMOKED SHEET

IRRESISTIBLE

Engineer Bob Gore loved
to play with Teflon. The
substance was used as
an insulator against heat,
cold and all kinds of
acids. What was more, it
stretched, as he found
out in 1969, into a water-
resistant fabric that was
breathable, too — Gore-Tex.

COURTESY W.L. GORE &
ASSOCIATES , INC.

<

IMPERATIVE

Introducing artificial rub-
ber! Its developer, Waldo
Semon of the B.F. Good-
rich Co., called it Ameripol,
in 1940, because it was
made of all-American mate-
rials, just in case our
foreign rubber supplies
were cut off by war.

CORBIS / BETTMANN-UPI

>

UNFORGETTABLE

Won't someone save this
fricasseeing feline? No need.
It's sitting on a clear sheet of
silicon rubber called
RTV 615, which conducts
almost no heat. That's why
it's used in fluorescent
lamps and telescopes.

JOHN ZIMMERMAN

338

Queen Margherita's Limousine
(QUEEN DOWAGER OF ITALY)
Is Upholstered with

DU PONT FABRIKOID
REG. U.S. PAT. OFF.

MOTOR QUALITY

NO BETTER evidence can be offered that Motor Quality Fabrikoid is the choice of discriminating buyers, not because cheaper than hide leather, but because superior. Looks and feels like leather. Water, heat, cold and light proof. Guaranteed one year against cracking or peeling. Several American manufacturers have adopted it. Any automobile maker can furnish it on your car if you so specify.

Send 50c for Sample 18x25 Inches
Enough to cover a chair seat. Mention this magazine and specify Black Motor Quality Fabrikoid.

DU PONT FABRIKOID COMPANY, WILMINGTON, DEL.

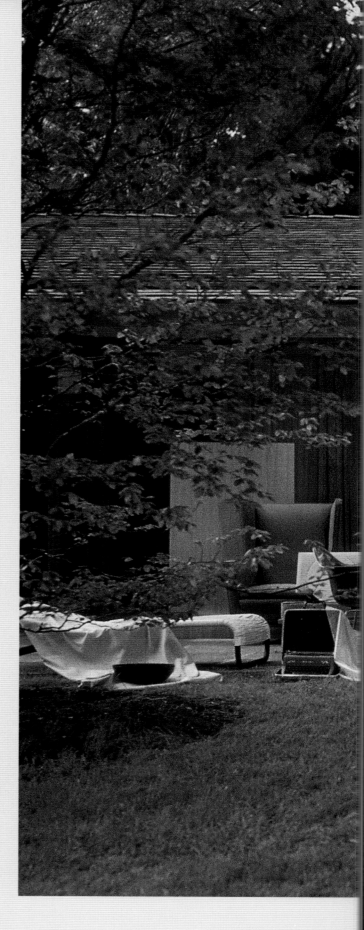

<

WAR CHEST

There were seven million casualties during World War II — in the factories and defense plants back home. In 1943, this plant in L.A. mounted a safety campaign to protect its growing population of female workers. Safety goggles were an easy sell, but the hefty protective bra took some getting used to.

CORBIS

NO FLAMINGOS, THOUGH

When members of the Margulies family of Scarsdale, New York, were asked how much they relied on plastic, they emptied their house for a photo (right). Orlon, Lucite, Formica in the kitchen. Something called Koroseal Strawtex as upholstery material. Dad was in Dacron, the acetate doll in saran hair. It was 1952, and polyester wouldn't be along for another year.

LESLIE GILL

<

SUMMER SHOWER

On the far left, a man in a tropical worsted suit got hosed and lost a wrinkle test to a man with the good sense to wear a wool-blend suit. What was in the blend? The miracle fabric Dacron. Suits of 100 percent Dacron sold in 1951 for a pricey $79.50, but they resisted almost any stain without needing to be dry-cleaned.

ALBERT FENN / LIFE

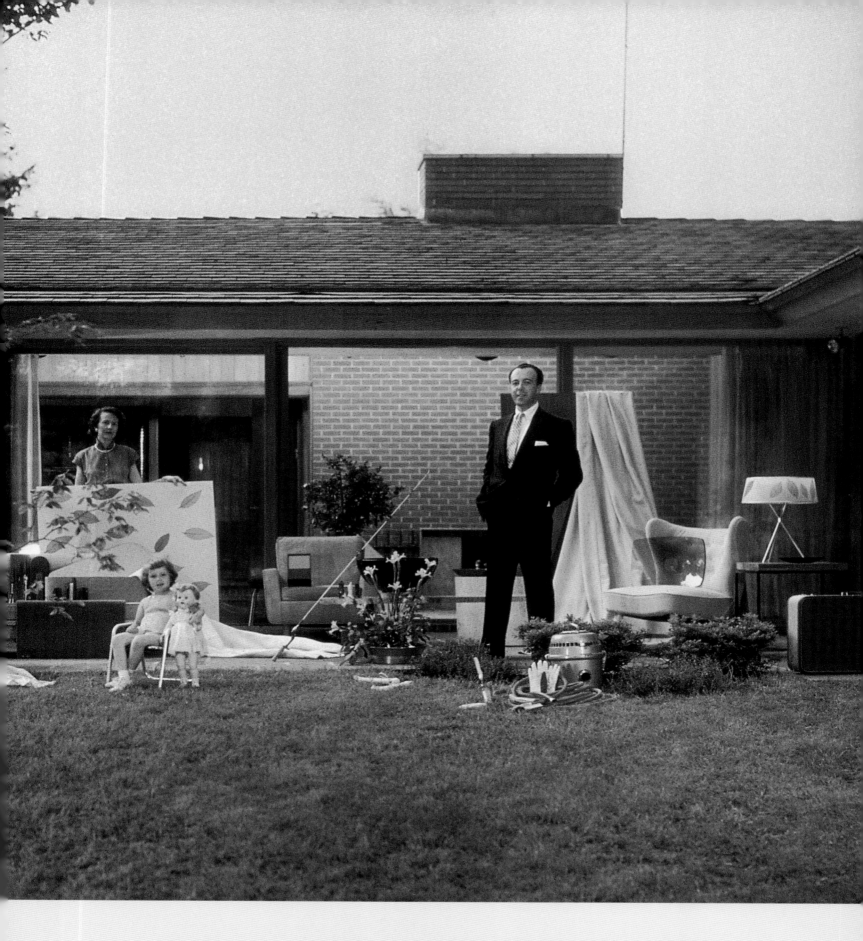

WARTIME EDGE

The secret weapon in the river-patrol boats used in the Vietnam War was fiberglass. About 500 boats with hulls made of threads of glass instead of steel were sent overseas, where their light weight made them easy to maneuver in tight, shallow waterways. Fiberglass was discovered in France in 1836, but it took more than a century to find such practical uses.

CORBIS / BETTMANN

THE DEFLECTOR

Knights' shields were made of metal. That's because they didn't have Kevlar, discovered by Stephanie Kwolek in 1965. With five times the strength of steel and less weight than nylon, the synthetic was soon being marketed by DuPont in bulletproof vests (right) and helmets. How many police officers' lives has it saved? The company estimates 2,000.

COURTESY DUPONT

FAR-OUT GEAR

Astronauts who leave their spacecraft to engage in extravehicular activity (EVA, NASA calls it) must wear gloves flexible enough to perform delicate tasks and insulated enough to protect them from 200° heat and minus-250° cold. Teflon coats the outside; beneath that are 11 layers of plastic; cotton (far right) keeps palms from being rubbed raw. The gloves have worked since 1965.

NASA

<

A REAL STRETCH

Look out, here comes spandex! It can stretch to 500 percent its original size, then ping back to its original shape. Designers had trouble finding uses for it, in 1987, which may explain why the models look somewhat skeptical. (That's Courtney Cox sitting, and Lisa Hartman with a bite out of her hip.) Little did they realize the material would wind up in swimsuits, ski pants and lots of other apparel.

GREG GORMAN

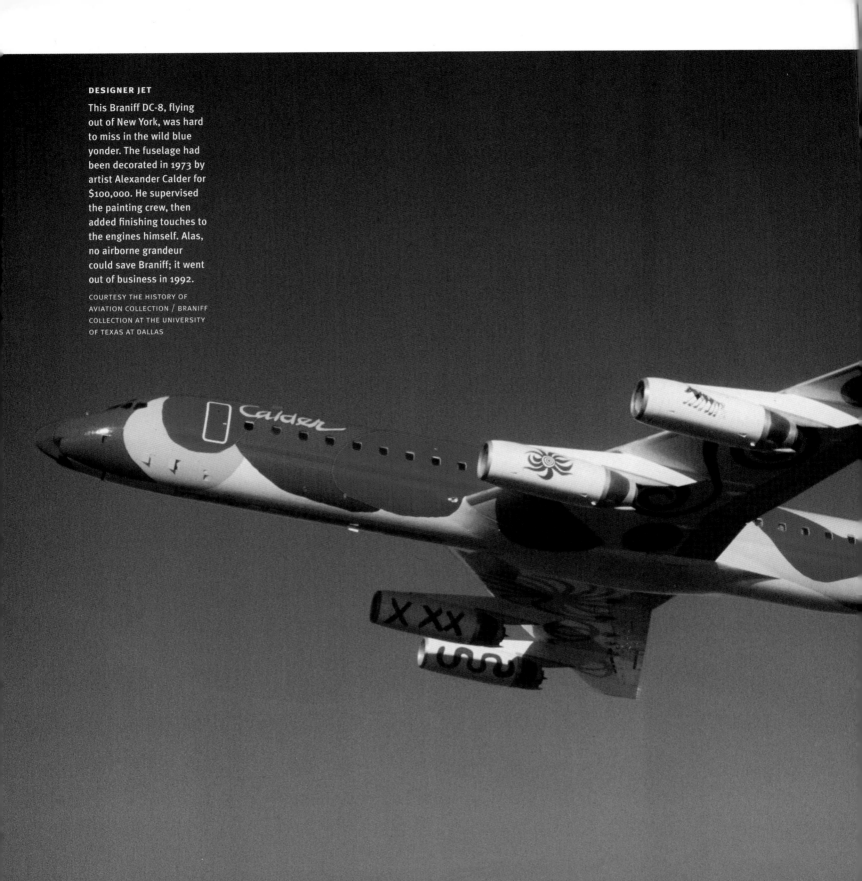

DESIGNER JET
This Braniff DC-8, flying out of New York, was hard to miss in the wild blue yonder. The fuselage had been decorated in 1973 by artist Alexander Calder for $100,000. He supervised the painting crew, then added finishing touches to the engines himself. Alas, no airborne grandeur could save Braniff; it went out of business in 1992.

COURTESY THE HISTORY OF AVIATION COLLECTION / BRANIFF COLLECTION AT THE UNIVERSITY OF TEXAS AT DALLAS

> **SHORT STORY**

When Mary Quant began lifting women's skirts in London in 1962, she wasn't the only designer baring some leg. But hers were truly minis. Quickly, the game was, how high can they climb? Jaques Tiffeaus took the style to the max, eight inches up the thigh. And they were measured — mini, micro, micro-micro, "Oh, my God," and "Hello, officer!"

VERNON MERRITT / LIFE

> **HOUSE OF WAFFLES**

In 1972, Bill Bowerman, track coach at the University of Oregon, gave his athletes more traction (thus more speed) when he cooked up on his waffle iron some new soles for their running shoes. He first sold his invention, called Nikes, out of his car but lived to see the celebrity sneaker era — and Nike worth $8.7 billion.

JEROME HART PHOTOGRAPHY / COURTESY NIKE INC.

> **GLORIA'S BRAND**

She was a designer, but she didn't design these jeans; she just put her name on them, which had the effect of turning farm duds into fashion. Gloria Vanderbilt had been a debutante, as well as the Poor Little Rich Girl in a famous Thirties custody battle. Women knew her name and, in 1979, wore it, grossing her and Murjani, the jeans' manufacturer, $120 million.

EVELYN FLORET

THE GIGOLO SELLS

The fashion industry was captivated by Richard Gere in *American Gigolo* — not for his performance as a male hooker but for his wardrobe. Except for his birthday suit, Gere wore only Giorgio Armani clothes in the film. The Italian designer's 1976 sales in the U.S., before the movie, were $90,000. In 1980, after Gere showcased the soft, elegant outfits, sales rose to $120 million.

PARAMOUNT /
NEAL PETERS COLLECTION

FASHION COURT

Michael Jordan started the baggy look in 1984 because he wanted to wear his college trunks under his Bulls uniform. Then the University of Michigan's Fab Five (shown here in dark blue), including future NBA stars Juwan Howard, Jalen Rose and Chris Webber, made the long, loose shorts official — for college, pro and even playground hoops.

JOHN W. MCDONOUGH /
SPORTS ILLUSTRATED

ART FOR ART'S SAKE

Architect Richard Meier saw a chance to capitalize on California: West L.A. hilltop, view of the Pacific, all that sunshine. The result: the $1 billion J. Paul Getty Museum, whose linked courtyards and light-drenched pavilions were finished in 1997 after 10 years. For much of the time Meier lived on-site, to keep a close eye on what was called "the commission of the century."

ROBERT LANDAU / CORBIS

DIFFERENT STROKES

Blueberry, tangerine, grape, strawberry, lime — and don't forget graphite. The cheery colors signaled a new dawn for customers: Computer packaging was finally in good hands. The savvy iMac, which debuted in 1998, 25 years after the original PC , was the first computer with graceful style. It doubled Apple's share of the retail market.

COURTESY TBWA / CHIAT DAY, INC.

Internet expressway.

 Think different.

celebrity

The price of fame has usually been privacy. In 1910, financier J.P. Morgan, self-conscious about his bulbous, scarred nose, kept photographers at cane's length. Teenage pop singer Britney Spears took a more benign approach to paparazzi in 1999, administering only a tongue-lashing.

THE LIMELIGHT—
LOVE IT
OR LEAVE IT

Horace Meets Henry Kissinger

BY JOHN LEONARD

IN A COOL ODE between hot epistles in the first century B.C., the poet Horace told us: "Many brave men lived before Agamemnon; but all are overwhelmed in eternal night, unwept, unknown, because they lack a sacred poet." Horace knew what he was oding about. For years, along with Virgil and Livy, he had written the ancient Roman equivalent of publicity releases and liner notes for the Emperor Augustus. So pleased, in fact, was Augustus at the job his pet writers did for him in the department of *pontifex maximus* image enhancement that he scrapped his own memoirs.

It should come as no surprise that from these same writers Antony and Cleopatra got a bad press. Who knew, for instance, that Cleo before Actium had been a working queen as well as a sexpot? That she spoke nine languages, wrote some books and cut a deal with the Nabataeans for oil rights in the Dead Sea?

But in the long history of celebrity — from Achilles sulking in his tent to Lindbergh over the Atlantic, from Alex the Great on coins to Elvis on a stamp, from Socrates to Kurt Cobain, not to mention Jesus, Napoleon, Joan of Arc, Louis Armstrong and Mother Teresa — what goes around comes around. In later centuries, whenever they needed a bad girl or a femme fatale or a campy Sphinx, Cleo attracted a slew of publicists: poets like Chaucer, Shakespeare and Pushkin; novelists like Charlotte Brontë and Edith Wharton; painters like Tiepolo; composers like Berlioz; and moviemakers like Cecil B. DeMille. What boys have done to impress girls, from Helen of Troy to Jodie Foster, will always be written up at epic length, either by sportswriters like Homer in the old Greek league or by gossip columnists like Plutarch and Liz Smith.

Honor, fame, glory, buzz: Winning at war has usually been good for a monument and maybe a marching song. Sainthood helps. So does kingship. And ever since Jack the Ripper, serial killers have gotten a lot of ink. The fame game is unpredictable. Notice that, in the long run, Horace and Virgil beat out Augustus. While it's easy to see in retrospect that the first Elizabeth of England and the 14th Louis of France ended up emblematic of their epochs because they had Shakespeare and Racine to stage them, nobody knew at the time that these writers would become even bigger names, ushering in a cult of the artist that was to endure, through the Romantic poets, at least till Hemingway. As once upon a Renaissance, hero-worshipers, the first fans, flocked to the noble feet of Erasmus or Spinoza, so in the 18th and 19th Centuries, the Grand Tour came to include Rousseau, Goethe and the Meistersinger of Bayreuth. Boswell, taking time off from Dr. Johnson, went so far as to sleep with Rousseau's mistress, Thérèse, hoping that greatness would somehow rub off on him. Lord Byron popularized incest, as well as dying young abroad.

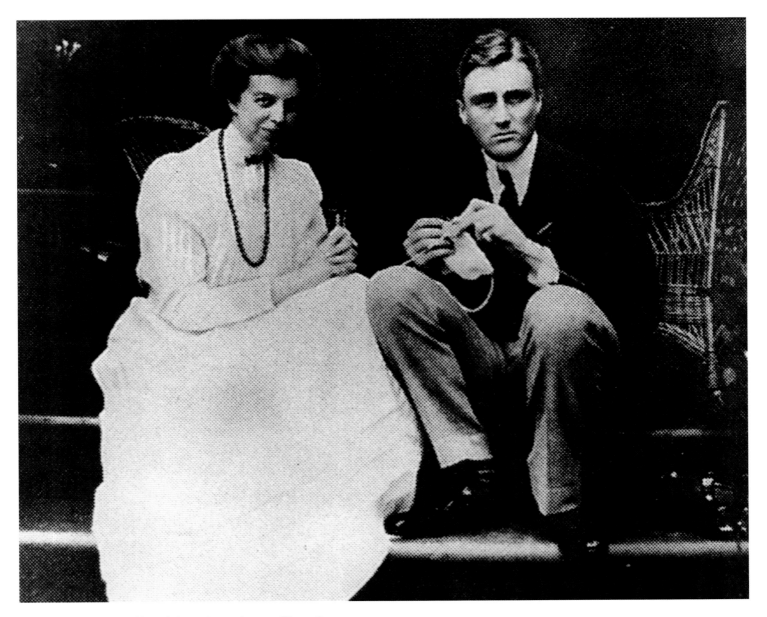

After marrying in 1905, Franklin and Eleanor Roosevelt wove a life together for 40 years. No First Couple had more durabilty or impact than these fifth cousins, whose record White House run lasted from 1933 to 1945.

It is in the protean nature of celebrity to shift shapes according to what a society in any given period has been encouraged to value — or taught to fear. Thus, on the one hand: the unique, the unprecedented, the fabulous surprise, the terrible waste, the incredibly lucky, the superbly athletic; wise men, gurus, the self-sacrificing and the Cinderellas; the first or last; pirates and cowboys. While, on the other hand: the monstrous, power mad, genocidal, filthy rich and kinky; the satanic prince and the black witch; traitors and infanticides; Attila and Rasputin. But such shapes also shift according to the technology available. Until 1839, in order to celebrate our leaders and our heroes, we had to get along with theaters and cathedrals, sculpture and paintings, ballads and folktales, slowly moving type and the loose change of the realm's coin. (And tombs too: Tutankhamen may have been a third-rate king, but he got himself buried in a style so gaudy as to stick forever in the mind's eye.) After 1839, all of a sud-

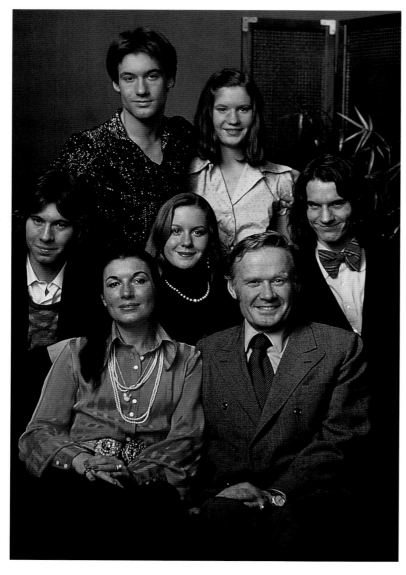

"For cryin' out loud," the country exclaimed when William and Pat Loud of Santa Barbara, California, and their five children bared their souls in a 1973 PBS documentary. The fallout: The parents divorced and one son declared he was gay.

RICHARD NOBLE

lege, artistic license or plutocratic clout — the self-made man! "It occurs to me," wrote the English poet Philip Larkin, "that the apparatus for the creation and maintenance of celebrities is vastly in excess of material fit to be celebrated." This missed the point. In America, beginning with the mass-circulation magazines of the late 19th Century; on to the Jazz Age conjunction of vaudeville and Broadway theater, ad agencies and tabloid newspapers, best-seller lists and Billboard charts, Tin Pan Alley and Harlem nightclubs, Madison Square Garden and radio variety shows; up through Hollywood, Ed Sullivan and the first television networks; all the way to Microsoft and Matt Drudge, we were inventing brand-new categories of the glamorous and delirious, the gossiped-about and envied; Rambos and dreamboats, Times Square and Graceland.

Return with us now to those thrilling days of yesteryear and an end run around Protestant respectability, in a backstage idiom of peekaboo, know-it-all and what's-it-to-you, a saloon-society pastiche of racetrack and underworld lingos, a pastrami slanguage of fan speak, jive talk, promoter hype, punk attitude and populist nose-thumbing — when the legs of the chorus girls went on forever, the gangsters were as cute as Gatsby, and motormouth Walter Winchell, under his signature snap-brim fedora, with a cigarette hanging out of his mouth like a fuse, got up from his table at the Stork Club after collecting confidential tips from lickspittle press agents (Babe Ruth, Charles Lindbergh and J. Edgar Hoover *all* had press agents) for his Hearst column and his radio broadcast to "Mr. and Mrs. America and all the ships at sea" to tool the predawn New York streets listening to his police band and packing a snub-nosed .38.

Or when Ed Sullivan, whose "rilly big shew" lasted 23 years on CBS, brought on animals and acrobats, ventriloquists and marching bands, David Ben-Gurion, Brigitte Bardot and the Singing Nun.

den, there were photographs, to be followed in bewildering rapidity by motion pictures, radio, television, a World Wide Web and branding: Michael Jordan for Nike Swoosh.

Matthew Brady meets P.T. Barnum. A democratic society and a popular culture changed the fame game utterly. Instead of royal fiat, aristocratic privi-

For Ed, who went to newspapers instead of college, all that mattered was the talent, the uniqueness. Anybody, by being better at what they did than everybody else who did it, could achieve his show, the odder the better. What we saw on his screen was the peculiar sanction of the democratic culture — from Willie Mays, Phyllis Diller, Tiny Tim and Tanya the Elephant, to Wernher von Braun, the Nazi rocketeer, or Rise Stevens singing "Cement Mixer Putty-Putty." Ed's role was to confirm, validate and legitimize singularity. Had he been around in fin de siècle Vienna, he would have put on Freud, Herzl, Schnitzler and 12-toned Schoenberg. History *mit Schlag*! Or in Weimar Germany, Kurt Weill, Lotte Lenya, Rosa Luxemburg and Bertolt Brecht.

After Ed, this role was assumed by Johnny Carson on the *Tonight* show, telling us when it was all right to laugh at Richard Nixon or Tammy Faye Bakker. But after Carson, there seems to be an absence of sanctioning authority, a hole in the wall into which Letterman and Leno rush; MTV, E!, *Talk Soup* and the Comedy Channel; *Saturday Night Live* with jokes about Monica, O.J., Michael Jackson and Lorena Bobbitt; Oprah, Geraldo and Montel; *People* and *Entertainment Weekly*; Jim Romesko's Media Gossip and *Vanity Fair*'s Oscar party; starlets who babble on about their substance abuse, their molestations, their anorexia and their liposuction; rock musicians addled on cobra venom, war criminals whose mothers never loved them and survivors of sperm-sucking alien abduction. Hostages are celebrities and so are assassins and fertility-pill quintuplets. They all write best-selling books. They all arrive at rehab with a public-relations agency, an entourage, bodyguards and paparazzi. Because of the wiretaps and the surveillance cameras, nothing they ever do will go unnoticed . And none of it will ever be forgotten because the great omnivorous media maw, in the frantic business of telling stories about the celebrities it

A secretive billionaire engrossed in conspiracy theories, political independent Ross Perot, 62, mesmerized the public with folksy infomercials during his 1992 run for the presidency.

AP

has manufactured by the gross then gobbling up everything that moves, finds itself hungry still for more, and thus regurgitates what it has already devoured in Nick at Nite reruns or on classic movie channels or with rental video cassettes, an endless recycling of faces that ought decently to have been allowed to fade and of sins that should long ago have been forgiven. There's hardly anyone left who hasn't already been and will forever be a soft-boiled 15-minute Warhol egg.

Then again, as Henry Kissinger has pointed out, "The nice thing about being a celebrity is that when you bore people, they think it is their fault."

John Leonard is media critic for CBS Sunday Morning, *TV critic for* New York *magazine, book critic for* The Nation *and the author of nine books of fiction and criticism. He has been editor of* The New York Times Book Review *and a columnist for* Life, Newsweek, Esquire *and* Ms.

POLE VAULTING

In 1909, Robert Peary, 53 (above, left), and his black partner Matthew Henson, 42, announced that they were the first explorers to reach the North Pole. Rival Frederick Cook said he had gotten there five days earlier. A bitter feud erupted that went on for decades. Today, it's believed both expeditions may have missed the mark. Though they considered themselves a team, Peary was revered back home as the Columbus of the Arctic; Henson was known only as his "faithful colored servant."

ABOVE: ROBERT E. PEARY COLLECTION / THE NATIONAL GEOGRAPHIC SOCIETY IMAGE COLLECTION
ABOVE RIGHT: THE GRANGER COLLECTION

THE PRINCESS WEDS

Alice Roosevelt was a wild child, Teddy's first of six from two wives. She careered around Washington in carriage and automobile and smoked in public. When she went out, she often took a pet snake along. Her nickname, not totally admiring, was Princess Alice. But when the president gave the 22-year-old away in the White House on February 17, 1906, to Ohio congressman Nicholas Longworth (right), the nation was delighted.

BROWN BROTHERS

FANNY'S FOLLIES

Fanny Brice sang and mugged her way from amateur shows to *Ziegfeld's Follies*, where at 19 she melted Broadway audiences with Brooklynese ballads and mock ballets like *The Dying Duck*. Her legend grew when her first husband, con man Nick Arnstein, was jailed and later fled. She married impresario Billy Rose and inspired the 1964 musical *Funny Girl*.

CULVER PICTURES

Harriet
Quimby
Pioneer
Pilot

USAirmail
50

HEAVEN BORNE

Before Earhart, even before Lindbergh, there was Harriet Quimby, an aviatrix so celebrated, she wound up on a 1991 airmail stamp. The first American woman to receive a pilot's license, she was honored in April 1912 for flying her French Blériot monoplane across the English Channel. That summer, at a Boston air show, Qumiby, 37, fell out of her plane and died. This was before seat belts.

FILMLAND'S FIRST COUPLE

America's Sweetheart, Mary Pickford, and America's Heartthrob, Douglas Fairbanks (here hauling a tree she gave him on their wooden fifth anniversary), presided over 1920s Hollywood from a 42-room refurbished hunting lodge called Pickfair. Besides enrapturing early filmgoers, Pickford was the silent era's first powerful woman, founding United Artists with her husband, Charlie Chaplin and D.W. Griffith.

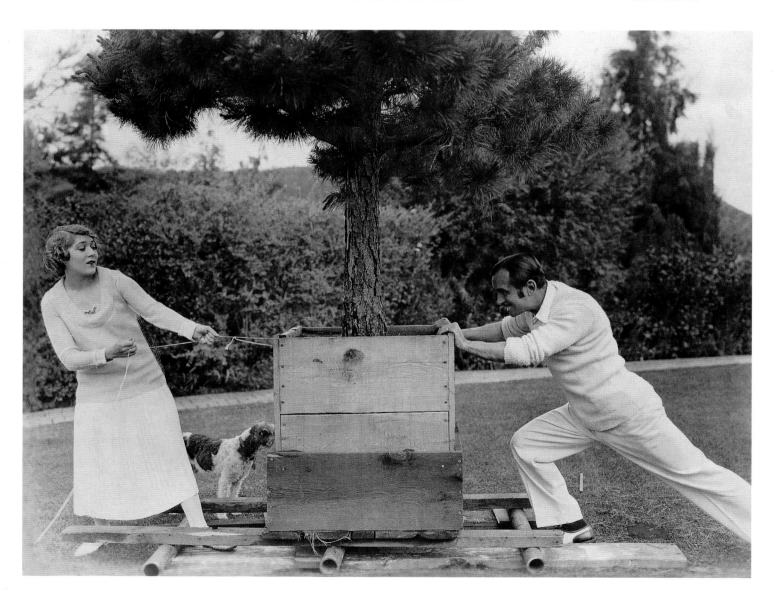

ALL THAT JAZZ

This happy Christmas scene in 1925 — Scott and Zelda with daughter Scottie — did not foretell the Fitzgeralds' tragic ends. He captured the spirit of the Jazz Age in his classic novel, *The Great Gatsby*, but later turned to hack scriptwriting, drank too much and died of a heart attack. Zelda, a gifted painter who suffered from emotional problems, died eight years later in a fire at a sanitarium.

MRS. FRANCES SCOTT
FITZGERALD LANAHAN

FREE AT LAST

Harry Houdini became a national hero by creating a repertoire of daring escapes: from a straitjacket while suspended from a skyscraper, out of prison cells and coffins, through padlocked trunks submerged in rivers. He tapped into a deep American desire to be free, goes one theory. He died from an unexpected punch to the stomach in 1926.

BROWN BROTHERS

CLOSE UP

THE BARRYMORES

Talented Trio

The Fabulous Barrymores, they were called, and for more than 150 years they provided America with stage and screen idols. Lionel and Ethel were prodigiously talented, but neither was as gifted, or as relentlessly self-destructive, as John. During his golden age, from 1915 to 1935, he was the most cherished actor of his generation. His great profile — always the left side; the right, he explained, resembled a fried egg — was displayed in 57 films, including 1926's *Don Juan* (below), the first feature with "sound," which then meant music only. His siblings continued to work, but John eventually became an embarrassment: a burnt-out drunk who died broke in 1942.

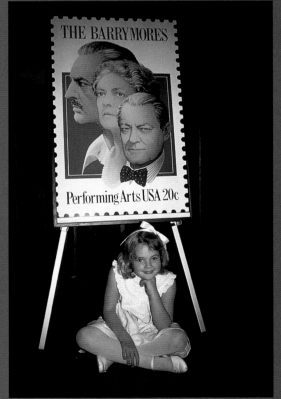

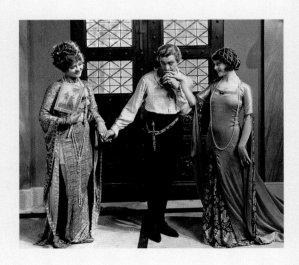

The matriarch of the clan, Georgiana Drew (right), wed fellow actor Maurice Barrymore. Their three children grew up to barnstorm the country in many plays but appeared together only once, in the movie *Rasputin and the Empress*, a 1932 costume drama in which (above, from left) Lionel was the mad monk; Ethel, the Tsarina; and John, a prince. At age seven, John's granddaughter Drew (left) shot to stardom in Steven Spielberg's *E.T.* Like John, she had an eerie ability to self-destruct in public. She was a drug addict by 12, but resurrected her career in her 20s.

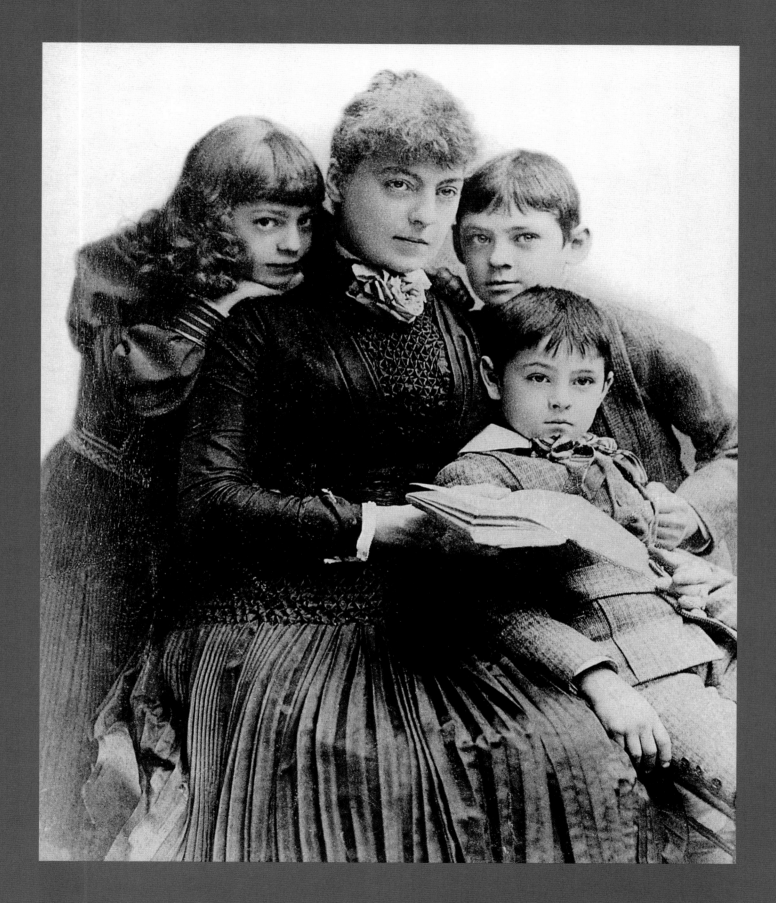

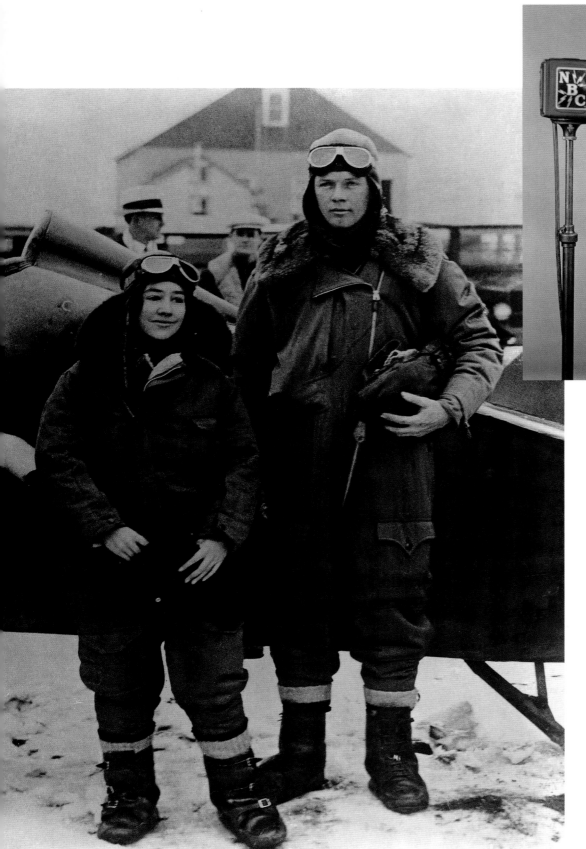

IT WAS WALT'S FAULT

In the Thirties and Forties, Walter Winchell was the voice of America. His snappy daily column ran in 2,000 newspapers, and his Sunday evening radio broadcast was at one time the most-listened-to show in the country. Feeding the public a diet of pure (and often right-wing political) gossip, the father of the modern cult of personality was as big as the big shots he covered.

<

LINDY AND WIFE

Charles Lindbergh's 1927 solo flight from New York to Paris made him the first global media star. The world cheered again two years later when Lucky Lindy, 27, married Anne Morrow, 23, the daughter of Ambassador Dwight Whitney Morrow. They flew together to the Orient and grieved together in 1932 when their son was kidnapped and murdered. She later became a best-selling author.

BROWN BROTHERS

THE LONG WAY

A small-town Louisiana reformer turned ruthless machine politician, Huey Long rose to national prominence as the state's demagogic governor and flamboyant senator from 1928 to 1935. Feared, hated and loved, the folksy, thuggish Kingfish (right, in boater) was so controversial that he required his own security detail (here, National Guardsmen). Though constantly protected, he was assassinated in 1935.

AP

WE KNOW YOU, AL

After hightailing out of his native Brooklyn and blasting his way to the top of the Chicago mob, Al Capone took elocution lessons and became perhaps the first public-relations-conscious gangster. As Public Enemy No. 1, he always cooperated with the press, scored the cover of *Time* and even visited the set of *Scarface*, a 1932 film based on his career in crime.

TIME INC.

>
A LEGAL KNOCKDOWN

The first black heavyweight champion was Jack Johnson, whose marriages to Irene Pineau (right, in 1925) and two other white women were denounced in Congress and led to miscegenation laws in several states. Not only did his dominance in the ring spur a bigoted search for a Great White Hope to defeat him, but he also spent seven years in exile and eight months in prison for alleged "immoral behavior."

BROWN BROTHERS

KISS ME, KATE

The first power couple of Hollywood's sound era took wing in 1936 when actress Katharine Hepburn, 29, began dating commercial aviation pioneer Howard Hughes, 30. The eccentric Hughes, the only individual ever to own a movie studio, womanized his way across the Twenties and Thirties; the headstrong Hepburn rose from box office poison to four-time Oscar winner.

GEORGE CUKOR COLLECTION

ROOM FOR IMPROVEMENT

No author anticipated the onrushing celebrity culture better than Dale Carnegie, here at 48, whose *How to Win Friends and Influence People* was the first self-help best-seller (more than 10 million copies). Americans gobbled up such fortune-cookie wisdom as "believe that you will succeed, and you will" and learned how to make themselves, if not successful, at least more dynamic.

AP

KANE ENTERTAINS

When William Randolph Hearst was not throwing lavish costume balls for Hollywood notables, here in 1938 (from left, Jack Warner Sr., director Raoul Walsh, hostess and Hearst girlfriend Marion Davies, Hearst, Mrs. Raoul Walsh), the newspaper publisher was in the business of building them up and knocking them down. Hollywood got even in Orson Welles's savage 1941 bio film, *Citizen Kane*.

CORBIS / INTERNATIONAL NEWS PHOTO

<

PUTTIN' ON THE SPRITZ

New York City mayor Fiorello La Guardia was a tireless show-off who read the funnies to kids on the radio during a newspaper strike, conducted the New York Philharmonic and doused a blazing dollhouse at a black-tie dinner to celebrate fire protection. For three terms (1934–45), the colorful Little Flower was a bridge between reformers and ethnic communities.

BROWN BROTHERS

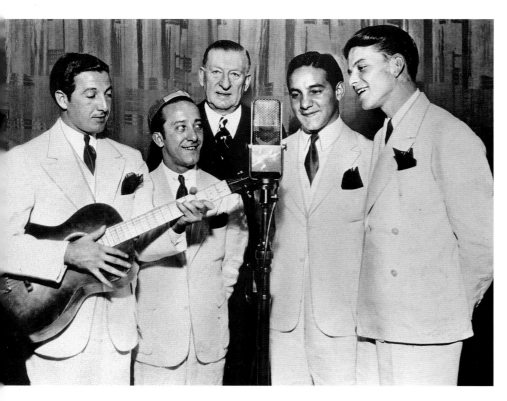

MAJOR STARMAKER

Not since Galileo has there been a greater starmaker than radio's Major Bowes. His 1935–46 amateur hour introduced such luminous talents as Teresa Brewer, Beverly Sills (at age 13) and the Hoboken Four (above), a clean-cut combo featuring Young Blue Eyes, Frank Sinatra, 20. Contestants got $10 an appearance, plus all they could eat on the night of the broadcast.

QUEEN ELIZABETH

Elizabeth Taylor, 12, wanted the part in *National Velvet* but was considered too small. She stuffed herself, grew three inches and nailed the role. Nailed America's heart too. Movie queen, businesswoman and wife to seven men, Liz has received more scrutiny and stirred more scandal than any other actress in Hollywood history.

MGM / NEAL PETERS COLLECTION

CAT IN THE HATS

Crowned by one of her trademark hats, gossip columnist Hedda Hopper, 54, reigned over Hollywood from her throne at the *Los Angeles Times*. From 1937 to 1965, she was a powerful and, at times, feared celebrity journalist. Hopper and rival gossipmonger Louella Parsons decided who was on the way up and down, and who was misbehaving with whom.

RALPH CRANE / LIFE

DEATHS IN THE FAMILY

More than half a century before Private Ryan was saved, the loss of the Sullivan brothers grieved, and inspired, the nation. When a friend was killed at Pearl Harbor, the five brothers from Waterloo, Iowa, quit their meat-packing jobs and enlisted. Newsreels celebrated their patriotism. All five died in 1942 when their ship, USS *Juneau*, was torpedoed near Guadalcanal.

CORBIS / BETTMANN-UPI

MONROE DOCTRINE

In the shadow world of postwar Hollywood, Marilyn Monroe (here at 24) embodied smiling-on-the-outside, crying-on-the-inside celebrity. She began as Norma Jean and ended with a drug overdose, maybe accidental, maybe not, in 1962. The quintessence of white, feminine sex appeal, she played her greatest role as the world's supplicant, making and remaking her identity. Her fragile life inspired the adoration of millions.

GEORGE ZENO COLLECTION

> **TO BE ALONE**

The woman crossing a New York street in dark vestments and clunky shoes was the once unattainable Swedish beauty, Greta Garbo, in 1955. After the release of her 31st film, the poorly received *Two-Faced Woman*, in 1941, she retired. She had not liked surrendering her privacy during her career. Now she lived in virtual seclusion, occasionally glimpsed and photographed. She died in 1990.

LISA LARSEN / LIFE

INTO THE WOODS

When his 1951 book *The Catcher in the Rye* hit big, writer J.D. Salinger, 32, promptly withdrew from the world. Finding the publicity and publication process intolerable, he retired to a house in New Hampshire to watch old movies and practice homeopathy. Though he apparently continues to write, he has not published since 1965. Fans still make pilgrimages to his home.

MURRAY GARBER

THE UNION FOREVER

An angry, smudged John L. Lewis had just visited a coal mine accident site in 1951. For five decades he was the gritty hero of American labor, waging war against mine owners, other union leaders, Congress and the White House. Voted president of the then powerful United Mine Workers in 1920, Lewis dominated the mass media with dynamic if sometimes unpopular actions, such as leading a series of coal strikes during World War II.

ED J. BURKHARDT / ST. LOUIS POST-DISPATCH

THE FIGHT DOCTOR

Joyce Brothers, the mother of media psychology, pummeled her way to TV eminence in 1955 as a winning contestant on *The $64,000 Question*. An unlikely expert on boxing — her answers ranged from the name of the glove that Roman gladiators wore to the number of times Dempsey knocked down Firpo — she was asked to wait before cashing the check. The producers hadn't budgeted for her victory.

BOB WENDLINGER /
CORBIS / BETTMANN

IVORY HUNTING

At a maddeningly precocious 23, Van Cliburn, out of Louisiana by way of Julliard, became the first American to win the International Tchaikovsky Competition in Moscow. The 1958 triumph, at the height of the cold war, endeared him to the Russian people and earned him a ticker-tape parade in New York City. The pianist's subsequent world tour sold out everywhere.

PAUL MOOR

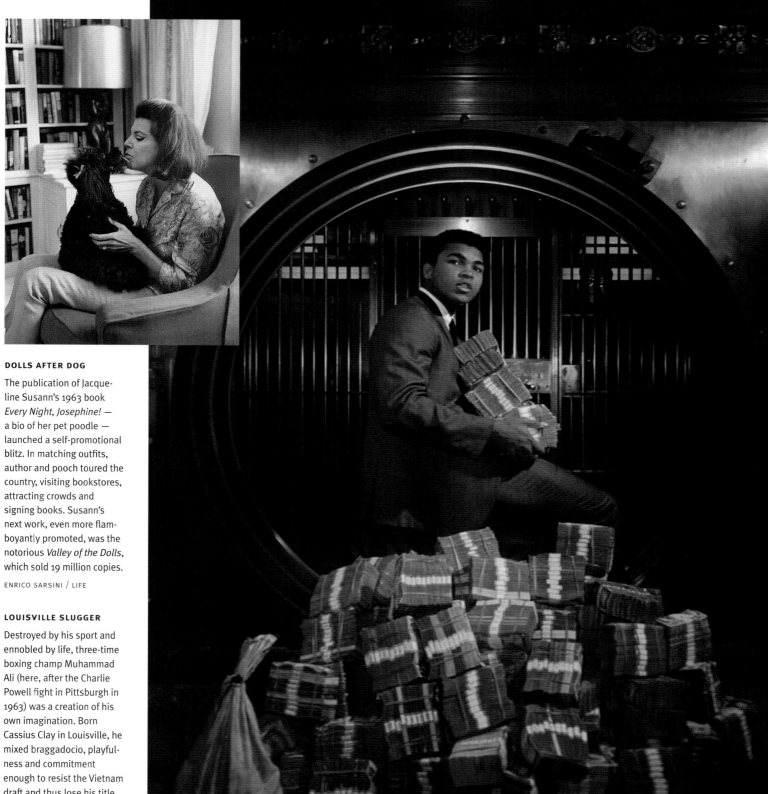

DOLLS AFTER DOG

The publication of Jacqueline Susann's 1963 book *Every Night, Josephine!* — a bio of her pet poodle — launched a self-promotional blitz. In matching outfits, author and pooch toured the country, visiting bookstores, attracting crowds and signing books. Susann's next work, even more flamboyantly promoted, was the notorious *Valley of the Dolls*, which sold 19 million copies.

ENRICO SARSINI / LIFE

LOUISVILLE SLUGGER

Destroyed by his sport and ennobled by life, three-time boxing champ Muhammad Ali (here, after the Charlie Powell fight in Pittsburgh in 1963) was a creation of his own imagination. Born Cassius Clay in Louisville, he mixed braggadocio, playfulness and commitment enough to resist the Vietnam draft and thus lose his title. Talking almost as well as he punched, Ali always commanded center stage.

RICHARD MEEK / SPORTS ILLUSTRATED

TURNING POINT

Who, Me?

In his 17th Century comedy *Twelfth Night*, William Shakespeare wrote, "Some are born great, some achieve greatness, and some have greatness thrust upon them." Throughout the 20th Century, comic and tragi-comic thrustees periodically appeared on the world stage. They were often innocent bystanders to history who happened to be in the right place at the right time or the wrong place at the right time or the right place at the wrong time. About the only thing these athletes and artists, cave explorers and home movie enthusiasts had in common is that they were never in the wrong place at the wrong time.

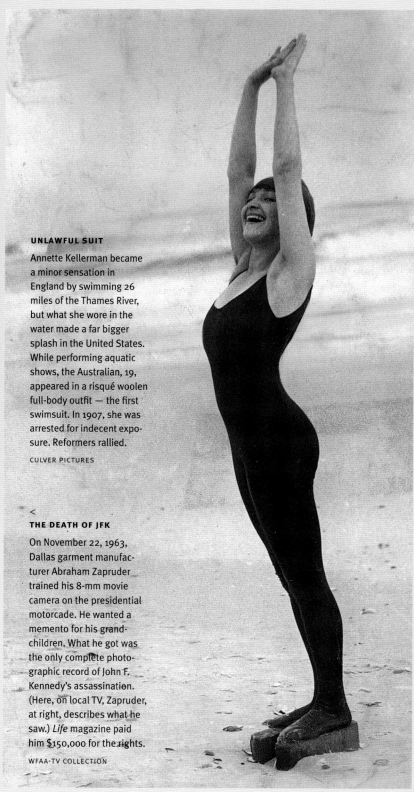

UNLAWFUL SUIT

Annette Kellerman became a minor sensation in England by swimming 26 miles of the Thames River, but what she wore in the water made a far bigger splash in the United States. While performing aquatic shows, the Australian, 19, appeared in a risqué woolen full-body outfit — the first swimsuit. In 1907, she was arrested for indecent exposure. Reformers rallied.

CULVER PICTURES

<

THE DEATH OF JFK

On November 22, 1963, Dallas garment manufacturer Abraham Zapruder trained his 8-mm movie camera on the presidential motorcade. He wanted a memento for his grandchildren. What he got was the only complete photographic record of John F. Kennedy's assassination. (Here, on local TV, Zapruder, at right, describes what he saw.) *Life* magazine paid him $150,000 for the rights.

WFAA-TV COLLECTION

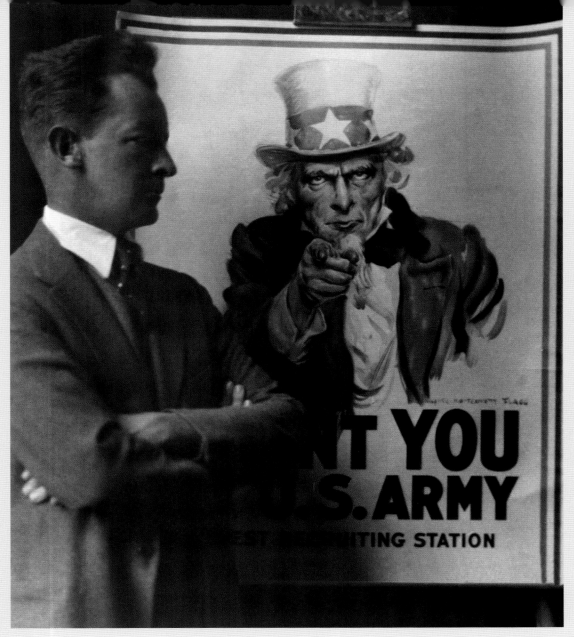

GRAND OLD FLAGG

Commissioned in 1917 to produce a recruiting poster, James Montgomery Flagg, 30, drew a portrait of himself in a white beard, old-fashioned coat and star-emblazoned top hat over the caption: "I Want YOU." The poster was as ubiquitous as Kilroy: Four million copies of the "Uncle Sam" notice were printed during World War I and another 400,000 in World War II.

ARNOLD GENTHE / CORBIS

UNDERGROUND VICTIM

In 1925, the nation was mesmerized by the efforts to rescue Kentucky caver Floyd Collins, 37, who was trapped underground. Collins (here on an earlier expedition) had been searching for a tourist attraction like Crystal Cave, which he had discovered on the family farm eight years before. After 17 days, he died of exposure.

CORBIS / INTERNATIONAL NEWS PHOTO

WRONG WAY RIEGELS

Roy Riegels blundered into sports infamy by running the wrong way during the 1929 Rose Bowl. The University of California lineman picked up a Georgia Tech fumble on the 20-yard line, spun around and sprinted toward his own goal. A teammate tackled him on the one. On the next play, a Cal punt was blocked for a safety; Reigels's team lost the game, 8–7.

CULVER PICTURES

<

MOTION TABLED

Edward W. Browning, 51, was a New York City real estate tycoon with millions in the bank when he fell for Frances Heenan, who was only 15. He called her Peaches; she called him Daddy. They married on April 11, 1926. Peaches fled after seven months; her newspaper accounts of life with Daddy were juicy reading. Her divorce settlement came to $170,000.

CULVER PICTURES

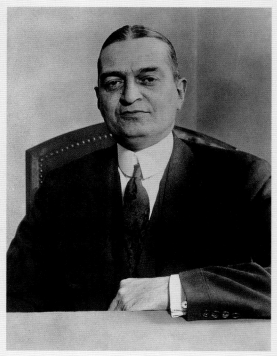

MAKING A NAME

Having a crime named for him was the legacy of Charles Ponzi (here, eating spaghetti), who fleeced 40,000 investors out of nearly $15 million. He worked a pyramid con in trading postal reply coupons, using new investors' money to pay off earlier investors, and of course keeping some for himself. "Fifty percent profit in 45 days!" he claimed. He went to prison in 1920 for mail fraud.

CORBIS / BETTMANN

WITHOUT A TRACE

One of the century's great mysteries was the August 6, 1930, disappearance of Judge Joseph Crater. He took some papers from his New York City office, cashed two large checks, later hailed a cab and vanished forever. There was some speculation that he was murdered by gangsters, but no firm evidence was ever found.

CULVER PICTURES

MEET CHRISTINA

She sits on the ground, her hair blowing in the wind, staring at the horizon. That's how Andrew Wyeth painted his Maine neighbor, Christina Olson, in the widely recognized *Christina's World*. Crippled by polio, Christina (with her brother Alvaro, also a model, and Wyeth in the photograph at left) was painted other times by Wyeth, but she never exploited her fame and died in 1968 in relative anonymity.

ABOVE: MUSEUM OF MODERN ART
LEFT: KOSTI RUOHOMAA / BLACK STAR

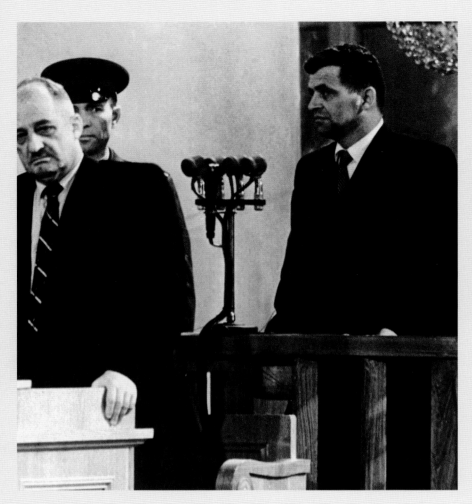

WANING POWERS

After his high-altitude espionage plane was shot down in 1960 over the Soviet Union, pilot Gary Francis Powers, 30, was captured and put on trial (above), imprisoned until 1962, then returned home in a dramatic East-West spy swap. Criticized for not committing suicide, Powers was snubbed by his former CIA bosses. He died in a 1977 helicopter crash.

CORBIS / BETTMANN

> FROM THE JAWS

In January 1982, an Air Florida jet crashed into the Potomac in Washington, D.C. Most passengers died, but one, Priscilla Tirado, 22, struggled desperately to swim ashore. Passerby Lenny Skutnik, 28, plunged into the frigid water and towed her to safety (top right). He was hailed as a hero. The two, savior and saved, met again later that year at her home in Florida.

TOBEY SANFORD / WJLA-TV
BELOW RIGHT: DAVID HUME KENNERLY

< FAIR WARNING

The right to remain silent after arrest comes from this man, Ernesto Miranda. Though he confessed to kidnapping and sexual assault in 1963, the Supreme Court ordered a new trial because the Phoenix police failed to tell him he could have a lawyer present at questioning and then say nothing. Bad men sometimes make good laws. Miranda later spent six years in prison, then died in a bar fight.

AP

< FACING THE MUSIC

Fawn Hall, 27, was an overnight sensation in the 1987 Iran-Contra hearings (arms to Iran; funds to anti-communist rebels in Nicaragua). She testified that when her White House boss, Lieutenant Colonel Oliver North, ordered her to destroy or alter government documents, he was obeying "a higher law." Eight years later, Hall confessed that she had become a crack addict.

STANLEY TRETICK / CORBIS SYGMA

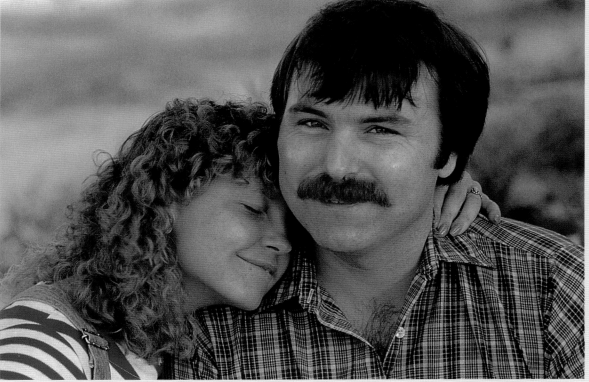

In 1997, disgruntled onetime White House secretary Linda Tripp, 47, began making secret telephone tapes of co-worker Monica Lewinsky's stories of a sexual relationship with Bill Clinton. When Tripp gave the recordings to investigator Kenneth Starr, a presidential scandal erupted. Though she claimed her actions were altruistic, the whistleblower was widely reviled.

JAMAL WILSON / AFP

>

THE KNOWN SOLDIER

Twenty-six years after his plane was shot down in Vietnam, Air Force Lieutenant Michael J. Blassie (inset) of St. Louis was ID'd as the Vietnam serviceman buried in the Tomb of the Unknowns in 1984. At the request of Blassie's family, DNA testing verified the remains. The government has decided not to put anyone else in the sacred crypt.

THOMAS D. MCAVOY / LIFE
INSET: COURTESY BLASSIE
FAMILY

KING'S APPEAL

In 1991, construction worker Rodney King, 25, was arrested by Los Angeles police after a high-speed car chase. A plumbing-store manager videotaped four officers repeatedly kicking and hitting the prostrate King as 11 others stood by. When the cops were acquitted of the beating, deadly riots broke out. King publicly pleaded (above), "Can we all get along?"

LEE CELANO / REUTERS /
ARCHIVE PHOTOS

THE MOOCHER

Aspiring actor Brian (Kato) Kaelin, 35, was America's best-known houseguest during the 1995 murder trial of O.J. Simpson. Because Kaelin had spent the night of the crimes in the former football star's house and remembered nothing unusual, he was treated as a hostile witness by prosecutors. Afterward, he had a short career as a radio talk-show host.

RICHARD MACKSON

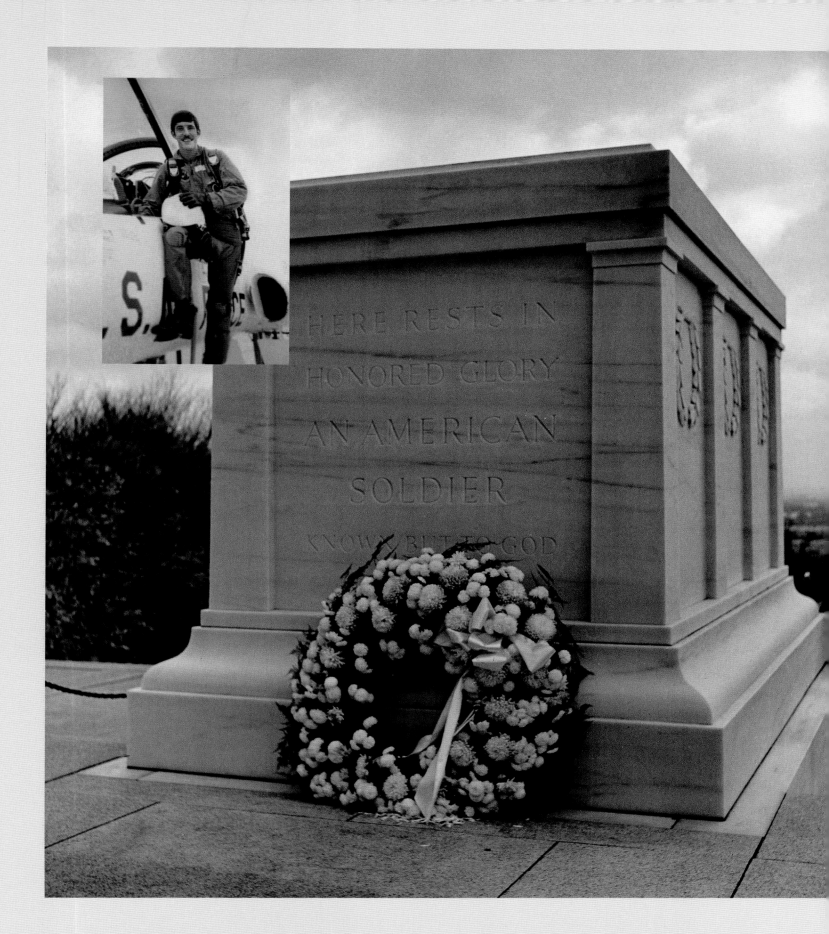

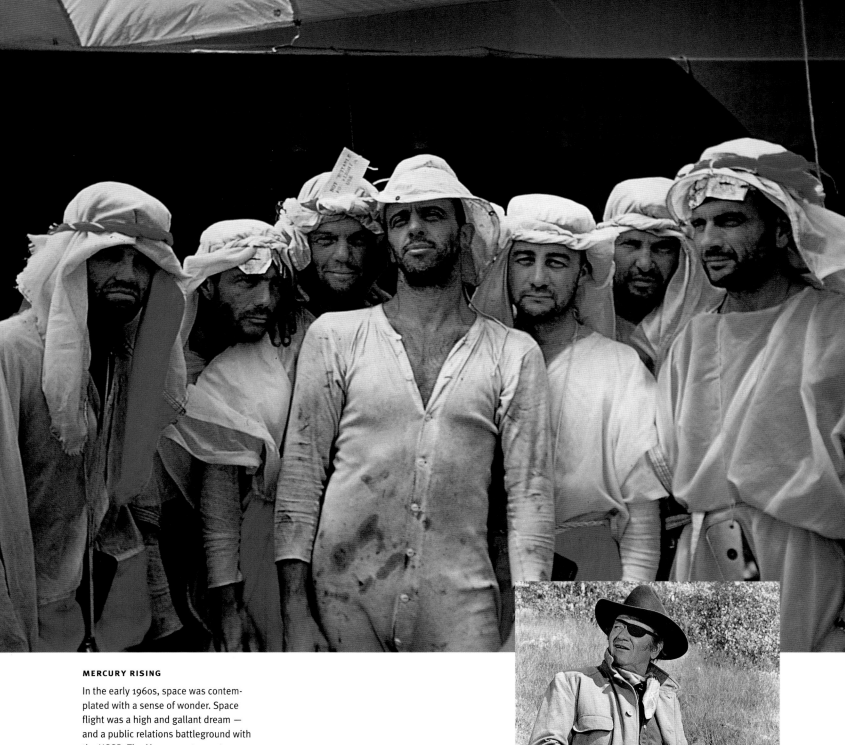

MERCURY RISING

In the early 1960s, space was contemplated with a sense of wonder. Space flight was a high and gallant dream — and a public relations battleground with the USSR. The Mercury astronauts were the U.S.'s not-so-secret weapons. Their training rituals were assiduously covered, especially when the seven ex-pilots came off a desert survival course looking rugged and mean. Still, the first man into space was not one of them, but a Soviet.

NASA

WAYNE'S WORLD

John Wayne, 62, won an Academy Award as a drunken, one-eyed cowpoke in *True Grit* in 1969. He died in 1979. Yet so resonant was his memory with Americans that 16 years later, they still ranked him as their favorite movie star. Here and abroad, he came to represent America itself.

MOVIE STAR NEWS

TWIN PEAKS

When it came to dispensing advice, no one was more widely read than Ann Landers (above, left). Unless it was her twin, Abigail Van Buren. The siblings from Sioux City, Iowa (where they attended their 40th high school reunion, above, in 1976, at age 58), became the nation's top columnists on romance and families. Despite the rivalry, they are still on speaking terms.

DECLAN HAUN

CHECKMATE CHAMP

When he was not relaxing at the bottom of the pool, Bobby Fischer, 29, of Brooklyn (left) was beating the Soviets at their own game: chess. In 1972, when the superpowers were still in a deep freeze, Fischer took on USSR grandmaster Boris Spassky, 35, in Reyk-javik, Iceland. An unconscious master of the art of intimidation, Fischer outpsyched and outplayed his opponent, $12\frac{1}{2}$–$7\frac{1}{2}$.

HARRY BENSON

MATERIAL CULTURE

The first annual MTV Video Music Awards in 1984 marked the coronation of Madonna Louise Ciccone, 26, as the queen of pop. One critic complained that she performed "dreadfully in her underwear and a smile." But it worked: *Like a Virgin* soon vaulted to No. 1. Later, the Boy Toy made movies, a book, more music and two babies.

DAVID MCGOUGH / DMI

OUT OF JUICE

Until displaced by Mother Teresa, Anita Bryant topped *Good Housekeeping*'s list of Most Admired Women. But the beauty queen turned religious singer turned orange juice pitchwoman fell out of favor in the late Seventies when she bashed gays. One activist smacked her with a pie in 1977. Others picketed her concerts and boycotted OJ. She lost her contract and faded into oblivion.

CORBIS / UPI

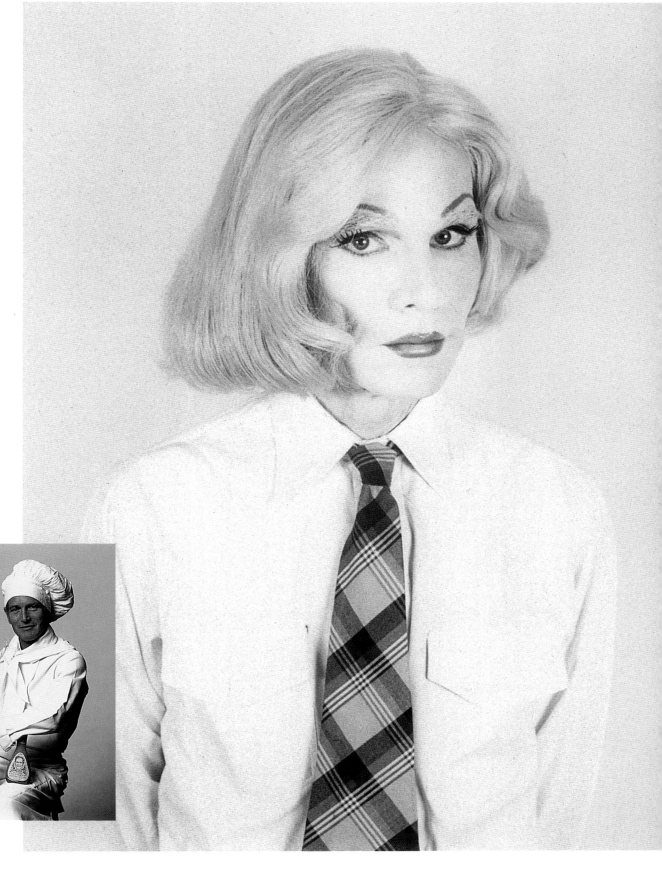

> **IT'S A DRAG**

Andy Warhol's fame lasted a lot longer than 15 minutes. A flagrantly commercial antihero of the Sixties subculture, he was lionized by New York's beautiful people. His absurdist pop images of soup cans and Marilyn Monroe (whom he dressed up to eerily resemble, right) attracted wide attention and, after his death in 1987, eight-figure sales.

CHRISTOPHER MAKOS / CORBIS SYGMA

SALAD DAYS

Actor Paul Newman decided one Christmas that the salad dressing he bottled for friends was good enough for the public. Ignoring lots of well-meaning advice, he went commercial in 1982. Since then, thanks to his second career as food mogul (besides dressing, he sells popcorn, pasta sauce, salsa, lemonade), Newman has donated $100 million to charities.

STEVE CALHOUN

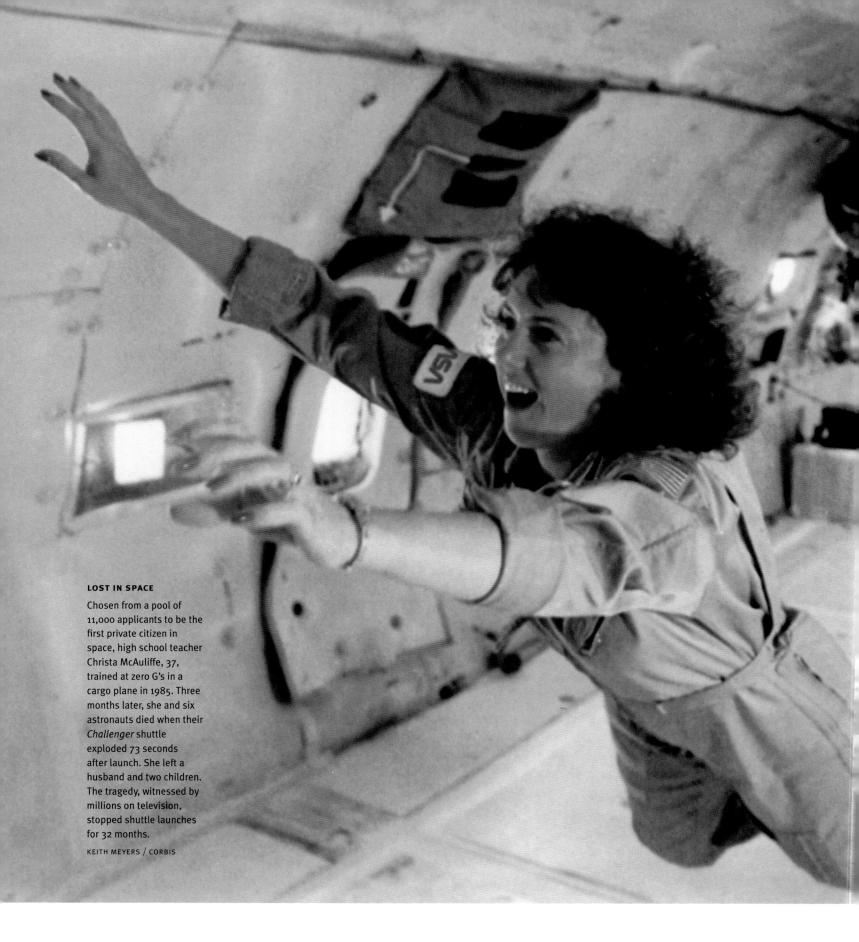

LOST IN SPACE

Chosen from a pool of 11,000 applicants to be the first private citizen in space, high school teacher Christa McAuliffe, 37, trained at zero G's in a cargo plane in 1985. Three months later, she and six astronauts died when their *Challenger* shuttle exploded 73 seconds after launch. She left a husband and two children. The tragedy, witnessed by millions on television, stopped shuttle launches for 32 months.

KEITH MEYERS / CORBIS

HOW FAR IS DOWN

How are the mighty fallen, intones the Bible. Yea, verily. And few plummets were steeper than Jim and Tammy Faye Bakker's. The married hosts of their own high-rated Christian TV show slunk off in disgrace after Jim admitted to adultery and financial scandal. He spent five years in jail for defrauding followers of an estimated $158 million. The long-lashed Tammy divorced him in 1992.

AP

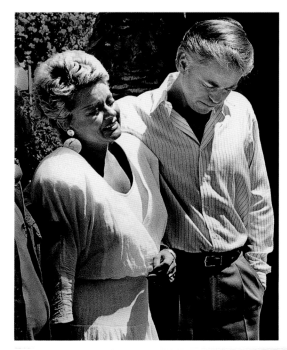

BUILDING A FUTURE

Jimmy Carter may have ennobled the presidency more since he left it in 1980 than when he was there. While other ex-Presidents golf, Carter is an active humanitarian. Every year he (here nailing shingles in Charlotte, North Carolina, in 1987) and wife Rosalyn join other Habitat for Humanity volunteers to build a house for the poor. His Carter Center helps settle international disputes.

STEVE McCURRY / MAGNUM

THE HIGHEST HONOR

In 1993, Toni Morrison became the first black American woman to receive the Nobel Prize in Literature (right, with King Carl Gustaf of Sweden). Her novels, including *Beloved* and *Song of Solomon*, reflect the African-American experience. In her acceptance speech, she said, "We die. That may be the meaning of life. But we do language. That may be the measure of our lives."

PRESSENS BILD AB / LIAISON

CLOSE UP

JAMES CARVILLE

Spin City

A political Napoleon, James Carville devised both the strategy and the tactics that catapulted Bill Clinton from a virtual Arkansas unknown to the presidency in 1992 (above). Carville deftly maneuvered through every campaign obstacle with a combination of Cajun charisma and Rottweiler ferocity, propelling his candidate into the White House and himself into national prominence. He went into politics in 1980 after practicing law for seven years and ran the Clinton campaign from the Little Rock headquarters known as the War Room (upper far right). The victory produced the first Democratic administration in 12 years.

A sweet-faced baby (right) — but look at those piercing eyes then and later (below) — Carville grew up the oldest of eight children in an eponymous, one-stop-sign Louisiana town named at the turn of the century for his grandfather, who was postmaster. His father, Chester James Carville, was postmaster too and ran a general store; his mother, named Lucille but known as Miss Nippy, sold World Book encyclopedias door-to-door and helped pay for college for the whole brood.

Democrat Carville, 54, married Republican Mary Matalin, 45, deputy campaign manager of George Bush's unsuccessful 1992 re-election bid. Their public disagreements on politics are the stuff of popular TV (below), but their apparently thriving marriage has produced two young daughters. In 1994, they co-wrote a best-selling book: *All's Fair: Love, War and Running for President.* Says Carville about sleeping with the enemy: "It's the most American thing you can do."

LEFT: SPENCER TIREY / AP
BELOW: RICHARD ELLIS / LIAISON

RUSH TO JUDGMENT

With his blunt, off-the-cuff rants about "tree-hugging, pot-smoking, tax-hiking liberals," talk-radio host Rush Limbaugh, 41, became the voice of American conservatism, a best-selling author and the loudmouthed poster boy for millions of devoted Dittoheads. The tree huggers countered with their own best-seller: *Rush Limbaugh Is a Big Fat Idiot* by Al Franken.

JAMES LUKOSKI

>
CYBER SNITCH

Laboring alone in his apartment with a cheap computer and modem, gossip Matt Drudge, 32, broke the Monica Lewinsky story. Working on the Internet, he became the controversial buzz of the media-industrial complex. He posed here with his pants around his ankles because, he said, that's the way the president was caught.

MICHAEL GRECCO /
ICON INTERNATIONAL

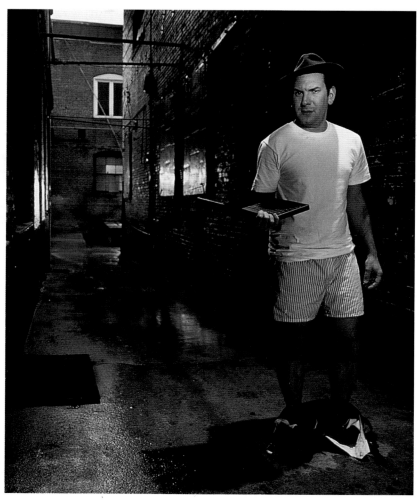

FIRE ON ICE

After rival figure skater Nancy Kerrigan was truncheoned just before the 1994 Olympic trials, Tonya Harding, 23 (above), of Portland, Oregon, played the villain. Though not implicated in the assault, she pleaded guilty to hindering the investigation. Tonya was banned from the sport for life, though she has since skated as a pro.

ENRIQUE SHORE /
REUTERS / CORBIS

>
THE WIND UP

Every step Elián González took, every pitch he made, was covered by the press. The six-year-old was the center of a bitter Cuban-American custody battle after he was found off the Florida coast in November 1999. His boat had capsized and his mother had died in an attempt to reach the States. He was finally returned to his father, Juan Miguel, who took him home.

GUERRERO / SIPA

INDEX TO PICTURES

Extended Picture Credits

While every effort has been made to give appropriate credit for photographs and illustrations reproduced in this book, the publishers will be pleased to rectify any omissions or inaccuracies in the next printing.

Page viii: Solomon D. Butcher Collection. **Page 7, top right:** George Eastman House; **middle right:** State Historical Society of Wisconsin, negative number (D28) 85. **Page 9, bottom:** Photograph by Jacob Riis. **Page 14, top:** Photographer unknown. **Page 18, top right:** Walker Evans Archive, The Metropolitan Museum of Art. **Pages 37; 41, bottom; 42, left; 55:** Milstein Division of the U.S. History, Local History and Genealogy, The New York Public Library, Astor, Lenox and Tilden Foundations. **Page 47, bottom:** Photographer unknown. **Page 57, bottom right:** The Procter & Gamble Company, An Ohio Corporation. **Page 68:** National Archives, American Image number 218. **Page 72:** Photographer unknown. **Page 87, top:** Corbis Sygma. **Page 90, top:** Photograph by J.R. Eyerman. **Page 97, top:** Hutchins Photography Inc., Watertown, Mass. USA. **Page 107:** Globe Photos. **Page 115, top left:** *Nude Descending a Staircase* 2000 Artists Rights Society (ARS), New York / ADAGP, Paris / Estate of Marcel Duchamp as per Duchamp estate rep. **Page 119, bottom right:** Disney Enterprises, Inc.; **bottom center:** Disney Enterprises, Inc. / Photograph by Ted Thai. **Page 120, top left:** Cartoonbank.com. **Page 129:** T.H. Benton and R.P. Benton Testamentary Trusts / Licensed by VAGA, New York, N.Y. **Page 136, bottom left:** Reprinted with permission from TV Guide Magazine Group, Inc., 1953, TV Guide, Inc., a registered trademark of the TV Guide Magazine Group, Inc. **Page 148, top:** Photograph by Michael Grecco / Icon International. **Page 151, bottom:** Printed by permission of the Rockwell Family Trust, 1962, The Norman Rockwell Family Trust. **Page 176, bottom right:** JELL-O is a registered trademark of KF Holdings. **Page 183, bottom right:** Albert Bonniers Forlag/AB. **Page 188, top left:** JOY OF COOKING is a registered trademark of The Joy of Cooking Trust, Reprinted by permission of McIntosh & Otis, Inc.; **top right:** Copyright Hormel Foods Corporation 1938, reprinted with permission. **Pages 210 and 211, top:** Milstein Division of United States History, Local History and Genealogy, New York Public Library. **Page 222, top:** National Archives, negative number 210-G-10C-839. **Page 241:** Photographer unknown. **Page 242:** Photographer unknown. **Page 255:** Courtesy The Hagley Museum and Library. **Page 257:** Courtesy Coca-Cola Company. **Page 262, bottom left:** Photograph by Bill King / Janet McClelland. **Page 263:** Photographs by Eddie Adams. **Page 267, left:** Harvard University. **Page 270, top right:** www.johnmcgrail.com. **Page 283, top left:** Photographer unknown. **Pages 320 and 321, top:** Photographer unknown. **Page 328, top right:** Copyright Halsman Estate. **Page 336:** From the Collection of Henry Ford Museum and Greenfield Village. **Page 339, top:** Courtesy The Hagley Museum and Library. **Page 360, top right:** Photographer unknown. **Page 361, bottom left:** Photographer unknown. **Page 370, bottom left:** The Sixth Floor Museum at Dealey Plaza.

LIFE: Century of Change

Editor: Richard B. Stolley
Deputy Editor: Tony Chiu
Designer: Susan Marsh
Picture Editor: Vivette Porges
Research Coordinator: Patricia Clark
Copy Editor: Richard McAdams
Writers: Tony Chiu, Leslie Jay, Marilyn Johnson, Franz Lidz, William McCoy, Robert Sullivan
Associate Picture Editors: Sheilah Scully, Cornelia Jackson
Photo Researchers: Marcia Dover Hoffman, Arnold Horton, Debra Cohen, Gretchen Wessels, Ellen Graham, Phil Brito, Frank Pisco, Kristine Gentile Smith
Researchers: Evelyn Cunningham, Zoraida Matos, Robert Paton, Annette Rusin, Carol Weil, Joan Levinstein, John Lovari

Special thanks to Daniel Chui (scanner), Lynn Dombek (research), Jill Jaroff (copy editor), Alana Cash (indexer), Sally Proudfit, Melissa Osorio and Jennifer McAlwee.

Produced in cooperation with Time Inc. Editorial Services

Director: Sheldon Czapnik
Research Center: Lany McDonald
Picture Collection: Kathi Doak, Daniel Donnelly
Photo Lab: Tom Hubbard, Tom Stone
LIFE Gallery of Photography: Maryann Kornely

Published by Time Warner Trade Publishing

Chairman: Laurence J. Kirshbaum
President: Maureen Mahon Egen

Bulfinch Press/Little, Brown and Company:
Publisher: Carol Judy Leslie
Senior Editor: Terry Reece Hackford
Associate Editor: Stephanie Vander Weide
Production Manager: Sandra Klimt
Production Coordinator: Allison Kolbeck

Bulfinch Press is an imprint and trademark of Little, Brown and Company (Inc.)

FIRST EDITION
ISBN 0-8212-2697-5
Library of Congress Control Number: 00-105956
PRINTED IN THE UNITED STATES OF AMERICA

Mars is the next frontier. It has always intrigued us: the vivid Red Planet (from rusted iron oxides on its surface),

about a quarter of our surface area, only 34.6 million miles away at the closest point. By deep space

standards, its surface is already crowded with gadgets from Earth — three landers and a rover —

with more coming in the next three years. We already suspect that Mars is not a dead planet,

that it may have volcanoes that were active as recently, in space terms, as 40 million years

ago and underground water, meaning the possibility of biologic life.

Astronauts some day may tell us even more.

U.S. GEOLOGICAL SURVEY / SCIENCE PHOTO LIBRARY / PHOTORESEARCHERS

LIFE: CENTURY OF CHANGE

DESIGNED BY SUSAN MARSH

PICTURES EDITED BY VIVETTE PORGES

COMPOSED IN META AND ITC BODONI BY RICHARD MCADAMS AND SUSAN MARSH

SEPARATIONS BY PROFESSIONAL GRAPHICS INC., ROCKFORD, ILLINOIS

PRINTED AND BOUND BY QUEBECOR PRINTING,

KINGSPORT, TENNESSEE